ANCESTRAL
CONNECTIONS

HOWARD MORPHY

ANCESTRAL CONNECTIONS

ART AND AN ABORIGINAL SYSTEM OF KNOWLEDGE

THE UNIVERSITY OF CHICAGO PRESS / CHICAGO AND LONDON

HOWARD MORPHY is lecturer in the Institute of Social and Cultural Anthropology at Oxford University.

The University of Chicago Press, Chicago 60637
The University of Chicago Press, Ltd., London
© 1991 by The University of Chicago
All rights reserved. Published 1991
Printed in the United States of America

00 99 98 97 96 95 5 4 3 2

Library of Congress Cataloging-in-Publication Data

Morphy, Howard.
 Ancestral connections : art and an aboriginal
system of knowledge / Howard Morphy.
 p. cm.
 Includes bibliographical references and index.
 ISBN 0-226-53865-6. — ISBN 0-226-53866-4
(pbk.)
 1. Murngin (Australian people)—Rites and
ceremonies. 2. Bark painting—Australia.
3. Philosophy, Australian aboriginal.
4. Symbolism in art—Australia. 5. Murngin
(Australian people)—Kinship. 6. Murngin
(Australian people)—Social life and customs.
I. Title.
DU125.M8M65 1991
306.4'7'0899915—dc20 91-15544
 CIP

∞ The paper used in this publication meets the minimum requirements of the American National Standard for Information Sciences—Permanence of Paper for Printed Library Materials, ANSI Z39.48-1984.

To the memory of NARRITJIN MAYMURU

Contents

Figures

Preface and Acknowledgments

I applied to the Australian National University in the early 1970s to study for a Ph.D. in anthropology, applying linguistic models to art in Malekula in what was then the New Hebrides. I eventually received a letter back, from an entirely different department than the one I had applied to, offering me a scholarship if I would study social change as reflected in the bark paintings of Northeast Arnhem Land. And that is how I ended up doing fieldwork among the Yolngu clans of Yirrkala on the Gove Peninsula between 1974 and 1976. I later became a lecturer at the same university and could discover no other occasion on which a scholarship had been offered with such conditions attached. I am still not entirely sure how it happened, but I will always be grateful that it did.

I never intended this book to be such a long time in the making either. I thought it was nearly ready for publication when I wrote it as a thesis at the end of the 1970s. I wanted to publish it quickly to get it off my hands and move on somewhere different, but somehow other things always inter-

vened. When I eventually made the time to put the finishing touches to it, I found it needed to be entirely rewritten—which was not as bad for me as it was for certain others who had to read it all over again. One thing that intervened was more fieldwork that enabled me to see more clearly the direction of change and the way in which the art was integrated within the process of reproduction of Yolngu society. I returned to Yirrkala in 1982 and 1988, and on several occasions Yolngu people came to live with us in Canberra and Darwin, sometimes for months at a time. Other things that intervened were teaching and other people's writing, both of which changed the way I thought about Yolngu art, and which in particular helped me develop a more complex perspective on the study of meaning. However, while the context in which it is embedded has shifted wildly, the central analysis has remained very little altered.

Because this book is in part an analysis of a system of restricted knowledge, I have had to be guided at times by ethical considerations in ensuring that certain things are not revealed. Although I argue later on that the place of secrecy in the Yolngu system is, to say the least, ambiguous, that the system in no sense depends on secrecy per se but on control of contexts where secrecy can be continually re-created, I have nevertheless adopted a cautious approach. I spent much time going through my thesis with Yolngu people, reading sections to them and showing them the photographs I intended to include in the book. As a result of this process I have cut certain illustrations out of the book and have not taken interpretations of the paintings as far into the realm of the "inside" as some might have wished. On the whole I was not told that something could not be included; rather, certain things were said to be suitable for anthropologists, lawyers, or politicians. Because I cannot guarantee the audience for the book, I have chosen in such cases not to include the information. However I am conscious of the danger of anthropologists and others creating secrecy through their actions and misinterpretations in contexts where, if anything, the Yolngu people themselves are opening out areas of their society from within.

I have also been faced with the problem of whether or not to disguise the individuals in the book. In principle I am against disguises since anthropologists are writing other peoples' history, and much of the usefulness of history is lost if it is impossible to connect it with real people and places. This has been particularly the case in colonial situations, and anybody who is aware of the way anthropological writings have been used in the southern part of Australia by contemporary Aboriginal people in reconnecting themselves with a past that had been

stolen from them should think twice before depriving people of their names. This is also a book about art created by painters, many of whom are well known. Apart from the fact that this makes disguise difficult, it goes against the wishes of many Yolngu who have struggled to gain recognition as artists in what I refer to later as the European frame. I have used disguise only where it is necessary to conceal sensitive information.

I have accumulated a great debt to others through the process of writing this book. My greatest debt is to Narritjin Maymuru, whose genius as an artist and a teacher guided my whole work. All members of his clan, the Manggalili, and their close relatives made my wife Frances and me welcome, but I must mention in particular his wife Bangara, his children Banapana, Bumiti, Galuma and Ganyul, his brother's children Baluka, Naminapu, Nyapililngu and Yikaki, and his granddaughter Leanne Ralwurranydji. Daymbalipu Mununggurr of the Djapu clan, once he had accepted my seriousness of purpose, spent many hours of his time discussing Yolngu law. Welwi early on enchanted me with his paintings and delighted in explaining to me their subtleties. Gambali gave me hours of formal tuition, and his brother Dula, ritual specialist of the Yirritja moiety, spared some of his great energy for me. Liyawulumu, an artist of imagination and knowledge crippled by an unknown disease, made me his friend. Lumaluma 2, Roy Marika, Yangarriny, Durndiwuy, Mithili, Maaw', Munggurawuy, Marrkarakara, Mithinari, Bokarra, Mutitjpuy and his daughters Djilirrma and Ngalawurr, and Laartjannga and Gaawirriny all helped immensely.

At Yirrkala, Leon White provided support, animated discussion and ideas, and frequently loaned us his vehicle, even after we turned it over while it was still brand new. Many members of the staff of the Uniting Church provided assistance, in particular the Noskes, the Hendrys, and the Rikas. Dan and Libby Gillespie provided hospitality and logistic support at Maningrida. The linguist Bernard Schebeck gave me sound advice my first night in the field and continued to be generous with his help and friendship throughout our stay. Several other anthropologists overlapped with us in the field: Jan Reid, Neville White, David Biernoff, and Nancy Williams. All contributed in different ways to my understanding of Yolngu society.

A number of museums made their collections available to me for study. In particular I must thank Alan West of the National Museum of Victoria, Jim Specht and David Moore of the Australian Museum in Sydney, Michael Quinnel of the Queensland Museum, and Mrs. Noel Keith of the Institute of Anatomy in Canberra for the assistance they

gave me. I am most grateful to Judith Wiseman, cataloguer of the Donald Thomson collection held in the National Museum of Victoria, for the many hours she spent guiding me through Thomson's field notes, photographs, and collections.

My initial fieldwork was funded by the Australian Institute of Aboriginal Studies in Canberra, with contributions from the Australian National University. The staff of the institute helped in every way to make our fieldwork a success by sensitively and promptly responding to mundane requests and unforeseen problems.

This book arises very much out of a discourse with others. In the field, Nancy Williams brought the intense atmosphere of the seminar room to our smoke-filled fibro hut. When writing up my doctorate I was fortunate enough to be able to have a continual exchange of ideas with Ian Keen, who was at the same time and in the next building writing his thesis on the neighboring Yolngu community at Milingimbi. Nic Peterson was always supportive, and his analysis of Yolngu ecology and territorial organization provided much important groundwork. Frances Morphy converted from anthropology to linguistics during the process of our fieldwork, and I have been fortunate in having the companionship of an expert friend and critic. I also had the great fortune to encounter and work with the filmmaker Ian Dunlop. His films, archival footage, and continual questioning on Yolngu art and ceremony ensured that I could continue with fieldwork at a distance.

Since this book, in its various forms, has taken over a decade to complete, I have accumulated debts to many supervisors, examiners, and readers. Peter Ucko converted me to seeing the importance of formal analysis and to a continuing questioning of assumptions. Anthony Forge always encouraged me to go beneath the surface of things. Nancy Munn went beyond the call of duty by examining this work as a thesis and then reading it twice again as a book. She forced me to think more rigorously about many conceptual issues and suggested several new theoretical directions. Deborah Battaglia read the final draft of the manuscript and helped point out a number of remaining weaknesses. The late Dick Davis shared our house when I was writing up the first time, provided detailed criticism, and showed me the direction in which my conclusion should go if I rewrote it as a book. The new conclusion necessitated a complete rewrite. John Mulvaney, who started the whole project, encouraged me to think about matters of clarity and style, and gave me an article on how to convert a thesis into a book. Les Hiatt read my thesis, gave valuable suggestions, and encouraged me to rewrite it as a book. Margaret Clunies-Ross, Luke Taylor, Fiona MacGowan, and Karel Arnaut have all read the manuscript in some form or another and made helpful comments.

In preparing the manuscript for publication I have been greatly assisted by Gillian Nash who typed out the bulk of it, Joan Goodrum, who prepared the drawings, and by Gerry Brush, who with great patience ironed out frequently occurring problems with the computer. My parents, Hugh and Grace Morphy, have always supported me and never caused me to doubt the value of what I was doing, even if at times they wondered if it need take quite so long. I will always regret that my father did not live to see the book completed since, apart from for myself, it was written for him and Narritjin. Becky and Ben will be pleased that the book is finished; they have grown up with it, and as often as not it has taken up the energies of both their parents, for Frances Morphy's talents as a linguist, field-worker, critic, and editor have been used on this book almost as much as mine. But as convention demands, I still claim credit for the errors.

1

Introduction

In a temporary shade made of cloth and canvas covering a framework of sticks, two men sit painting the lid of a coffin. They paint for hours at a time at the back of the shade, separated from the open entrance by other men who sing songs of clans connected to the person who has died. At some distance from the shade sit groups of women, children, and a few other men. Every so often, women or children bring things to the entrance of the shade—water, tea, cups, or something else that the men have requested. They leave the things they have brought outside the shade and return to where they were sitting. The painting is never seen outside the shade. When it is finished, the body is placed in the coffin, the lid is nailed on, and the coffin is wrapped in cloth prior to burial. A week after the funeral, one of the men who painted the coffin lid is again at work. This time he is sitting on the veranda of a house, painting a sheet of bark. Children play around him; people come and go. After a while a woman, his daughter, takes over the painting, and for the next few hours it is she who paints the fine crosshatched lines that characterize Yolngu art. The painting, produced in the

open, will be displayed in the craftshop and sold to a European. The form of the painting is the same in both cases. At the time of the Yolngu's first contact with Europeans, the same painting in an unmodified form would not have been seen by women in public.

This example dramatizes quite well the complex place of art in Northeast Arnhem Land society today. From one perspective it is a parable for the opening out of art, which has occurred as a result of colonization. In the years since first contact, some paintings have moved from the closed space of the men's ceremonial ground to the outside space of the craft shop, and beyond that to the art galleries of the world. Yet from another perspective, the same example illustrates the continuities that exist over time in some of the contexts of Yolngu art, and the way in which the shift to the outside has still left the inside apparently intact. Paintings still occupy closed as well as open spaces, and though in some contexts they have become commodities, in others they remain part of the substance of ritual. But the continuities of practice exist in relation to the changes that have taken place. The value of Yolngu art depends in part on the relationship between the contexts in which it occurs, and new contexts alter those relationships. That is why in analyzing Yolngu art one cannot draw an a priori distinction between art that is produced for internal purposes— Graburn's (1976:4) "inwardly directed arts"—and art produced for sale to the outside world. Ultimately both are part of the same system, and an understanding of one necessarily involves an understanding of the other. For in Yolngu society the outside has consequences on the inside and vice versa.

Yolngu Art in Time and Space

Perhaps all anthropologists in the course of their research, and in particular in its writing up, go on a journey through the history of anthropology which eventually ends wherever they decide the present should be. I think this is partly because anthropologists tend to inherit and accumulate the tasks of previous generations of researchers. Anthropologists often reject the work of their predecessors for very valid reasons, yet many of their predecessors' ideas are carried forward as a kind of intellectual unaccompanied baggage freed from the specific theoretical connotations they once had. Anthropology almost refuses to limit its field of study and the body of data that can be thought relevant to a particular problem. *Holistic* is a word commonly associated with an anthropological approach and explains in part the past focus on relatively small wholes: island communities, small-scale societies, total institutions, and so on. But over time, for theoretical reasons and

as a result of the development of a world system, the relevant whole has either got inexorably bigger or has been deconstructed, and this has not simplified the task at hand.

All anthropologists writing on Aboriginal Australia in the 1990s are faced with an enormous problem in limiting their field of study. The period when anthropologists used the ethnographic present to describe a society as if it operated in a precolonial world, although they observed it within a postcolonial world, has long since past (see Myers 1986:12). The longer the colonial period, the more the present is determined by postcolonial interactions. The synchronic perspective of Radcliffe-Brownian functionalism could once be justified on two main grounds: one, that the history necessary for diachronic analysis was not there, and the other, that society had to be studied as a phenomenon sui generis in relation to its structure at a given point in time. While in their time such perspectives were a necessary corrective to much of the speculative theory that preceded them, and resulted in ways of looking at society that are still relevant today, in the strong form in which they were expressed they are untenable. If history is necessary to understanding a certain phenomenon, then it is not good enough to say it is not there. The analysis must be done with reference to its necessity, and the mark of historical process on present events must be sought. Implicit in this position is that structure is something that is produced at the same time that it structures action (Giddens 1979; Sahlins 1981, 1986), and rather than being something that exists synchronically, it is forever emergent.

In order to analyze the present-day artistic system of the Yolngu, it has been necessary to place it as the product of its history, much of which, since the establishment of the mission in the 1930s, is known or recoverable. As Yolngu art has moved through time, the space it has occupied has changed as it has begun to fill spaces that are part of an ever-widening world of action. Prior to European contact, Yolngu art was primarily a system operating in the small-scale clan-based societies of Northeast Arnhem Land. One must not overexaggerate the local nature of the system, as it has clearly been influenced by several centuries of contact with the peoples of eastern Indonesia as well as forming part of an interconnecting chain of communication that stretched across Australia. But in relation to later events, its scale was local. With the coming of the mission, the arena in which it operated widened, and gradually it became incorporated within the Australian market economy. As far as many Europeans are concerned, Yolngu art has become a commodity. It is impossible to analyze Yolngu art without taking this into account. Nor is it desirable to do two separate

studies: one of Yolngu art in the Yolngu world; the other of Yolngu art in the European world. While art may be framed differently from the perspectives of Yolngu and European Australians, members of both cultures live in the same world. The model of two worlds is a familiar one in writings about Aborigines, but it is a misleading one, except as a metaphor. Yolngu live in a world that includes both European and Aboriginal institutions, systems of knowledge, and languages; they are influenced by both. Yolngu clans have taken on functions and arguably a constitution that they did not have before, and those new functions are going to affect the trajectory the clans have over time. The process is a two-way one, and European institutions in northern Australia must sometimes take account of Aboriginal practices and institutions (see Peterson 1985). Thus while my primary focus is on an institution—Yolngu art—that Europeans do not have, the institution has to be placed in a wider context in order to understand it today.

It is arguable that to the Yolngu, art has never become an alienable commodity in the sense that Europeans understand it. Yolngu, as we shall see, entered into exchange relations with Europeans partly for economic returns and partly to engage them in a discourse over cultural values. Art was of high value internally, and its use in exchanges with Europeans created a value in a new context. Clearly the involvement of art in these transactions with outsiders had the potential to change its internal value. In initial stages the consequences were minor, for the interactions mimicked those of the internal system. Until well after World War II, the main exchanges were with long-term missionaries incorporated into the system of classificatory kinship as father (*baapa*) or brother (*waawa*), who respected the conditions of exchange in the local arena. Paintings sold to missionaries and others could be painted by men in closed contexts, taken to the missionary wrapped in cloth or under the cover of darkness, and would disappear "forever" into the southern void. The sale of art would have appeared for a while to be an activity that took place on the fringes of the Yolngu world and one that remained molded to its fabric and unlikely to change internal values. A truer perspective might be that a relatively stable colonial relationship had been established in a geographically remote place and the rate of change was slower than it subsequently became (cf. Young 1987:132). As the market for Yolngu art increased and the audience widened, the conditions changed; it became impossible to maintain the same internal controls, and it was no longer possible to continue treating external trade as if it were internal exchange. The situation was reached where major changes occurred in the categories and contexts of Yolngu art. Yet these changes happened as the result of a process that remained in continuity with the past: for

what Yolngu art was once and the properties it had as a system were, with other factors, codeterminants of what it subsequently became. An understanding of the changes that have taken place is necessary to the main aim of this book, which is to explain the form of Yolngu art.

The Explanation of Form and the Reproduction of Society

For heuristic purposes I take the main aim of studies of material culture (and for present purposes I include art within what Kubler 1962 refers to as this "ugly rubric") to be the explanation of form in relation to use. Questions such as Why does the object have the shape it does? Why is it made in the way it is? are central to the approach I adopt. As a heuristic method it does not have to be followed in all cases. There may be cases where the detailed form of the object has no relevance to understanding its present use (including its meaning), and, if present use is of primary interest, then pursuing the explanation of form may be irrelevant to the particular project. However, I would be reluctant to exclude form as a factor in selection for use. I only feel the need to add the qualification "in relation to use" because in some rare cases the explanation of form may take the analyst into areas that are not of central relevance to the general concerns of anthropology. Very often, however, pursuing the question of form beyond what is required to understand present use provides information about the structure of cultural systems or historical relations that is central to the anthropological enterprise. By way of analogy, it is impossible to explain the morphology of a word by analyzing its use in a particular context, but that does not mean an analysis of morphology is irrelevant to understanding language use and linguistic change.

There are many ways to approach the explanation of form in a body of art. It can be approached through an analysis of style, which sees form in part as the relatively autonomous product of a process of replication over time (see Kubler 1962). It can be analyzed in terms of certain principles of composition, without reference to meaning or cultural context. This approach is exemplified in Holm's (1965) work on Northwest Coast art and Faris's (1972) analysis of Nuba art, which applies methods derived from Chomskyan linguistics. Others have attempted to explain the form of art in relation to style as a boundary-maintaining mechanism or as a marker of ethnic identity (see, for example, studies in Hodder 1982; Salvador 1976), and still others have analyzed art as a system of communication (see, e.g., Forge 1966, 1979; Munn 1962, 1973). Certainly there is no reason why any of these methods should be mutually exclusive, and the relative weight given may depend on the particular system under study. The general nature of the rubric "art" may be misleading, as it contains within it

many different kinds of systems. I have found it most productive to approach Yolngu art, in the first instance, as a communication system and hence to seek explanation of form in relation to the ways in which meanings are encoded in paintings; my broader aim is to show how Yolngu art works as a meaning creation system. I use the word *communication* rather than *representation* (Munn 1973) or *symbolism* (Forge 1973:xviii) because it is a more all-embracing concept and forces attention on the context of use and interpretation as integral parts of the system. However, the perspective I adopt is similar to those of Munn and Forge in that it sees art as an independent system of communication which is languagelike in the systematic way it encodes meaning and in its capacity to generate new forms. Much of what others have referred to as *style* in Yolngu art is the product of the particular way in which meaning is encoded in relation to the use of art in social contexts. By analyzing the art from this perspective, it is possible not only to show some of the changes that have occurred but to explain them in structural terms.

Many of the critiques of semiotic and structuralist anthropology (e.g., Sperber 1976) have argued that Saussurian-inspired studies have imposed a synchronic, acontextual, and overly abstracted analysis of symbolic systems. While I believe that the degree to which this is the case has been exaggerated, it is important to emphasize the praxis-oriented perspective adopted in this study (see, for example, Parmentier 1987). Meaning is not produced by grammatical structures and formal codes, though they have important roles to play; it is created through individual action a part of cultural process, which for present purposes can be taken to include the political and institutional frameworks of people's existence. Much of this study is concerned with the way meaning is produced and sometimes created in context. It includes an analysis of the potentialities of the codes themselves but much more besides: the ways meanings are encoded, the conditions for interpretation, the position of the interpreter, the integration of meaning and structures for producing meaning within a system of knowledge, the importance of theme and context in creating meaning (see Volosinov 1986), and many other considerations. Nonetheless, structures and continuities of structure are necessary in order that meaning can be communicated at a social level, and structured processes are integral to my concept of social reproduction.

In analyzing the structure of a communication system, I am faced with the dual problems of where the structure is located and how the artistic system articulates with the sociocultural system as a whole. The answer at one level is that the structure exists through the way in which it is used by people acting in particular contexts: its articulation

is through its use; its structure is manifest in its use. Yet that concep-
tualization is a little too concrete, for the structures must also exist in a
form whereby they affect what it is possible to produce and how it is
possible to act. The socialization of individuals involves a process of
structuration (Giddens 1979), and social action involves the existence
of shared structures in the sense of Durkheimian "collective represen-
tations." A system of communication is one of the institutional
structures that transcends the individual actor and makes action in a
social context possible; yet it is not something that is self-reproducing.
Rather, it is reproduced through use in contexts where the very process
of its production may involve the changing of its structure. Both the
system of communication and the context of its use involve a concept
of structure. As well as being structured internally through the way it
encodes meaning, the system is in turn involved in a structuration pro-
cess through its articulation with the sociocultural system as a whole.
This dual location of structure is not so much the equivalent to the
Saussurian distinction between *langue* and *parole* as between gram-
matical structure and pragmatic structure—pragmatics being at the
point of articulation between language and society (see Keesing
1979).[1] In a more general way this distinction as it applies to art is ex-
pressed by Bateson (1973:237) when he writes, "it is . . . of prime
importance to have a conceptual system which will force us to see the
message *both* as internally patterned *and* itself part of a larger patterned
universe: the culture or some part of it."

Yolngu art as a system of communication is closely integrated with
two other key institutional structures: the system of restricted knowl-
edge and the system of clan organization, which, as Keen (1978, 1982)
has shown, were linked in turn to gerontocratic polygamy and to the
political organization of the society. My analysis shows how the form
of the art can be partly explained in relation to this articulation and
how the artistic system helps reproduce the forms of the institutions
over time. The concepts translated here as "inside" and "outside," for

1. Keesing (1979) considers these issues from a different but complementary perspec-
tive. He deals with the questions of the relationship between linguistic and cultural
knowledge and demonstrates the extent to which linguistic knowledge "presupposes,
draws on and is motivated by hierarchically structured cultural knowledge" (p. 29). In-
fluenced by Silverstein (1976), Keesing conceptualizes pragmatics as occupying an
articulatory position between the structure of a particular communication system and
the more general structure of the cultural system in the context of language use. "Prag-
matics is best taken as analysis of the operating principles for applying general
knowledge to particular situations, for communications with signs in social situations
and real world contexts" (Keesing 1979:29). He goes on to argue that "pragmatic
knowledge can in this sense be taken as a shorthand for those segments or subsystems of
a native actor's cultural knowledge drawn upon in *embedding messages in social contexts*."

example, are major organizing principles of the Yolngu system of knowledge. The artistic system expresses that distinction in its structure; it is set up to encode meanings according to such relationships, and as individuals are socialized into Yolngu art, they are socialized into the system of restricted knowledge. Yolngu art is an ordering system (Munn 1973:5) in the dual sense that it orders knowledge by the way it is encoded, and, as an institution, it orders the way knowledge is acquired. By reproducing Yolngu art as they have been socialized into it, people are reproducing both the internal structure of the artistic system and contributing to the more general process of social reproduction.

However, it is important to stress again that the system is reproduced through its use, and in the context of change. Art has been an active component in the process of change in Yolngu society. An analysis from this perspective should enable us to show how Yolngu art as an internalized system of communication has enabled people to produce new paintings to fit new contexts, how the relationship between certain categories of paintings has changed, and how the use of paintings in some contexts has changed. The individual actors using the system over time have changed it, and as those changes have been accepted, the process of structuration has taken on a new direction for those entering the system. Such changes occur in the kinds of meanings encoded in paintings, in the ways in which they are encoded in paintings, and in the way art articulates with the more general cultural structure through the ways in which paintings are used. These changes are not mutually independent of one another, and as we shall see, the way in which meaning is encoded affects the way in which a painting can be used and the kinds of meanings that can be encoded in it. From early on, art has been one of the ways in which Yolngu have interacted with the colonists and hence shows well how Yolngu are reproducing themselves in the changed context of their incorporation within postcolonial Australian society.

The Order of Presentation

The order of chapters in this book is designed to show and, to some limited extent, explain the structure and the operation of the Yolngu system of art. I use *explain* here in the sense of showing how something works as opposed to explaining why it is there is the first place. Since structure is reproduced through the system in operation, the book should sometimes be read as if it were several parallel texts which of necessity have been ordered in a linear form through the constraints and conventions of writing. Knowledge of the formal structure of the system would be useful to the reader from the very beginning, but un-

derstanding the formal structure is difficult without knowing the context in which it operates; knowing something of the meaning encoded in paintings may help show how they are integrated in ceremony, yet information on the formal structure of the semiological system and the sociological context in which knowledge exists are both prerequisites to understanding meaning in Yolngu art. So in ordering the book I have followed a pragmatic sequence by which I hope the reader will come to understand how Yolngu art works as a system of encoding meaning. I begin by examining the historical and social contexts of production; I then look at the structure of the system, and finally I examine in detail the iconography of one clan's paintings. My object in this last section is partly to give the reader a perspective on the cumulative and interactive nature of meaning in Yolngu art. We also move through a process where the number of persons interpreting the art is reduced finally to one. While many meanings are shared, ultimately the organization of meanings and their productive form exist at the level of individual consciousness. I hope to show that these culturally patterned but individually formulated and experienced understandings are part of the dynamic of the system and feed into its use in social contexts. Both the meanings encoded in Yolngu art and its articulation with the sociocultural system as a whole are reproduced through individual action. Indeed, ironically, in the Yolngu case the highly structured system of knowledge and authority gives a pivotal position to those who are on the "inside" in influencing the course of events. It is often those people who make decisions that alter the relationship between the "inside" and the "outside" and that affect the way the outside should be let in, even if the very structure itself as currently operated makes it appear that nothing substantial has changed.

2 Art for Sale

I remember standing in the hot sun beside the Toyota feeling uncomfortable. The truck was in the carpark in Nhulunbuy airport. I was waiting with Narritjin Maymuru, an Aborigine from the settlement of Yirrkala, and members of his family. I remember feeling dirty, though I'd put on a clean shirt for effect. The red dust from the bauxite mine was everywhere, and the air was thick with the smell of oil that pervades tropical airports. And I think I remember feeling that our venture was doomed—or is that the effect of hindsight—for I also remember feeling that we ought to succeed.

The back of the truck was loaded with artwork and handicrafts—carvings, bark paintings, string bags, and didjeridoos. All were the work of members of the Manggalili clan, Narritjin's clan, and they ranged from finely executed soft-wood carvings aimed primarily at the tourist market, to large paintings on bark that would have made excellent additions to the collections of a national art gallery. In many respects Narritjin was already a famous artist. His paintings were included in many national and private collections, they frequently appeared on book

covers, and books and films were beginning to be made about his life and work as an artist. I knew that the works laid out in the back of the Toyota were very, very cheap. There were works of tourist art of a better quality and lower price than could be obtained in any shops selling souvenirs in the towns as well as bark paintings that, in another place and at another time, collectors would be competing with each other to buy. This was a unique opportunity for someone.

The coach pulled up in the airport carpark, and the smartly dressed tourists from a European country got out and were ushered as a flock toward us by a man from the town manager's office. Narritjin had been preparing for this moment for several weeks, though neither he nor I were sure what to expect. Messages had come to him from the Yirrkala Town Council offices that some tourists would be coming and that they would be wanting to buy artwork and handicrafts. The message had originated somewhere in the white township of Nhulunbuy, and as always with such messages, when they finally reached Narritjin their status and content were somewhat unclear. The usual pattern was for tourists to visit Yirrkala to buy artwork and handicrafts from the craft store managed by the Uniting Church. The craft store regularly bought handicrafts from Aboriginal producers and sold locally or wholesale to outlets in the southern states. The craft store, however, had been closed for several months. The previous manager of the general shop, who also ran the craft business, had left, and no one had been appointed to take over. At the time the shop was closed, the craft industry had been booming and had provided a major source of earned income to the Aboriginal community. However, as it grew bigger it grew financially more complicated, and it seemed that the Uniting Church had decided not to be involved any longer with the enterprise. And so for some six months, very few handicrafts had been sold, and only the most dedicated and entrepreneurial producers continued to make artifacts on a regular basis. That is why the news of a tourist bus was so welcome. Although, with some help from me, Narritjin had still been able to sell some of the major bark paintings he produced, it had been impossible to sell more than a small proportion of the carvings and string bags and baskets that his family could make.

Narritjin had planned that the bus should drive to Yirrkala and buy handicrafts from a stall set up outside his house or outside the old craft store.[1] However, the day before the tourists were due to arrive, a mes-

1. Narritijin had previous experience as an entrepreneur. In 1971, soon after the building of the mining town of Nhulunbuy, he opened a memorial ceremony for his brother to the town's European population. He also opened a "shop" outside his house, where members of his family sold paintings and craft. Many of the complexities of the event are recorded in Ian Dunlop's film, *One Man's Response* (and see p. 30).

sage reached Narritjin saying they would not be able to visit the settlement and asking if he could arrange for handicrafts to be brought to the airport. And that's how we ended up at the airport—Narritjin to sell his art, and me to help him. Although Narritjin's English was good, his accent was difficult to understand unless one were used to it, and in any case most European Australians treated him as if he did not speak English. Many of his children who accompanied us spoke English with clarity, but they felt more shy and uncertain than he in the presence of Europeans. I was there as a kind of broker to mediate between the unknown Aborigines and the unknown tourists, who should have been able to communicate directly but who, because of the history and structure of relations between Aborigines and Europeans in the Northern Territory, were unlikely to do so.

The tourists arrived at the back of the Toyota and looked at the artwork and handicrafts and picked things up and put things back. They asked if the work was genuine and how they would know, they asked the prices and said they were too much, they liked some of the paintings but said they were too large and would not fit into their cases. And then they started to point at Maymirrir's baby and said, "Can we?" and not waiting to see if she understood, let alone agreed, were pulling the child from her arms. Then they held the baby and tickled it and giggled at it and smiled and were photographed with the pretty black baby in their arms. Maymirrir's baby passed through quite a few hands before eventually being returned to her mother. One of the tourists gave Maymirrir a five dollar tip for the loan of her baby and one small tourist carving was sold and then they were gone, away to the airplane. I was left with a feeling of outrage and anger. "Never mind," said Narritjin, and we returned to Yirrkala.

There are two main reasons why I begin my account of Yolngu art with this episode. First, it allows me to introduce Narritjin Maymuru, who, as teacher and artist, figures so prominently in what follows. And second, it is a depressing rather than a triumphant or even simply a positive episode. In much of what follows, perhaps I pay too little attention to the negative aspects of being a Yolngu artist today—to the lack of control they still experience over some aspects of their lives and their powerlessness in certain contexts. This episode places my analysis in a context I do not want the reader to forget, even if sometimes it appears I have left that context far behind to explore issues that seem arcane and of little relevance to the contemporary world. The main focus of this book is on the traditional art of the Yolngu and its place in Yolngu society, on art as a system of meaning that is integral to the reproduction of Yolngu society. My more general aim is to use art as a

point of entry into Yolngu society, to convey to readers from a very different cultural background something of how the Yolngu understand the world. In Geertz's (1975:24) terms, my aim is to try and gain "access to the conceptual world in which our subjects live so that we can in some extended sense of the term, converse with them." And my hope is that this book, as part of the process of developing understandings, will contribute to the developing relationship between Aboriginal artists and craftspersons, on the one hand, and their audiences and markets on the other, and make the conversations between them more productive than they were that day at Nhulunbuy airport.

Art was, and is, a central component of the traditional Yolngu way of life, of significance in the political domain, in the relationships between clans, and in the relations between men and women. Art was and remains an important component of the system of restricted knowledge, and at a more metaphysical level is the major means of re-creating ancestral events, ensuring continuity with the ancestral past, and communicating with the spirit world. After fifty years of intensive European contact and effective colonization, art remains a major part of Yolngu culture and a symbol of Yolngu identity. In many respects art is still important in the process of social reproduction and will remain so as long as Yolngu continue to maintain a certain amount of autonomy and separation from the rest of Australia. As the years have passed, Yolngu society has become increasingly incorporated within the wider Australian society. Yolngu art has not suffered as a consequence. While maintaining its value in internal contexts, it has been also a part of the process of incorporation and has taken on additional functions in new institutional contexts, as commodity, propaganda, and symbol. In the long term, however, the survival of Yolngu art and its significance in Yolngu life depend on the mode of articulation between Yolngu and wider Australian society. The Yolngu are an encapsulated people, and the degree of autonomy they maintain is dependent on government policy. Yolngu, however, together with other Aboriginal people, have actively influenced the form of articulation in such a way as to increase their control over their land and their way of life. In the Yolngu case, art has played a significant role in the process of social and cultural transformation, and has been an important element in the political struggle to affect the form the transformations have taken.

Art as Commodity, Symbol, and Propaganda

Art objects entered transactions between Europeans and Yolngu early in the history of contact. In the mid-1930s, within months of the estab-

lishment of Yirrkala mission station, the Reverend Wilbur Chaseling had commissioned paintings and carvings from the Aborigines who moved into the settlement. The paintings were sold to museums in the southern states, and a few objects were marketed in Sydney through the Methodist Overseas Mission. On both sides there were dual motives for the transactions. Chaseling saw craft production as a means of earning the money to provide Aborigines who moved to the mission station with luxury items, in particular with tobacco. Tobacco, indeed, became the currency with which people were paid for handicrafts. "Luxury" is perhaps a misleading term to employ, as a ready supply of tobacco was one of the reasons Yolngu were attracted to mission settlements, and hence the provision of this "luxury" was necessary to the success of the missionary enterprise. In this respect the production of craft was integral to the mission's overall objective of achieving economic self-sufficiency. In itself this objective required cultural transformation. Within a short while after the establishment of the mission, the Aboriginal population became too large to be supported by hunting and gathering from the resources of the surrounding region. To maintain its congregation the mission had to establish, as soon as possible, an agricultural base which could be supplemented by rations provided from the limited resources of the mission. There is, however, some evidence that economic necessity was not the only reason for the introduction of agriculture and craft production. The Northern Synod of the Methodist Overseas Mission saw the establishment of a sedentary lifestyle as a prerequisite for successful missionization, not simply for practical reasons, but also because agriculture was considered a necessary step on the road to Christianity. Thus artwork and handicrafts became commodities sold by Yolngu to obtain tobacco and resold by the mission as a small but necessary part of its overall economic strategy.[2]

Missionaries such as Chaseling and T. T. Webb, from the neighboring settlement of Milingimbi, had another reason for sending collections of art and material culture to cities in the south. They saw it as a means to educate, in the broad sense of the word, their church's congregation and the more general public about the Aborigines of Arnhem Land. There were both economic and humanitarian reasons for adopting this policy. First, it was good mission practice to encourage the supporting congregations to feel knowledgeable about and to a certain extent sympathetic toward the Aboriginal population It was part of a process

2. Chaseling (1957:16) and Webb (1938:57–62) provide accounts of the mission's concept of work, and Webb (n.d.) of the way art and craft production fitted into the overall scheme.

of gaining financial support for the mission both directly, in the form of support from members of the congregation, and indirectly, by creating an informed lobby that would encourage government support. Second, however, in the particular case of the Methodist Overseas Mission in Arnhem Land, it seems that many of the early missionaries had a genuine interest in and respect for Aboriginal society and saw the Yolngu as possessors of a culture and lifestyle that were uniquely their own and which had in many respects proved successful. Many of these missionaries had a syncretic attitude to their task, seeing the maintenance of Aboriginal culture as necessary to the morale of the population and to its long-term survival. As well as sending collections of artifacts to museums, Webb and Chaseling published books and articles on Aborigines in Arnhem Land, which, in addition to outlining the work and achievements of the mission, painted positive and informed pictures of traditional Yolngu life. Such an approach was particularly important in the political context of the time.

In the late 1920s and early 1930s, Yolngu from Northeast Arnhem Land had become involved in a number of conflicts with outsiders, who they saw increasingly as invaders of their country. Yolngu trace these hostilities back to a massacre that took place at the beginning of the century, around 1910, but which has been largely overlooked in the written history of the region. In that massacre many Yolngu were killed, mainly at Gaarngarn, inland from Blue Mud Bay, and at Caledon Bay and Trial Bay. The killings seem to have been part of a punitive expedition that was launched in error. A party of police and stockmen set out to exact vengeance on the Aborigines for the supposed murder of the geologist and explorer S. Love. Love, it turned out in the end, had not been killed or even attacked, but was merely late returning (Love 1953).

This was among the first and was probably the most lethal encounter between the Yolngu of Northeast Arnhem Land and a "police expeditionary force." The details of this and subsequent massacres are hard to sort out, as they have been largely expurgated from the history of the Northern Territory. On the European side, records have been lost and the event concealed; on the Aboriginal side, events have been condensed and memories are associated with place rather than time. This makes it difficult to reconstruct a sequential history. However, from Aboriginal accounts it seems likely that one of the men killed during the expedition of 1910 was an elderly man of the Djapu clan from the area of Caledon Bay. It was that man's son, Wonggu, who in subsequent years became a leading figure in Yolngu resistance to European invasion. From the European viewpoint, hostilities reached their peak in the early 1930s in the killing of a policeman, Mounted Constable

McColl, on Woodah Island in 1932, followed by the killing of the crew of a Japanese pearling lugger in 1933 at Caledon Bay.[3]

The killings of McColl and the Japanese led to extreme anxiety among the authorities, an almost hysterical press campaign, and calls for government action against the Aborigines. There was suggestion that a punitive expedition be sent out to bring the region under control, and the southern press, though in many ways sympathetic to the Aborigines, helped create an image of a wild and dangerous country filled with savage people. In reality the situation was not nearly as desperate or as hostile as it seemed at a distance. Throughout the period of the later killings, some Europeans had lived in close quarters with the Yolngu without their lives having been threatened.

Fred Grey, an Englishman who collected pearls and trepang, had his main camp in Caledon Bay and had regular contact with Wonggu and his relatives. Successful mission stations had been long established at Roper River, on Groote Eylandt and at Milingimbi, all places on the boundaries of Yolngu-speaking territory. And the people of Caledon Bay had had considerable contact with missionaries from those places.

Perhaps because of pressure from the missions and people like Fred Grey, and supported by public sentiment and international pressure, the commonwealth government decided against sending a punitive expedition. The policy they adopted involved three stages: the arrest of those who had actually killed the Japanese, the establishment of a mission station in the area, and the funding of a fact-finding expedition by the anthropologist Donald Thomson.[4] According to Yolngu, Wonggu had decided independently to establish peaceful relations with the Europeans and, in consultation with Fred Grey, handed over a number of people, including three of his sons—Ngathiyalma, Djeriny, and Maaw'—to be tried for killing the Japanese. At the trial in Darwin, the Yolngu, against Grey's expectations, were sentenced to life imprisonment for murder. After a year's imprisonment, however, they were released and returned to Caledon Bay.

It was against this historical background that the craft industry began to develop in Northeast Arnhem Land. As far as the Methodist missionaries were concerned, this industry had a dual aspect from the start. Works of art were commodities, but they were also a means of widening Australians' understanding of Aboriginal culture, in hopes of redressing the imbalance of propaganda or adverse publicity associated with the preceding years. At the same time as Chaseling was

3. For an outline history of the region, the main source remains Berndt and Berndt 1954.

4. Thomson (1983) provides a detailed account of these events and his involvement in them.

beginning the art and craft industry at Yirrkala, Donald Thomson was engaged in his fact-finding expedition among the Yolngu. Art and material culture were central to Thomson's method of anthropology. Indeed his whole enterprise in some ways centered around the making of an enormous and systematic collection of Yolngu material culture. Thomson collected everything from major sacred and secret ceremonial objects, through the painted skulls of the deceased down to the most mundane of everyday objects. Everything was meticulously labeled and cross-referenced. By decoding the labels and reconstructing the set of objects and relating them to the ceremonies that Thomson witnessed, it is possible to gain as clear a view of Yolngu society from the racks of shelves laden with his collections in the National Museum of Victoria as it is from reading the most detailed ethnography of the region.

In many ways Thomson was engaged in precisely the same task as Chaseling. Officially he too was a mediator and peacemaker (or perhaps pacifier) intervening between European colonists and the Yolngu of Arnhem Land. He saw his role unambiguously as an advocate for Yolngu rights and the right of Yolngu culture and way of life to continue. And he, like Chaseling, made an enormous collection of art and material culture that he paid for with tobacco.

I cannot state for certain when Yolngu first became aware of the connection between artifact and advocacy that figures so prominently in the work and enterprises of Thomson and Chaseling. It is likely that Thomson and Chaseling both presented themselves at times as cultural brokers and justified the collection of objects that people valued in such terms. Certainly, some Yolngu today argue that from the start they were engaged in a process of education—in educating Europeans about Aboriginal culture. But such claims may well be retrospective, and no first-hand evidence exists from the time. Yolngu who remembered making paintings for Chaseling emphasized the economic aspects of the exchange, and indeed one commented that they were painted "anyhow—just for tobacco."

Whatever the case in those early days, it is certain that by the mid-1950s Yolngu had begun to appreciate the value of their art as a means of both asserting cultural identity and attempting to get Europeans to negotiate with them on their own terms. Yolngu organized ceremonies for departing missionaries, visiting politicians, and occasionally for anthropologists, that usually involved the gift of paintings and other objects of material culture. Such ceremonial presentations of gifts continue to the present. The more loved a person was, the longer term a person's relationship with the community, and today the more powerful a person is politically, then the more elaborate the ceremony

17

and the more generous the gifts. Bark paintings have been used by Yolngu since the 1950s as evidence in court cases, as petitions to Parliament, as gifts for members of Parliament and lawyers, and as ceremonial offerings to government departments. (See Morphy 1983b for a detailed discussion.)

The most famous occasion on which the Yolngu have used their art to attempt to assert their political rights is the case of the bark petition sent to the commonwealth government in Canberra in 1963. The government had granted leases and property rights to a French aluminium company over a large area of Northeast Arnhem Land, including the land on which the settlement of Yirrkala was built. Yolngu sent a petition demanding that their rights be protected and recognized and asking that they be consulted before such projects were allowed to go ahead. The petition was not sent as a telegram, but was attached to a bark painting bordered with designs belonging to the clans whose lands were most immediately threatened by the mining. The petition was unsuccessful, but it resulted in a Parliamentary Enquiry which, in the long term, was important in the process of achieving land rights for Northern Territory Aborigines. The bark petition became a symbol to the Yolngu from Yirrkala of their struggle for land rights and today has a prominent place in the new Parliament House in Canberra. More importantly, the bark petition was part of a process of negotiation that introduced elements into the discourse between European Australians and Aborigines which for a time altered the terms of the argument. The discourse focused attention on the difference between European and Aboriginal concepts of land ownership, asserting that Aborigines had title deeds for their land that arose out of their spiritual relationship with it and which Europeans had no part in. If Europeans were ever to take such claims seriously, then the claims could not be easily incorporated within existing institutional frameworks but would require the development of new legislation and new administrative structures. For most of Australia's colonial history, such claims would indeed have caused no problem: they would have been disregarded as absurd or irrelevant. However, in the 1960s and 1970s it became increasingly difficult to adopt such a dismissive attitude, especially as events like the bark petition had become news and captured the public imagination. With the passage in 1976 of federal land-rights legislation for the Northern Territory, paintings and other components of Aboriginal sacred law that had previously been evidence to Aborigines of their spiritual relationship with the land also became evidence in European Australian courts of Aboriginal ownership of land.

An event that was almost as significant as the bark petition and which was in its regional context much more spectacular took place a

few years before, at the neighboring mission station of Elcho Island. In 1959 the Elcho Island memorial, to use Berndt's (1962) term for it, was erected outside the Elcho Island church.[5] It consisted of representations of sacred objects and collections of bark paintings belonging to many of the clans of the region, including some from Yirrkala. The memorial was part of a complex syncretic adjustment movement which was directed toward internal and external changes. Many of the paintings and objects had previously been restricted. They were unknown not only to Europeans but to uninitiated Yolngu men and to Yolngu women. They were among the clans' most valuable property, objects of ritual power, and in Yolngu terms the most important things they had to give. The intention of the leaders of the movement was not to reduce the power of the objects by releasing them from their shroud of secrecy but to assert to Europeans that Yolngu too had objects of great spiritual power and that they were willing to open these up to Europeans if Europeans were willing to reciprocate. From Europeans the Elcho Islanders wanted both greater autonomy and greater assistance, in particular in the areas of employment and education.

The opening up of so many secret things for public inspection was bound to have certain internal consequences. The leaders were conscious of this and saw the movement as a means of creating unity across clan boundaries. They saw the holding of sacred objects separately and in secret by the clans as a sign that the clans were divided against each other. It was thought that by displaying the objects in public, those barriers would be broken down and the Yolngu could act jointly in relation to the wider Australian society. It is unlikely the memorial in itself achieved this. But interclan unity is an important theme of Yolngu debate when dealing with Europeans, and there is a determination to keep divisions beneath the surface. The memorial itself has been largely neglected, and clan-based divisions and politics surrounding secret objects associated with them remain strong.

The display of paintings in 1962 in the Yirrkala church provides another example of the use of art to assert identity and the value of Yolngu culture in the face of introduced institutions. Large boards with paintings on them representing each of the clans resident at Yirrkala were placed on either side of the altar in the newly built Methodist church (see Wells 1971). On this occasion the event was supported by the Reverend Edgar Wells, a missionary who inherited the attitudes and objectives of his predecessors Webb and Chaseling. He saw himself and the church in a mediating role and strongly supported the mainte-

5. Berndt's book *An Adjustment Movement in Arnhem Land* (1962) provides an excellent account of the history and aims of the movement. See also Morphy 1983b and the introductory chapter of Maddock 1972.

nance of Aboriginal culture and religious practice where it did not contradict central tenets of Christian doctrine. The motives of the participants were surely complex and diverse, but placing the paintings beside the altar was done partly to demonstrate the compatibility of Yolngu religious beliefs with Christianity and to assert Yolngu identity in an introduced context. That the paintings were thought to be spiritually powerful is evidenced by their subsequent expulsion from the church a decade or so later at the hands of a more fundamentalist and less syncretically oriented minister.[6]

The commercialization of Yolngu art—its development as a commodity—must be seen in relation to its uses as symbol and propaganda in the developing discourse between Yolngu and Europeans. The sale of artwork and handicrafts is certainly a way of making money, but it is also seen by many Yolngu as a way of widening the understanding of Yolngu society and of persuading Europeans to value Yolngu culture. It is the hope of many that such understanding will result in a greater respect for Yolngu rights and in greater autonomy. Such purposes are in many ways in harmony with the objectives of those non-Yolngu who market Yolngu art and with the way in which the art has been sold. Such apparent harmony of purpose has not always operated in the commercial interests of the producers. Missionaries in charge of marketing art in the 1960s and 1970s held views that were in direct continuity with those of Webb and Chaseling, seeing the propaganda value of Aboriginal art as very significant. In one case the express aim of the missionary was to ensure that enough cheap paintings and carvings were produced so that every front room in Australia could have one. While such an objective is not necessarily incompatible with the development of fine art production aimed at a more restricted and affluent market, it could be, especially if emphasis was put on the mass market. For example, it could result in the production of near-replicas aimed at the tourist and souvenir markets— objects which would be of little cultural value to the Yolngu and which would do nothing to enhance the status of the individual artists or to inform the audience of the complexities of Yolngu culture. While the aim of the Yolngu is not to sell to an elite market, the type of paintings

6. The paintings were restored to a place of dignity in 1988 with the opening of the museum at Yirrkala, where they form the centerpiece of the exhibition of Yolngu clan art. However, their addition to the museum incorporates them into an institution that is very European, an institution in which Yolngu at present show little interest. In the church the paintings were an active symbol of the relationship between Yolngu religion and Christianity and were part of the process of change within the community. Their position in the museum suggests that today that role is over and that the discourse has changed, though as active symbols they were always to an extent a European creation.

that they feel reflect their cultural values and are appropriate for educational purposes are ones that fit primarily in the fine art category and thus are the ones which, as art objects, are going to be less accessible to a mass market. However, because these works are reproduced in books and displayed in museums, their accessibility is to an extent restored.

Paintings in recent times have been sold with accompanying "stories," which tell the purchaser something of their meaning and significance. Indeed the stories have become such a selling point that it is harder to sell a painting without one. While this may seem compatible with the objective of broadening understanding (for a painting without documentation may convey very little cultural information), it too can have its problems. The demand for stories may itself be an imposition on the Aboriginal producer: it may be seen as a request to reveal more than he or she is prepared to reveal. Documentation is, moreover, a time-consuming process. The market's demand for stories can easily result in the spread of misinformation, in the invention of spurious documentation, or in the production of standardized stories that are applied to very different paintings and themselves act as a mask obscuring the complexities of culture.

Artists in Two Frames

Yolngu art is art in two frames—the Yolngu world, and the European-Australian world. I use *frame* here to refer to the encompassing set of cultural practices and understandings that defines the meaning of an object in a particular context.[7] Frames may exist at different levels of generality: the same object can occur in many different frames within a culture. At this stage I am concerned less with these intracultural frames than with the more encompassing intercultural frames: the indigenous context and the context of the European-Australian art world. Although the same or a very similar product is used in both frames, its meaning is quite different in each case. Within the Yolngu frame, paintings are part of a clan's ancestral inheritance. Painting is a ritual act surrounded by rules and restrictions on who can paint which design in what context and who can see which design where. Paintings are usually destroyed within hours of being produced or at least are made invisible, either by rubbing out the designs, as with body paintings, or by burying the objects with the paintings on them. If the paintings survive for longer it is not to be admired or preserved but, as is the case with hollow log coffins and memorial posts, to be left to un-

7. My use of the word *frame* is influenced by Goffman 1974, though Goffman is more concerned with the definition of frames *within* a culture.

dergo a natural process of decay. The individual artist is almost absent from the process of painting: paintings are frequently done by a number of people, usually men, working together. Although one man may sketch out the initial design, the painting is not thought of as an individual's work, nor is it referred to as "his" painting. The paintings are done for religious purposes, sometimes with a hint of political intent. Paintings on a person's body mark the status of the individual and demonstrate his or her relationship with the ancestral world; they may summon up ancestral power and direct it to the purposes of the particular ceremony, for example, the strengthening of the initiates or those to whom a sacred object has been revealed, or the guiding of the soul of the dead on its spiritual journey. Within the Yolngu frame, the significance of a painting depends on the specific features of its context (and contexts are multiple). I will not fill out the frames within the frame any further at this point since they are the subject of most of this book. They are alluded to here mainly for contrast with the second general frame, which concerns Aboriginal art as art in the European sense.

Aboriginal fine art consists of paintings purchased by and displayed in those museums and galleries in Australia and overseas that have a reputation for displaying fine art. More generally, it consists of paintings that are of the "quality" to belong to that category. The paintings and sculptures that fit into the Aboriginal fine art category are defined as fine art not by the producers but by their final purchasers: by the collectors, art gallery curators, trustees, dealers, and expert consultants associated with the fine art world. In the case of Aboriginal fine art, which is a recently expanding category, the criteria for inclusion are not fully worked out and are subject to constant change. It is a category in the process of being created, but that does not mean people are not yet investing in it. Indeed investment is a part of the process of creation of Aboriginal fine art, for it is a commodity to be bought and sold, marketed and displayed, usually without any reference to the artists' original intentions. Paintings that gain recognition as fine art are conserved and curated so that theoretically they will last forever, and they are displayed periodically to the art-viewing public in exhibitions held at art galleries. And it is important that they be authenticated, for it is important who painted them and when.

The Aboriginal fine art market is a fairly new development (see Jones 1988; Morphy 1987; Taylor 1988). Few people thought that Aboriginal art *was* art until after World War II. No art gallery had collections of Aboriginal paintings; they were restricted to ethnographic collections of museums of natural history. There were no major private collectors of Aboriginal art before the war, and the few works that were sold were bought either by museums or as ethnographic curios,

symbols of an exotic culture that once occupied Australia. A few individuals, such as the artist Margaret Preston and the anthropologist A. P. Elkin, argued for the recognition of Aboriginal art, but they were voices in the wilderness and went largely unheeded. Although it is possible to see the seeds of a differentiated market quite early on in the existence of purchasers with different motivations, such factors were not reflected at the level of production. On the whole the purchasers of ethnographic objects, art, and souvenirs were all purchasing the same kind of thing.

In the forty-five years following World War II, the situation has changed dramatically. Aboriginal art is now accepted by the institutional art world as fine art, and the market has become complex and differentiated. Since the war there have developed two distinct but somewhat overlapping markets: a souvenir market and a fine art market. The souvenir market requires goods that are portable, cheap, and readily identifiable as Aboriginal products. The requirements of the fine art market are harder to define as they were (and are) subject to change, but they include such criteria as works that are "authentic," that is, like those that would be used for indigenous purposes and largely uninfluenced by Western contact, works that are aesthetically pleasing, and works that are finely executed. The markets remain overlapping precisely because they are still in the process of being defined and because they do not correspond neatly to categories of production. Some objects, such as small carvings produced in bulk almost in a production line, false smoking pipes, and imitation didjeridoos, are manufactured specifically to be sold at low prices to tourists. However, the line between a tourist carving and a work of art can sometimes be a fine one—a line that depends on the aesthetic judgment of the purchaser and the salesmanship of the entrepreneur. Many works purchased as souvenirs have ended up being resold as fine art. This was especially likely with works made early on because then few people were buying Aboriginal works as art, since they were not generally accepted as such.[8]

Since the late 1960s and early 1970s, the change in the status of Aboriginal art has been remarkable (Morphy 1987). Exhibitions of Aboriginal art that include the work of individual as well as groups of artists are now a regular occurrence. Art galleries, in particular the National Gallery in Canberra, have increased their collections impressively and have begun to devote greater exhibition space to Aboriginal art. Individual artists are gaining renown, and their works are highly sought after. Works by leading Aboriginal artists sell for

8. I have considered these issues in a number of papers (Morphy 1980, 1983a).

prices within the same range as works by white Australian artists painting within the European tradition. Aboriginal art has been discovered by the market, and around it is developing that whole system of enterprise that surrounds the sale and promotion of art. Dealers and marketing companies are developing strategies for the marketing of Aboriginal art, the promotion of particular styles and particular artists is beginning, and the necessary background literature on the artists and their cultures is being manufactured. Aboriginal art has become established in its second frame.

Although the two frames—the Aboriginal and the European—are very different, there are some areas of overlap in their contexts and there are some ways in which one frame can affect the other. Indeed the inclusion of aboriginal art in the European frame means the partial capture of the Aboriginal frame in two senses. First, the European purchaser wants Aboriginal art to be from the Aboriginal frame and not produced in the European one, because the purchaser wants to maintain the illusion that Aboriginal art is an exotic art—art from another culture whose inclusion in the European present creates a shift of time. Aboriginal fine art is, after all, the successor in part to what was once called "primitive" art, with a brand new label more suited to postcolonial times. Many negative characteristics of the primitive art market remain despite the name change; the separation of the artists from the market and the imposed definition of what is art are examples. Some positive changes have occurred: the art is no longer anonymous, and the artists are better informed about the fate of their works.

The second sense in which the European frame includes the Aboriginal one has been referred to earlier in a different context: by absorbing the paintings, Europeans are bringing to mind the culture that lies behind them. For example, the purposes of paintings seem at first to be quite different in the two cases: in the Aboriginal case the purpose is an instrumental one (the painting does something), whereas in the European case the painting is there to be admired and appreciated. But, ironically, part of the value of Aboriginal art to European audiences is its meaning and significance to Aborigines. Aboriginal art has been accepted as art which tells a story, art which presents Aboriginal culture. In some respects its meaning is part of what is exhibited, and its meaning involves in part the reason why it would be used for a particular purpose in a particular context in the Aboriginal frame.

There are many ways in which the inclusion of Aboriginal art in the European frame can affect the Aboriginal frame. For example, although secrecy plays a role in dealings within the European art world,

paintings bought on the open market can theoretically be exhibited to the public, and indeed most art galleries would refuse to buy paintings if they were not allowed to exhibit them. However, in the Aboriginal frame, many paintings are made in restricted contexts, revealed in secret, and should never be viewed in public. Some European-Australian institutions have attempted to mimic Aboriginal practices by creating closed storage areas for secret objects and by withdrawing certain objects from public exhibition. Such strategies reflect the complex articulation between European and Aboriginal cultures as well as being exercises in curatorial diplomacy. They enable restricted objects which escaped into the European frame to be buried away, they are a statement that Aboriginal wishes are being respected, and they provide a temporary solution to a number of problems (e.g., what to do with objects that cannot be exhibited, that the producers do not want, and that the museum ethic says cannot be destroyed). In the future the "secret object" stores may take on other functions, as new relationships between Aborigines and European institutions are created; in the long term the storing of secret objects could play a role in the creation of a new type of ethnographic museum with a particularly Australian flavor. But on the whole the primary function of museums, and especially art galleries, continues to be the exhibition of their collections to the widest possible public, or at least the provision of public access to them. The reputation of an art gallery indeed rests on the creation of public objects, for the more its objects are reproduced in books and catalogues, the more its fame spreads. The value of the Aboriginal painting in the European frame depends on how many people know about it, whereas in the Aboriginal frame its value may depend on how restricted its audience is. Because Aboriginal people may walk through the European frame—visit art galleries, see paintings reproduced in books—any painting exhibited in a gallery loses its closed status. Once a painting has been exhibited, even by a responsible institution, the damage may have been done. The painting can be withdrawn, but its image could already have escaped through reproductions. And even if this has not happened, knowledge that the painting was once made public may change its status in the producing society. In the case of the private market, the situation is even less controllable. Private collectors also enhance the value and renown of their collections and in turn of themselves through producing catalogues and by organizing exhibitions. Moreover, paintings become public through their sale. While at least within Australia, public institutions are likely to take a moral stand, the private market is less responsive to Aboriginal interests. The sheer scale and complexity of the market to-

day in any case makes control exceedingly difficult. As a consequence, over the years the sale of art has been one of the factors that has opened up some sectors of Yolngu art inside as well as outside Yolngu society.

Early on, Yolngu were not fully aware of the consequences of selling or exchanging their art with outsiders, and as a result some restricted things found their way into public collections. In more recent years, Yolngu have become aware of the openness of the European frame and have had to decide whether or not to open out their art further. The market has encouraged an opening out for reasons we have touched on already. The European demand has been for the religious and sacred art of the Aborigines, and that is more likely to be restricted than other forms of art. Furthermore, European aesthetic preferences created a demand for Yolngu art of the style that characterized the more restricted contexts.

The topic of secrecy figures prominently in later chapters. I introduce it here simply to dramatize the contradictions that may exist between the use of paintings in a European as opposed to a Yolngu frame. It is important to stress, however, that the Yolngu have not been passive subjects in these events. They have initiated many of the changes which have taken place and have devised strategies to deal with the contradictions that confront them (Morphy and Layton 1981; Morphy 1983b). Changes that have occurred in the artistic system as it operates within the Yolngu frame are clearly determined in multiple ways and must be seen in relation to other changes that have occurred in the internal dynamics of Yolngu society as a consequence of the colonial encounter.

Actors in Two Frames

All Yolngu artists are increasingly operating in both the European and the Aboriginal frame, and in doing so are actors in the transformation of their society. Both frames are essentially European creations, for until the Europeans came the Yolngu frame was the Yolngu world; only through invasion did the other frame begin to affect their lives.

At the start, the outside world of the European colonists influenced Yolngu lives at a distance. This world was largely mediated through missionaries, government officials, and anthropologists. On the whole, Yolngu did not act in this outside world except on occasional visits to towns like Darwin; they interacted with the outside world indirectly through the changed conditions of existence at the local level. The idea that these local agents were supported by a higher authority backed up by military force may have been an early factor in determining the course of relations between Yolngu and local representatives of European power, but direct relations with the outside world were vir-

tually impossible. Over the years, as the articulation between Yolngu and European societies has become more complex and as the Yolngu have been incorporated within the wider Australian institutional framework, a number of different arenas for action have emerged. I use the word *arena* here to refer to a sphere of action in which Yolngu interact with Europeans, rather than the more restricted sense in which Turner (1974:132) employs the term when he applies it to a framework in which conflict is acted out and resolved. Although it would be possible to identify a multiplicity of arenas for action, contrasting, for example, legal with political institutions, or state with federal ones, for present purposes it is sufficient to draw up an opposition between two more generally defined ones: a local arena centered around the townships of Nhulunbuy and Yirrkala, and a national one not so much associated with place but with political action and power at a national level. With self-government for the Northern Territory, within which Yirrkala is located, a third arena is emerging as part of this set.

The local arena includes the immediate concerns of everyday life that are the products of colonization: the effects of alcohol on social harmony; the effect of alcohol, tobacco, and poor nutrition on the health of the community; the frequency of death; the problem of socializing children into a changing and unknown world; and the problems of law and order and relations with the local police and judiciary. It also includes everyday interactions between Yolngu and Europeans and the environment of community attitudes in which those interactions take place. In the national arena, the dominant issue since the 1960s has been land rights, but other issues such as cultural autonomy, the recognition of customary law, the status of Aboriginal artists and the marketing of Aboriginal art and craft, and the social impact of development, in particular of the mining industry, have become increasingly significant. Clearly events that occur in, and values and attitudes associated with, one arena can have consequences on the other.

Land-rights legislation, though enacted nationally, is implemented locally and affects Europeans and Aborigines in their daily lives.[9] Land rights give powers to Aboriginal groups that they did not possess before and therefore can be seen as reducing the power of Europeans. Consultation is required where previously none took place; permission must be asked where previously it was not thought necessary. The implementation of land-rights legislation can therefore make the local

9. The literature on land rights and its consequences is now extensive. See, for example, Hiatt 1984, Maddock 1980, Peterson and Langton 1983.

European population feel insecure and underprivileged, and can feed racist attitudes and create hostility between the local communities. Another example of the interaction between the two arenas concerns the status of Aboriginal art. The change of status of the Aboriginal artist occurs at the national level, but the production of art occurs in the local arena, the artist often being cut off from the national audience.

I have already used the concept of frame to show how the same painting becomes a different kind of object as it moves from the indigenous cultural frame to a European fine art frame. However, the picture is a little more complex than I have allowed for so far. There are clearly many ways in which the same painting can be framed; moreover, looked at from a diachronic perspective, new frames are continually being created as old ones pass into history. Aboriginal fine art, or Aboriginal art as fine art, has only just emerged as a possible frame for placing a painting and has to compete with many other ways of framing the same painting, some of which are complementary to one another, others of which are opposed. Aboriginal paintings have only recently entered the art galleries, been considered as objects of aesthetic contemplation, become the subject of art historical research, and been produced by creative art fellows at universities and art colleges. Before that the works were primarily classified as ethnography (or very occasionally as "primitive" art), exhibited in natural history museums, and written about as anthropological data. The change in status of Aboriginal fine art is very new, and many people are unaware of its existence. In the 1970s the category had yet to emerge, and many Europeans in Aboriginal communities held attitudes that were antithetical to its creation. Europeans at an Aboriginal settlement, indeed any localized population of non-art specialists, are likely to hold more conservative views overall than the metropolitan art world. Some people's conception of fine art may allow only for figurative art of the European tradition and hence may exclude by definition traditional Aboriginal art, together with much twentieth-century Western art. To others, by contrast, it may be precisely the "exotic" nature of Aboriginal art, its independence from the European tradition, that makes it a potential addition to the category of world fine art. Such competing definitions meant that many influential Europeans at Yirrkala in the 1970s, including teachers and community advisers, had a negative attitude toward Yolngu art and referred to it in derogatory terms just when it was gaining an international reputation. They referred to it as "childlike" or "crude," and found it incomprehensible and almost offensive that some paintings were beginning to fetch high prices and that some Yolngu artists were receiving invitations to tour overseas. Attitudes like these affected some of the young Yolngu people, who, for

example, asserted that it was they who should be doing the paintings because they had learned to paint figures properly at school.

The attitudes of some Europeans at Yirrkala were also clearly influenced by ways of framing Yolngu paintings as other than art. Some still framed all Aboriginal actions in relation to an evolutionary progression from a primitive Aboriginal to a developed European state. European styles of painting were by definition superior to Aboriginal ones and many steps upward on the "ladder of progress." Another historically persistent frame bracketed artwork and handicraft production with such activities as grader driving, farm work, and building work. We have already seen how, from the early stages of the development of missions in Arnhem Land, handicraft production was encouraged by missionaries such as Webb not for its own sake but as an instrument of moral development and as a means to integration. Encouraging Yolngu to produce handicrafts for sale was "designed to result in the economic development of the aboriginals and the creation of personal industry and initiative" (Webb 1938:61), "to safeguard the Aboriginal from the degradation which is the inevitable result of casting off life's responsibilities" (p. 60). Craftwork for wages was seen as a good place to begin to instill the European values that would eventually lead to a complete integration within the Australian economic system. The manufacture of handicrafts was an initial small step that would eventually be replaced by other productive activities. It was not seen as something that would eventually lead to the creation of Aboriginal fine art. In the 1970s, many of the mission staff still saw handicraft production as a transitional activity. It was felt by some that it was "holding the people back," that being an artist was not a proper job, and that people would be much better off doing one of the other jobs introduced by Europeans into the settlement. Art and handicraft producers were behind the times; the evolutionary stage of craft production was over. Attitudes like this affected some up-and-coming Yolngu artists. One man in his thirties who was gaining a reputation as the leading artist of his generation and whose works were represented in major art galleries was persuaded to give up bark painting and take up a "proper" job as a house painter, even though he could earn more money as an artist. It would seem almost inconceivable for a European artist to take up a job as a decorator in similar circumstances. But this simply dramatizes the fact that circumstances are unlikely to be similar. The Aboriginal artist in this case did not see his work in the same way as did his European audience; he did not share their values about art, and he did not share the same goals and aspirations as a European artist of a similar reputation would—all partly because of the ways in which Aboriginal art is viewed through the frames that exist in the lo-

cal arena. The attitudes of the local white community may be crucial in the long term to the future production of Aboriginal fine art, even if the product is ultimately defined at the level of the national arena.

Some individual Yolngu have participated in the process of change by acting in both arenas more fully and more consciously than have others. The reason the message about the tourist coach eventually ended up with Narritjin Maymuru was because he was known as an artist of considerable reputation and as a person who might seize an opportunity for selling his art. He had done something similar before, though in a situation in which he had much more control over the events. In 1972, soon after the mining township of Nhulunbuy had been established, Narritjin held a memorial ceremony for his brother Nanyin, who had died a few years earlier. He decided he would open up part of the ceremony to the Europeans from the mining town, as a way of introducing them to Yolngu culture. The ceremony was a particularly spectacular one, focusing on the burial of a large coffin painted on all sides with intricate designs and containing possessions of the dead man. Narritjin charged people for coming to see the ceremony, and he opened up his own craft store beside the ceremonial ground, from where he sold art and crafts to the viewing public. He never repeated the venture, but, in part stimulated by it, he continued to develop ways of helping Europeans learn about Aboriginal culture and at the same time making money from teaching them.

Narritjin was someone who early on had had dealings with Europeans, and throughout his life he tried to create the space for Yolngu culture to survive in a changing world. As a young man in the 1930s, he worked for Fred Grey, first as a cook and pearl diver and later assisting him in developing the settlement of Umbakumba on Groote Eylandt. He had traveled with Fred Grey to Thursday Island and the Daly River and had been one of the Aboriginal witnesses at the trial in Darwin of those accused of killing the Japanese. He left Fred Grey in the late 1930s to live at Yirrkala, where he was employed as "houseboy" for the missionary Chaseling. During World War II he spent much of his time working on the mission boat as it plied its way between the islands, and following the war he worked for a while as a carpenter building the mission houses. In the 1940s and early 1950s he worked as interpreter for a number of anthropologists and scientific expeditions as well as playing a prominent role in a feature film that was partly filmed in the Yirrkala area but was never completed. His earliest known paintings date from that period, having been collected by the anthropologist Mountford in 1948. By the late 1950s, Yolngu art was beginning to arouse some interest in the Australian art world, and that interest culminated in the expedition to Yirrkala by Dr. Scougall, a

Sydney surgeon who had ambitions to become a trustee of the Art Gallery of New South Wales. Scougall was accompanied by his secretary, Dorothy Bennett, and by Tony Tuckson, curator of Australian art at the gallery. The expedition was a great success, resulting in the gallery's acquisition of a magnificent collection of paintings that was widely exhibited and publicized. Narritjin was one of a number of Yolngu artists who were on the verge of being discovered by an art market they scarcely knew existed. However, within a couple of years other events occurred at Yirrkala that transformed the situation.

Until the late 1950s the local arena was the one in which almost all significant events occurred. Northeast Arnhem Land was remote from the rest of Australia, connected to it by a slow-moving mission barge and an occasional other vessel. Air travel was possible but very expensive. The outside world impinged through the presence of the mission and the overflow of great events such as World War II, which brought a temporary military population to the area. The mission had certainly transformed Aboriginal life in the region, but as a region it had remained relatively self-contained. Then the land the Yolngu had occupied for generations turned out to have one of the largest reserves of bauxite in the world, and the exploitation of that resource would bring about profound changes. At first it threatened, almost literally, to sweep the people of Yirrkala aside, as the settlement itself was built on one of the richer areas of bauxite; instead it ended up surrounding them.

The details of the events have been recorded elsewhere, so here I make do with a brief sketch (see Wells 1982; Williams 1986). The first the Yolngu knew about the bauxite was when surveying began, by which time it was effectively too late for them to prevent the mining. They quickly discovered that the events could only be dealt with in the national arena, and it was then that they sent their bark petition to Canberra to the federal Parliament. Their petition brought an enquiry which, though sympathetic, did nothing to stop the mining. Finally the Aborigines from Yirrkala took the government and the mining company to court in a historic case, arguing for the recognition of their traditional rights in land under European Australian law. In 1969 the case was lost, and the following year work on the construction of the mining town began. Almost overnight, the people of Yirrkala found themselves in a minority in their own land. In the short term the Yolngu had completely failed, but in the process they had helped create the political environment for granting Aboriginal land rights (see Morphy 1983b).

Indeed since the threat to their cultural survival and to their ownership of their land emerged in the early 1960s, Yolngu have been

remarkably successful in acting in the national arena. The passage of the Aboriginal Land Rights (Northern Territory) Act in 1974 created the conditions for developing a mode of articulation with the wider Australian society that left some room for autonomy. The development of land councils, the idea of local courts, and the development of out-stations (small settlements located at a distance from European townships and European-dominated Aboriginal settlements) were all part of a creative response to the postcolonial situation and were im-plemented through political action at the national level. All this was done, in part at least, with the aim of creating the conditions in which Aboriginal culture could continue and Aboriginal ceremony would survive. This ideal was to some extent being created and manipulated in the European Australian political arena.' Indeed in many parts of Australia, Aborigines would see such a simple model as against their interests and objectives. However, in Northeast Arnhem Land it was seen as a possible reality and a guiding idea.

For much of the last twenty years of his life Narritjin was caught up in these concerns. He played a prominent role in sending the bark peti-tion and in the subsequent enquiries and court cases which followed. He saw meetings as increasingly taking up too much of his life and frustrating his work as an artist. He helped map out the routes of the roads into the heart of Northeast Arnhem Land that subsequently be-came the arteries linking the outstations with Yirrkala, and hence made the movement of people back to their clan territories possible. He gave evidence to innumerable enquiries, to the Law Reform Com-mission and to the Commission of Enquiry into the Public Service. At the personal level and the local level where most of his life was lived, he suffered many disappointments and frustrations. His own outstation took a long while to establish and had to be abandoned be-cause of deaths that occurred the following year. He suffered more than most from the disrupting effect of alcohol on community life. Although he did not drink himself, his work was often disturbed by the drunkenness of others and his nights made sleepless by inter-ruptions and outbreaks of violence. His two eldest children died before him, and he felt keenly the problems of raising children in a chaotic world.

Through all this Narritjin kept painting. He would spend hours bent double over his sheets of bark, his head inches from the surface as he drew the long thin hair of the brush across the painting, meticulously covering it with infilled lines. Often he worked late into the night, the bare electric light bulb on the veranda illuminating his work. If ever I interrupted him while he was painting, with one of my endless ques-

tions, he would threaten to charge me for the answer. For he was a painter and painting was work which brought him money, and my interruptions cost him time. He saw himself as an artist and wanted to be recognized as that by others. Unlike most other Yolngu, Narritjin had become aware of the status accorded artists in white Australian society. In the 1960s he had lived for a while in Darwin and had won first prize in the Aboriginal art section of the Darwin show—an insignificant event in the art world, I am sure, but one of the ways in which Northern Territory Aborigines could begin to get a hint of the European attitude to art. He toured the southern states of Australia with an Aboriginal dance group and saw paintings displayed in galleries and museums, including those Aboriginal works collected by Scougall that were by then housed in the Art Gallery of New South Wales. At Yirrkala he began to realize that his works were in demand, that people were writing to the mission requesting them; in conversation with European art collectors and cultural entrepreneurs he learned that he was thought of as an artist whose works were highly valued. By the time I met Narritjin in 1973, he was well aware of the category "artist" in Australian society and was determined to be accepted as an artist by European Australians. One of the things he felt most frustrated about was that he had little direct contact with the market. Indeed, mission policy was that all artists should sell their work only to the mission store. Though artists were unwilling to be bound by such a rule, the market was so distant that few opportunities arose to deal directly with it. Narritjin almost always sold paintings to the craft store and had no further say in their marketing. He was unhappy with this arrangement because he felt that if people wanted to buy his paintings, they should deal directly with him, and he felt he was being financially exploited. He knew his paintings were in great demand, and he suspected they were being sold for much more than he was being paid for them. In this he was quite correct, as it was official policy of the craft store to subsidize the works of lesser artists and craftsmen by profits made on major artists' works. The store operated a "swings and roundabouts" policy: what they lost on poor or low-value work they made up on good-quality and high-value work.

In the mission context, Narritjin's paintings were framed as "mission work" to be paid for at piecework rates of return that were broadly similar to those of other bark painters. The missionary buyer in the early 1970s saw the craft industry in the same way that Webb and Chaseling had seen it at the beginning. Yet the missionary also knew that certain artists had a better reputation than others and set the price accordingly. When they moved out of the mission store, some paint-

ings moved straight into the fine art frame. But to the Yolngu the transformation seemed to occur by sleight of hand behind the doors of the mission store. Early on, in the 1940s and 1950s, there may have been no feeling that there was deception involved. Painting in ritual is referred to as *miny'tji djaama* (painting work), in harmony with the missionary objective. The artists produced for the missionaries who were becoming part of their world, and the paintings were effectively consumed by the mission. They were sent to the mission shops and to museums in the south, and for the foreseeable future no Yolngu would see them again. Yolngu were unaware of the European frame of fine art, and the missionaries were not so much selling the Yolngu work as art as they were selling examples of Aboriginal labor. However, forty years later, some Yolngu were not only aware of the European frame but had been actively involved in getting their paintings included in it and were painting for it. Yet the local intervention of the "mission work" frame still was able to frustrate them, preventing them from establishing direct links with the market and getting a higher percentage of the returns that their work fetched as fine art.

In keeping with the policy of modifying the return to artists whose work was in high demand was a failure to encourage the reputation of individual artists or to organize exhibitions of individual artists' works. Non-Aboriginal employees of the community used the supposed "egalitarian ideals" of Aboriginal society to argue against the organization of individual exhibitions. An individual exhibition would result in one artist being paid more than another artist, which would lead to jealousy, they argued. It would result in the artists getting "big-headed" and developing "unrealistic" expectations of the prices they might be paid for their work. An exhibition was, after all, a special circumstance, and everyday prices could not reflect prices paid at a well-promoted event. No one gave as a reason for discouraging greater involvement of the artist with the market the fact that artists might thereby become aware of the "swings and roundabouts" policy that had been operated on their behalf. However, one argument put forward to me on many occasions, when alternative policies were suggested to those that were presently being followed, was that such suggestions would "confuse the people." Just what was meant by "confuse" was never stated, but the argument was linked closely to another—that it was very important at this stage in Yolngu history that people should move forward in small steps.

The entrepreneurial enterprise of an artist like Narritjin put him out of step with the model of evolutionary development held by many of the long-term workers at the mission. One missionary explained to me

how he conceptualized the situation by drawing an explicit analogy with a stepladder. In terms of their development, Europeans were at the top of the ladder, agricultural societies such as the Fijians were in the middle of the ladder, and hunters and gatherers such as the Yolngu were at the bottom.[10] It had taken a long time for Europeans to get to the top of the ladder, so the first stage was to get the Aborigines up to the level of the Fijians, but if one tried to jump steps then the people would probably fall down. The "elevation" (for under such a model that is the way it must been seen) of an individual to the status of an artist in the European frame was clearly a leap too far, and it was very difficult for people holding such a model to provide the kind of community development assistance that an artist such as Narritjin needed. In many ways he saw the position much more clearly than any of the staff on the mission, who had little knowledge of Aboriginal art and of the changing perception of it in the art market. In marked contrast to the Reverend Edgar Wells, who in the 1950s and early 1960s had played a significant role in the promotion of Yolngu art, the missionaries of the 1970s were influenced by an earlier paradigm. Narritjin knew what he wanted done, but no one seemed to listen; in part this was because the advisers were working to construct a different frame, and the individual interests of an artist did not fit in. The roots of paternalism often lie in situations where advisers are working in a different frame to those they are advising, without even being aware of the fact (see Myers 1986: 276ff. for a relevant case study).

Many of the problems raised by non-Aboriginal advisers and employees were valid ones, and their motives were surely of the best. If the running of a craft enterprise was seen as something akin to a social service, the problem of what to do with people who produced unsalable or low-value crafts was a real one. If there was no outside subsidy then perhaps an internal subsidy could be justified, subsidizing one part of the operation by profits made in another. It was also reasonable to argue that Aborigines, who had lived most of their lives outside a Western economic system and who were still only marginally integrated within the Australian economy, could find economic aspects of the craft industry confusing, not to say contradictory. However, taking decisions in the best interests of other people without explaining to them the basis of those decisions, let alone allowing the people concerned to assent to them, is in itself a recipe for confusion and the development of misunderstanding. Narritjin found himself in a posi-

10. From the earliest days of the Methodist missions in Northeast Arnhem Land, Fijian missionaries have been included among the staff.

tion where he felt himself to be gaining a national reputation as an artist but was denied the kind of contact with the market which would bring him a better return for his paintings. However, as a Yolngu living for much of the time on an outstation remote from the rest of Australia, and having little knowledge of the intricacies or economics of the marketing of art, he depended on the mediation of others. And if those others had different objectives from his own then it was difficult to find alternatives.

Toward the end of his life, the situation of Aboriginal artists had changed radically, largely through the efforts of Aborigines like Narritjin, who refused to allow others to know best, who continually pressured government instrumentalities like the Aboriginal Arts Board, the Institute of Aboriginal Studies, and the Department of Aboriginal Affairs to provide them with the resources and institutions they required, and who continued to look for new opportunities themselves. From the mid-1970s onward, a network of advisers employed by the Aboriginal communities was established to develop community artwork and handicrafts, a central marketing company was formed to increase sales in southern cities, and an artists' agency was created to protect the rights of artists and to act as agents on their behalf. Artists began regularly to accompany exhibitions of Aboriginal art to major cities and on visits overseas to Europe and America. And exhibitions of paintings by individual artists or groups of related artists began to be organized.

In 1979, three years after the failed venture at Nhulunbuy airport, Narritjin and his son Banapana held an exhibition of their art in Canberra at which all of the paintings and carvings were sold. The exhibition was the culmination of three months as visiting artists to the Australian National University, during which time they had worked under conditions similar to other Creative Arts Fellows: they were paid a salary while producing their own work and discussing their art with students. The money from the exhibition was saved to take back to Arnhem Land, where it was used to buy a vehicle to help reestablish the Manggalili outstation at Djarrakpi, a day's drive from Yirrkala on an isolated promontory to the north of Blue Mud Bay. To Narritjin, recognition as an artist was a means to an end: the right to exist as a Yolngu in his own land, independent to an extent from European Australian society. The sale and exhibition of the art still had those dual aspects that the sale or exchange of paintings had had in the early days of European contact; the motives were in part economic and in part concerned with a more abstract exchange of value. In order to live at an outstation Yolngu need money, and the sale of Narritjin's and his

family's paintings was one way his clan could earn the money to live on their land. However, Yolngu also need a government sympathetic to their objectives and prepared to support them in maintaining a way of life and cultural traditions that are very different from those of mainstream Australian society. From a Yolngu perspective this involves ensuring that white Australians recognize the value of Yolngu culture. And that was why, in Canberra, the center of white Australian government, Narritjin gave one of the finest paintings he had produced to the university. He hoped that through understanding Yolngu art, Europeans would recognize the value of Yolngu society. At the opening of the exhibition, Narritjin addressed the audience with the following words:

Good evening, ladies and gentlemen. My name is Narritjin Maymuru—the artist fellow. I have been here now for two and a half months, that's when I did all these bark paintings. All these paintings have got meanings. It doesn't matter whether it's the littlest thing or the biggest. All got meaning, their own story. Everything has been done here in order to teach the Europeans in Canberra, so that they can understand the way we are traveling and why we are carrying on and the way and why we are living. And that's my message.

And this painting I am going to give to Canberra. Nobody has to pay. I just give to Canberra my paintings: the biggest one from my Manggalili clan. A present back to you in this country. That's all my message.[11]

Two years later, in 1980, Narritjin Maymuru died from a heart attack while intervening in a drunken brawl. A year later his son Banapana was dead. Yolngu continue to pay a terrible price for the space they occupy in history. Throughout most of his life Narritjin, like many other Yolngu of his generation, had struggled to construct a world in which his children and grandchildren could live in some kind of peace. The circumstances of his existence had shifted much more radically than they will in most people's lives. Born a hunter-gatherer beyond the effective boundary of the colonial frontier, he died a member of an encapsulated minority culture living at the edge of a huge mining venture that boasts the longest conveyor belt in the Southern Hemisphere. He spent a lifetime negotiating with Europeans, devising new ways of making a living, and attempting to persuade Europeans to value the Yolngu way of life and recognize their rights in land.

I was simply one of the Europeans Narritjin talked to on the way, and I listened a bit longer than most. My earliest efforts to act as a me-

11. This speech is transcribed from Ian Dunlop's film *Narritjin in Canberra*. The film shows Narritjin and Banapana during their Creative Arts Fellowship and also provides footage of Narritjin talking about his paintings to students at the Australian National University.

diator on that hot day at Nhulunbuy airport ended in dismal failure. This book is an attempt to do a little better—to continue the dialogue I had with Narritjin and to pass on my understandings to a different audience so that others can share the "lived-in other world" that lies beneath the surface form of Yolngu art.

3

Yolngu Society:
An Outline

The Yolngu, as a label for the Aboriginal population of Northeast Arnhem Land, is the last of a long line of names that have been coined for them by outsiders. Among anthropologists, Lloyd Warner (1958) called them the Murngin, Ronald and Catherine Berndt (see R. M. Berndt 1955) the Wulamba, and Warren Shapiro (1981) the Miwuyt. Each author recognizes that the term he or she has chosen is unsatisfactory and, in as much as it is used by the people themselves, has localized and specific application (see, for example, Shapiro 1969:17). I follow recent practice in referring to the people as Yolngu because it at least has the advantage of being a word they sometimes use to refer to themselves, even if not in quite the same sense as it is used by outsiders.

Yolngu means "Aboriginal person" in the languages of Northeast Arnhem Land and is sometimes used by speakers to refer to the languages themselves (*yolngu matha*). However, even today when they know that other people refer to them as the Yolngu, Yolngu most frequently refer to themselves and to the language they speak by a more specific name which identifies them with a more nar-

rowly defined group of people—a clan, an aggregate of clans, or a dialect group—names such as Djambarrpuyngu, Manggalili, or Djapu.

The problem of finding a label is a symptom of a problem at a different level, that of defining the group. Indeed perhaps we should see the word *Yolngu* as applying to a form of social organization, a culture area, a linguistic entity, or a social universe rather than to a named group of people, for these indeed are the ways it has been used. *Yolngu* refers to a group of intermarrying clans whose members speak a dialect of one of a number of closely related languages (see fig. 3.1). Although the clans fought at times among themselves and on occasions formed alliances with groups outside the region, and although intermarriage took place with outside groups, Yolngu clans formed part of a system of social and religious organization that differed as a whole from neighboring systems.[1]

There are three large settlements where Yolngu people predominate: Milingimbi (founded in 1922), Yirrkala (founded in 1935), and Elcho Island (founded in 1942). Although all these settlements were sited on traditional camping grounds, the places themselves were in no sense the nodal points of interaction between Yolngu clans that they subsequently became. Prior to the establishment of the mission stations, Yolngu clans were dispersed widely throughout Northeast Arnhem Land. Although the size and structure of communities varied seasonally, for much of the year the population lived in bands of around thirty to forty individuals (Peterson 1972:26). The majority of the population was concentrated along the coastline, which provided one of the major routes for communication and interaction between separate groups. There were, however, inland routes connecting the people of the Milingimbi–Cape Stewart region with the Yolngu clans living in the northern area of Blue Mud Bay in the Gulf of Carpentaria (Thomson 1949a:70).

By the late 1940s the majority of Yolngu spent at least the wet season living permanently in one of the three Northeast Arnhem Land mission stations. Over the years the economy became increasingly centered on the missions, and introduced occupations and institutions began to take over much of people's lives. However, even at the peak of the centralization and concentration of the population in the 1960s, young people still acquired the skills and knowledge of hunting and gathering, though they practiced them less often and less essentially

1. The extensive literature on the Yolngu system of social organization includes the work of Berndt 1955; Keen 1982, 1986; Morphy 1978; Shapiro 1981; Warner 1958; and Williams 1986.

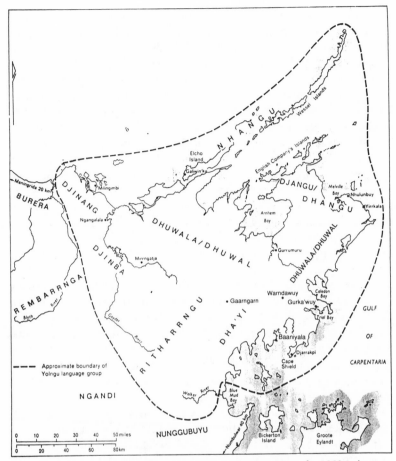

Figure 3.1 Yolngu languages and their neighbors. *Source:* F. Morphy 1983:xxiv.

than had their parents. Members of clans still maintained their spiritual links with and rights in their own clan territories, though they may have been living far away from them. A few people never really moved into one of the mission stations but remained living as hunters and gatherers off their land; most other people visited their countries for short periods when the opportunity arose or conditions were favorable. By the time I first visited Yirrkala in 1973, the process of centralization had been to a considerable extent reversed. In the early 1970s, people began to return again to live permanently on their own clan territories in small settlements known as outstations.

Outstations consist of small groups of fifteen to sixty people. The out-

station population is similar in structure to that of the Yolngu hunter-gatherer band of the immediate postcontact period (see Peterson 1986; Altman 1987). The outstation group tends to form around a core of people linked by patrilineal descent to the land on which the settlement is built, people who are often referred to as the "owners" of the land. Other members include people linked to the group by marriage, by descent from female members of the owning group, and by ritual affiliation to the group and the land. In some cases the outstation group is based at a single settlement site throughout the year; in other cases the members move among a group of sites, more closely paralleling the traditional Yolngu pattern of land use and settlement. Each outstation tends to have one or two four-wheel-drive vehicles which are used in hunting, in moving from site to site, and in visiting the main settlements such as Yirrkala for provisions or in an emergency. Links are also maintained with the main settlements by radio and in many cases by air since an airstrip is often one of the first things built at an outstation.

In the outstations, hunting and gathering is again playing a major role in the Yolngu economy. Hunted foods are supplemented by food purchased from the settlement shop, which provides the bulk of carbohydrates. The manufacture and sale of handicrafts are an important component of the outstation economy. Together with social service benefits and contributions earned by people employed in the main settlements, it provides the means of purchasing the food and equipment needed to keep the outstation going.

An outstation community is not equivalent to the hunter-gatherer band, though in its composition, its structure of authority, its mechanisms of distribution of resources, and in patterns of consumption it hints strongly at a past system of organization. Outstations are one part of a regional system and depend for their existence on the main settlements, on governmental institutions, on the development of an infrastructure of roads and airstrips, and on an income from outside. Without such support they could not exist in the form they do and would be a much less attractive option for the young in particular, who would miss the flexibility provided by rapid transport by road and air and would soon resent being cut off from their peers and the excitements provided by the main settlements. On the other hand the outstations are clearly not European institutions. In their present form they are an option created by Yolngu (and Aborigines elsewhere in Australia) which enables them to live a life relatively free from outside intrusion, in which people are in control of the events of everyday life and can to an extent set their own goals. The outstations physically distance Yolngu from some of the more destructive aspects of Euro-

pean society—from alcohol, from mining towns, and from the intrusiveness of government and individuals from outside. Many Yolngu feel that living on outstations gives them the time to devote to their own concerns, the space to become again the center of their own lives, instead of constantly being called upon to make decisions about things that ultimately always seem to be in other people's interests. Outstations thus provide an environment in which articulation with the outside world is mediated through a Yolngu cultural fabric. They enable people to maintain some control over their everyday lives, and to have some influence on the processes that are involved in transforming their society.

Moiety Organization

The population of Yirrkala is divided into two exogamous patrilineal moieties—Dhuwa and Yirritja. Two of the main characteristics of Yolngu social organization are the independence of the moieties from one another and their priority as an ordering system over other systems of classification. Individuals belong to the moiety of their father and marry a person of their mother's moiety.[2]

Although the moiety as a whole is not the landowning unit, the ideology is that land belongs in perpetuity to a clan of one or another moiety and is never jointly owned by groups of different moieties. Thus Dhuwa land will always be owned by Dhuwa moiety clans and Yirritja land by Yirritja groups. Should a landowning group become extinct, then ownership of the land is transferred to another group of the same

2. No cases of marriage between members of the same moiety have been recorded in the Yirrkala or Elcho Island regions of Northeast Arnhem Land. Shapiro (1967:461) reports one case of moiety incest at Elcho Island, but I heard of no similar case at Yirrkala. Indeed people's reaction to the question was that moiety incest was impossible.

In the case Shapiro reports, the child of this intramoiety relationship was allocated to the moiety opposite that of its parents. This case causes Shapiro to argue that the principle of recruitment to a moiety is by what he terms "relational affiliation"; the rule is that "an individual belongs to the moiety opposite to that of the mother." Shapiro comes to the conclusion that "the dual division constitutes an order of social classification which is distinct from that of the patrilineal groups" (Shapiro 1969:20). While this statement corresponds in many respects to my own view (as is shown later), Shapiro's rule for moiety affiliation is unsatisfactory. The ideology unambiguously stated by the Yolngu is that an individual belongs to his father's moiety, which is by definition the opposite of his mother's. If in the case of intramoiety incest the individual was affiliated with his mother's moiety, and assuming that he was brought up by his mother, he would be in a totally anomalous position, unable to marry, as all the relationship terms he applied to other members of the Yolngu society would be to members of the opposite moiety from that to which the terms usually applied. The only solution is to "forget the father" and allocate the child's moiety affiliation according to the exogamous norm. The fact that relationship terms are matri-determined is consistent with patrilineal recruitment to groups, as Maddock (1970:80) has shown.

moiety. To the Yolngu, neither land nor clan should change moiety. There is no evidence to show whether in the immediate past Yolngu clans or individuals have changed moiety or whether the ownership of land has crossed moiety boundaries. Demographic factors suggest that both possibilities could have occurred. There are documented cases of individuals and groups changing moiety affiliation in the region immediately to the south and to the west of the Yolngu area (Hiatt 1965:131; D. H. Turner 1974:73). Some people at Yirrkala are aware of the Groote Eylandt case discussed by Turner. I was told that today people could not marry Groote Eylandters as they had mixed up their moieties and did not know if they were marrying Dhuwa or Yirritja women. In a similar case, I was told that the Nunggubuyu, who live to the south of the Yolngu, married "just like animals" as their moieties were the wrong way around. The fact that moiety changes occur on the fringes of the Yolngu area suggests that similar adjustments could have taken place previously within the region. The response to this kind of change by the present-day Yolngu is in accordance with their ideology of the immutability and independence of the moieties over time.

The independence of the moieties is strongly emphasized in the mythological system and in the system of totemic classification associated with the mythology. Everything is classified as belonging to either the Dhuwa or the Yirritja moiety. As Warner states, "there is nothing in the whole universe . . . that has not a place in one of the two categories" (1958:30). Each ancestral being is referred to almost exclusively in the mythology of one of the moieties only, and in that sense can be said to belong to that moiety, although such beings also have significance to members of the opposite moiety. Their creative land-transforming acts took place in the land belonging to the one moiety, and their tracks avoid land belonging to the opposite moiety. When confronted with an adjoining area of the opposite moiety's land, the ancestral beings either avoided it by taking a circuitous route around it, or crossed it by diving underground or flying over it. Thus the shark *maarna*, moving from one Dhuwa moiety area to another, bypassed territory belonging to the Yirritja clan Makalganalmirri by diving under it, and the Yirritja *guwak* (koel cuckoo) flew from Djarrakpi to the Wessel Islands, passing over Dhuwa land. There are few exceptions. One example is that of Wuyal, a Dhuwa moiety ancestral sugar-bag hunter who crossed into Yirritja territory at Cape Shield (Djarrakpi). He tasted the wild honey there, but finding it salty, quickly retreated into Dhuwa land to the north. Such excursions into the territory of the opposite moiety are rare, and interaction between Dhuwa and Yirritja ancestral beings still rarer.

Although Dhuwa and Yirritja myths rarely join together, and Dhuwa and Yirritja ancestral beings meet, if at all, only in passing, it is still possible, conceptually at least, to establish contemporaneity between certain sequences of events which took place in the separate mythologies. A nexus of cross-references exists which establishes temporal sequences transcending the moiety division. For example, the phrase *Wuyal time* can be used to locate events in the mythology of Yirritja moiety clans, although Wuyal is a Dhuwa moiety ancestral figure. *Wuyal time* in this sense refers to a time of constant change when individuals were breaking the established law. Laanydjung, a Yirritja moiety ancestral being, is said to be contemporaneous with Wuyal. Laanydjung was sent out to show various Yirritja moiety clans a set of sacred dances and designs which would form the basis of the men's ceremonies. However, he sometimes showed the dances to the women and as a consequence was killed. His actions are seen to symbolize disorder and change—change that was occurring at the same time in Dhuwa moiety land at the instigation of Wuyal. However, it would be wrong to see this correspondence as a means of establishing an invariant, chronologically based, sequence of mythic events. Because of the nature of the Yolngu concept of time, mythological events are not simply located in the distant past but are also in some senses seen to be part of a continuous present. They can therefore be used to describe present and future states as well as the past.[3] The fact that cross-references can be made between the mythologies of the Dhuwa and Yirritja moieties does not affect their essential separateness. Shapiro (1969:20) goes so far as to state: "Dhuwa myths do not so much as assume the existence of Yirritja myths and vice versa."

Clan Organization

The ideology of the clan system is based on patrilineal descent, with men and women belonging to the clan of their father, which is a clan of the opposite moiety to that of their mother. The clans have many of the characteristics of shallow patrilineages, a point emphasized by Berndt (1955:94). Each clan as a rule traces its descent back to a single ancestor, usually about five generations back from the present. In several cases this is the product of a genealogical fiction linking together two or more otherwise unconnected lines.

Although the ideology is that clans exist in perpetuity, their members sharing the same *wangarr* (ancestral) inheritance which they pass

3. Thus Wuyal time can be applied to the present day to describe the chaos caused by European colonization. Moreover, as correspondences depend partly on reference (in this case a time of chaos and disorder), the correspondences of events within the mythological systems will vary according to the reference point adopted.

on patrilineally, the reality is somewhat different. A clan is, rather, a group which acknowledges joint ownership of *mardayin* (sacra) and adheres to a patrilineal ideology, but which contains within its structure the raw materials of fission and fusion: through internal segmentation, through its mythological links with neighboring groups, and through the differential control over the system of knowledge exercised by its members (see chap. 4).

No single term in the Yolngu language is precisely equivalent to my use of the word *clan*. Shapiro (1969:19) regards the word *baapurru* as the generic term for "sib" (the equivalent of my *clan*). Berndt used the term *"mala-mada (mala-matha)* pair" to represent clan–dialect group and uses the word *bapuru* (*baapurru*) in a more restricted sense (Berndt 1976:25). Neither is correct in his usage. Schebeck (n.d.) has taken Berndt to task for using the terms *mala* and *matha* in a misleading way. Schebeck makes two main criticisms: the first is that the terms have more general application than Berndt allows and can be applied at different levels; the second is that the groups to which Berndt applies the terms are frequently groups at different levels of organization or of contrast within the system.

Mala is a pluralizer: as a suffix it converts a singular noun into a plural. Used as a free-standing word it has many of the connotations of the mathematical usage of the word *set*. A *mala* is one set (of people) as opposed to other sets of people which can be identified as the same level of contrast. Thus Daymbalipu Mununggurr, a Djapu man, can be referred to as a member of the Djapu *mala*, the Balamumu *mala*, the Yirrkala *mala*, or the Institute *mala*. The first refers to him as a member of a clan, the second as a member of a set of clans of both moieties living in the area of Caledon Bay, the third as a resident of Yirrkala, and the last as a worker for the Australian Institute of Aboriginal Studies. These represent four of an infinite number of sets to which an individual may belong, some of which may have largely overlapping membership, others of which he may be the only link between. The crucial fact is that the question What *mala* do you belong to? produces a variety of responses, depending on the reference point adopted.

Matha is similarly ambiguous, meaning something like "set with respect to language" (the word *dhaaruk* has recently been preferred to *matha*, due to the recent death of a man with a similar-sounding name).[4] Thus Daymbalipu can be referred to as a speaker of Dhuwal

4. On the death of an individual, the Yolngu, like many other Australian Aboriginal people, cease to use words that sound like the name of the dead person. A synonym, or a loanword from a neighboring language, is substituted. The length of time for which a word will be avoided is variable, depending on such factors as the importance of the dead person and the closeness of the speaker's relationship to him or her.

matha, Djapu *matha,* or Yolngu *matha.* Bunbatjiwuy, a man of a differ-
ent clan, could also be referred to as a speaker of Dhuwal *matha* and
Yolngu *matha.* He does not, however, speak Djapu *matha* but Djambarr-
puyngu *matha,* which is another "language" existing at the same level
of contrast (F. Morphy 1983). Djambarrpuyngu is also Bunbatjiwuy's
mala at one level of contrast. By selecting the level of *matha*
represented by Dhuwal *matha* and the *mala* level of Djapu versus Djam-
barrpuyngu, and by applying the specific terms as labels for the two
individual's clans, one produces the Dhuwal-Djapu clan and the
Dhuwal-Djambarrpuyngu clan. As long as one is certain that the differ-
entiating terms are selected at the same level of contrast, and that one
knows something of the significance of the contrast, then this is clearly
a valid analytic procedure to adopt, even though it is inappropriate to
translate *mala-matha* as "clan."

Shapiro also distinguishes between clan (sib) and dialect group, for
which he uses the same term as Berndt (i.e., *matha*). Interestingly
enough, Shapiro selected terms at different levels to those selected by
Berndt. This is demonstrated by the fact that my clan names are the
equivalent of Shapiro's clans and of Berndt's linguistic groups.
(Berndt's clan names are the same as Warner's phratries, which Warn-
er defines as sets of allied clans.) None of this is surprising when it is
understood that the Yolngu terms *mala* and *matha* can be applied to the
same group. As I have shown, Djapu is both a linguistic group and a
social group (that is, a clan). The clan cannot be defined by the use of
either Yolngu term, although both can be applied to it.

The groups to which I apply the term *clan* are named patrilineal de-
scent groups which acknowledge common ancestry, hold in common
rights over land, and have the same *mardayin,* that is body of sacred
knowledge, or "sacred law."[5] Clan names are the ones most frequently
given when an individual is asked what group/clan/tribe/people he or
she belongs to. The surnames recently adopted by Yolngu for bureau-
cratic purposes correspond to the individual's clan, although they are
not the names of the clans. Thus all Top Djapu people use the surname
Mununggurr.[6] When a clan has more than one name, then the name I
use is the one most frequently employed by the Yolngu. The names are

5. Williams (1986:95) provides a complementary definition of a clan as "a group
sharing an ideology of patrifiliation and made corporate by its ownership of land." She is
concerned to show that land ownership is integral to the Yolngu concept of clan.

6. "Top" and "bottom" are translations used by the Yolngu for the Yolngu terms *gupa*
and *dhurdi* when these are applied to pairs of clans sharing the same name. The primary
reference of these terms is anatomical: they may be translated respectively as "nape" and
"buttocks." In the case of clan names, *gupa* designates clans whose main territories lie on
the coast, while *dhurdi* refers to clans of the inland.

Table 3.1 Some Yirrkala Clans

Dhuwa Moiety	Yirritja Moiety
Djapu 1 (maari/dhudi/bottom)	Gumatj 1 (gupa/top)
Djapu 2 (gutharra/gupa/top)	Gumatj 2 (Martamarta)
Rirratjingu	Gumatj 3 (Yarrwidi)
Marrakulu	Dharlwangu 1
Marrakulu/Dhurrurrnga	Dharlwangu 2 (Gurrumuru)
Ngaymil	Manggalili
Gaalpu	Mardarrpa
Djambarrpuyngu	Munyuku
Djarrwark	Warramiri
	Wan.guri

Notes: A number following a clan name indicates that more than one clan shares that particular name. The words in parentheses following a clan name are the most common modifiers applied to that name (see fn. 6).

used in contrast to one another and can be considered to represent groups at the same level of segmentation. The named clans represented at Yirrkala and its outstations are shown in table 3.1.

Although everybody at Yirrkala did in fact claim membership in and was acknowledged to be a member of their father's clan, the statement that clan membership is patrilineal must be qualified in a number of ways. First, individuals may be affiliated to clans other than their father's (although this is always in addition to membership of their father's clan); second, links traced through women unite sets of people across clan boundaries, correspond with points of fission within clans, and have the potential to create new clan groupings either by fission along matrilineal lines or by fusion or absorption on the basis of matrifiliation.

Many clans are subdivided internally into a number of separate patrilines or sublineages. The existence of these subdivisions is manifested in a number of ways: patrilines may have a different set of ritual responsibilities and be more closely linked with one section of the clan's territory and the associated *mardayin* (sacred law) than with other sections. Moreover, rights in marriage and relations of alliance based on them may be reflected at, and operate at, the subgroup level rather than at the level of the clan as a whole. Subdivisions of a clan are also reflected in residence patterns and daily interaction: members of subgroups tend to live together, and they interact with one another more than they do with other clan relatives.

The Property of Clans: Land and Mardayin

Membership of a clan gives an individual sets of rights and obligations with respect to the ownership of land and *mardayin,* which according

to Yolngu ideology are jointly owned by the members of a clan as a whole. *Mardayin,* translated by Yolngu as "history law," "sacred law," or simply "law," centers around the songs, dances, paintings, and sacred objects which relate to the actions of the *wangarr* (ancestral) beings in creating the land and the order of the world.

Rights in mardayin and rights in land are two sides of the same coin. To simplify slightly, rights in land were given to the founding human ancestors of a clan by the wangarr ancestral beings, who journeyed across the respective areas of land and created features in them. The clan was also entrusted with the sacred law that derived from the actions of the wangarr and which formed the basis of ceremonial reenactments of ancestral events. Continued ownership of the land was conditional on the clan maintaining the sacred law of the land, performing the ceremonies, and passing on the paintings to succeeding generations. "Looking after" the mardayin, then, is a requirement and responsibility of the landowners. However, use of the mardayin is also a statement about rights in land since the mardayin represents an ancestral charter to the land.

The issue of the ownership of mardayin is complex. Although a clan owns a unique set of mardayin, a single mardayin can be jointly owned by two or more clans and indeed is rarely the property of a single clan. For example, the Munyuku share the *birrkurda* (the Yirritja wild honey) mardayin with Dharlwangu and Gumatj, the snake (*mikarrarn*) with Manggalili and Mardarrpa, and the whale (*wuymirri*) with Warramiri and Gumatj. In the Munyuku case, the mardayin is grounded firmly in Munyuku territories, the songs refer to Munyuku places, and the Munyuku paintings and sacred objects show some variation from those of other clans sharing the mardayin. On the other hand, the song cycles may be the same (with place-names having different reference according to clan), and the performance of a ceremony will involve the agreement and participation of a number of clans sharing the mardayin. The members of each clan thus possess rights to a unique set of mardayin which overlaps to some extent with the sets of mardayin belonging to other clans of the same moiety.

Differential Rights to Mardayin Within a Clan

Although there is a strongly asserted ideology that all members of a clan exercise joint rights in the clan's mardayin, some evidence shows that differential rights to mardayin exist among the members of a clan. For example, certain members of a clan produce bark paintings predominantly associated with one mardayin or one part of the clan's territory, whereas other members produce predominantly another set. When I questioned people about this apparent contradiction, they

tended to confirm my observations, but denied the conclusions I have drawn. They asserted that although X did produce that painting exclusively, other members of the clan could produce it and it belonged to all members; "we are all one people" or "we are all one *baapurru*."[7]

Bokarra of Manggalili patriline 2 and Narritjin of patriline 1 produced different but overlapping sets of paintings for sale. Narritjin primarily produced paintings from the country of Djarrakpi on Cape Shield, which refer to the wangarr *guwak* (koel cuckoo). Narritjin rarely produced paintings relating to the other main Manggalili mardayin, the *nguykal* (kingfish); when he did, he produced paintings related to the saltwater section of the kingfish's journey, which links it to the *guwak*. Bokarra, on the other hand, painted mainly kingfish designs, in particular ones associated with the inland section of the wangarr's journey. The division of the paintings reflects the different links each patriline has with the patrilines of other clans. The wangarr kingfish traveled from Dharlwangu country, passing by Marrakulu country (Bokarra's mother's country) before reaching Manggalili clan territory. The *guwak,* on the other hand, connects Manggalili clan territory to Gumatj 3 territory.

Similar factors operate in the case of the Munyuku clan, which is also divided into two patrilines. Each patriline is said to belong to different parts of Munyuku territory, each of which has a different set of paintings associated with it. However, despite the fact that in the case of the Munyuku and Manggalili certain patrilines are more closely associated with one area of the clan's territory and one mardayin than they are with the others held by the clan, members of the clan still assert that all of the land and mardayin are jointly owned by the clan as a whole. Joint ownership of the clan's land and mardayin is thus a crucial component of the definition of a clan.

One of the main signs of clan fusion is the fact that groups which previously asserted separate ownership of paintings and land acknowledge joint ownership of land and mardayin (often uniting to form a single clan). Three clans with similar names temporarily united to form a single clan in the late 1960s. Prior to this, one clan owned a unique set of paintings characterized by a clan design different from that employed by the other two. In 1974 I frequently saw members of the clans doing each other's paintings. I was told that at the time of the Gove land-rights case in the late 1960s, some members of the clans felt

7. There is some evidence of regional variation in the relation between groups and land within the Yolngu area. Keen (1978) presents a somewhat different picture of land ownership in the Milingimbi area in the west of the Yolngu region. There the association between the separate lineages within a clan and particular areas of land seems more formalized.

it would complicate their case if more than one clan with the same name laid claim to different areas of land. Senior men had held a meeting and had decided to become one group jointly owning their land and mardayin. Since that time, senior men of all three groups have been able to produce each others' paintings without asking permission. Prior to this development, the clans were in any case linked mythologically, sharing many mardayin in common. This may have made the process of temporary fusion much easier.

Whether or not the explanation I was given is correct, it is important to emphasize that the fusion of clans in this case involved the decision to exercise joint rights in mardayin and acknowledge joint ownership of land. There is evidence that today the situation has reverted to what it had been before the land-rights case, with the groups concerned stressing their separate rights to land and mardayin. This is consistent with the explanation I was given: people believe they have now obtained land rights, and therefore the situation which necessitated the fusion no longer obtains. The groups are now effectively reasserting their individual claims to land.

Marriage and the Relationship between Clans

The Yolngu system of kinship and marriage has been the subject of extended anthropological debate. Here I try to leave the controversy aside and merely outline briefly some of the main features of the system that provide a background to understanding Yolngu art.

For the majority of Yolngu, kinship terms for sets of siblings (EB, *waawa;* EZ, *yapa;* and YB/Z, *gutha*) are equivalent in terms of both how they are addressed by others and how they address other kin. Thus, for example, both a woman and her brother refer to her children as *waku* and to his as *gaathu*. The kinship system is a broadly classificatory one, and every Yolngu person is incorporated within it, though in certain contexts distinctions are made between close and distant kin. To a limited extent the terminological system is also used at a sociocentric level to refer to relationships between clans that reflect aspects of the pattern or structure of ego-centered networks. The key terms employed are *maari, ngaarndi, yapa, waku,* and *gutharra.* With the exception of ngaarndi and yapa, the terms are ones that apply to or are applied by siblings of both sexes: MM/MMB for maari, C/ZC for waku, and DC/ZDC for gutharra. Although it could be argued that the reference of the terms is ambiguous in these cases, much evidence suggests that the focal relationship in all cases is the female one, since the sociocentric relations are structured on the basis of links drawn between clans on the basis of matrilineal connections.

Yolngu marriages are arranged between people who belong to the

appropriate kinship categories: a man marries a woman he calls *galay,* and a woman marries a man she calls *dhuway. Galay* can be glossed in genealogical terms as MMBDD or MBD. A man has strong claims to marry a daughter of his actual MB and whose mother is also his actual MMBD.[8] However, frequently people marry more distant classificatory members of the correct kin category.

Yolngu marriage is polygamous, with some senior men having ten or more wives, though the majority today would have two or three. Keen (1982) has shown that powerful men are more likely to succeed in marrying women to whom they have a distant claim, or even no legitimate claim at all, than are less powerful men or men from numerically weaker clans. Marriage is the subject of negotiation, and the more powerful a person the more he or she can influence the process of bestowal. Many people have a say in the bestowal of a woman in marriage, but the strongest set of rights are held by a set of matrikin (male and female) operating in the context of preexisting relationships of alliance between clans or, in the case of large clans, lineages of those clans.

When discussing marriage relationships and the flow of women between groups, Yolngu focus on the passage of women between groups of the same moiety. For example, a Manggalili man said, "We marry Gumatj women," and when asked who Manggalili gave women to, replied, "We give women to the Dharlwangu." Manggalili, Dharlwangu, and Gumatj are all Yirritja moiety clans. As moieties are exogamous, the replies are in need of some explanation. In each case the person concerned was clearly referring not to the actual clan affiliation of the respective spouses, but to the process of bestowal.

According to Shapiro (1970; see also 1981), a woman is bestowed primarily by her M and MB, which accords with the situation reported by Hiatt for the neighboring Gidjingali, and by Maddock for the Dalabon to the south of the Yolngu area. A woman's MF also exercises rights of bestowal, as Maddock (1969:20) suggests. A man's wife's

8. My understanding of the Yolngu system of bestowal is close to that of Williams (1986:53) and Shapiro (1969). Keen (1986) lays greater stress on the role of MB in the system of marriage, and on men gaining rights consequent on their father's marriage. Differences reported by Keen (1986), Morphy (1978), and Shapiro (1981) may reflect regional differences in the way marriage arrangements are conceived and differences in the extent to which they are phrased in terms of individual rights or relationships between groups. The genealogical pattern of marriage relations appears to be similar across the region and is clearly determined by a multiplicity of interests (group and individual), by (crosscutting) structural relations among kin, and by different ways of framing marriage ideologically, all of which are differentially emphasized or expressed on a regional basis and which are subject to change over time.

mother's group is the same as his MMB group, and it is to his MM[B]'s patriline that a man looks for the promise of a wife. A man may have little say in whom his daughters should marry, but a considerable say in whom his daughters' daughters and sisters' daughters should marry. In practice, however, a senior man takes part in negotiations concerning his daughter's marriage, as well as those of his daughters' daughters. Women also play a considerable role in marriage arrangements, as Hamilton (1970) has shown to be the case for the neighboring Gidjingali. Women take part in discussions on marriage arrangements on the same basis as men do, according to relations of kinship and clan membership, though their role is less strongly emphasized than that of men. The structure of the bestowal system is illustrated in figures 3.2 and 3.3. In alliance terms it can be seen that ego's group and his MM[B]'s group stand in a wife-receiving–wife-bestowing relationship.

A complicating factor of the Yolngu marriage system is that mothers-in-law and wives should be members of different sections of clans from sister's husbands and sister's daughter's husbands, and indeed they usually belong to different clans. This means that the wife-bestowing–wife-yielding relationship between maari (MM[B]) and gutharra ([Z]DC) clans or sections of clans cannot be reciprocal. A clan is linked by marriage to a set of maari clans and to a separate set of gutharra clans. Looked at from the point of view of a male ego, a man is closely linked by marriage to four other clans: the clan of his wife, his mother-in-law, his sister's husband, and his sister's daughter's husband (see fig. 3.4).

At a sociocentric level, clans of the same moiety stand in either a maari (mother's mother's [brother]), a gutharra ([sister's] daughter's

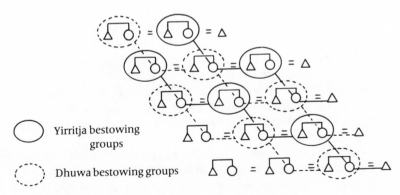

Yirritja bestowing groups

Dhuwa bestowing groups

Figure 3.2 The structure of bestowal—rights along the matriline.

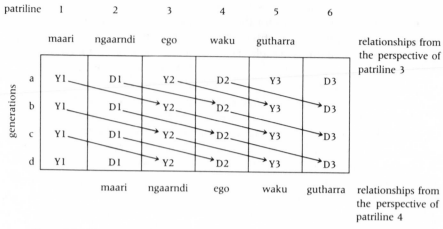

Figure 3.3 The passage of women and the relationships between groups.

child), or a yapa (sister) relationship to one another. Such classifica-
tions reflect the actual balance of individual relationships between the
respective clans and their structural position within the system of mar-
riage alliances. Clans referred to as maari are, or have been, prominent
in providing mothers' mothers and mothers-in-law to male members
of gutharra clans. All members of a gutharra clan refer to such clans as
maari, irrespective of whether or not their actual mother's mother was
a member of the clan. Clans which have in recent generations pro-
vided the majority of mothers' mothers to a clan are more important
than other maari clans in, for example, ritual affairs, and are the most
likely source of mothers-in-law. Some clans referred to as maari may
not have any actual MMB-ZDC linkages with a particular gutharra
clan. In such cases the relationship of maari and gutharra between the
clans does not signify any close and active relationship between them;
rather it reflects their structural position within the regional system.
Sister clans (yapa) are clans which share particular mardayin (sacred
law) in common and are thought to be spiritually and ritually allied,
but which do not stand in a wife-receiving or -bestowing relationship
to each other. Yapa clans are often in a structurally similar position to
one another in the marriage system and may share maari and gutharra
clans in common.

The case with ngaarndi (mother's) clans and waku (sister's chil-
drens' clans [male ego], own childrens' [female ego]) is different from
that of relations between clans of the same moiety. Indeed there is no
sociocentric set of relationships between ngaarndi and waku clans
which is equivalent to that between maari and gutharra. An individual

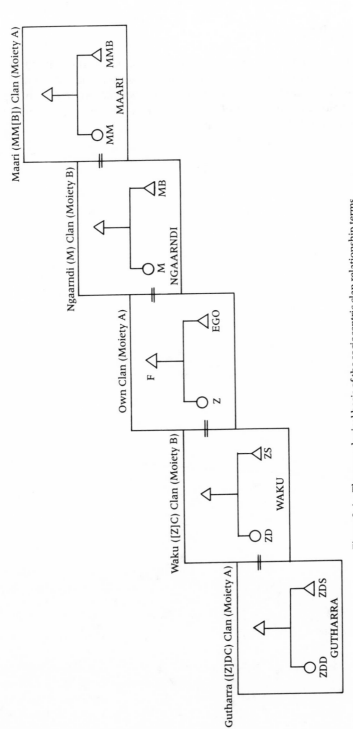

Figure 3.4 The genealogical basis of the sociocentric clan relationship terms.

will only call a clan ngaarndi if his or her actual mother came from it, or if it is closely associated with his or her mother's clan through ritual or mythological ties. A clan is thus linked as ngaarndi to a set of waku who belong to a number of different clans of the opposite moiety, but all of whom "share the same mother."

4

The Rights to Paint

Rights in paintings must be distinguished
from ownership of paintings. Paintings are
part of the ancestral (wangarr) inheritance of
clans. They are as much the property of clans
as the land itself. They are not so much
owned as integral to the very existence of the
clan. But because they refer to ancestral
beings and because those beings traveled
across the territory of many clans, paintings
may be connected to more than one clan.
Clans on the same ancestral track may own
paintings which are formally very similar,
and in such cases the paintings belonging to
two or more clans may be said in certain con-
texts to be the same. It may even be said that
a formally similar painting belonging to an-
other clan is "our painting." In other con-
texts, however, the different ownership of
the respective paintings is unambiguously
acknowledged and, unless there is dispute
over the ownership of an area of land or the
constitution of a clan, the paintings are lo-
cated firmly as the property of a particular
clan. However, ownership is only one of the
rights people can have in paintings. Other
rights include the right to produce certain
paintings, the right to divulge the meanings

of a painting, and the right to authorize or restrict the use of a painting. These rights are distributed much more widely than the membership of an individual clan, and it is the distribution of these rights that I am concerned with in this chapter.

It is necessary to distinguish between the possession of rights in paintings and the exercising of those rights. A person may assert his right to discuss a particular painting or exercise control over its production without ever having produced the painting himself. For example, a Djapu (Dhuwa moiety) man at one stage asked me to obtain permission from him before commissioning any more Bottom Gumatj (Yirritja moiety) paintings. As a senior member of a waku ([Z]C) set he had a strong say in the production of Bottom Gumatj paintings, although he was acknowledged never to have painted one. He held the right to produce Bottom Gumatj paintings, but he never exercised it, whereas he both possessed and exercised the right to control their commercial production.

Young people frequently have the right to produce paintings which they are not allowed to discuss, irrespective of any knowledge they have of the meaning of the painting. A younger man (or woman) will always defer to an older man when discussing a painting if the older man has equal rights in the painting.

The exercising of rights in paintings is part of the more general issue of the exercising of rights over anything connected with the clan's mardayin. In such cases there is a general rule that nothing can be done without the assent of the eldest nonsenile individuals who have rights in the mardayin concerned.

A distinction must also be made between rights in paintings and knowledge of paintings, although the two are closely connected. Rights in paintings include rights to knowledge of paintings and their meanings. Such knowledge, once gained, can be converted into rights at other levels, for example, rights to divulge the meanings of paintings to others. However, knowledge of the meanings of paintings does not in itself imply the right to disseminate that information to others.

Knowledge of paintings may be gained in a number of ways: through teaching by a senior clan member, through individual exchange of paintings, and by watching paintings produced in ceremonial contexts. Access to a ceremony implies the right to gain certain knowledge of the currency of meaning associated with it. The more times an individual participates in a ceremony, the more knowledge he acquires about it. A recognized way of gaining knowledge about a ceremony is to travel widely and see related ceremonial performances organized by distant groups. Such journeys are built into the structure of male initiation (Warner 1958:262).

Women's acquisition of knowledge follows a pattern similar to that of men, though it is publicly acknowledged that their access to knowledge is less than men's, and they are less likely to have the opportunity to exercise rights in sacred law. There are no separate major ceremonies for Yolngu women, and there is no separate body of women's ancestral knowledge. Women, like men, are members of their father's clan, and on the basis of kinship they have a potential set of links with the mardayin of other clans, as do their male siblings. Just as with men, women gain knowledge partly according to their age, ability, and motivation. However, women are excluded from many of the ceremonial contexts in which men acquire knowledge, and in public their access to restricted knowledge is routinely denied. Women do not go through the same stages of initiation as men and are seldom called upon to exercise rights in religious knowledge in public. We shall see in a later chapter that this brief summary does not really do justice to the reality of women's sacred knowledge, but it does reflect public ideology concerning the limited extent to which they have control over it.

Ceremonies generally have more and less restricted phases. For example, as will be seen in the next chapter, most ceremonies have stages that are performed publicly in the main camp as well as stages of more restricted access. The revelation of the most sacred objects of a clan and discussion of their significance are said to involve only the most senior male members of the clan and related clans, in addition to senior initiates. Sometimes the sacra of a number of clans of the same moiety may be revealed at the same time. An area where the male elders of a group of clans display and jointly bury sacred objects belonging to their respective clans is termed a *ringgitj* area. Knowledge obtained in the context of a *ringgitj* ground is considered the most definitive, as the *ringgitj* is the context of agreement between members of different clans sharing the same, and even on some occasions different, mardayin (Peterson 1972:229).

When interpreting paintings for me, men would often refer to the various contexts in which their knowledge was acquired:

What I tell you I learned standing in the *ringgitj* ground.

Old Mundukul [his MMB] told me everything when they held the ceremony.

The old people they wanted me for the ceremony. Old Wonggu, old Mundukul, Watjung, Yaama, dead fellow my uncle and Wandjuk's father, they called me from Blue Mud Bay where I was living right up here [Yirrkala].

People construct in this way the genealogical credentials of their knowledge, proving its authenticity. This is clearly consistent with the

Yolngu ideology that paintings and the mardayin are basically unchanged over time from their ancestral form. Access to knowledge can therefore be seen as access to the conservation and perpetuation of knowledge. As Djewiny graphically put it: "We are just rushing up to Laanytjung and Barrama, and trying to catch up with what they have been doing before, because they remind us to look to our history. That's why we have sacred paintings and dilly bags and sacred objects, so that we can learn back from our history."

Although people gain knowledge of this history in a number of ways, they do not acquire the right to use this knowledge without the permission of the owning group. Thomson (1939b:2) and Warner (1958:160) give many examples of the consequences of infringing on the rights of owning groups by using their paintings without permission or by divulging information about the clan's mardayin (see also Elkin, Berndt, and Berndt 1950:62). Such infringements frequently lead to conflict between clans and in the past possibly led to the death of the guilty person or another member of his clan. However, should the owning group become extinct or should senior members of the group die out without passing on their knowledge of the clan's paintings to the younger members of the clan, then the status of nonclan members who hold this knowledge changes. It becomes their responsibility to pass on their knowledge of the clan's paintings to the younger members of the owning clan when they are of the right age. In order to do this a man must produce the paintings. One of the motives for releasing knowledge to nonclan members is precisely this: to ensure that if senior members of the clan should die, then knowledge of the clan's mardayin will not die with them, but will ultimately remain with the clan's members. Even if the clan becomes extinct, the mardayin will still be conserved and taken over by other groups.

In addition to acquiring rights in his own clan's paintings, a man may acquire rights in paintings of his ngaarndi (M) or maari (MM[B]) clan. A man may also obtain rights in the paintings of certain clans of his own moiety, notably of clans he calls yapa (sister) (see also Elkin, Berndt, and Berndt 1950:61).

Rights in One's Own Clan's Paintings

Until recently, complex sacred paintings were exclusively produced by men, often painting in seclusion from women. Today the situation is beginning to change, particularly if the paintings are produced for sale, but in ceremonial contexts paintings are still mainly done by men, and Yolngu accounts of the acquisition of knowledge in paintings and the exercising of rights in them place the major emphasis on the role of men in this process. For these reasons, this section is written predomi-

nantly from a male viewpoint. As the argument of the book unfolds, it will become clear that this situation is by no means an inevitable one and that increasingly women are exercising rights that are similar to men's. Where women have exercised these rights, they have done so on a basis similar to their brothers and in a way that reflects similar networks of relationships linking people with clans and ancestral places.

A man first obtains rights to produce his own clan's paintings. He generally learns by watching his father paint and subsequently assists his father in infilling sections of half-finished paintings. The ideology is that young boys are taught painting only after they have been circumcised, an event which takes place between the ages of nine and thirteen. The teaching of paintings is seen as part of the ongoing process of initiation, and takes place in conjunction with the learning of songs and of some of the meanings of paintings. Old men stress that willingness to learn the songs and some success in learning them are a precondition of teaching young men paintings. Songs are considered the most public medium for expressing the mardayin and should be the first thing learned. Along the same lines, the first paintings a young man is encouraged to produce are "outside," or public, ones. Observation suggests that this norm is consistently adhered to. Thus Narritjin's son Mowarndi was producing only outside paintings in 1976. At this time he was thirteen, and it was three years after his circumcision. In 1974, Lumaluma 2,[1] then in his early twenties, produced his first "inside" painting. Prior to that he had become an accomplished bark painter, but had produced only outside paintings of his own invention depicting clan *mokuy* (ancestral spirits). At the same time that they begin to produce outside paintings by themselves, young men start assisting their fathers or elder brothers in the production of sacred paintings, but do not, as yet, paint them on their own.

Once a young man has produced his first sacred painting, he fairly rapidly acquires the right to produce a number of other paintings belonging to his clan. Thus Lumaluma learned three further paintings in the weeks following the occasion on which he produced his first sacred painting. However, the right to produce paintings that represent the designs on *rangga* (sacred objects) or which are closely associated with the most restricted sacred objects remains restricted to the senior male members of a clan.

One of the main contexts in which men learn their clan's most re-

1. When two people share the same name, they are distinguished (in English) by number. The elder is referred to as X number 1, and the younger as X number 2. As far as is known, this does not translate directly from any Yolngu-language naming practice.

stricted paintings is shortly before or soon after their father's death. Thus I was told that Mawalan, a senior Rirratjingu man, taught paintings to each of his children in the months before he died. Significantly, Mawalan is acknowledged as the first person to include his daughters equally in the transfer of rights to the next generation, teaching paintings to both of his. Although ideally a man should be taught his clan's paintings by his father, frequently a father dies before he has been able to pass on his knowledge to all his children. Before his death in 1973, Bununggu told his eldest son Liyawulumu to begin teaching Lumaluma 2, the eldest son of his second wife, paintings that he had previously taught to Liyawulumu. It was those paintings that Liyawulumu began to teach Lumaluma in 1974.

If a man dies when all his children are too young to be taught the paintings, the responsibility is passed on to someone else. In explaining why they taught the children of a dead man the paintings belonging to his clan, people often alluded to deathbed conversations in which the dying man entrusted them with the responsibility of teaching his children the clan's mardayin at the appropriate time. Indeed one of the signs of a natural death as opposed to death at the hands of a sorcerer is that the dying man has had sufficient time to explain his wishes to the living. Balu, for example, was taught the set of paintings belonging to the Djarrwark clan in the 1940s, shortly before the last senior man died. Galkanga, the son of that man, was a child of about ten at the time. In the year and a half before his own death in 1976, Balu lived for most of the time at Gaarngarn with Galkanga and taught him for the first time many of the paintings he had learned from Galkanga's father.

Rights in a clan's paintings are distributed among its male members on three bases: generation, primogeniture, and subgroup affiliation.[2] The ideology is that all members of a clan who are of equivalent status have equal rights in the clan's paintings; the practice is somewhat different. In particular in the case of clans which consist of a number of separate lineages or in other ways show internal differentiation, members of different subgroups tend to produce different, though often overlapping, sets of paintings. I consider this issue further on.

Members of the most senior generation exercise maximum rights, and members of junior generations exercise correspondingly fewer. Rights to paintings pass from father to son, and while the father remains alive he is ultimately responsible for the paintings. Ideally, a

2. Williams 1986:98ff. provides a detailed discussion of formal principles of defining leadership among Yolngu at Yirrkala. Williams 1985 provides an excellent example of the way in which the system of leadership and clan organizations operates in the context of decision making.

man should ask his father's permission to do paintings that he has been taught, and in the context of commercial production he should give his father money obtained from selling a painting for his father to redistribute. Or rather that is what fathers often say sons should do. In practice, a son only tells his father what painting he intends to do if he is present and rarely gives his father the money obtained from selling a painting. This can cause considerable conflict between father and son. Djangala, for example, refused to give his father, Gurrapin, any of the money earned from paintings he produced. He moved away from Gurrapin's house and set up camp with his wives elsewhere. Gurrapin's response was to cease all communication with his son, thus implying he would teach Djangala no further paintings. This threat of withholding knowledge of the clan's mardayin is the main one employed by a father against his children. Wamatun, for example, refused to teach his two eldest sons the clan's paintings unless they stopped drinking: "If I tell them about the paintings, then they will tell everyone in the pub, and soon people in Darwin and Alice Springs will hear."[3]

The eldest son should be taught first, and the eldest son of an eldest son is acknowledged to have priority over other members of his generation with regard to rights in paintings. The principles of primogeniture and generation may occasionally be in conflict. An eldest son usually has more authority over a clan's paintings than members of the senior generation who are younger than him. When the only members of his father's generation who are still living are younger than he is, conflict may develop between the eldest son and his father's younger brothers.

Rights in Ngaarndi Clan Paintings

The second set of paintings in which an individual may acquire rights are paintings belonging to his ngaarndi (M) clan. Rights in M clan paintings are of two different kinds: (1) those rights and obligations toward an individual's actual mother's clan; and (2) those rights and obligations toward sets of clans related in a particular way through myth and ceremony to an individual's own mother's clan. The first may be termed rights in the M clan; the second may be termed rights in the M clan set. In both cases the rights involved can include the right to produce M paintings for sale and the right to be consulted by M clan

3. One consequence of the increasing consumption of alcohol by young men in the 1970s was a greater emphasis on the role of women as repositories of religious knowledge and participants in ritual. Senior men would use the unreliability of their sons as an explanation for why they passed knowledge on to their daughters. The implications of this trend are considered in detail in later chapters.

members before they may use the paintings in ceremonial contexts. Among the obligations entailed are the responsibility of acting as "workers" for the M clan the production of ritual paintings and of participating in the organization of the M clan's ceremonies.

Different mother's clan affiliations are dispersed throughout the membership of a clan. An individual's actual M clan may be different from his paternal half brother's, from his father's, and from his son's. It is likely, although not certain, that members of the same patriline will have M clans which belong to the same ritual set, that is, they will belong to the same M clan set. Narritjin's mother belonged to a small Djambarrpuyngu clan. This Djambarrpuyngu clan is nearly extinct and has no female members. Narritjin's wife was Djapu. Therefore his sons' M clan is Djapu. Two of his sons have married Djapu women, and one is married wrongly to a Gaalpu woman. At this stage then, Narritjin's sons' sons have either Djapu or Gaalpu as their M clan. According to Narritjin, Djapu and Djambarrpuyngu belong to the same set, and hence he has rights and obligations to both. He claims no such rights in Gaalpu paintings. The mother of Narritjin's "clan" brother Bokarra is Marrakulu, a clan associated with a different set of clans from either Djapu or Djambarrpuyngu.

Marriage out of the M clan does not affect an individual's status in relation to that clan in any way at all. Narritjin's case exemplifies this, as does that of Mutitjpuy, who is senior waku [Z]C to the Mardarrpa clan, although his own wives are Gumatj.

M clan-set rights and obligations operate mainly in the context of ceremonial performance. When producing commercial bark paintings, men usually only use designs belonging to their actual mother's clan. Narritjin only produces Djambarrpuyngu M paintings and never produces paintings belonging to Djapu, his wife's clan.

People sharing the same M clan form a group that crosscuts the clan organization of their own moiety. In the context of ceremonial performances, all those whose mothers belong to the clans which own the ceremony can be referred to by the word *djunggayarr.* As Djewiny put it, "All the wakus ([Z]C) go back to their mothers' ground for ceremonies, they are the *djunggayarr* and come close to their mothers' people." *Djunggayarr* are ranked in a way analogous to ranking within a clan. The senior *djunggayarr* is ideally the eldest living son of the eldest woman of the most senior generation represented in the ceremony. Thus Bokarra was recognized as the senior *djunggayarr* for the Marrakulu. In Djewiny's words, "Bokarra's mother is the eldest sister of the Marrakulu. She is boss over all our mothers, as they were younger sister to her." Bokarra was of the Manggalili clan; Yanggar-

riny, the second senior man, is Dharlwangu, and the third, Watjinbuy, is Mardarrpa. The Marrangu clan belongs to the same M clan set as the Marrakulu. There are no longer any Marrangu men living at Yirrkala, and the responsibility for Marrangu ceremonies held there have been taken on by the Marrakulu. Dula, a Munyuku man whose M clan is Marrangu, takes second place to Bokarra, ahead of Yanggarriny, with respect to Marrangu-Marrakulu ceremonies. Frequently in ceremonies all three would work together.

Young men begin to learn their mother's paintings after they have begun learning paintings belonging to their own clan. They may be requested to learn the paintings by their *ngapipi* (MB) and must obtain permission from him and other senior members of their M clan before beginning to produce the designs. If a man has the same M clan as his father, then his father may with permission teach his son his mother's paintings. More often a man is taught by his own MB, or by a classificatory MB belonging to his M clan. Although the son of the "eldest mother" should be taught first, for various reasons this may not happen. For example, a clan may have no waku, or the people in the appropriate structural position may be considered unsatisfactory. One case illustrates both these points.

Wamatun is the son of the senior Munyuku woman of her generation. The next generation of Munyuku had only sons. In this case, Wamatun's eldest sons by his senior wife should have been taught Munyuku paintings in addition to their own mother's paintings (Gupapuyngu). However, Wamatun's eldest sons were considered irresponsible. A senior Munyuku man explained: "Wamatun's sons are always drinking, they don't learn very much, so maybe Balipu will have to take over responsibility for the Munyuku side too." Balipu is the eldest waku for Gumatj, his actual mother's clan, and has a considerable role in their ritual affairs. Gumatj and Munyuku share many of the same mardayin and belong to the same ritual set.

This example illustrates two principles. First, when a clan has no ZS to carry on the role of waku for their ceremonies, they can select an individual who obtains his rights in that clan through his father. Second, if a particular individual proves unsatisfactory, then his structural position is overridden and the rights and obligations he should have inherited are taken over by another man. In this case they will be taken on by a man who is senior waku to a different clan which, however, belongs to the same ritual set.

An individual may thus obtain rights to the paintings of a number of different M clans if he is considered both responsible and able to learn. Wamatun is the main painter for both Munyuku and Warramiri at

Yirrkala, while his sons may fail to play a significant role in any M clan's affairs. Balipu, on the other hand, may obtain a significant role in both Munyuku and Gumatj affairs.

People can obtain permission to make their mother's clan's paintings for sale. However, in practice this right only seems to be exercised by the senior waku of a clan. Thus Wamatun does Munyuku and Warramiri paintings, Mutitpuy does Mardarrpa ones, Bokarra does Marrakulu ones, and Narritjin, Djambarrpuyngu ones. In each case the artist is the son of the "eldest sister." Other people in the correct relationship do not produce the paintings for sale, although they may produce them on their mother's clan's behalf in ritual contexts. Dakana, Wamatun's younger brother, told me he is only allowed to do one Munyuku painting for sale, whereas Wamatun produces a number of Munyuku paintings.

If requested, people should give some of the money made from selling an M clan painting to senior members of that clan. Generally, people do not ask, and the artist keeps the money himself. On occasions when his MB Matiwuy was present, Wamatun asked me to hand money for a painting to him, which Matiwuy then handed to Wamatun. On the other hand, Wamatun was on several occasions asked by members of his mother's clan to produce paintings for sale on their behalf. He did this and was not paid.

The nature and distribution of rights in mother's clan paintings can be explained by the system of bestowal and the moiety-based nature of land ownership. A man has no rights to marry women of his M clan except those he obtains through the marriage of an MMBD into that clan and through his mother's brother, who is his powerful ally. A man would have rights to marry the daughters of the MMBD, irrespective of the clan into which she (the MMBD) married. There is no agreement between his clan and his mother's clan, or any section of those clans, as to the passage of women from one to the other. Thus, M clan rights are vested in a group of [Z]C which crosscuts patrilineal clan organization; its members are those individuals whose actual mothers came from the clans concerned.

M clan rights primarily consist of the right, or perhaps obligation, to act as "workers" for the M clan in the context of certain ceremonies, and as custodians or managers of the M clan's mardayin. I suggest the following explanation for these two roles: (1) *Waku* are obligated to work for their mother's clan to compensate their mother's clan for producing their father's wives. This is a continuation of their father's obligation, manifested in bride service and the continuous payment of gifts to his MB and WB throughout his life (see Warner 1958:42). (2) As waku they are children of clan members, yet they belong to a

clan of the opposite moiety. As a group they are thus in the ideal structural position to be caretakers of the clan's paintings and to arbitrate any internal disputes within the M clan, since they are competitors for neither land nor women.[4]

Rights in Maari Clan Paintings

Rights in own-clan and M clan paintings centrally involve the right to produce the paintings. The case with MM[B] (maari) clan paintings is different. A man is usually the recipient of (or perhaps canvas for) his MM[B] clan painting rather than its producer: he has it painted on his behalf by a member of his MM[B] clan rather than painting it himself. Conversely, a man is often called upon in his capacity as MMB to paint one of his own designs for a member of his [Z]DC clan. MM clan and own-clan designs are used in similar contexts: a male may have either design painted on his body at circumcision, and either or both painted on his body or coffin after death.

MM clan paintings are rarely produced for sale. The right most frequently exercised with respect to them is the right to discuss them and interpret them. Thus although men rarely do their MM clan paintings, they are taught their significance and have the knowledge to make them should it be required. There are certain circumstances in which it is legitimate for an individual to produce his MM clan paintings, for example, on an occasion when the MM clan painting is required and no members of the MM clan are present.

People may also use their MM clan's paintings if the clan is extinct or has no living male members, or if it consists only of young men or men who have not learned their clan's paintings. Thus in 1977, Djapu 1 produced the paintings of their MM clan, Djapu 2, both in ceremonial contexts and commercially. Djapu 2 had no living senior initiated men. The oldest members of Djapu 2, men in their midtwenties, were beginning to learn their clan's paintings. In this case it seems that the powerful gutharra clan is operating positively on its maari's behalf and will eventually return knowledge and control of the mardayin back to its original owners. Ian Keen, however, gives several examples of leaders of a powerful gutharra clan failing to hand on knowledge of a maari clan's mardayin even after the latter's clan members became old enough to take back control of their knowledge. In such cases the gutharra clan leaders simply withhold the mardayin by never producing the paintings or performing the songs and thus never providing the

4. Maddock (1969:20) comes to similar conclusions regarding the Dalabon, though he implies that the M-ZS relationship operates at the level of clans, rather than between a "mother's clan" and a set of ZS which crosscuts clan affiliations. Williams (1986:47ff.) provides interesting discussions of matrilineal ties in Yolngu society.

maari clan with the opportunity to relearn their sacred law (see Keen 1978:254 and 1988:288). This enables the gutharra clan to maintain dominance over the maari clan and its members in secular and ritual affairs.

Once a clan becomes extinct, its songs, dances, and paintings may be kept alive by one or more of its gutharra clans, often as part of a struggle for succession in taking over the extinct clan's land. Two clans, clan X and Lamamirri, became extinct in the Yirrkala area at about the time of European contact. The paintings of these clans are now held by groups which stood in a [Z]DC (gutharra) relation to them. The Lamamirri paintings are held by members of the Gumatj clan, but I have never seen them used in any context. Clan X's paintings are used by several clans. Clan Y lives at a place which used to belong to the X clan, and the paintings concerned refer to the mythology of that country. The paintings are generally referred to as Y's by this clan's members. I was told, however, that the country and some of the designs once belonged to X. A second group, Z, also produces designs which once belonged to X. In their case they claim that X was an extinct subgroup of clan Z.

These examples are consistent in some respects with the Yolngu ideology that a clan should take over responsibility for the mardayin and land of MM groups that become extinct. They also fit Warner's description of the process of succession:

The writer recorded statements from some younger men that certain territories belonged to people now living upon it, while a few old men said this land really belonged to an older group that had died out. Once these old men are dead, it is likely that all memory of ownership by the former clan will be gone. . . . In the passage of time the group using it would absorb it into their own territory, and the myth would unconsciously change to express this. (1958:28–29)

In many respects, rights in MM clan paintings are similar to the rights a person holds in his own clan's paintings. Not only are the paintings used in similar contexts, but both are associated with land ownership. Paintings are seen explicitly as charters for land, and rights in MM clan paintings imply residual rights of ownership over that group's land. Such rights would only come into operation if and when the MM clan becomes extinct. Even when this happens there is no immediate transfer of ownership. There is, however, a recognized right and obligation to take over responsibility for the clan's paintings and mardayin, and to look after their land. With the passage of time it is easy to see how such rights could be converted into rights of ownership, as seems to be happening in the case of clan X.

These connotations of rights in land go a long way toward explaining why MM clan paintings are so rarely produced for sale except in cases where the MM clan is weak or extinct. The production of such paintings could imply competition for land ownership. Such is not the case with M clan paintings, since land cannot change moiety. A man has right of access to his mother's land, but neither he nor his clan can ever own it.

We can at this stage ask why an individual receives rights in the paintings of his MM clan, and in particular why MM and [Z]DC rights in paintings are not reciprocal. The main explanation provided for passing of rights from MM to [Z]DC clans by Yolngu is that someone must be able to look after the paintings and the land should the MM clan become extinct or should the senior members of the clan die out before passing their knowledge on to younger clan members. The extinction of knowledge is seen as a real possibility by the Yolngu, as illustrated by the following case of a clan I refer to as A.

The A are a large clan. They operate a most successful outstation and never lived permanently at a mission station. The clan leader is a man in his sixties, and the clan includes a number of men in their late middle age. Clan A is said to have "lost their paintings." The paintings they produce are those of clan B. This has caused considerable tension between the groups. One explanation given for the death of a boy of clan A in 1976 was that he had been killed by clan B because his clan was always producing clan B's paintings. I was told that clan A lost its paintings because the old men of the clan had died before passing them on, and that no waku knew them either. In this case, the system for maintaining knowledge had broken down.

People have strong emotional ties to their MM clan and may be thought to "look after" the ceremonies and paintings of the land properly. The members of a [Z]DC patriline represent the closest genealogical descendants of ego's clan who are of the same moiety. In some respects a [Z]DC can be seen as belonging spiritually to his MM clan. A person's conception spirit may come from his MM clan's territory, and on his death part of his spirit may be reincorporated in the sacred objects and paintings of his MM clan. A person's spirit can certainly be guided by the actions of members of the MM clan and by the spiritual forces imminent in their paintings. The spiritual link of people to their MM clan territory and the interest they have in the clan's paintings widen the power base of people with emotional attachment to the MM clan's mardayin. The ideology of descent is thus an important factor in determining the release of paintings by an MM clan to a [Z]DC clan and the use of those paintings on behalf of that clan by the MM clan. It would be both ideologically inconsistent and structurally inappropri-

ate for a clan to give rights in paintings to an MM clan, that is, for the system of the distribution of rights to be reversed. Rights in paintings entail rights in land. Should the MM clan cease to bestow women to ego's clan, it would still maintain rights in ego's clan paintings, although ego's clan had lost access to its [Z]DDs. Assuming that rights in a clan's paintings have to be distributed more widely than through its own members, then it is logical that these rights should go to a [Z]DC's clan, a clan that depends on ego's clan for wives, and with respect to which ego's clan can exercise some control through the threat of withholding wives.

Clearly part of the function of maintaining knowledge can be and is achieved by releasing paintings to members of the [Z]C set. The [Z]C, however, being of the opposite moiety, cannot perform the ceremonies necessary to maintain the M clan's land, nor can they take over the land if the clan becomes extinct.

The release of paintings to a [Z]DC clan is in some respects a double-edged sword because of the residual rights in paintings it entails. However, for these rights to become effective, the MM clan must itself be weak or on the point of extinction. In this context it may be suggested that a clan prefers to be succeeded in its estate by the closest living blood relatives of its moiety, should direct patrilineal succession be impossible. [Z]DC succession can be seen as enabling a clan to continue in its relationship with the land beyond its own extinction.

The case of the Lamamirri clan, referred to earlier, is again relevant here. I stated earlier that Lamamirri paintings had been taken over by the Gumatj clan, their [Z]DC clan. Munggurrawuy, a senior Gumatj man, explained the takeover as follows in his evidence to Justice Blackburn in the Gove land-rights case: "Before, or after he died the Lamamirri, boss of the country Bululunga; when he died, first he said to Munggurrawuy, this I will—now die: I'll leave this place without any people because we have all died. This country, hold it, look after it after me, when I die. The ceremonies, the songs and the people" (cited in Peterson, Keen, and Sansom 1977:397).

Other Rights in Paintings

The three categories of paintings discussed above together represent the major set of paintings to which an individual can acquire rights, but there are also other ways in which rights can be acquired. Individuals can obtain the right to produce paintings of clans which share the same mardayin. These clans are termed yapa (Z) clans. Such rights are only exercised by the most senior men of a clan and apply only to paintings of the other clan which represent the same mardayin. In other words, such rights apply exclusively to paintings connected with

the mardayin held in common and do not apply to any other paintings owned by the respective clans.

Wamatun (a Dhuwa man), for example, sometimes does paintings belonging to the Djambarrpuyngu clans living at Elcho Island and Milingimbi which are connected with the journey of *maarna* the shark. In wangarr (ancestral) times, *maarna* traveled across Northeast Arnhem Land from Buckingham Bay to Blue Mud Bay, connecting the Djapu and Djambarrpuyngu clans, which today share this same mardayin.

Narritjin (a Yirritja man) occasionally does Wan.guri paintings connected with the *gardawar* (mangrove tree) mardayin, which is shared with Manggalili and a number of other Yirritja clans. It is probably significant that Djambarrpuyngu and Wan.guri are only represented at Yirrkala by a few individuals, the majority of clan members living at other settlements.

The rights considered so far all concern the use of and knowledge of the form and meaning of designs owned by another group. They do not concern the transfer or extension of ownership over the design.[5] There are certain circumstances in which ownership of a design can be extended to members of other groups. One example is the transfer of a design from a Djambarrpuyngu group to the Dhurrurrnga clan. The design was originally connected with the water hole at Marrapay in Buckingham Bay in Djambarrpuyngu country. In the Dhurrurrnga case it became associated with water holes at Balmawuy on the north of Blue Mud Bay. The painting is still owned by the Djambarrapuyngu clan, but is today also owned by the Marrakulu-Dhurrurrnga clan. Extension of ownership of the design does not in this case signify any change in ownership of the respective water holes, since the design in each case is associated with different places.

Welwi, a senior Dhurrurrnga man, obtained the right to use the design from Gunung, a senior Djambarrpuyngu man. According to Welwi, the gift of the design signified the close mythological relationship between the two places. Both Marrapay and Balmawuy are associated with *wititj*, the "quiet" snake, and the Djan'kawu sisters. The Djan'kawu first visited Balmawuy and created a number of water holes there; later on in their journey they went to Marrapay. Welwi stated: "Djambarrpuyngu gave that law for me; they are giving it back to Balma. They gave me that design, and I am painting it for my place." He also confirmed that he could pass the painting on to his own children.

5. In the case of MM clan paintings, ownership of designs is never explicitly transferred. Rather, rights in paintings are converted over time into ownership after the MM clan has become extinct. See Morphy 1988, 1990; Williams 1986:174ff.

Elkin (1961:10ff.) provides an interesting account of a Maraian (mardayin) ceremony held at Mainoru in 1949, during which four members of the Rirratjingu clan of Yirrkala obtained rights in the mardayin of the "Djauan" (Djawany) people. The senior Djawany man painted designs associated with the mosquito mardayin on the Rirratjingu men after they had had the *rangga* revealed to them. The Djawany man explained that in the past the Rirratjingu and Djawany had shared the same mardayin, and that he was showing them the *rangga* so they would be able to look after it when he was dead and maintain the ceremonial performances linked with it. The case is analogous to the other discussed above, with the difference that the Djawany people are not Yolngu speakers. Their country is several hundred miles away from the Rirratjingu's, and it is doubtful whether members of the two groups had ever met prior to this occasion. Discussion between the Rirratjingu and Djawany men took place through a third party, a Djinba man who could speak both Djawany and Djambarrpuyngu, a Yolngu dialect. The case demonstrates the way in which ties can be created over great distances between groups sharing a "totemic" species in common, with the transfer of paintings affirming the reality of the ancestral track. It is also significant that the transaction should be phrased in terms of returning to a previous state of affairs and hence one that is closer to the ancestrally predetermined relationship between groups. The known extension of an ancestral track beyond the limits of one's own immediate area is clearly always a human artifact, but one which with the passage of generations feeds back into the local situation, providing external confirmation of the track's reality and contributing to the believability of the system. Although knowledge of the mardayin of distant groups may provide material which can be used in the context of political relationships between interacting clans, it also provides a politically neutral reference point outside the system of regular interaction which elevates the mardayin beyond the pragmatics of everyday politics.

Conclusion: The Distribution of Rights

Although it is acknowledged that a man has rights in paintings of his own clan, his M clan, and his MM clan, control of the way those rights are distributed is restricted to a very few individuals, and the majority of people exercise relatively few rights in paintings. In this concluding section I review the major factors contributing to this situation.

Through primogeniture and deference to the oldest members of the clan, control of a clan's paintings is vested in one or two senior male members of the clan. These clan leaders, together with the senior [Z]C group members, control the clan's paintings by determining the dis-

tribution of knowledge about them among the members of the clan and of related clans. Thus Narritjin decides the order in which his sons and brothers' sons should learn Manggalili clan paintings, which of the paintings they can produce commercially, and which of his ZS should be taught the paintings. His younger brother, Bokarra, although an important ritual leader and the second most senior member of the clan, always asked me to consult Narritjin for interpretations of Manggalili paintings. When Narritjin was away on one occasion, his eldest son, Banapana, consulted Mithili, the senior ZS of the clan who was married to Narritjin's eldest daughter, before interpreting a painting for me.

A second example of differential control of rights can be seen in the control exercised by senior members of the Djapu clan over the commercial use of their paintings. On the death of the previous head of the clan, Wonggu, in 1957, senior members of the clan decided that only a restricted number of designs should be used for commercial bark paintings. Wamatun and Balipu on separate occasions told me that Djeriny had made the decision with them. Djeriny and Wamatun were the eldest living sons of Wonggu, and Balipu is his eldest male grandchild. Following Djeriny's and Wamatun's deaths in 1978, the situation altered again: a different set of paintings became restricted, and a set of previously restricted paintings were made public.

Through the operation of the principles of seniority and primogeniture, an individual in a structurally favorable position can gain a major say in the control of his own, his MM, and his M clans' paintings. Thus Balipu, as the eldest male Djapu of his generation, already has considerable influence in the case of his own clan's paintings and over his M clan's paintings (Gumatj); by extension, through the principle of the M clan set, he has rights over Munyuku paintings. Although he never produces paintings himself, he exercises control over their production. Because the Djapu clan is the largest Dhuwa moiety clan at Yirrkala, he exercises rights that affect a large sector of the population.

An individual's structural position is not the only determinant of his rights in paintings and mardayin, however, since men in structurally weak positions can and do control the paintings of a number of clans, whereas senior members of large clans may exercise little control over their own clan's paintings. If young men are unwilling to learn or are considered untrustworthy and likely to reveal restricted information, they are not taught paintings. If a man is senile, he is no longer consulted. Rights are thus conditional on competence.

Overall, the decision to release paintings to those who potentially have rights of access to them depends on an assessment of a number of

factors. First, a clan must strike a balance between losing control of its paintings and mardayin through spreading knowledge of them too widely and losing knowledge of its paintings through failure to pass them on to succeeding generations. Second, a balance must be struck between maintaining control of its own paintings and mardayin—the unique inheritance of its members from the ancestral past and so central to its own identity—and releasing paintings to other clans as part of the process of recognizing and perpetuating social and spiritual links with them. Finally, from the perspective of male initiation, the senior generations of a clan must strike a balance between releasing knowledge of paintings and authority over them to succeeding generations of initiates and maintaining the restrictedness of the knowledge as a means of exercising control over the system. These factors operate on three dimensions: control versus release of knowledge, the independence versus interdependence of clans, and the passage of knowledge from one generation to the next. These dimensions can be applied to all aspects of Yolngu art.

5

Inside and Outside: The Yolngu System of Knowledge

Yolngu art is part of the Yolngu system of knowledge both in itself and as a system of encoding meaning. The form of paintings is part of the ancestral knowledge that is transmitted from generation to generation, yet in addition, paintings encode meanings about the ancestral past and are one of the main ways in which people gain access to knowledge of the events of the ancestral past. More than that, paintings, as we see much later on, are involved in the process of creating new meanings and understandings about the world, and in communicating these understandings to others.

Yolngu art is part of a system of restricted knowledge in that not all people appear to have equal access to the knowledge contained within it. Secrecy appears to intervene to affect who can learn what. According to Yolngu ideology, restrictions operate in a relatively straightforward way on the basis of age and sex. The ideology is that women and uninitiated men are allowed access to knowledge that is generally available to all people, that is, to public knowledge. A man, as he progresses through life, gains increasing access to restricted knowledge until eventually he learns all he can of those aspects of sacred law that he has rights in. In reality such a division into public and secret knowledge is an oversimplification, as are the categories (un-

initiated men and women versus initiated men) with which it is associated (cf. Williams 1986:45). There is no set and agreed body of public or secret knowledge. Certainly in specific cases, general agreement can be reached over whether something officially belongs to the public or restricted domain. Over time, however, the content of the categories changes: what was once restricted becomes public and what was once public becomes restricted. Certain categories of objects, and events that take place in certain contexts, would fit most definitions of restricted objects and events in that they should never be seen by a member of a particular out-group. However, knowledge of the object and of the event frequently extends beyond the group of people who have direct access to it, to include people who should only have access to public knowledge. Women in particular gain increasing access to restricted knowledge according to their age, status, and the interest they show in ritual matters.

Yolngu art as a system of knowledge is articulated with the hierarchy of ritual authority which is associated with restriction imposed on access to many things. Who can visit certain places is restricted.[1] Who can touch certain objects or take part in particular phases of a ceremony is restricted. Restrictions are placed on who can act a particular ceremonial role and on who can eat ceremonial food or smoke tobacco from a particular tin.[2] However, in many cases it would be wrong to place a primary emphasis on the restriction of knowledge. There is a tendency on the part of the observer to assume that because a particular context is restricted, then the knowledge that is revealed with it, for example, the painting that is done on a man's chest (and in the past after her death, on a woman's), is likewise restricted. Indeed it is often assumed that the purpose of restricted contexts is the restriction of knowledge. In the Yolngu case this is far from true: the same painting may appear in both a restricted and a public context, and an object produced in a restricted context may be displayed in the open for all to see. Even where it is knowledge that is restricted, we must define precisely what is meant by knowledge in the particular case. For example, what may be restricted is knowledge that a painting was done, not knowledge of the painting itself.

There are other reasons why too much stress should not be placed

1. Biernoff 1978 provides a good discussion of how access to place is incorporated within the system of restricted knowledge among the Yolngu and how secrecy is used to enhance the sense of danger associated with certain places.

2. Thomson (1939a:8–9) shows how paintings can be used to restrict access to certain objects. Sacred paintings on the stem of a pipe can restrict the smoking of the pipe to members of a particular group and, according to Thomson, make smoking into a ritual act.

on the significance of secrecy to the system as whole. There has been a tendency among anthropologists, when analyzing systems of knowledge in which secrecy plays a part, to see secrecy itself as a major component in the creation of the power of the knowledge (Simmel 1950; Barth 1975; La Fontaine 1985). Knowledge is seen as powerful because it is restricted and because some people are denied access to it, rather than because it is powerful in itself.[3] It is powerful not because one thinks with it or uses it but because it is concealed. The creation of secret knowledge is part of a process of mystification by which other members of society are persuaded of the authority and power of those who have access to it. Control of such knowledge enables groups of people—elders, members of a secret society—to exercise some degree of control over other members of society (see Bern 1979). This line of argument can be applied irrespective of other features of the system of knowledge—for example, its internal coherence, logical consistency, explanatory power, or usefulness—which may be to an extent quite independent of its secrecy. It is possible that in some societies or institutions, secrecy is all there is, and once that has gone, the knowledge in effect vanishes or becomes "archaic lore" to be dredged from the minds of those who remember it from earlier days. I hope to show that this is not the case with Yolngu religious knowledge.

Yolngu religious knowledge is of two kinds: knowledge of objects and actions that are a means of realizing ancestral powers and that are indeed thought to be manifestations of ancestral beings, and knowledge about the world and ways of understanding the world. The apparent layering of knowledge that is produced by its incorporation in a system of restricted access does not create a series of arbitrary divisions but a coherent system in which understanding is increased in individuals as they pass through the system. Yolngu knowledge is cumulative, and in many respects the layering of knowledge can be thought of as a pedagogical technique, though it is one that emphasizes the variability in understanding that exists at a given moment among different members of the society. The layering is as important as the secrecy, and secret and nonsecret knowledge are organized in an analogous way so that all members of society have the possibility to progressively acquire knowledge and understanding. Within the system of knowledge, the content of the layers and the principles of ordering the content and relating layers one to the other are equally important. Together they provide for a generalized understanding of the world that can be applied to new situations. I begin my more detailed discussion by looking at two concepts that together provide the

3. Herdt (1990:365) refers to this position as "the miserly theory of secrecy."

key ordering principle within the system. These are the concepts of "inside" and "outside" knowledge and meaning.

Inside and Outside

The concepts of inside and outside are crucial to understanding the Yolngu system of religious knowledge. They provide a rationale for the existence of levels of knowledge and, at the same time, provide a logical schema (analogous to Parmentier's [1987:107] "diagram") that can be applied to solve particular problems as well as, at a more general level, to order relationships in the world.

"Inside" (*djinawa*) and "outside" (*warrangul*) can be used to refer to a continuum of more restricted to less restricted knowledge,[4] for example, interpretations of songs, dances, or paintings. What is inside and what is outside is relative. A particular interpretation is inside only until one has been told a further interpretation that is said to be more inside; then, consequently, relative to the second interpretation, the first becomes outside. However, the original interpretation remains inside relative to interpretations that are less restricted than it is. Things that are inside, including interpretations, are not necessarily secret as we shall see. They may be obscured, they may be treated with awe, they may be unremarked, or they may simply be a second but quite public level of meaning. However, there is a uniform belief that a level of inside knowledge exists which may consist of sacred objects or stories; this level is secret in that it is only known to a restricted set of people—adult initiated men. To this extent then, the inside : outside relationship between things forms part of a system of controlling the distribution of knowledge by providing boundaries between what should and should not be known by particular categories of people and individuals.

The inside : outside distinction is an all-pervasive one in Yolngu culture. Almost everything has an inside and an outside form or can be divided into inside and outside components. Yolngu languages tend to have a number of words for each object. One word (or sometimes more than one) will be in regular use as the public name for the object. Other words for the same thing will be used in ritual contexts or when employing esoteric language. In rare cases some words may be secret

4. Although the ordinary words for "inside" and "outside," *djinawa* and *warrangul*, are used when classifying knowledge, people can also use other words to characterize the distinction. For example, the contrast between *mardayin* and *garma* can be used, the former referring to sacred things in general but more specifically to manifestations of the ancestral past associated with closed contexts, and *garma* referring to a category of public songs and ceremonies (see Warner 1958).

and cannot be used in public places. The public word will be referred to as the outside word and all other words are inside relative to it. The secret word will be the most inside, and all other words are outside relative to it. Although the words share the same core meaning, they usually have slightly different shades of meaning or refer primarily to one aspect of the thing rather than another. For example, *mikararn* is the outside word for a particular species of snake. *Mundukul* is an inside word for the same snake. It is not a secret word but the one most commonly used when talking about the snake as ancestral being. Although both words have as their referent "death adder," *mundukul* refers specifically to the ancestral snake as the creator of thunder and lightning. In fact, there are a series of inside words for *mikararn*, some of which are clan-specific, many of which refer to different attributes of the ancestral snake. One word, for example, refers to the snake as the creator of a fish trap which he made from his ribs and which became transformed into a stretch of rapids on the Koolatong River.

The inside : outside relationship between words changes over time. On a person's death, any word that sounds like the person's name ceases to be used and a substitute has to be found. This can be done in a number of ways, for example, by borrowing a word from a neighboring language or by making one of the alternative inside words the outside and public one. This in effect results in a recycling of the vocabulary over time, with outside words becoming restricted and inside words becoming public.

Although the terms *inside* and *outside* refer to a continuum of knowledge involving degrees of restrictedness which are defined in terms of context or access, inside : outside can also refer to an opposition. Inside things are ancestrally powerful and sacred whereas outside things are mundane; inside things are restricted whereas outside things are unrestricted. The contrast between *inside* and *outside* can be applied to all sorts of natural and cultural phenomena, and in every case it carries the same range of connotations. The bones of the body are inside relative to the skin; the center of a tree is inside relative to the bark; below the ground is inside relative to the surface; and the men's ceremonial ground is inside relative to the main camp. In each case the contrast is embedded in metaphors that convey the idea that wood, bone, and below ground are sacred and ancestrally powerful relative to bark, skin, and surface. For example, the sacred objects (*rangga*) of the clan, which are only revealed on the inside ground, are referred to as the "bones of the clan" or the "underground one"; they are made from hardwood with bark stripped off, and between ceremonies they are kept buried in the mud at the bottom of water holes.

However, although it is possible to associate *inside* and *outside* with opposed poles of meaning, inside forms are always linked in a continuous chain which associates them with outside forms. Just as with words, there are a number of versions of the same objects and paintings, some of which are inside relative to others. The most restricted category of objects is that of the main sacred objects revealed to adult men during certain ceremonies, in particular the Ngaarra ceremony. In most cases there are variants or aspects of the object that occur in semirestricted or public contexts. For example, there are "messenger" forms of the sacred objects which are used to announce that a ritual associated with the sacred object will be held, or which can be used to give added authority to someone who is mediating a dispute. The messengers are frequently miniature versions of the sacred object. The form of the sacred objects may also be incorporated in the design painted on the chest of a person to whom the object has just been revealed. Such designs can be used quite independently of the sacred object, for example, on the chest of a youth at his circumcision ceremony, and although they will be treated with awe and circumspection, they may be seen publicly in the main camp. In the case of paintings themselves, as we shall see later, there are also multiple versions. The most inside painting or design is the one that occurs on the surface of the sacred object. However, for every inside form there are several outside variants that elaborate on different aspects of the meanings encoded in the inside paintings. It is not surprising that there are outside versions of inside things, for such a state of affairs is entirely consistent with the Yolngu idea that everything stems from the ancestral past. As Stanner (1967) has shown so convincingly for the Murinbata, there is no absolute distinction between the sacred and the profane. The ancestral world extends into the everyday world, the inside flows into the outside. Outside forms are in a sense generated by inside forms and are not separate from them.

As well as being used to categorize things, the concept of inside : outside can be used as a logical schema that can be applied to many situations, for example, to formulate an argument, to put forward a proposition, or to attempt to grasp the essential structure of something. It does not, of course, do any of these things in an entirely neutral way but in relation to a Yolngu view of the world.[5] The examples I give below are taken from secular contexts and show the way the

5. As a logical schema, inside : outside is analogous to what Parmentier (1987:107), in his analysis of Belauan myth and history, refers to as "diagrams." The difference is that most of the diagrams in the Belauan case are iconically motivated (e.g., the four cornerposts of a house), though they have general application and, as a result, multiple in-

inside : outside schema is applied in everyday situations, but they provide insight into the way the concept operates in the sphere of religious knowledge.

Example 1: The Arnhem Highway

For many years, various governments have been trying to persuade the people of Northeast Arnhem Land to agree to the building of an all-weather road from Nhulunbuy to Darwin, thereby linking the two main European-Australian centers in the region. In order to build the road, permission has to be obtained from the clans owning land across which the road will be built. On several occasions, delegations of planners and politicians have visited Yirrkala to put forward the case for building the road. A Yolngu elder described one of those meetings to me. The Balanda ("white people," derived from Hollander) kept putting forward reasons why the road should be built. It would mean that Aborigines could visit their clan territories more quickly. It would make supplying the outstations easier and would facilitate the craft industry. It would enable people to live more comfortably in the outstations during the wet season and would enable medical treatment to be obtained more rapidly in an emergency. A better road would also make the outstation vehicles last longer. Despite all these good reasons, the Aborigines still said no to the road. The Balanda advocates expressed their surprise that the Yolngu could reject something that would be so obviously beneficial. And so a Yolngu elder got up and explained. He said that the Yolngu now knew the outside reasons for building the road, the reasons why Balanda thought that the road would be good for the Yolngu. However, they would continue to say no because of the inside story, which had not been brought up in the discussion—the reasons why the Balanda wanted to build the road for themselves.

In this example, *inside* refers to the underlying reason, the reason that has been held back or concealed, and the reason that the Yolngu take to be the true one for Balanda wanting to build the road: the fact that it will serve their own interests. The concepts of inside and outside are used frequently in such situations as a way of dealing with requests from Balanda and as an attempt to model the issues involved.

stantiations in a variety of different forms. Inside : outside is most similar to the Belauan diagram of larger : smaller, which has behind it the core idea of a ranked series (p. 112). The Yolngu model of inside : outside shares in common with Belauan diagrams the fact that, as well as being analytical, it simultaneously represents a "presupposed causal model which generate[s] patterned social reality" (p. 113).

Example 2: Inside and Outside Medicine

Some Yolngu companions and I visited a man in Nhulunbuy hospital who was due to have a prostectomy. When we returned to Yirrkala we continued to discuss the case. The man was going to have to go to Darwin to have the operation performed by a surgeon in the hospital. Several other Yolngu had been there for a similar operation. The discussion led to a consideration of the different types of doctors and the fact that general practitioners, the doctors who people were most familiar with, did not as a rule perform operations, which were the province of specialists. The issue was clarified when someone said that there were really two kinds of doctors. A general practitioner was an outside doctor who traveled around examining the outside of people and diagnosing what was wrong. However, if anything serious was wrong they had to send the patient away to a specialist who knew the inside story and was able to perform an operation.

In this case it seems obvious why the distinction between inside and outside should be used to try and make sense of Western medical practice and the role of different kinds of doctors. The inside doctor, in this case, is the one who operates inside the body, who possesses specialist knowledge and status, and who works in a restricted context, the operating theater. The outside doctor deals with the surface of the body, travels to visit patients, and defers to the specialist when it comes to surgical treatment.[6]

Example 3: My Brother or My Mother's Mothers' Brother

I was talking about kinship with a man, X, who I called maari (mother's mother's brother). He told me that on the inside I was really his *waawa* (brother). He said that his father and my father (that is, the father of the man, Y, who had adopted me as his "brother") had called each other brother and that by tracing descent through our fathers we should call each other brother. I put this view to my adoptive brother, Y, who was the real reference point of the discussion, and he assured me that although the facts presented were correct, the interpretation put on them was quite wrong. He argued that on the inside, Yolngu trace descent through women. The father of X had married a woman who was a classificatory wife's mother's mother to Y and who should have married a man Y called maari (mother's mother's brother). The marriage resulted in the two lines, that of X and that of Y, standing in the classificatory maari (mother's mother's brother) : gutharra (sister's

6. Reid (1983) provides a detailed analysis of Yolngu medical knowledge and the changes that have taken place in the medical system in response to colonization.

daughter's child) relationship. Hence X was referred to by Y not as *waawa* (brother) but as maari (mother's mother's brother).

This case is interesting for a number of reasons. It shows that what is inside and what is outside may be relative to a particular position. X argued that patri-determined kinship terms were the inside ones, whereas Y argued that matri-determined ones were. What is inside shifts according to the perspective adopted. In both cases the inside story or inside interpretation, if followed, would transform the kinship relationship between the two people concerned. In Y's case the inside way of tracing relationships had changed a brother into a mother's mother's brother, reflecting the state of affairs that was generally accepted by the community. In X's case the inside interpretation, if accepted, would change the situation back to what it had been before the wrong marriage took place. Such a change would have been of considerable personal and political significance. X had no potential wives, whereas Y had many. If he could be accepted by the community as Y's brother, then X might well have a chance of gaining access to wives. Again in both cases the inside story, from the perspective of the person putting it forward, had the connotations of the true underlying state of affairs.

Inside : Outside as a Conceptual Structure

Inside knowledge is part of an active way of relating to the world. Inside knowledge is created not by arbitrary restrictions or impositions of secrecy, but because it is logically related to other knowledge in an inside : outside way. The Yolngu concepts of inside and outside are clearly in harmony with a worldview in which everything ultimately stems from ancestral power and ancestral design. However, although they have an underlying metaphysical basis, the concepts are also used as principles for ordering knowledge in ways that reveal and sometimes create meaningful structured relationships between things. Inside knowledge can be something that, when related to outside knowledge, provides an explanation; it is the reason why a particular kin term is applied, the reason why some people want a road built and others do not. In the religious domain it is the reason why a public dance takes the form it does, the reason why a particular place is avoided. Inside knowledge in these respects is concerned with the more general, with the more true, with the underlying properties of things, with the generation of surface events. The most inside of forms, a single sacred object, is associated with a large number of outside forms that are ultimately relatable back to it as a manifestation of the ancestral world. At first it seems that the case of language is somewhat

different. In language the outside form is the most general, whereas the inside words have more specific meanings. However, inside words are complementary to other inside knowledge in that they refer to specific details of the ancestral creation of the world. Inside words refer not to the snake as a species of animal but to the places created by the ancestral snake and the clans with which it is associated. Inside knowledge in this case represents a fuller and more detailed picture of the world.

Exclusion and Inclusion: The Knowledge Hierarchy

Yolngu do not have a formal system of age grades or ceremonial grades based on age and sex (as, for example, Barth 1975 shows the Baktaman have). The one absolute division according to Yolngu ideology is, as I have stated, between knowledge available only to initiated men and knowledge available to uninitiated men and women as well. However, within the categories, not everyone has equal access to knowledge, and certainly not everyone is thought to be equally knowledgeable. Although there are no formal age grades, the Yolngu system of knowledge is a progressive one that is linked to a hierarchy of status. Individuals acquire rights to knowledge by passing through certain ceremonies, by being of a particular sex, by being in a particular structural position within their clan, and by being of a particular kinship relationship to a certain ceremony. (Ceremonies take on the classificatory kinship status, relative to ego, of the owning or organizing clans [see Keen 1978:179]). Individuals acquire the knowledge often in a relatively informal way—through participating in ceremonies, being taught by senior members of their clan, showing a willingness and capacity to learn, and being trusted. The formal part of the system centers on access to restricted contexts and the extent of people's involvement in closed phases of rituals, for to Yolngu these are the main contexts in which restricted knowledge is acquired. In this section I look at the way formal and informal divisions are created during the performance of the Djungguwan, a regional ceremony that has secret phases. The particular Djungguwan I refer to was held at Trial Bay on the Gulf of Carpentaria.

The Djungguwan ceremony reenacts the journey of a number of female ancestral beings across Arnhem Land, of whom the most notable are the Wawilak (or Wagilak) sisters. The Wawilak sisters traveled from southern Arnhem Land to Liyagalawumirr country in the north. At Mirrarrmina, a water hole on the upper Woolen River, they encountered an ancestral python. One of the sisters was menstruating, and her blood dripped into the snake's water hole. The snake came out from his hole and swallowed the women, though they tried

to prevent him from doing so by performing sacred songs and dances. Eventually the snake vomited out the women, but they were swallowed again, together with their children. Men who had overheard the women singing their songs and who had watched them perform the dances took over the performance of ceremonies. From that point on it was men who performed the ceremonies and women who were excluded.[7]

The Djungguwan at Trial Bay was concerned with the earlier part of the journey and did not refer directly to the events at Mirrarrmina. The journey from Trial Bay inland to the country of the Wagilak clan is associated with hunting themes. The female ancestral beings are looking for long-nosed sugar-bag (Dhuwa moiety wild honey) found in stringybark trees. The songs record how they cut down the trees with stone axes. The trees crashed to the ground, clearing areas of forest and sending beeswax, honey, and splinters of wood flying through the surrounding forest. The Wawilak sisters and Ganydjalala, and other female ancestors, hunted as men do today, using fire to drive wallabies and spears and spear throwers to kill them.

Apart from reenacting ancestral events, the Djungguwan ceremony has a number of themes. At a general level it is a regional fertility ceremony performed by members of clans of both moieties from a wide area.[8] Its successful performance is thought to enhance the fertility of the land and people and to create a feeling of well-being in the participants. At a more specific level the Djungguwan can be used as the ceremony for circumcising young men and as a memorial ceremony for dead members of the participating clans.

The ceremony at Trial Bay involved two ceremonial grounds, a public one and a restricted one. The restricted area simply consisted of a clearing in the forest where men prepared sacred objects, painted their bodies, and performed secret phases of the ceremony. The public ceremonial ground was much more elaborate. Indeed in the Yirrkala region the focal point of the Djungguwan ceremony, as it is performed today, is the creation of the public ceremonial ground and the setting up of ceremonial posts within it. The ground is called *molk* and is triangular in shape. It represents the ground where the Wawilak sisters performed their sacred dances and the watercourses that were formed in the landscape when the women cut down the stringybark trees in their search for honey. The posts that are erected inside the ground are

7. There are many published accounts of this myth, the best known being those of Berndt (1951) and Warner (1958). The fullest account of the Djungguwan ceremony is in Warner 1958 and in Dunlop's film monograph *Djungguwan*.

8. Keen (1978) provides a useful discussion of the different types of Yolngu ceremonies and their main themes.

called *djuwany.* They represent the trees the sisters cut down and also the women themselves. The posts are connected by lengths of feather string that represent the route the Wawilak sisters traveled. The main sacred objects of the ceremony are two trumpets made of wood hollowed out by white ants. Although similar in form, one of the trumpets is secret and the other is public. The public trumpet is called *dhumarr,* and it represents the bee fly (Bombyliidae) that hovers at the entrance to the hive of the long-nosed sugar-bag. The trumpet is blown over the bodies of initiates and people being painted, and at the climax of the ceremony it is blown over the feather string, the posts, and the assembled company. The ceremony concludes with a group of senior women dancing in a line toward the posts, carrying with them spears, spear throwers, and dilly bags, enacting the Wawilak sisters on their journey. They dance up to the posts and enigmatically leave their dilly bags hanging from a forked stick beside one of the posts.[9]

In the Djungguwan at Trial Bay, most of the ceremonial action took place in the main camp and at the public ceremonial ground. Not everything that took place in the main camp, however, was public. Women and children hid beneath blankets while the ceremonial ground was being marked out and when the posts were being erected. For the most part the men's ceremonial ground was a workplace, where people made ceremonial objects under the direction of the ceremonial leaders (the heads of the owning clans and the senior waku, sister's sons). However, on one evening, three boys, as yet uncircumcised, who were taking part in their first Djungguwan, were taken away from their mothers and brought to the men's ground. On another evening a group of young unmarried men aged eighteen to twenty-five were taken to the ground to see certain dances performed and to be given ritual instruction and moral guidance, and on a further occasion boys in their midteens went to the ground to have their faces painted.

In the Djungguwan, exclusion : inclusion operates on two main dimensions—female : male and uninitiated male : initiated male. The exclusion of women from certain contexts and from the observation of certain events is absolute. Women are denied access to the men's ground where paintings and preparation for the ceremony are carried

9. In this case, men urged women to take this role in the ceremony on the grounds that it once was the women's ceremony (see Dunlop's film *Djungguwan*). As well as referring to the Wawilak sisters mythology, hanging up the dilly bags echoes an event in the mythology of the Djan'kawu, when the women hung their dilly bags containing sacred emblems in a tree from where they were stolen by men, thus instituting a period of male ceremonial control. These issues are taken up in later discussion.

out and where certain dances are performed. They also may not witness certain events that take place in the main camp; to avoid seeing these events, they hide themselves beneath blankets. The exclusion of women from certain contexts was dramatically enacted on a number of occasions, notably when the youngest initiates were led up to the men's ceremonial ground. The women followed behind the men along the path to the men's ground, but halfway up they were ritually driven back by the men. As well as dramatizing the women's exclusion from the men's ground, this episode also emphasized the women's loss of control over the young boys and the separation of the initiates from the sphere of the women. However, in the Djungguwan it seems that women are excluded more from certain contexts and occasions than from acquiring substantive knowledge, since they subsequently see most of what has been initially concealed from them. Women, however, are only allowed to see things when they are brought out into the open; women are not allowed to witness or take part in what goes on backstage.

The second dimension of exclusion : inclusion operates between uninitiated males : initiated males. In contrast to the male : female dichotomy, this dimension as a whole is only relatively exclusive, consisting of different stages in the process of incorporating young men into the arena of the men's ceremonial ground and in the achievement of the status of adult, initiated man. Four stages of inclusion can be identified in the Djungguwan. These stages correspond to "levels of involvement" in the activities of the men's ground. (I prefer this phrase to "grades of initiation" as the latter has connotations which are too formal). The four stages are (1) being taken to the ground for the first time as a young boy; (2) having one's face painted on the men's ground as a youth; (3) being taught sacred dances on the men's ground as a young man; and (4) having freedom of access to the men's ground as an adult man.

Only the first stage is accompanied by dramatic ritual events in the public arena that signal the change of status. The young boys who had their faces painted for the first time were taken by senior men from the main camp to the ritualized protestations of women and led up to the men's ground, where they were presented with their sacred dilly bags. The boys' visit was exceedingly brief, all sacred objects were carefully concealed before their arrival, and they were given no instruction. This is the stage of the ceremony at which circumcision takes place if it is to be part of the ceremony. In this case the children were circumcised the following year.

The youths going through the second stage spent a longer time on

the men's ground while they had their faces painted. In this case there was no attempt to conceal the *djuwany* posts from them, though they were given no instruction as to their meaning.

The third stage involved young men spending a still longer time on the men's ground while they were instructed how to perform certain restricted dances and were taught sacred words associated with the ceremony, as well as receiving moral instruction. After learning the dances, they performed some of them in the ritual that followed in the main camp, while the women and children were hidden beneath blankets.

The fourth stage consisted of adult men who had been through the previous stages. These men spent most of their time on the men's ground for the duration of the ceremony, singing clan songs and assisting with the manufacture of the sacred objects. Younger and less knowledgeable members of this group received instruction from other men present, in particular regarding the correct way to produce elements of the paintings.

The main distinction between the fourth stage and the first two stages is between doing and having things done to one. The third stage is intermediate between the two in that the initiates are taught dances which they subsequently perform. From an early age, men gain limited access to the restricted context of the men's ground. As they pass from one stage to the next they become increasingly involved in the activities that go on there, their visits increase in duration, until finally they gain freedom of access to the closed sphere.

Women's involvement in the Djungguwan also depends on their age and status. Female clan elders are included among the owners of the ceremony and play a major role in organizing the ritual, in particular the public phases. Senior married women perform the major women's dances, sometimes supported by younger married women. They also paint the face and body designs of other women. Young girls are taught the dances during the ceremony and on some occasions are encouraged to perform them.

The Spread of Knowledge

The Yolngu's public ideology is fairly straightforward: knowledge is ultimately in the hands of the male elders, and women and uninitiated men have access only to public knowledge. In most situations, Yolngu defer to the senior right-holder when it comes to discussing religious knowledge. This system of deference makes it extremely difficult to assess most people's actual knowledge, as there is seldom a context in which it is revealed other than when they are participating in a ceremony. Senior male right-holders, however, demonstrate their knowl-

edge frequently. This condition applies also to public knowledge: in both cases the senior right-holders are deferred to. Still, knowledge of things that are in some ways restricted and inside extends well beyond the boundaries of the men's ceremonial ground, and in many respects men's and women's access to knowledge is fairly equivalent. In fact, in private contexts men perhaps more than women acknowledge that this is the case.

First consider the ceremony I have just discussed. In the Djungguwan, women know much of what goes on at the men's ceremonial ground. Women know, for example, that men produce paintings on the *djuwany* posts and on the bodies of initiates, as they see both of these things once they are completed (though body paintings are often partly obscured when the initiate reenters the main camp). There is certainly an element of mystification in the production and revelation of the *djuwany* posts; the posts are erected at night, and the first women see of them is in the light of dawn the following day. Women are not supposed to know that the posts have been made by the men, and every effort is made to conceal evidence of their manufacture from women. However, women do know that the posts are manufactured in the men's camp and today see the same paintings being produced on commercial bark paintings in public contexts.

Women also know much of what happens when the initiates are taken up to the men's ceremonial ground. A young girl's account of the Djungguwan ceremony included the statement that "the men frighten them but nothing happens to them; they tell them to be good Aborigines and to respect their fathers and their mothers." It is significant that women know that they only frighten the boys. The women are told the same as the boys—that the boys will be swallowed by the snake—and yet they know that nothing in fact happens to them. Women do not see some of the dances the initiates are taught, but the initiates perform them subsequently in the main camp while the women are hidden beneath blankets, tantalizingly close, separated by no more than a thin veil.

A second example returns the discussion to parallel vocabularies and inside words. The discussion is of necessity somewhat anecdotal as a systematic study of the issue would be invasive. The majority of inside words are nonsecret. They are called out by a ritual specialist in incantations during certain phases of a ceremony, for example, in mortuary rituals when the body is about to be moved or when the grave is being filled. Public ideology is that women should neither know the references of the words nor utter them. However, women, as well as hearing the words, sometimes utter them, for example, when they are in ritual mourning, and it seems they must know something of their

reference (see Berndt 1965:276). On one occasion Frances Morphy asked a woman a question, the answer to which required, as it turned out, use of a restricted word. The woman concerned neither uttered the word nor avoided reference to it. She asked Frances to ask me to find out what a particular person's second name was, as this was the word concerned.[10]

Another example concerns the transcription of a set of power names (*likan*) incanted during a burial ceremony. The names were called out during the performance of a dance that referred to the yellow ocher quarry at Gurunga on Caledon Bay. The set of ancestral beings concerned were looking for yellow ocher; the power names referred to stages of the journey and to actions and objects associated with the place. One set of names consisted of words that had as a core component of their meaning "digging stick." The final word was the public or outside word for the object (*wapitja*). I must have looked puzzled, as I was given an explanation for the inclusion of the public word: "It is so that women know what we are singing about and what the ceremony means." Certainly the sequence of inside words that preceded the outside word had other connotations, referring, for example, to mythological associations of the digging stick and to clan-owned ceremonial digging sticks. However, this example illustrates again the proximity of secret to public knowledge and the opportunity for deduction available to uninitiated men and women. Furthermore, it illustrates an intent on the part of initiated men that women should be able to understand and share in knowledge of the ceremony. Ian Keen (1978:328) has shown convincingly how dances that are performed in the most secret phases of ceremonies have their public analogues, and how Yolngu ceremonies are concerned with the same fundamental meanings for both men and women.

The Power of Knowledge

One might think that the spread of knowledge beyond boundaries imposed by secrecy reduces the power of restricted knowledge and runs counter to the functions of secrecy. This is only so if one assumes

10. Elsewhere (Morphy 1984:115) I have shown how women can, in certain contexts, perform steps of dances that are usually restricted to the men's ceremonial ground. Strathern (1985), analyzing Gillison (1980), argues that in the case of the Gimi Papua New Guinea group, "secret" knowledge likewise spreads across categories—male initiates, for example, miming female "secret" rites in male ceremonies. Strathern also argues (p. 72) that many "secrets" are not so much about "dissembling information than about the orchestration of secrecy as an event." Williams (1986:45) argues that in the Yolngu case, in certain circumstances, men may reveal to women "the most sacred of all ritual objects . . . and reveal their meanings." See also Keen 1988:281.

that secrecy creates the power of knowledge. I would rather see the Yolngu case at least, as a two-way process: knowledge is also involved in creating the power of secrecy—the knowledge that there are powerful secrets.[11] The spread of knowledge is not a sign of a leaky system but a sign that secrecy is only one component of it. The idea that men have access to powerful knowledge to which women are denied access is partly a matter of belief, but because of the spreading of knowledge and because the veil of secrecy is thin it is also a matter of experience and near-experience.

Returning to the Djungguwan ceremony again, I have argued that women know about many of the things from which they are excluded. This knowledge dramatizes and accentuates their lack of control in the system as a whole. What is dramatized above all is the lack of control women have over the production of paintings in ritual and over the direction of ritual performance. This lack of control has added force and poignancy in that women know that once it was they who controlled the ceremony and that the men are acting out dances women originally learned from the ancestral Wawilak women (see Warner 1958:258). Indeed, as we have seen, the final dance of the Djungguwan consists of the women enacting the journey of the Wawilak sisters advancing on the ceremonial ground and hanging their dilly bags on the *djuwany* posts, which are culturally produced representations of the Wawilak women. In the dance, women carry spears and spear throwers and perform versions of the sacred dances that the Wawilak sisters performed in wangarr times and that the men perform today. Elsewhere in the ceremony it is the men who perform these dances, some in public, others in secret contexts. The ceremony as a whole abounds with symbols of female fertility that are manipulated and produced by men. The young male initiates themselves are made into women during the ritual, dressed in feather-string breast girdles, made beautiful, and, in certain contexts, adopting the role of women. The initiates indeed are identified with the Wawilak sisters. The final dance thus highlights the oppositions and reversals involved in the triadic relationship between men, women, and the wangarr Wawilak sisters. Women today do not have the social attributes of men that the Wawilak sisters possessed (i.e., control of ceremonial performances and the technology of hunting); men, on the other hand, enact in the ceremony the female attributes of the Wawilak sisters and manipulate symbols of female fertility manifest in the sexual and procreative powers of human females. The final episode demonstrates women's

11. As Herdt (1990:281) writes "Secrecy and power are inseparable but they should not be confused."

lack of control over the culturally produced manifestations of ancestral power, yet at the same time it demonstrates the relationship between that power and female fertility.

Although secrecy is important in the creation of men's power, it is equally important that women and uninitiated men know something of what men are controlling. This is what creates the power of secrecy. It is in this context that paintings are so important. Paintings are known to be produced by men and to be a central element in men's control of ancestral power, but women's control over the paintings is minimal and their knowledge of some of their meanings is restricted. Women see the *djuwany* as evidence of the creative powers controlled by men. They glimpse paintings on the chests of initiated men, sometimes smeared out, sometimes covered with a vest, sometimes unmodified. In burial ceremonies, women know that men, secluded in a temporary shelter, are painting the coffin lid; they may catch sight of the painting, but by convention they avoid looking directly at it. They never see it in the open, as the coffin is wrapped before it is taken from the shade.

Women know the complexity and variety of paintings; they know there is something to be controlled. These brief glimpses of the products of the knowledge that men control are clearly important in two respects. Women know many of the things that they are excluded from, and this knowledge dramatizes and accentuates their lack of control. Yet at the same time, the fact that knowledge is partially shared and partially experienced by women and uninitiated men may clearly be an important element in binding women emotionally to the male-controlled cults and in making the cults effective at a societal level.

The Yolngu System in Perspective: The Mask of Secrecy

One of the best-known recent analyses of a system of restricted knowledge is Frederick Barth's study (1975) of the Baktaman of Papua New Guinea. The Baktaman system contrasts markedly with the Yolngu one and helps reveal its significant characteristics.

Barth sees Baktaman ritual knowledge as parceled out into a series of packages, each of which corresponds to a grade of initiation. He uses the image of Chinese boxes to characterize the system: "It is constructed with multiple levels, and each level is organized to obscure the next level" (1975:218). He goes on to state that "there is every indication that this [set of boxes] depicts the distribution of actual knowledge, and not just pretenses about secrecy, and [that the knowledge] at one level, bears witness, in terms of knowledge at deeper levels, of having been purposely distorted and garbled at certain

points" (p. 218). In other words there are no knowledge leaks (each box is watertight), nor is it possible for an individual to deduce what is contained in a more restricted box from the knowledge he has acquired in passing through the less restricted and earlier stages of initiation. In terms of Bernstein's concept of knowledge frames, the Baktaman system is characterized by extremely strong boundaries between the knowledge contained in adjacent frames. To slightly simplify Bernstein's definition, a knowledge frame consists of a body of knowledge associated with a particular context of occurrence. The examples he uses are drawn from the English education system of the immediate World War II period. For example, one frame would be the body of knowledge available to sixth formers in grammar schools, which would contrast with that available to less gifted students placed in technical streams. According to Bernstein, "a frame refers to the degree of control teacher and pupil possess over the selection, organization and pacing of the knowledge transmitted and received in the pedagogical relationship" (1971:50). In the Baktaman case, options are greatly constrained. The initiate has no control over what he learns, the order in which he learns it, or the speed of learning. All of these are determined by those who control the system of initiation—by his teachers. The teachers themselves operate under severe constraints on which knowledge each frame contains. They must always define the knowledge contained within one frame according to its dialectical relations with knowledge contained in other frames, such that it obscures interpretation and knowledge contained in higher, more exclusive frames and reverses what knowledge the individual has learned so far. It is almost as though the system is designed to create an arbitrary relationship between what has been learned and what is still to be learned.

The logical result is that, to quote Barth, "the striking fact of Baktaman life is the *absence* of such common premises and shared knowledge between persons in intimate interaction. The tradition of knowledge is structured like Chinese boxes precisely in that persons have different knowledge and different keys to interpret meaning" (1975:264). Another result of the system is that an individual gets to know of "the pervasiveness of secrecy and direct deception on which the structure is built" (p. 219). It is difficult to imagine what motivates initiates to learn if ultimately they know that what they are asked to learn is false or will soon be denied. Indeed, Barth himself reports that those who have passed through all the grades and acquired the contents of every box are still uncertain that any of what they have learned represents the truth, though he feels that having passed through all the grades, an individual ultimately gains a deeper understanding and a

subjective awareness of his command over at least limited sectors of life.

Although there are some surface similarities between the Baktaman and Yolngu systems, they contrast markedly in many respects. Certainly in the Yolngu case, a person has to become a member of a restricted set in order to gain certain knowledge. Certain objects, dances, and secret words occur only in restricted contexts. However, there is an important difference in the relationship between ceremonial performance and initiation grades in the Yolngu and Baktaman cases. Among the Baktaman, a separate frame marks each grade and each frame contains a discrete body of knowledge. With the Yolngu, the same overall ceremony includes within its structure more or less restricted contexts which people can be denied entry to or admitted to. Individuals, as they go through the ceremony again and again, are gradually admitted to more aspects of it, until finally (for men) the barriers are removed and they gain freedom of movement. As Simmel (1950:361) writes, "the essence of the secret society . . . is autonomy." The process of becoming a fully initiated man involves experiencing the same ceremony in different ways from different perspectives. The slate of symbols and meanings, rather than being wiped clean, as appears to happen in the case of the Baktaman, progressively accumulates, and is viewed from different perspectives which may alter the significance of previous interpretations but does not relegate past experience to the realm of trickery and mystification. Yolngu knowledge, far from being fragmented and broken up into boxes labeled by grade, exists independent of the system of male initiation.

Another difference between the Yolngu and Baktaman systems, directly related to this, concerns the extent to which an individual is able to deduce meanings that he or she has not been taught. Later on I show how, as far as the interpretation of paintings is concerned, the iconography of a clan's set of paintings represents a coherent whole and there is a logical relationship between the various layers of meaning. Although certain knowledge is restricted to a few people, there are constraints on what that knowledge should be: what is known most widely and what is logically possible within the system of meaning both act as constraints on the content of the more restricted categories. A corollary is that it should be possible for those who gain knowledge of the system at one level to deduce meanings at other levels—that given a certain level of knowledge, knowledge then becomes productive. Such insights often remain unspoken, as in some respects they run counter to the system of deference to elders. Certainly women and uninitiated men would be unlikely to voice such inference in public contexts. However, Keen (1978) has shown that inference is a legiti-

mate way for men to acquire knowledge about the meaning of sacred designs, even though such knowledge has to be confirmed by men who are considered fully initiated—men who already "know" it.

The idea of secrecy as a spoke in the wheel of rational discourse does not seem to apply in the Yolngu case. To Kermode, for example, "secrets are those non-sequential bits of creative indeterminacy which get into and apparently seem to foul up all coherent protocols, scripts, texts, whatsoever little hints of the abyss of subjunctivity, that break in and out like Exu, and threaten the measured movement toward climax on cultural terms" (cited in Turner 1982:77). While this seems to apply well to the Baktaman, in the Yolngu case, secrecy seems to be in harmony with the system of knowledge, and though it may create an unknown, when that unknown is finally revealed, it is not unexpected. Secrecy is articulated with the logical structure and layering effect of inside and outside knowledge, and as people progress through the system, in Yolngu terms, they learn more about the surface form of the world and what orders it, as well as moving closer to the sources of spiritual power.

What role then does secrecy play in the Yolngu system of knowledge? Is the Yolngu system a faulty version of the Baktaman ideal type, a system with leaks and pretenses? Clearly I do not think so. Secrecy has many roles. The Yolngu system is a system of revelatory knowledge, and secrecy helps structure the process of revelation. Secrecy often marks the divisions between inside and outside knowledge and creates pauses in the transmission of knowledge. Secrecy reinforces the system of deference and controls the broadcasting of insight. Secrecy supports male control of knowledge. And finally, the imposition of secrecy is a clear demonstration of men's power. In the Yolngu system, the convention of secrecy can be effective even if most knowledge is widespread. Knowledge can still be treated in many contexts as if it were secret knowledge. In the Baktaman case it seems that secrecy is necessary to preserve the knowledge.

Secrecy in Yolngu society is clearly related to political power and authority (Bern 1979). But even if control of religious knowledge enhances or provides a basis for male control of other aspects of society, its value cannot be reduced to this. The Yolngu view would be more that certain things are secret because they are powerful rather than the other way around. The men control the ceremonial ground because it is closest to ancestral power; they know how to manipulate that power through the ownership and control of the songs, dances, paintings, and ceremonies. The powers are dangerous for them but more dangerous for others, who require the mediation of the men. However, the men's own power stems from and is supported by their

control of the ceremonies and their closeness to the wangarr ancestors. Adult men are closer both to the truths of ancestrally generated and authorized world order and to the sources of spiritual power. It could be argued that this view—that secrecy is necessary because of the power of the knowledge—is ideologically motivated since it masks the reality that secrecy creates the power which is used by one sector of society to dominate another. I would argue to the contrary, that the real issue is control of knowledge and that secrecy is a mask, not the means whereby knowledge is controlled. The mask of secrecy is an illusion and a tease; knowledge slips out from behind its locked door into the public arena and back again. Not everything comes out into the open nor does everything go back, but in most respects the body of public knowledge is broadly equivalent to and overlaps with the body of secret knowledge, covering the same ground and conveying similar understandings about the world. But however much knowledge moves, it never escapes. It is always under control, and it is those who operate the mask of secrecy who also control the spread and use of knowledge. Secrecy is an assertion of that control more than it is the means of control in itself.

Conclusion

The complicating fact about the Yolngu concept of inside and the thing that makes it so different from, and so much more than, the English concept of secret is that *inside* is used in two different but complementary senses: one is *inside* in the sense of truth or generating power; the other is *inside* in the sense of exclusive or secret. In the first sense, *inside* is a property of the world that includes equally both men and women. Both men and women have access to inside in that they both experience its use as a logical principle for talking about the world, and they both gain access to things that are inside relative to other things. Through this experience, women as well as men gain an idea of the kind of things that are inside, the kind of things that represent the inside. *Inside* in this sense is both an essence or a truth and a form of logic about relations in the universe. The sacred objects of the clan, the *rangga,* are representations of the inside, or, in the Yolngu terms, manifestations of the ancestral past, but they are not equivalent to it. It is these manifestations of the inside that women are denied access to, and this is the second sense of the word *inside.* In this sense, inside is the space created by the exclusion of women from certain contexts and certain knowledge. Control of access is the way in which men make inside knowledge, in the first and more general sense, a partner in their control over women, but it does not create this kind of knowledge in the first place. The denial of access may enhance the value of those

representations of the inside that men keep to themselves but does not create their value, for value in the form of inside knowledge is part of the way Yolngu understand the world. Secrecy may, however, affect the kind of power a particular category of inside knowledge has, and in turn the role that sacred objects, for example, have in the reproduction of relations of subordination and superordination in Yolngu society. The myths of the prior ownership of the sacra by women and of their theft by men are seen by men and women alike as myths of appropriation whereby men seized control of certain ultimate manifestations of the inside, which thereby gave them the power to act in ritual (see Berndt 1965:269).

The implicit contradiction between the two senses of *inside* adds both force and poignancy to a comment that Narritjin often made to me that "really, women are the inside." In this he was referring both to the fact that inside meanings often refer to female things, and also in a more fundamental sense to the logical place of women in the scheme of things and their positioning on the inside : outside continuum as generators and sources of power. Women are instances of ancestral power but are less able than are men to utilize that power themselves. Men, through physical force and sleight of hand, control the things that produce women's power; they control the most powerful manifestations of ancestral power and through spirit conception have a primary role in human procreation. In this way women's power, though of the inside, is produced on the inside by men and released on the outside to women. The most powerful manifestations of ancestral beings, the *rangga,* are kept under the control of men on the restricted inside, occupying a space created by the exclusion of women, their secrets held there by the threat of the physical and mystical sanctions that will be applied should they be released by the unauthorized. The close association between a *rangga* and the senior man or men who are holding it results, as Keen (1978:341) has shown, in such men eventually becoming identified with it, being addressed as the *rangga,* and even being buried with it; in this way some men during their lifetime in effect become part of the inside. Women, though they are closely associated with the inside, are denied the possibility of establishing such close relations with the *rangga* and hence in life must remain, relatively speaking, on the outside.

The inside is constituted as much through the release of knowledge to the outside as through restricting it to the inside. The only way Yolngu become aware of the relativity of inside knowledge is through its release. Release of knowledge occurs both through incorporating outsiders in the inside group and making previously restricted knowledge public. Inside and outside are a part of public discourse, but it is

97

discourse cut off at a particular point when it can be taken up only by members of an in-group. It is one of the ironies of a system of restricted knowledge, at least of the Yolngu type, that knowledge both gains and loses power through its release. It loses power in the sense that it is distributed among more people, yet it gains power through more people using it. The assumption is often made in anthropological studies of systems of restricted knowledge that if secrecy is its only source of power, then its power will gradually or rapidly disappear through its release. But I hope that in the Yolngu case I have demonstrated that notion to be false. The spread of knowledge of the inside will, however, change its value to those who control it and may affect their position in society. Yolngu men must always maintain a delicate balance between holding and releasing knowledge. By releasing it too lightly, its value may be diminished and the power of the individual over others may be reduced. But the ultimate loss of power of knowledge is its nonrelease through death of the possessor. It is true that in many circumstances, such power vacuums are soon taken up by new knowledge; but the potential power loss, as the loss of knowledge will be seen by the Yolngu, is an effective factor in people's lives, since to them it seems very real and undesirable.

The delicate and complex relationship between inside and outside provides the context for understanding the release of knowledge to Balanda. The release of knowledge to them involves their incorporation within the Yolngu system of knowledge. In order that Balanda should value the inside, they too have to experience it through its release, and their inclusion. I have shown elsewhere that an explicit reason for releasing knowledge to Balanda has been to get them to acknowledge the value of Yolngu culture, to make them understand and consequently to recognize Yolngu rights (Morphy 1983b). In such a case, Balanda first have to be persuaded that the knowledge is of value. This process of getting Balanda to accept the value of Yolngu knowledge has involved both the release of knowledge on a broad basis to Balanda through the sale of paintings in the crafts store and the opening out of ceremonies to a wider public (see Dunlop 1987), and the selective release of inside knowledge to people such as missionaries, teachers, anthropologists, lawyers, and politicians. Such releases of knowledge can be easily understood as an extension of indigenous practice in a new context. If, as I have argued, inside knowledge was always leaked, and if the nature of inside knowledge was always widely known, what could be more natural than attempting to extend that access to the Balanda invaders in order to bring them within the Yolngu system. The possession of knowledge has always been one of the ways by which Yolngu demonstrate rights over property, including

land, and again in this case, the delicate balance has to be maintained between demonstrating or persuading people that one has the knowledge and maintaining control over it. The implicit layering of knowledge by differentiating between two categories of Balanda—the general public, and people of influence or people who have a special relationship with the Yolngu—and treating those categories differently, also creates an apparent structural homology with the indigenous system, the people of influence being an in-group who have privileged access to power. In such ways Yolngu incorporate Balanda within their structure. It does not matter that Balanda society is not structured like that, so long as at the point of articulation individuals can be persuaded to operate as if it were. The more Balanda can be persuaded to act in terms of Yolngu cultural categories, the more chance they will begin to see their value—value, in part, being what one is acting in relation to.

In the case of a Baktaman-like system, such a strategy would only work if the outsiders agreed to accept the constraints of the system in the same way as the Baktaman, something Balanda are unlikely to do. The Yolngu seem to have been less dependent on Balanda following the rules of the game, and indeed to a considerable extent the Yolngu seem to have changed the rules to fit the new context, without it destroying the fundamentals of the system. In the Baktaman case, the secrets can only be revealed by letting people into the boxes where they are kept; once the secrets are out of the box, the box is empty. In the Yolngu case the release of secrets creates a new outside but does not destroy the inside—indeed, by implication a new outside creates the room for a new inside to take its place, just as the recycling of words creates spaces to be filled. However, the inclusion of Balanda has not left the system unaffected: both quantitative and qualitative changes have occurred. Whereas in the past, time wiped clean the public slate as people died and what had once been exposed could become hidden again as memories lapsed, today once something is public it is likely to remain visible. The overall body of public knowledge is increasing. More significantly, however, the relations within which secrecy were embedded are changing: the inclusion of Balanda in the Yolngu world has changed, or is in the process of changing many of the internal relations within Yolngu society, and the system of knowledge is beginning to articulate with those new structures of relations. Increasingly there has been a substantive opening out as women in particular gain access to certain contexts from which they were previously excluded. Although changes appear to leave the inside : outside continuum intact, the point where exclusion enters into the system and the value of exclusion do, however, change.

6

Paintings as Meaningful Objects

Yolngu ceremonies have a major role in framing Yolngu art, for to the Yolngu, what Europeans call art is sacred law that becomes manifest through ceremonial performance. This does not mean that those qualities Europeans associate with the aesthetic, such as beauty and the perfect execution of form, are absent from Yolngu motivations in producing their art; rather the aesthetic dimension is integrated within the wider purposes of the ritual. In creating beauty, Yolngu are creating ancestral power. In urging people to dance with more vigor, to paint with more care, or to use finer lines, Yolngu are aware of both an aesthetic effect and an ancestral imperative.

This chapter explores what paintings, as objects, mean to the Yolngu—what they are understood to be, what properties they are deemed to have, and what purposes they can be used for. I consider attributes that cannot be easily understood or labeled as part of a painting's meaning in a semiological sense, such as the fact that paintings are thought to possess ancestral power. Such properties certainly contribute to making the paintings meaningful objects and may be enhanced by meanings which the paintings encode and

which refer to ancestral events, but they are not themselves encoded meanings: rather they are attributed properties. At this stage, semiological meaning may be briefly defined as what the signifying object represents to an interpreting individual.

Paintings as Meaningful Objects

The substance of Yolngu ceremonies consists of the songs, paintings, dances, incantations, and ritual actions that form the mardayin or sacred law of the Yolngu clans. As we saw in the last two chapters, the mardayin are both the property of clans and manifestations of ancestral beings. They are specific to certain clans and yet, at the same time, are of much more general significance. Paintings, as components (or in Keen 1978's terms, elements) of the clan's mardayin, have a meaning quite independent of their use in a particular ceremonial context. Together with other elements, paintings are parts of what I have elsewhere termed "chunks" of ancestral law associated with particular named places within a clan's territory (Morphy 1984). Together the components of the chunk tell the story of the ancestral creation of that place and of the mythological transformation of the landscape. Within the chunk, each painting is linked to the sets of songs and dances which help fill out its meaning. Outside the chunk, paintings are linked to other chunks that belong to the same ancestral track, or which belong to the same clan, or which can be connected with them in a number of ways. However, although the chunks exist independent of ceremony as the foundations of the clan's existence, they have to be performed in order to be known. In other words they have to be used in ceremonies. The clan's mardayin, the chunks of ceremonial substance associated with "big name" places, are normally only produced for ritual purposes, and usually only a few components of a chunk are used on any one occasion. The songs for a place may be used at a purification ceremony but not the paintings or dances; the paintings may be executed on a coffin lid, but only a few of the songs may be sung and none of the dances performed. On each occasion only part of the chunk is reproduced, and in order to gain knowledge of it as a whole, a person has to be present at a large number of ceremonial performances. If a person misses a performance where something new to him was produced, then he has to defer to those who were present. It is this fact—that ceremonies provide the context for acquiring knowledge—that gives power to those who already possess that knowledge and enables them to exercise control over others. On occasion it enables members of one clan to dominate members of another (see Keen 1978). Knowledge of a clan's mardayin is necessary if its members are to fulfill their obligation to the ancestral beings who entrusted them

with looking after their land. Any denial of access to that knowledge reduces the control clan members have over their own land.

Paintings and Ancestral Power

Paintings as ancestral designs do not simply represent the ancestral beings by encoding stories of events which took place in the ancestral past. As far as the Yolngu are concerned, the designs are an integral part of the ancestral beings themselves. By painting the designs in ceremonies, by singing the songs and performing the dances, Yolngu are re-creating ancestral events. What ultimately makes the paintings more than mere representations of the ancestral past is that the designs themselves possess or contain the power of the ancestral being.

The power (*maarr*) that paintings have is the same as that which emanates from the sacred objects of the clan and which can be created by the invocation of sacred names (*likan*) sung out by the ceremonial leader (*djirrikay*). In all cases the power derives from the ancestral being who once wore those paintings or called out the names. Thomson (1975:8) provides an excellent description of this dimension of ancestral paintings (*miny'tji*): "*Miny'tji* are derived directly from the totemic ancestor . . . the designs used today are the *malli* [shade, spiritual manifestation] of the *miny'tji* that exist on the *wangarr*."

Maarr is intrinsically good and cannot be used for negative purposes. Thomson's analysis of the nature of maarr is relevant here: "*Maarr* is power, the power which gives influence and prestige in the sense that it has religious, totemic or supernatural implications, quite distinct from visible force" (1975:5). He goes on to quote one of his informants at length, contrasting ancestral power, which is located in the sacred objects and paintings of the clan, with power that can be used in an aggressive context: "When a man is warlike and kills many people—that is not *maarr,* it is anger [i.e., aggressiveness]. . . . A man does not fight by *maarr. Maarr* belongs to sacred things. . . . My *maarr* is really part of the spirit life of my clan" (p. 8). The power of the wangarr is certainly beneficial, can bring success in hunting, and is believed necessary to the well-being and fertility of man and land, but it cannot be directed by human action to cause death or harm to other human beings. For example, maarr cannot be used for sorcery (Thomson 1961:102).

However, although maarr cannot be used by human beings for negative or aggressive purposes, it can be dangerous and it can be associated with aggressive images and have terrifying manifestations. The animal forms of many ancestral beings are animals renowned for their dangerousness and hostility toward humans: for example, crocodiles, death adders, and many species of shark. The dances associated with

such ancestors frequently emphasize the aggressive life-destroying aspects of the animals, sometimes in a heightened form: the shark ancestor struggling to escape from a fish trap, the stingray lashing out with its barb after it has been speared. Ancestral power emanates from such images of death, anger, and potential destruction. Moreover, in certain circumstances, that power can be fatal to humans.

Ancestral power can be dangerous to those who infringe on prohibitions surrounding sacred objects and other manifestations of the ancestral beings, especially to uninitiated men and to women. It can also be dangerous to persons physically weak through illness or emotionally exhausted through anger or grief. Persons who are weak for any of these reasons or who are in a state of pollution through contact with death should avoid all contact with ancestral power until they are in a less susceptible condition.

Maarr is generalized power in that it is necessary for the health and fertility of the Yolngu world, including the environment in which people live. In regional ceremonies such as the Gunapipi and the Djungguwan where members of many clans participate, maarr can be spread wide and be beneficial and bring a sense of well-being to all those who participate with good heart. The maarr of ancestral beings of one moiety can be effective for individuals of both. However, although it can be general in its effect, it is always specific in its source. Maarr is always power that emanates from a mardayin, a specific set of ancestral beings associated with an area of land or a set of places. It is the power of the crocodile or the shark ancestor and comes from the ancestor through the songs, paintings, dances, and land forms that are the visible manifestations of its being. In this respect it can always be referred to as the power of those people who are linked to the mardayin by membership of a clan or by belonging to the same *baapurru*. In cases where ancestral beings are associated with many places in different clans' territories, many clans may be connected to the same mardayin. However, it is likely each clan will have its own connection to the mardayin through manifestations of the ancestral being that are uniquely its own and which can be conceptualized as providing unique access to the source of power.

Maarr is linked to individuals in a number of ways. People are said to come from the *rangga*, the clan's sacred objects, which are the most powerful manifestations of the ancestral beings. People are thought to be conceived from the ancestral beings through spirit conception, and throughout their lives they continue to accumulate maarr in ceremonies through seeing and touching sacred objects and by having paintings produced on their bodies (figs 6.1 and 6.2). Very old people who have been through many ceremonies are thought to have accu-

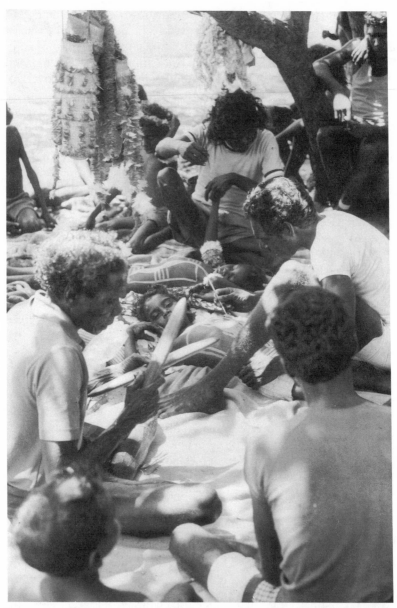

Figure 6.1 A circumcision ceremony at Yirrkala. A number of boys of the Dhuwa moiety are having their chests painted. In the foreground Roy Dardaynga Marika of the Rirratjingu clan leads the singing.

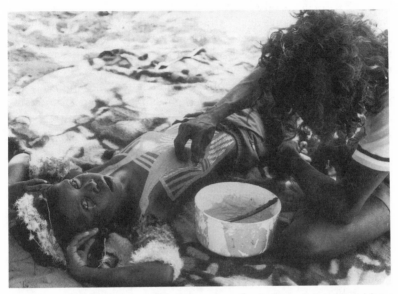

Figure 6.2 Larrtjinga of the Ngayimil clan paints a boy's chest prior to circumcision.

mulated so much power that they have almost become sacred objects; they are thought of as closely connected to the ancestral world. Such individual maarr represents an extension of the ancestral into the everyday world, almost a blurring of boundaries between the two, and is a sign that living human beings in part originate in the wangarr. In a sense, human beings are ancestrally reproduced.

A corollary of the ancestral production of clans is that to ensure that clans continue to be reproduced, clan members must maintain control over the spiritual world and ensure its replenishment. These two objectives seem to underlie much of Yolngu ceremonial practice. Control over the ancestral beings is achieved by controlling and structuring their manifestations in ceremonies and in ensuring that the knowledge of the mardayin is not lost. Because the knowledge consists in part of things which are individually powerful—sacred objects, paintings, and so on—their maarr is maintained by ensuring that the knowledge is passed on from generation to generation. This is the Yolngu explanation for holding Ngaarra ceremonies in which the clan's sacred objects are revealed shortly before the death of a senior old man, thus enabling his power to be passed on to the next generation of clan elders. Another way in which the source of power is ensured or maintained is by returning the power of the deceased back to the spiritual reservoirs from whence it came. Each clan has areas of land or particular places

that are associated with conception spirits that originate from the wangarr. On a person's death, the spirit is directed back to become reabsorbed in the reservoirs of spiritual power in the clan's territory, to be reborn subsequently in the form of another member of the clan. Thus part of the process of ensuring the reproduction of the clan is the performance of mortuary rituals for its dead members. The spiritual cycle of clan members involves the movement of power from the ancestral domain to the world of actual human existence. The ancestral beings provide the power to create life and ensure growth, and this power is returned on death to the ancestral world (see Morphy 1984).

Use of Paintings in Ritual: Painting the Coffin Lid

Paintings are used in ceremonies because they are one of the manifestations of ancestral power, and they are used to direct that power to specific ends, which vary according to the purposes of the ceremony and the stages of the performance. At this point I consider just one example of the use of paintings in ritual— the painting of clan designs on a dead person's body or today, more commonly, on the coffin lid.

Yolngu believe that a person has two kinds of spirits, *birrimbirr* and *mokuy*. The *birrimbirr* spirit is the one associated with the wangarr, and on a person's death it returns to the ancestral domain. One aspect of it returns to the clan lands of the deceased, while another goes to one of the Yolngu lands of the dead (see Warner 1958:280). The *mokuy* is a capricious spirit or ghost. On a person's death the mokuy is believed to be angry and vengeful. It can return to the place of death and cause trouble or even kill Yolngu against whom the person bore a grudge when alive. The mokuy is not derived from the wangarr but is associated with a separate set of spiritual beings also called mokuy who live in isolated places and can cause harm to people.

The dichotomy between birrimbirr and mokuy spirits is consistent with the emphasis on maarr as a positive force, one which cannot be used for antisocial or negative purposes, and which hence cannot be used by sorcerers. The birrimbirr spirit is one of the ways in which this essentially positive force is created. The positive feelings toward the dead are focused on the fate of the birrimbirr spirit, which in turn is reabsorbed within the reservoirs of wangarr ancestral spirits associated with the dead person's clan, to become, in effect, maarr. The negative feelings, on the other hand, are directed toward the mokuy spirit and away from wangarr. In such ways, emotions are culturally structured to reinforce the separation between essentially positive and productive powers and angry, unpredictable, and vengeful powers. The separa-

tion is not absolute and to an extent is relative to the definition of the purpose of a particular action. For example, clan members setting out on an avenging expedition following the death of one of their members can call upon the support of certain wangarr beings to give them strength and increase their resolve. In such a case, wangarr powers are being summoned for a destructive purpose. From the perspective of the participants, however, no contradiction may be involved, since they are carrying out a task that is morally sanctioned by their community. Indeed it could be argued that the use of maarr defines the vengeance expedition as moral action.

One of the principal themes or objectives of burial ceremonies is the guiding of the birrimbirr spirit back to the reservoirs of spiritual power in the clan territory (see Morphy 1984). The birrimbirr spirit's journey provides the ordering theme of the ceremony and affects which ritual elements are selected and the order in which they are performed. People are also concerned with the mokuy spirit, but in this case their purpose is to drive it away from where people are living into the forest, and they are not otherwise concerned with its fate. The opportunity is taken to drive the mokuy away by screams and shouts, by smoke and aggressive gestures at various stages of the ceremony, but it is not a major factor in selecting ritual episodes.

In primary burial, the moving of the body from place of death to the grave provides the framework for enacting the journey of the birrimbirr spirit from place of death to the place where it will rejoin the clan's ancestors. The ceremony consists of a series of key events: making the coffin, painting the coffin lid, carrying the coffin to the body, placing the body in the coffin, carrying the body to the grave, and finally burying it in the ground. Each of these events is or can be performed in a ritual way, accompanied by song, dance, and incantation. The ritual chosen is both appropriate to the event and associated with a stage on the spirit's journey. For example, when the coffin is moved to the body, a dance may be performed which represents the floodwaters of the wet season at a place in a clan's territory halfway between the place of death and the final destination of the spirit. When the coffin is lowered into the grave, a dance may be performed that represents the ancestral beings at the spirit's journey's end. What happens to the body is an analogue for what happens to the birrimbirr. The coffin painting is incorporated firmly within this structure in terms of both its purpose and its integration with other ritual elements.

Warner (1958:416) provides the following interpretation of the purpose of painting the body of the dead person (which has today largely been replaced by the painting of the coffin lid):

The painting, according to native thought, is so done that the old ancestors can see which totem well the dead belonged to and carry the soul immediately to its proper resting place. The old dead *marikmo* [FF] is supposed to announce loudly, "Oh, that is my young *maraitcha*" . . . the design upon the dead man definitely places him in the hands of his proper ancestors . . . and takes him back to his totem well.

Though today the overt aim of the coffin paintings is also to help guide the birrimbirr soul back to the clan well, Warner's account over-simplifies the situation. As well as communicating with actual dead relatives, the painting is believed to communicate in a more direct way with ancestors in the clan well.

The painting is itself a manifestation of the ancestors, and thus provides a way of mediating directly between the birrimbirr spirit and the ancestors of the clan. By placing the ancestral painting on the coffin, the *mali* (shade) of the ancestor becomes directly associated with the birrimbirr spirit. The painting is the ideal mechanism for transferring the spirit from the human to the ancestral plane.

These two levels of communication, first with the actual deceased ancestors of the person's clan and MM[B] clan and second with the wangarr ancestors, are structured in an outside and inside relationship to one another in Yolngu thought. The outside explanation for the incantation of power names (*likan*) that occurs at various stages throughout the ceremony is that the *djirrikay* (ritual leader) is calling out the names of dead ancestors connected with the mardayin associated with the ritual episode. The inside meaning of the incantation is that the *djirrikay* is shouting out the power names of the *rangga*. In both cases the intention is the same—to guide the spirit (birrimbirr) of the dead: "We call out the name of the *rangga*, the underground one, to give power to the dead person's soul." Or as Thomson (1939b:3) records (with reference to paintings on a dead body), "His skin has *miny'tji* and therefore his ghost will have *miny'tji* too." Apart from the *rangga* itself, the clan's sacred paintings are the most powerful humanly produced manifestation of the wangarr ancestors. They are also one of the most durable in that they can last beyond the ceremony, unlike the actual performances of the dances and incantations. The use of the painting is a central element in the process of reincorporating the birrimbirr spirit within the clan's mardayin.

Paintings are used as part of a process in which the soul of the dead person is transformed back into ancestral substance. In Yolngu thought, flesh is associated with the corrupt and profane human aspects of the person and is identified with the mokuy spirit. A dead body with flesh on it can still be referred to as alive, and indeed it lives through the process of decay, a fact emphasized in the symbolism of

Yolngu mortuary rituals (see chap. 11). The dead body with flesh on it is referred to as mokuy, the same as the term applied to the potentially malevolent trickster ghost. As flesh decays after death and, essentially, leaves the body, it becomes dispersed about the environment in the bodies of flies and maggots and scavenging animals. In the past, Yolngu assisted this natural process by digging up the body some weeks after primary burial and cleaning the remaining flesh from the bones. The bones (*ngaraka*) are the sacred core of the body and are associated with the wangarr. The flesh of the body is dispersed just as the mokuy spirit is driven away; the bones of the dead person, on the other hand, are retained just as the birrimbirr spirit, through its return to the ancestral domain, is retained or conserved by the members of the clan.

The skin (*barrwarn*) of the dead contains both the flesh and bones, and although it is on the outside of the body and as a substance is closer to flesh than bones, it has a symbolic value through painting that associates it more with the birrimbirr spirit than with the mokuy. The skin is the medium through which the birrimbirr spirit initially leaves the body: the skin is transformed into ancestral skin through paint; the design that was on (is on) the ancestor's body is now on the person's; in essence the person becomes contained within the ancestor. It is also significant that clan designs, a major component of the paintings that are put on a dead body, can be referred to as *ngaraka*, that is, as the bones of the ancestral being (for details see chap. 8). Thus the body painting associates the person's skin with ancestral bone, prefiguring the process of transformation.

In later stages of the mortuary rituals, when the flesh has decayed and the skin has disappeared, the skin has to be replaced. After the bones have been cleaned of all flesh, they are collected and placed within a bark coffin which is painted with ancestral designs. *Barrwarn* means "bark" as well as "skin." The bones are kept in their container for many years and carried around from camp to camp. Finally they are broken up and placed within a hollow log coffin, in a final memorial ceremony for the deceased.

The hollow log coffin is made from the naturally hollowed out trunk (*rumbal*) of a tree with the bark stripped off and the surface painted. *Rumbal* is also the word used for the body, and the hollow log indeed represents the body of a totemic animal appropriate to the particular clan. The bones have been placed in a new body (though in a sense a skinless one, since the bark has been removed). At this stage the spirit of the dead person is thought to have returned to its spiritual home, becoming again part of the ancestral past. As we shall see later, the designs on hollow log coffins belong to a different category from those

painted on the body or the bark coffin. They belong to a public category of paintings that is considered less spiritually powerful than the others, a sign of both the public nature of the ceremony and the end of the spirit's journey (though as always ready for a new beginning).

The set of mortuary rituals thus involves a series of transformations from a live and potentially dangerous state to a dead and relatively inert state. The body begins as flesh and bones contained within skin, becomes bones within a bark skin, and ends up reconstituted in a dead or inert form, as the bones inside the hollow log coffin. In the meantime the spiritual components of the dead person have been separated out, the mokuy spirit has dispersed with the flesh, and the birrimbirr spirit has returned to the ancestral domain. The bones have ceased to be the bones of the person and have, to use a Yolngu metaphor, become part of "the bones [ngaraka] of the clan" (cf. Rudder 1980:41). Under the surface of the ancestral skin, the body has first decomposed and then been separated out into its metaphysical constituents.

Although some Yolngu continue to perform all of the stages of the mortuary ritual as set out above (see Clunies-Ross and Hiatt 1977), in the Yirrkala region there have been substantial changes in the form (see Morphy 1977c, 1984). The relative importance of primary burial ceremonies has increased, and the painting is done on the lid of the coffin rather than on the body. The bones of the dead are no longer disinterred and carried in a bark coffin, and their final resting place is the grave not a hollow log. However, the ritual sequence continues in a changed form, with analogues for the bones of the dead being treated as if they were the bones. Clothes and possessions of the dead are kept in suitcases and buried in painted wooden boxes at secondary "burial" ceremonies, and hollow log coffins and memorial posts are still erected on occasions, though they are left empty of human remains. The imagery of the ceremonies is in continuity with the past, and the same symbolic themes dominate. In primary burial ceremonies, the main instrumental function of the coffin painting is the same as that of painting the dead person's body: it plays a role in reincorporating a person's birrimbirr soul into the realm of the wangarr ancestors by guiding it or powering it on its spirit journey.

The selection of a coffin painting depends on two main factors: the dead person's relationship to members of other clans, and the route along which his or her birrimbirr spirit is to be guided. Frequently the coffin painting represents a central place on the journey of the birrimbirr spirit. Ritual episodes which precede the nailing of the lid on the coffin refer to earlier stages of the journey, and episodes which follow it represent the final stages of the journey.

Again we see the transformative power of paintings. The ancestral

beings transformed themselves into land, and paintings, songs, and dances emerged out of that transformational process (see Munn 1970). It is in the form of landscape, paintings, and so on that the ancestral beings continue to exist and in a sense ensure their own existence, for it was they who made human life conditional on the performance of the evidences of their being. The ancestral beings were transformed into the landscape in the course of their journeys; in an analogous way, the dead person whose origin lay in the ancestral past is in turn transformed into the landscape through the use of signs from the ancestral past. The spirit's journey is accomplished through transforming the body into stages of the journey. Sometimes the subject of the coffin painting may have little connection with the other episodes of the ritual except as a marker of a particular stage of the spirit's journey. On other occasions, the content of the painting chosen may be connected with the content of previous and subsequent episodes to create a continuity of symbolic action that flows through the ceremony as a whole.

A Marrakulu woman, whose spiritual home was at Trial Bay, died at Yirrkala, many kilometers to the north. Her MM[B] group, the Djapu clan, was in charge of organizing the ceremony, and the painting chosen for the coffin lid belonged to that clan. The painting was of the shark ancestor at Wurlwurlwuy, inland from Trial Bay, and it was Wurlwurlwuy and the shark that became the pivot of the spirit journey of the woman. The shade in which the coffin lay represented a fish trap in the river. A trellis of sticks was built at the entrance to the shade, representing the barrier wall of the fish trap. When the body was placed in the painted coffin, it represented the shark trapped in the fish trap. The time came to move the body, and dancers acting as sharks held the coffin and burst out of the shade, smashing down the wall of sticks. The shark had escaped from the fish trap and torn it to pieces. The coffin was then carried forward to the vehicle that was to drive it to the cemetery in a dance that represented the flow of water released from the broken wall of the fish trap. In the context of the mortuary ritual, the sequences of action were an analogue for the journey of the woman's spirit, the shark breaking out of the fish trap symbolizing the soul's struggle to leave the body and the struggle of the journey ahead. The energy of the shark and the power of the waters represented the power of the ancestral forces summoned to help the soul on its way.

Although the painting chosen for the coffin lid may be central to the semantics of the ceremony, it is not selected on this basis alone. Its selection depends also on the dead person's relationship with members of other clans, as it did in the ceremony described above.

According to Warner (1958:415), a person always had a painting

representing his or her own clan well, the destination of their birrim-birr spirit, painted on the chest after death. Thomson (cited in Peterson 1976:97) also recorded that the painting on the dead body should belong to the person's own clan, but that in the absence of the "right people," the clan design of the actual MM[B] was used instead. Neither of these statements applies to Yirrkala today, although Thomson's statement fits the data most closely. Of the six coffins I saw painted, four were painted with the person's MM[B] design and two with both the person's MM[B] and own clan's painting. In all cases, members of the person's own clan were present.

In the case where the person's own clan's painting was used, it represented the place that was to be the final destination of the birrimbirr spirit. In the cases where an MM[B] clan painting was used, the totemic well represented was not the final place to which the spirit was being directed.

When I asked different people which clan's painting should be on a coffin lid, I received conflicting information. Some people said that a person's MM[B]'s clan painting should be on the coffin lid if the individual is buried a long way from his or her own clan's country. If the person is to be buried in his or her own country, then their own clan's painting should be used. Others insisted that the MM[B]'s clan painting should always be used as this was the responsibility of that clan in funerals. Based on the evidence I obtained, the statements seem less contradictory than it appears at first. In the two cases where a person's own-clan painting was included on the coffin lid, the person was indeed being buried in his or her own country. On the one occasion when a person was buried in his own country without his clan's painting on the coffin lid, the circumstances were exceptional, since he had died a long way off and his body was flown in to his clan's outstation. Furthermore, although in two cases a person's own-clan painting was painted on the coffin lid, on both occasions at least one of the paintings on the coffin belonged to an MM[B] clan.

Perhaps there has been an increase in the frequency with which MM[B]'s paintings are produced on the body or the coffin in mortuary rituals, and the increase may indeed be in response to the changed conditions following from European colonization. Today people are perhaps more likely to die at considerable distances from their clan territories than in the past, and hence the spirit's journey overland may be relatively longer and require greater assistance from members of intervening clans. Whatever the case, it is considered appropriate today that MM[B]'s clans should produce coffin paintings, and this fits the more general pattern of closeness in relationship between MM[B]'s and [Z]DC's clan.

During their lifetime, individuals obtain rights in their MM[B] clan's paintings and become close to their MM[B] clan's mardayin through gaining knowledge of it. Knowledge of the clan's mardayin enables an individual to gain some control over the clan's sacred objects as expressions of ancestral power. This access to the power of the MM[B] clan is compatible with the Yolngu ideology of descent: a person may be affiliated with his or her MM[B] mardayin through spirit conception, and [Z]DC's clan may take over the MM[B] land should the latter clan become extinct. I was told on several occasions that in deciding on the structure of a burial ceremony, people follow the line from which a person was born, that is, the matriline: "The spirit goes through the mother to the mother's mother and back to his own clan." As far as a person's own moiety is concerned, one is seen to be a product of one's own clan and MM[B] patriline. It is therefore quite appropriate that a person's MM[B] clan painting should be used to reincorporate that person's spirit within the body of spirits associated with the wangarr ancestors to whom he or she is closest by descent. Indeed an MM[B]'s clan painting is sometimes painted on a person's chest in other contexts, as when a sacred object has been revealed to him or when he has recovered from illness. A boy may also be painted with his MM[B]'s clan painting during his circumcision ceremony if for some reason it is impossible to have his own clan painting done. Such use of MM[B]'s clan paintings in situations where otherwise one's own-clan paintings could be used signifies that a person's ancestral inheritance is wider than that associated with the mardayin of one's own patrilineal group. At a sociological level, the role of the MM[B] clan reaffirms the close relationship between an MM[B] group and a [Z]DC group, which is of central importance as far as rights in women and rights in land are concerned.

Conclusion: Why Paintings Are Used

There are three reasons why paintings are used in Yolngu ceremonies—reasons that make paintings into meaningful objects. These apply equally well to other components of a clan's sacred law such as songs and dances. First, paintings are loci of maarr, ancestral power. Maarr is something that certain categories of paintings possess especially, but not exclusively, in ritual contexts. Maarr is an attribute of paintings that exists quite independently of any meaning they have or of any group to which they belong. Second, paintings are used for political purposes. The use of particular paintings demonstrates the rights of individuals, as members of a clan, to use those paintings, and is a sign of consensus about the purposes and an affirmation of the fellowship of a ceremony. The use of the mardayin in ceremonies is also a

way of ensuring that it is passed on to the next generation, which is also of political significance. Finally, paintings are used because they are restored ancestral behavior or substance (see Schechner 1981). The painting of a design is part of the process of re-creating an ancestral event, of bringing forward an event from the ancestral past and integrating it within a contemporary context—a ritual performed for a particular purpose. The design is restored behavior in two senses: it was painted on the ancestral being's body or originated through his or her actions, and it encodes meanings which refer to the ancestral events that took place in a particular locality, resulting in the transformation of the landscape. In the first sense the design is believed to be an actual part or creation of the ancestral being; in the second sense it is a representation, and an ancestral representation at that, of the events that took place.

In many respects these are reasons that Yolngu themselves give for producing paintings in ceremonies. Paintings are used "to give power to the *birrimbirr*" or to make a person strong; their production shows "we are all in agreement" or that "we are all one *baapurru*"; they are done because that is what the ancestors did, because "we are just following in their steps."

To summarize: paintings are used in ritual because they are meaningful objects; they are spiritually powerful ancestral designs which are the property of clans and which store information about ancestral events.

7

The Meanings
of Paintings
in Ceremony

While a painting has a meaning independent
of any particular ritual (as part of the chunk
of ancestral law associated with a particular
place, for example), it is in ceremonies that
specific meanings are elaborated and addi-
tional connotations arise. Ceremony, more-
over, is an important context for acquiring
knowledge about paintings. Although indi-
viduals are given some formal instruction
about the meaning of paintings outside the
ritual context, just as often knowledge of
paintings is acquired through observing se-
quences of ritual action which belong to the
same mardayin or which concern the same
ancestral being. Ritual provides the main
communal context for learning about the
meaning of paintings.

Such learning often relates to paintings
that are not actually produced in a particu-
lar ritual. Paintings, songs, and dances pro-
vide different perspectives on the same an-
cestral events, and it is possible to learn much
about the meaning of one from learning
about the others, for example, by learning
about the meaning of paintings through ob-
serving dances being performed. The major-
ity of ritual episodes in a ceremony are likely

to refer to ancestral events that are not related to any painting used in the ceremony. However, the songs and dances will usually belong to a chunk of ancestral law which also includes among its manifestations a painting of the place where the events took place. The knowledge acquired through observing dances or sequences of ritual action can subsequently be applied to the interpretation of paintings.

Moreover, paintings that are used in a ceremony may not have an important place in the iconography of the ceremony as a whole, and in such cases little may be learned about their meaning through participation in the ceremony. A painting on a boy's chest at his circumcision ceremony may hardly be referred to in other parts of the ritual. While it is being painted, a few songs may be sung that relate to the place it represents but otherwise its denotative meaning is not exploited in the ceremony as a whole, though considerations of meaning will certainly have been relevant to its selection in the first place. On occasions, however, a painting does figure prominently in the iconography of a ceremony, especially if it belongs to a chunk of ancestral law that is extensively represented in the performance. The shark painting discussed in the previous chapter is a case in point. Here the painting was integrated within a sequence of ritual action which elaborated on meanings it encoded. For example, the painting included geometric elements signifying the sticks of the fish trap, which was also represented by a trellis of sticks at the entrance to the shade. In such cases the meanings of the paintings are not seized upon and elaborated for their own sake; rather, the ancestral events depicted in the painting are relevant to the structure of the ceremony as a whole. The purpose of the ceremony is not in any sense the elaboration of the meanings of paintings that are used, though the content of a painting may be one of the factors affecting the selection of other elements included in the ritual.

A number of different kinds of meaning are associated with the use of Yolngu paintings in ritual. Some meanings are primarily denotative in that an element of the painting signifies or represents a particular object. Others are essentially connotative in that they involve particular ways in which the object signified is understood by the interpreter in light of the overall context in which the meaning is embedded.

By employing this distinction I do not intend to imply that in the case of denotative meaning we are dealing with a fixed and context-free level of meaning. However I do intend that the meanings are more like those found in dictionaries than connotative meanings are, without arguing that a dictionary is the best way of representing them. In any sign system the relationship between signifiers and signifieds is a

dynamic one, and meaning is continually being fixed and refixed through semiological and political process by the use of the system in context (Coward and Ellis 1977). Meaning is characterized by what Volosinov (1986:66) refers to as "the ceaseless flow of becoming." In this respect, denotation and connotation are interacting components of the same overall process of linguistic change. Yet speakers also act as if "a certain rule (a code) [exists] enabling both the sender and addressee to understand the manifestation in the same way" (Eco 1984:16). And such requirements have produced and continue to produce formally structured systems of similarity and difference which are integral to the process of linguistic production and reproduction, even though they must be understood as parts of dynamic systems that are integrated within the context of their use. Shanks and Tilley (1987:74) summarize this perspective quite well when they write: "In structure signs have an abstract sense, signifying within a collective scheme of signification in terms of their relations with other signs. Although signs relate to other signs in an abstract fashion, their relationship to action entails a different significance. It is one of potential rearticulation and the constitution of fresh meanings."

Although at this level of abstraction all meanings are equally subject to change, meanings differ among themselves both in the ways in which they are produced and in the ways they are understood by interpreters. To Eco (1984:25), for example, the existence of metaphor implies the existence of other kinds of meaning: "If signs (expressions and content) did not preexist the text, every metaphor would be equivalent to saying something is something. But a metaphor says *that* (linguistic) thing is something else." What I classify as denotative and connotative meanings are both produced in context, but I would argue that they are produced in different ways and are conceived of as being different. Connotative meaning may affect denotative meaning and may be an active component in language change, but that does not mean it acts in the same ways as denotative meaning.

In analyzing the meaning of Yolngu art, I have defined five subtypes. The first two, *iconographic* and *reflectional,* fit broadly into the category of denotative meanings. The next two, *thematic* and *particularistic,* are, broadly speaking, connotative. The final type, *sociological,* derives from the fact that Yolngu paintings are indexical of social groups and intrinsic to those groups' existence (see Morphy 1988). Under sociological meanings I discuss both denotative and connotative aspects of designs that relate to these indexical properties of paintings. These types of meaning can be applied equally well to all components of Yolngu ritual and in the discussion that follows I do not restrict myself to paintings.

Iconographic Meaning

Iconographic meanings are collective meanings denoted by elements of the painting. I do not intend to imply by the word *collective* that the meanings are known to everybody. In a system of restricted knowledge, this cannot be the case with all meanings. Rather, they are collective in the sense that they are there to be known by members of society should members qualify to gain access to them. They are not individual meanings, where an element has a specific meaning to one person. Signified meanings of this type refer to the chunk of ancestral law associated with the paintings (or dances and so on), that is, to the ancestral events that took place in a particular country and the consequences those events had on the shape of the landscape. I take such meanings to be the primary denotative meaning of paintings in two ways: they are the meanings upon which meanings at other levels are built, and, from a Yolngu perspective, they refer to originating and authenticating events.

In ritual, iconographic meanings are part of a representation of an ancestral reality. The shark dance at the Marrakulu woman's funeral was recognized as an enactment of the journey of *maarna* the shark at Wurlwurlwuy, regardless of any other connotations it may have had in the context of the particular ceremony. By returning to the Djungguwan at Gurka'wuy (Trial Bay) referred to in chapter 6, we can look at aspects of the iconography of the ceremony, focusing on the meanings of the ceremonial ground and some of the objects and constructions associated with it.

The ceremony as a whole reenacted a section of the journey of two female ancestral beings, the Wawilak sisters, through Northeast Arnhem Land. The mythology of the Wawilak women provides the basic mythological theme for three of the major Dhuwa moiety ceremonies: the Ngurlmarrk, the Djungguwan, and the Gunapipi (see Warner 1958:244 ff.; Berndt 1951).

The songs (*manikay*) performed concerned a number of ancestral beings in addition to the Wawilak sisters, the main ones being Djaypin, Wuyal, Wurray, and Ganydjalala. The main events enacted were the journeys of these ancestral beings between Trial Bay (Gurka'wuy) and the country of the Wagilak clan, inland from the Baykurrtji River in the north of Blue Mud Bay. These ancestral beings interacted with the Wawilak sisters on the first part of the latter's journey to Mirrarrmina. Ganydjalala is sometimes said to be one of the Wawilak women. The direction of movement is important, since it differentiates the mythology of this ceremony and of the owning clan, the Marrakulu, from the myths recorded by Warner and Berndt. As I showed in chapter 5,

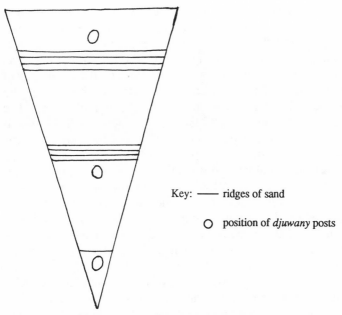

Key: —— ridges of sand

○ position of *djuwany* posts

Figure 7.1 The shape of the molk ceremonial ground.

the journey is associated with two key activities, the collecting of wild honey (*yarrpany*) and the hunting of rock wallaby (*dulaku*).[1]

The ceremonial ground (*molk*) (fig. 7.1) was constructed at night while women and children remained hidden beneath blankets. It was marked out by Bokarra, the senior waku (ZS) to the ceremony. The following night the senior initiated men went back to the men's ground to collect the *djuwany* posts, having first made sure that all the women and young men had their heads covered. The posts were then danced down from the clearing into the main camp and erected within the ceremonial ground, one at either end and the other in the center. Feather string was then attached to the posts, connecting them with each other. The *dhumarr* trumpet was blown over the posts, along the feather string, and over the assembled company.

1. Warner (1958:250 ff.) and Berndt (1951:250 ff.) record myths which state that the Wawilak sisters entered Northeast Arnhem Land from the south. According to Warner, the women originated in the country of the Wawilak people. Berndt discusses a number of alternative origins, referring in particular to the Roper River. In the Marrakulu myth, the rock wallaby, chased by fire, always manages to escape the huntress. This episode provides a linking theme with the myths recorded by Warner for Mirrarrmina. In Warner's version, the women early on in their journey named the kangaroo and "tried to catch these kangaroos, but they ran away" (1958:313).

The djuwany posts (fig. 7.2) represent the ancestral women, the stringybark trees that were cut down in their search for wild honey, and the initiates going through the ceremony.[2] The fringe of stringybark around the top of the post represents the hair of the ancestral women, and also their pubic aprons. The designs on the main body of each post represent different places on the journey of the women, the dashed design above the bark fringe signifying both honey bee (through the meanings "wax," "larvae," "stringybark flower," and "honey") and menstrual blood. The paintings on the posts can occur in other contexts as body or coffin paintings.

The molk ceremonial ground is similar to that used in other ceremonies associated with the Wawilak mythology (see, for example, Warner 1958:265, fig. 3). On this occasion it represents the molk at Marnbalala, where the Wawilak sisters performed the same ceremony in ancestral times. The women then owned all the sacred ceremonies and kept them secret from men. The ground also represents the stringybark tree and the watercourse at Marnbalala which was formed by the tree when it was cut down there by the sisters in their search for honey. The end section of the ground represents the hut which the sisters built at various places on their journey. In a closed performance of the Djungguwan ceremony, a shelter would be built at that end of the ground to contain the sacred objects used in the ceremony (see Warner 1958:265). The hut is associated with menstrual and afterbirth blood, and this is one of the meanings associated with the ground in the molk ceremony.

The *dhumarr* trumpet signifies the body of the bee fly (Bombyliidae) which hovers at the entrance to the hive of the long-nosed sugar-bag bee (*yarrpany*). The trumpet is decorated with feather string and painted at one end with red and white dots. It is blown over the body paintings and posts as they are being produced, over the feather string, and over the assembled company. It is seen as containing the spiritual power of the sugar-bag mardayin. The dots on the end have the same set of meanings as those on the djuwany posts.

The white feather string suspended over the ground between the posts has a set of meanings which overlap with those of the djuwany and dhumarr: "bees," "larvae," and "honey," which themselves in

2. *Djuwany* posts are not a feature of the Djungguwan ceremonies referred to by Warner. However, they are structurally similar to the *warngatja*, a bundle of green-leafed sticks, which are used in the ceremonies he describes. The *warngatja* also represents the Wawilak sisters, the stringybark trees, and the initiates. Warner (1958:263) reports that the number of component sticks in the *warngatja* represents the number of initiates in the ceremony. A *warngatja* with the same set of meanings as the *djuwany* posts was made for the Gurka'wuy ceremony.

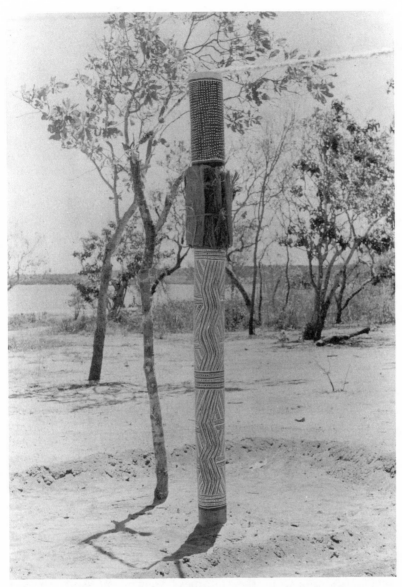

Figure 7.2 A djuwany post set in a ceremonial ground at Gurka'wuy, Trial Bay.

turn are parts that signify the whole "sugar-bag." The string also represents the journey of the Wawilak sisters. It is knotted at intervals along its length, and each knot represents an important site on the route of the journey. At the Gurka'wuy ceremony, the knots signified places between Trial Bay (Gurka'wuy) and Wagilak country. The precise places signified depend on which section of the sisters' journey is being enacted in a particular ceremony, and also on the location of the ceremony.

The iconographic meanings refer largely to those ancestral events and creations that provide the substance out of which the ceremony is constructed. In Yolngu terms, one way of reading the sequence of ritual action is to see it as a literal enactment of those events, a restoration of that behavior. In the case of the Djungguwan, for example, the ceremony represents the journey of the ancestral women, presents images or objects such as the sugar-bag or the ceremonial ground that are part of that journey, and refers to land forms and features that are a consequence of those events and journeys. However, when incorporated within a particular ceremonial enactment, which is concerned with the lives and spirits of known people, the ancestral behavior and objects cease to be located in past ancestral events and are reintegrated with the present, through the creation of metaphor and analogy.

Reflectional Meaning

Reflectional meaning as a process is relevant to all Yolngu art but in particular applies to simple monochrome paintings which, on the whole, only have specific referential meanings in the context of ritual action. White paint, for example, can be applied all over the bodies of dancers at various stages of ceremonies. Painting the body white is said to have many functions, one of which is to act as a mask for the body, protecting it from the dangers of pollution from a dead body or from the danger of some source of spiritual power. Its denotative meaning, however, can vary through the course of a ceremony, depending on the particular song topics that are being sung or the particular ancestral events that are being enacted. If the group of dancers painted in white dance the tide coming in, then the white is said to signify the white caps of the waves. If the dancers later perform a dance of bees in the paperbark swamps, then the white may be said to represent the bark of the trees themselves. The meaning of the painting in such cases is in a sense a reflection of the songs that are sung, but the significance of the white paint to the dancers and audience must be enhanced by their knowledge of its continual reintegration with the ritual which is echoed in the words of songs.

It could be argued that reflectional meanings are, strictly speaking,

neither denotative nor connotative but somewhere in between. I classify them as denotative since they are potential meanings of paintings that are keyed in by context but theoretically exist independent of it. Reflectional meanings are what white paint means as a component of the chunk of ancestral law of a particular place. The reflectional meaning is how white paint is taken up in the songs for that place, and what the power names for white paint associated with that place mean. From the Yolngu perspective, it is not something that arises from the context; it is a meaning that is always there. Its actual presence in the ceremony is brought about by the performance of songs or dances that refer to the specific meaning that the pigment can have. The signifier might be best expressed as the painting plus the song or other element that is reflected in it or is used to key in its particular meaning.

The specification of meaning by song is a regular feature of Yolngu ritual. Series of songs referring to meanings encoded in paintings can be sung to coincide with any stage of a painting and focus attention on a particular aspect of its meaning (see Morphy 1984:73). Yolngu paintings are multivalent and in some cases can be associated with a number of different locations. The performance of songs can specify the interpretation that is relevant and in many ways can locate a painting in space. For example, the painting on an initiate's face (fig. 7.3) in the Djungguwan at Gurka'wuy is one that is frequently associated with that phase of the ceremony wherever it is performed. The design can represent the wild honey that the ancestral beings collected on their journey and be associated with inland places; however, it can also represent bubbles in water and patterns made by the tide. Just as the painting was begun, a group of men sat discussing which songs they would sing:

DURNDIWUY: Where are we going to start? At the sea?
DARDAYNGA: Yes, the sea.
DURNDIWUY: Going into the sea?
DARDAYNGA: We will paint from the mouth of the river.
MILIRRPUM: We will sing oyster.
BOKARRA: At the other side of the bay.
MITHILI: At the rock.
MILIRRPUM: We will start with the tide coming out, and then when we are
 ready we will sing the spring tide flowing back into the river.[3]

In this example we see clearly how the particular denotation of a painting can be fixed for a while by the overall context in which it is embedded. The painting is linked by the songs to the salt water and

3. The translation of this discussion arises out of preparatory work for Ian Dunlop's (1990) film *Djungguwan at Gurka'wuy.*

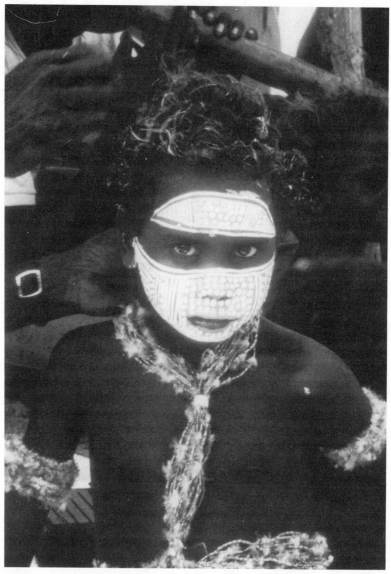

Figure 7.3 An initiate painted with a Dhuwa moiety wild honey design at a Djung-guwan ceremony at Gurka'wuy.

becomes for a while a manifestation of the ancestral forces associated with a rock in the center of the bay. Later on, as the songs shift to the movements of the tide, the focal meaning of the painting shifts with them, the lines on the paintings now reflecting patterns in the waters. Through the paintings and the songs, the initiate is able to participate in the ancestral journey. Because the painting lasts for many hours as a visible component of the ceremony, its meaning can shift as it is recontextualized. Ceremony also provides a potential context in which new denotations can be encoded in paintings, though I have no evidence that this actually happens.[4] Indeed Yolngu would deny that it does, since in their view a finite set of meanings was encoded in the paintings in the ancestral past.

Thematic Meaning

Whereas iconographic meanings are presented in ritual as part of the restoration of ancestral behavior and the re-creation of ancestral events, thematic meanings are created through the selection of a painting or other component of the mardayin for a specific purpose in the context of a particular ceremony. In some respects, thematic meaning can be seen as a connotation accorded an ancestral event through its use in a particular ceremony or its association with a particular kind of ritual event. The purpose for which the painting has been selected may affect which aspect of its denotative iconographic meaning will be emphasized and will influence the way it is understood in the ceremony as a whole. The denotative iconographic meaning becomes the raw material for the creation of a metaphor or an analogy that is appropriate to the performance of a particular ritual event. For example, the painting of the shark at Wurlwurlwuy refers to a chunk of ancestral law that includes many ancestral actions and their consequences. The shark created the river as it rushed headlong inland from Djambarrpuyngu clan country in Buckingham Bay, where it was speared by an ancestral harpoon. The shark's body was transformed into various features of the environment, including, for example, the trees that line the river. The painting that was used in the Marrakulu woman's funeral encodes references to the entire complex of events that took place at Wurlwurlwuy. In the ceremony, many of these events were referred to

4. I have plenty of indirect evidence that the meanings of designs have changed over time and that new meanings are encoded. For example, the iconography of designs that represent Macassan elements have been updated to include things that are part of recent postcolonization experience. Rooms in Macassan houses, for example, are said to include kitchens and bathrooms, and in associated song series, reference is made to bulldozers. However, Yolngu deny that such references are recent and argue that the objects concerned were figures in the ancestral past.

in the songs that accompanied the painting of the coffin lid (fig. 7.4). However, in structuring the performance as a whole, only certain events were singled out and represented, events which became the core metaphor for the two journeys that were to take place—the journey of the body to the grave and the journey of the woman's spirit to its spirit home. The shark bursting out of the fish trap became the structuring performative metaphor (Fernandez 1977) which, in the context of the mortuary ritual, enabled those journeys to be accomplished. Thus, although the painting at a very generalized level refers to the chunk of ancestral law as a whole, in ritual only a part of its potential denotative meaning is exploited. Yet it is exploited in such a way that it adds to the connotative meaning of the painting and gives it a sense that it does not have as an abstract component of the chunk. The shark represents the woman's spirit provided with the power to return to her ancestral lands. The ritual emphasizes the energy and force of the trapped animal as it summons up its powers to break out of the fish trap, power that the woman's spirit needs for its long journey. The breaking down of the fish-trap wall symbolizes the release of energy, and the flow of water that was held back by the wall represents the onward movement of the woman's spirit. These meanings are not what the shark painting denotes but what it connotes in the context of a particular ceremony.

The distinction I employ between iconographic and thematic meaning has some relationship to that developed by Volosinov (1986:99ff.) in distinguishing between meaning and theme—meaning being the entry in a dictionary, theme being the meaning taken up by the use of the word in a particular context (p. 102). Volosinov's theme is the theme of a whole utterance that gives meaning to its parts: it is something that specifies. My theme is likewise something that specifies or perhaps rather evokes the meaning of a part through a whole. Volosinov is primarily concerned with the denotative meaning of a word, whereas I am concerned with themes acting on denotative (iconographic) meanings. However, in both cases the theme alters the meaning that the particular sign or sign set has. My theme is in some ways even closer to Eco's (1984:117) theme, which he sees as a key element in the interpretation of metaphors. A metaphor gets released through its association with a theme, through the catalyst of a theme. My themes likewise provide an area of interpretation that narrows down the connotations of a symbol or at least sets a direction in which interpretations could be found and meanings should ramify. The thematic meaning of an element is the product of an interactive process. The potential connotations of a particular denotatum (shark = fierce, aggressive, angry, fish, ancestral being) are part of what create the

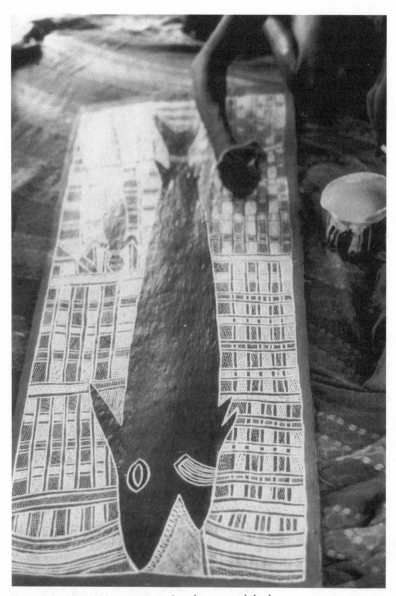

Figure 7.4 Maaw' Mununggurr paints the ancestral shark.

context, and they operate in conjunction with the themes of the cere-
monies (e.g., the fate of the soul, the initiation of young boys, gender
relations) to evoke more particular interpretations or more specific
connotations (the shark as soul struggling to escape).

Certain ancestral events become associated with particular phases of
a ritual for which they provide powerful analogical meaning. As such
they may become a conventional event for that phase whenever it is
appropriate, for example, when it is being performed by a clan or clans
of the correct moiety. The shark mardayin belongs to the Dhuwa
moiety and so could not be used for the burial of a Yirritja person.
Sometimes, however, a particular ancestral event (i.e., the songs,
paintings, and dances that represent it) may be used for the first time to
accompany or perform a particular ritual act, and the connotation it
gains through being used for that purpose may be, in part, a unique
creation of the ceremony. The use of existing elements in new contexts
and combinations is part of the dynamic of Yolngu ceremony, repre-
senting in effect the emergence of meaning from the inside. Whatever
the case, whether the ancestral event is conventionally associated with
a particular ritual act or whether the association is a newly created
one, the same event will almost certainly be used to create an image
with quite different connotations in some other ceremonial context.
This will involve the highlighting of quite different denotative mean-
ings through the introduction of a different theme. The shark ancestral
being may also be associated with avenging expeditions in which a
group of warriors sets out to kill a member or members of an opposing
set of clans. In such cases, rituals may be performed which focus on the
destructive powers of the shark, on its anger at having been speared,
and on its nature as a ruthless, powerful, fierce, and cold-blooded
killer. The fish trap will no longer be a key element, but the teeth of the
shark and the spear may come to the fore.

In the case of the Djungguwan ceremony, the iconographic mean-
ings encoded in the ground sculpture and the ceremonial objects can
be shown to have particular analogical and metaphorical connotations
when they are related to the basic themes of the ceremony. Such meta-
phors are, on occasion, explicitly stated by Yolngu and can be seen as
conscious understandings or interpretations of the iconographic
meanings in the particular ceremony, although I would argue that this
does not have to be so in all cases. Some thematic, analogical meanings
may be imminent in the understandings of the ritual action but may
never be fully articulated. On the whole, however, I deal with mean-
ings for which I have exegetical statements.

The ceremony as a whole was said to give strength to the partici-
pants in the ceremony, both male and female. It was said also to free

the people from taboos associated with deaths that had occurred in previous years and to free areas of land and make them good for hunting. The ceremony is also associated with fertility in a more literal sense, that is, with procreation. The term *djuwany* is said to mean "spirit children," and the Djungguwan ceremony provides one of the contexts in which the spirit conception of children occurs or is given formal recognition.[5] Two main symbolic themes which express fertility were enacted throughout the ceremony. One was the Dhuwa moiety sugar-bag, and the other was the reenactment of the journey of the wangarr Wawilak sisters.

At one level the ceremonial ground represents the structure of a beehive. The white feather-string suspended over the ground represents the white larvae in the hive, and the trumpet blown over the hive represents the abdomen of the bee fly. The white dots painted on the trumpet and included as an element in all the paintings produced for the ceremony signify the white flower of the stringybark tree, the source of nectar for the bees. Connection between these symbols and human fertility is explicitly made: one of the meanings given to the white dots and the feather down is that they represent spirit children.

At one stage in the ceremony the young initiates sit in the center of the ceremonial ground between the posts, their legs interlocked, and the *dhumarr* trumpet is blown over the feather string.[6] Men shake the posts, and feather down from the string floats over the assembled company. It is tempting to interpret this image as a symbol of sexual intercourse. The bee fly which the *dhumarr* trumpet represents is said by the Yolngu to hover in front of the entrance of a hive and is one of the ways the presence of a hive can be detected. Little is known about the life cycle of the bee fly, but McKeown's (1945) description provides information that is relevant. He writes that the larvae of the bee fly are parasites in the nests of bees and wasps: "I have seen the flies hovering about the entrance to these nests and have seen the fly bend its abdomen forwards beneath its body and apparently shoot its eggs into the burrow." The action of the bee fly in squirting eggs into the hive suggests the ejaculation of sperm from the penis. The Yolngu do not, however, interpret the bee fly in this way; rather they focus on the bee

5. Warner (1958:280), for example, records that women who believe themselves pregnant inform their husbands prior to or during the Djungguwan ceremony. The husband then recalls an incident which suggests to him the spirit conception of the child. The power names associated with the wangarr ancestor involved in the spirit conception are subsequently called out during the blood-letting phase of the ceremony, reinforcing the spiritual component of the child in the womb.

6. This phase of the ceremony did not occur in the Djungguwan held at Gurka'wuy but was a feature of another Djungguwan I witnessed at Yirrkala.

fly as a restorer of life to the bees. The bee fly is said to lick dead or dying bees and make them recover. In either case the blowing of the trumpet can be interpreted as a symbol of fertility and creativity. The ceremony reenacts a stage in the journey of the Wawilak sisters, focusing particularly on their actions in creating a major watercourse at Marnbalala, to the north of Cape Shield, by chopping down a giant stringybark tree. The chopping down of the tree connects the Wawilak sisters with the sugar-bag. A long-nosed sugar-bag was in the top of the tree when they chopped it down. On hitting the ground the tree split into many pieces, the honey and the bees were spread all over the country, and splinters of wood (djuwany posts) fell in the land of a number of different Dhuwa moiety clans. The Wawilak sisters can thus be seen to be involved in the spread of Dhuwa moiety sugar-bag. The white dots on the paintings and the feather string specifically represent spirit children left behind at Marnbalala by the Wawilak sisters. The two themes are thus interconnected and reinforce one another; meanings associated with both are encoded in the same elements of paintings and in the shape and features of the ceremonial ground.

During the course of the ceremony the youngest initiates are identified with the Wawilak sisters. The *warngatja* and djuwany posts represent both the Wawilak sisters and the initiates. Feather-string breast girdles are placed over initiates' shoulders and represent the breast girdles worn by women in general and the Wawilak sisters in particular. The girdle is explicitly stated to make the boys like women, and men make jokes about their "breasts" and how pretty they look. The identification of the initiates takes on an additional significance in the context of circumcision ceremonies, where the blood lost during the operation is seen as similar to menstrual or afterbirth blood. In particular it is like the blood that polluted the well at Mirrarrmina, which led to the ancestral snake swallowing the women (see Warner 1958:372). The red ocher painted on the chests of the boys also signifies the menstrual or afterbirth blood of the two Wawilak women.

Menstrual blood has both positive and negative connotations: it is dangerous and polluting when uncontrolled, but in ritual contexts it is a powerful symbol which is believed to give people strength and endow them with wangarr power. I suggest that in entering the Djungguwan ceremony, the initiates are taking the first steps toward acquiring the ritual knowledge that enables them to gain control of the symbols of female fertility. The placing of the breast girdles over the boys, as well as signifying that their status is close to that of women, signals the beginning of this aspect of the process of male initiation.

Particularistic Meaning

In contrast to the meanings discussed above, which operate at a collective level, paintings also acquire connotative meanings that would seem at first to be primarily of significance to individuals participating in the ceremony. I refer here to meanings that are created through the association of a painting with a particular event such as the burial of a relative or the circumcision of a child. The painting of ancestral designs on a person's body is a means of directly associating that individual with the ancestral world; it is part of the process of ensuring that a continuing relationship exists between members of a clan and the ancestral beings associated with that clan. Because the painting of the design on a person's chest or contact with a sacred object is thought to result in the transfer of ancestral power to that individual, the design afterward becomes a sign for part of the spiritual dimension of that person. However, something of a two-way process is involved. Not only is the person on whom a design is painted thought to be strengthened or assisted by the power of the associated ancestral being, but emotions are generated in ritual which link the person to the design. This can happen in a number of ways. The painting of a design on a person's chest (for instance, prior to circumcision) is a powerful experience which may be reflected in that individual developing feelings of attachment to the design. More generally, people may remember the designs painted on a boy's chest at circumcision and on a dead person's coffin lid, and the use of the design in those events contributes to its meaning to relatives who took part in the ceremonies. Some people, in particular ritual leaders, become so closely associated with certain designs or sacred objects that the objects become identified with them during their lifetime. The association of the ancestral world with meanings that are linked to known individuals is one of the ways that world has immediacy to the living (see Clunies-Ross 1989:165; Myers 1986:118).

This particularistic aspect of meaning comes out very clearly in the case of the Djungguwan ceremony, which has many of the aspects of an ancestor cult. A central theme of the ceremony is the transfer of spiritual components of dead clan ancestors to living members of the clan and to people of related clans. This transfer is mediated through the clan's mardayin manifested in the sacred objects and paintings used in the ceremony, and in the ritual performances that take place. It involves both the transfer of the power of the wangarr ancestors to the participants in the ceremony as a whole, and at a more specific level the transfer of spiritual power between recently deceased members of the clan and the initiates.

In discussing the themes of burial ceremonies, I showed that one of the main objectives was to return the spirit of the dead person to a source of spiritual power in his or her clan land. The spirit was reincorporated within the body of spiritual power associated with the clan's mardayin. In a sense the Djungguwan ceremony reverses the process, transferring spiritual powers from the wangarr ancestors to living members of the clan. The successful return of a birrimbirr spirit to its spirit home is a necessary precursor to the performance of a Djungguwan ceremony. This is the way in which the Yolngu discuss the process, stating that a Djungguwan ceremony must be performed a year or so after the death of a member of the clan. Although the return of a birrimbirr spirit is in this sense a prerequisite for the performance of a Djungguwan ceremony, the transfer of spiritual power is better seen as a renewal of the relationship between the wangarr ancestors and living members of the clan rather than the reincarnation of a specific individual's spirit.

The djuwany posts represent the Wawilak sisters, although other wangarr beings may be associated with them as well. A relationship is established between one of the initiates and one of the posts, and also between the post and a recently deceased member of the clan. The painting on the post represents a place to which the deceased's birrimbirr spirit has been directed or is more generally associated with, and is not necessarily the painting that was produced on the person's coffin lid. During the ceremony the spirit associated with the deceased is said to be transferred to the initiate associated with the same post.

Figure 7.2 illustrates one of the djuwany posts erected at the Gurka'wuy ceremony. The post was said to contain the spirit of the Marrakulu woman who died at Yirrkala. The painting represents the woman's country at Gurka'wuy, the designs signifying fresh water mixed with honey flowing along the course of the river created by the Wawilak sisters. The post represents the deceased woman in two senses. It was acknowledged to be a memorial for her—"when her children see this post they will be reminded of her"—and the painting on it contains aspects of her birrimbirr spirit. The post was linked with one particular boy who was entering the ceremony for the first time, in preparation for his later circumcision ceremony. The boy and the woman stood in a classificatory DC-MM (gutharra-maari) relationship, but there was no actual genealogical link between the two.

Durndiwuy, a senior Marrakulu man, told me, "Old Marrakulu woman who died—she gave her spirit to that djuwany post—the spirit goes to Dardaynga's boy. That's why they put the painting on, the spirit goes from the dead person into the post, where it is joined with the wangarr and then it is passed on to the boy."

This suggests that at least a close identification is made between actual known deceased persons and the sacred objects and paintings of a clan. When I questioned Durndiwuy further about the relationship between the spirits and the initiate, he stated that the spirit was not really the spirit of the woman: "Really the spirit comes from that post from the Wawilak women."

This second statement is compatible with the first, but suggests that the emphasis should be on the wangarr origin of power rather than on spiritual succession from one Yolngu generation to the next. The primary source of power is the rangga (i.e., the wangarr being), not the deceased person. The deceased person's power itself is derived from the rangga. Throughout a person's life, he or she continually accumulates maarr (ancestral power) through the performance of ceremonies, and the transfer of power to the initiates in the Djungguwan ceremony is one such example. An aspect of this power, in the form of a person's birrimbirr spirit, returns on a person's death to the wangarr realm, to the clan's sacred objects, paintings, and land, to be released subsequently to initiates and people in general in the context of ceremonial performances. The overall effect is one of recycling of ritual power. The use of actual named individuals is a way of modeling a process which is conceptualized at a more general level.

The particularistic meaning of a design or any other component of the sacred law is almost by definition something that changes over time, but the potential to create particularistic meanings is one that is integral to the way Yolngu use art. In each generation and to an extent in each ceremony, a sacred object or a design is linked to different human creators and subjects, and earlier associations are lost as memories of the people fade. The ritual components, organized into a unique configuration at a person's funeral as "a way of giving them an individual memorial full of aesthetic richness and emotional effect" (Clunies-Ross 1989:166), are soon made into elements of new configurations with new particularistic connotations. After a while the sacred object that had been so closely associated with a particular elder, an association it retained for a few years after his death, will become more strongly identified with its current holder(s).

In a sense, particularistic meaning refers to the actual transfer of knowledge of and rights in a design over time, as opposed to its ancestral continuity. Particularistic meaning links ritual elements directly to political process, to who held the designs in the past, how they were used, and to whom they were passed on. Ancestral continuity is read into this process as a form of legitimation. Particularistic meaning is the point of juncture between the mundane world of human operators and the ancestral world of prefigured determinations. The human op-

erators are united with ancestral process after death, as memories of them as past holders of the rangga fade. They merge with the object or design: their names become associated with the object as names of the object rather than as names of individual people. The process of transforming people back into wangarr is one in which ultimately the energy associated with the living and recently dead becomes the energy of the ancestral past, in which political process reaches a state of rest where the present represents the ancestrally stated order of the world. Here one is involved with the movement from the outside to the inside, from the association of power names with individual people to their association with the sacred objects, from the world of the present to the world of the ancestral past. Often this involves no more than a subtle shift of reference; the form remains the same, the same word signifies person and ancestor. From the Yolngu perspective, that move to the inside is seen as a move toward ancestral power, yet ironically that power can be seen in many ways to originate on the outside in the memories of relatives and in the politics of ownership. These things are present in the particularistic meanings of ceremonies, but end up ultimately as sedimented layers of the inside. The inside, the world of the ancestral beings, gets its power from the outside, the world of people. Ancestral power is, in part, though I must emphasize only *in part,* a reflection of the human use of that power, the human need for that power and human battles to control it, all projected onto another dimension.

Sociological Meaning

Paintings have a sociological meaning in an abstract sense that is analogous to their denotative, iconographic meaning as signs of ancestral events. Yolngu paintings, as I have shown, are the property of clans and are associated with particular tracts of a clan's territory (Morphy 1988). As such, they denote the clan and its land. This is reflected in the form of the painting since each complex painting has on it a design indicating the clan to which it belongs (clan designs are discussed fully in chap. 8). The clan ownership of paintings is relevant in many ways to their use in ritual.

Because Yolngu rituals are organized in part on the basis of kinship and clan organization, the fact that a painting belongs to a particular clan is often in itself a major factor involved in its selection for use in ritual. For example, the shark painting that was so appropriately integrated within the thematic structure of the Marrakulu woman's burial ceremony was selected in part because it belonged to her MM[B]'s clan. As we have seen, the MM[B]'s clan has a major responsibility in organizing a person's mortuary ritual and in ensuring that its own sa-

cred law is used to assist the birrimbirr on its spiritual journey. The use of the shark painting was therefore both a sign of the clan's willingness to carry out its obligation and part of the means whereby it was fulfilled. The decision to carry out a religious obligation, however, is always a political act: "It means we are in agreement." That is, relations among the clans involved are, for the duration of the ceremony at least, taken to be friendly.

In the Djungguwan ceremony this societal emphasis is a major theme in itself. The structure of the ceremony emphasizes the way in which paintings, and the mardayin more generally, have a significance that extends beyond the clan and involve interests that operate at a quite different level, though one that articulates with clan organization.

Although the ceremony is owned by one particular Dhuwa moiety clan set, the ceremony is performed on behalf of all the clans present and involves the participation of clans of both moieties on a regional basis. The ceremony is owned by clans associated with the Wawilak sisters mythology, which in Yirrkala consists primarily of two clans, the Marrakulu and the Rirratjingu. Other clans which owned the ceremony, notably the Marrangu, have recently become extinct in the male line, though their mardayin are used in the ceremony.

Although the majority of the paintings used in the ceremony belong to the Rirratjingu, Marrakulu, and Marrangu clans, other clans' mardayin may be involved in the ceremony in a number of ways. Some of the dances performed are owned by the Yirritja moiety, and paintings belonging to clans of both moieties will be produced on the boys who are to be circumcised at a Djungguwan. The boys' chests are always painted with a design of their own moiety, usually belonging to their actual MM[B]'s clan. Wangarr spirits belonging to both moieties are believed to be present at the ceremony and can enter people of the moiety to which they belong. The emphasis in the ceremony is on sharing the power of the wangarr ancestors among all the people present and on freeing the community from pollution. The action of blowing the drone pipe over the assembled company should be interpreted in this way.

Although the power of the ceremony is effective at a communal level, members of the two moieties have very different roles in the ceremony. The major distinction at the moiety level is between "owners" and "managers" or "workers." The owners are members of the Dhuwa moiety clan set linked by the Wawilak sisters, and the managers are members of the opposite moiety who are ZS (waku) to the owners. The ZS role is primarily that of worker for one's mother's group, though senior ZSs also have a decision-making role and are consulted before

the commencement of each phase of the ceremony. In the Djungguwan at Gurka'wuy, the senior ZS oversaw the production of every painting, initiating most of them himself, and marked out the shape of the ceremonial ground. Indeed, the ceremony can take place only with the agreement of senior ZS, and in their presence. Thus the success of the ceremony depends on the cooperation of members of both moieties. The structure of the relationship between the set of ZSs and the M[B] clan set emphasizes the communal as opposed to the clan-based aspect of the ceremony. As I have shown (Morphy 1978), the ZS form a group that crosscuts the clan organization of their own moiety, and the ZS set is formed in relation to a set of clans of the opposite moiety linked by the same mythological track. The owner-manager relationship also deemphasizes clan organization in another way—by emphasizing differences that operate at a moiety level, thus focusing attention on the relationship between moieties rather than clans.

The Djungguwan, however, also operates on a clan level. The display of paintings provides a context for instructing initiates into the clan ownership of paintings, and a Djungguwan held in Yirrkala was one of the few occasions on which I observed initiates being formally instructed in such matters. The ceremony can also be used to incorporate someone as a member of a clan by showing him where his rights in mardayin lie (see Morphy 1988).

Many implicit sociological meanings can be inferred from the use of paintings in ritual. These are connected with the ownership and change of ownership of paintings and land and the ways in which clans are allied. The use of paintings may also, in certain circumstances, signify the affiliation of individuals to a particular clan or set of clans. Although such meanings are not specifically encoded in the paintings themselves, they arise in part because the design system as a whole encodes the relationship between clans and because the relationship between clan, ancestral being, and land is acted out in ritual (see Morphy 1984).

The use of a painting or any other component of a clan's mardayin in ritual involves exercising rights in paintings and indeed is an assertion of those rights in a public arena. If a clan is unable to use its mardayin because its members lack sufficient knowledge of it or authority over it, then the lack of control they have over their own resources is dramatized (Keen 1988:286 ff.). In organizing ceremonies they will be dependent on other clans, and they will be unable to fulfill their ritual obligations to other clans by using their mardayin on others' behalf. The converse is the use of knowledge of other clans' paintings to make claim to their resources. The use by a strong clan of the mardayin of an extinct or near-extinct clan can, if it goes unchallenged, result in the de

facto recognition of that clan's right to take over the extinct clan's territory (Keen 1988; Morphy 1988).

The relationship between people and paintings (and other aspects of the mardayin) is thus acted out, produced, and established through ritual performance. As Keen (1988:291) has argued following Gregory (1982), Yolngu religious property is personified: "The connection between the thing and the holder was regarded as a causal one. The causal nexus that entitles a holder of religious property is the creation of persons, powers, places and ceremonies by the ancestral Spirit beings, and the chains of connection that link the living to the *wangarr*." The final links in this chain are the ones that are most recently created and validated through ritual, where religious property is produced and rights in it asserted, where indeed the sacred law (mardayin) is made indexical of clan.

The ownership of the mardayin can be one of the most secret as well as one of the most public of all subjects. It may be secret because it concerns things that are highly restricted, such as many of the rangga themselves. However, it is in the political arena that we see the relativity of secrecy and the fact that the designation of something as inside knowledge frequently has nothing to do with the intrinsic properties of the thing itself. The ownership of the mardayin is implicit in their use in ritual, and ritual provides the contexts in which individuals and social groups can publicly display their ritual property and assert their connection with the ancestral past through songs, dances, and paintings. But when there is a dispute over the ownership of those things or when there has been a failure to pass on the mardayin to the next generation of the owning group, then both the ownership, for example, of a set of songs and/or the songs themselves can become matters of the inside. Sometimes they have been deliberately withheld in order to ensure the domination of one group over another; sometimes they are withheld because agreement has not been reached as to who owns them or who holds the final link in the chain. In this way an earlier generation's "public" (*garma*) songs can become secret if someone is in a position to withhold them by not singing them in public and thereby not passing them on to a new generation of clan members. As a category of songs they remain *garma* and outside; as information they are restricted and inside.

The public acknowledgment of the ownership of religious property, its designation as the mardayin of a particular clan, is one part of the process of personification. Complementary to this is the subjective experience of the mardayin by individuals and their identification with a particular set of ancestral beings (see Keen 1988:291). Through spirit conception, through paintings and ritual action, through identifica-

tion with the landscape as an embodiment of ancestral actions, individuals are linked directly with the ancestral beings, bypassing Keen's chain of connection. Individual identity involves the person's absorption in the distal links of the chain of connection with the ancestral past, the ones that issued from ancestral action to become signs and aspects of their continuing existence and that are the reference of the iconographic meanings of the paintings and other mardayin. In some respects, ancestral past and concept of self are interrelated, since people are always in the process of becoming ancestors. In life the Yolngu "follow the way" of the ancestors, trace their footsteps (*luku*) (Keen 1978:45), and eventually on their death are transformed back into the wangarr of their clan (see Williams and Mununggurr 1989:79). The social designation of ancestral connection is, however, an important factor in that in times of dispute it may cut across an individual's experience or limit it. This can happen when an individual's clan is changed through the absorption of the rump of one clan by another (Morphy 1988) or when people are denied access to their mardayin by members of the group witholding information. In a sense, denying people access to their songs denies them access to their ancestral identity.

Conclusion

Paintings function in ceremonies to provide a locus of wangarr power. They have the advantage of flexibility and durability; they may be painted directly onto an individual's body and so bring the person into direct contact with the *mali* (shade) of the wangarr beings, or they may be painted on objects and in this form last beyond the duration of the ceremony. The fact that they encode the relationship between place and the actions of wangarr beings enables them to be integrated within the structure of ceremonies as a whole and to act as a suitable medium for symbolically transmitting wangarr power through space and time. However, the relationship between paintings and wangarr power (maarr) is a complex one. It must be seen in terms of the existence of different refractions or conceptualizations of wangarr power and also in terms of different means of objectifying or directing that power.

The source of maarr is in all cases the same—the wangarr beings. The shades (*mali*) of the wangarr, spirit children, the birrimbirr spirit, and the strengthening power of the *dhumarr* trumpet represent different conceptualizations of maarr operating at different levels of specificity. Ceremonial performances are articulated around several different objectifications of wangarr power: paintings, sacred objects, power names, and natural symbols such as blood and land forms. In the context of different ceremonies, different conceptualizations are

focused on, although the relationship between these conceptualizations is always recognized. In burial ceremonies, for example, the main emphasis is on the birrimbirr spirit, the refraction of ancestral power most closely associated with actual human beings. The songs, paintings, and power names are all organized with the objective of guiding the birrimbirr spirit back to its clan territory. The Djungguwan, on the other hand, is primarily concerned with a more generalized conceptualization of maarr, although the memorializing aspects are concerned with a refraction of ancestral power which is similar to the birrimbirr spirit.

The different material manifestations of ancestral power, which are objectifications of the wangarr beings, have different physical properties, act on different senses, and can be used separately or in combination with one another to transfer maarr and to endow objects and people with it. In Dungguwan ceremonies, a number of different manifestations of the wangarr beings are produced, all of which are endowed with maarr: the paintings, the djuwany posts, the trumpet and the sound it makes, the power names called out at various stages, the dances on the men's ground, and the blood of the initiated men. The different manifestations can be combined in a number of ways in sequences of concentrated action.

In the Dungguwan the trumpet is blown over the paintings and the power names are incanted above them, reinforcing the spiritual power of the paintings. The paintings, the power names, and the trumpet have different potentialities as means of contacting the wangarr beings. The paintings have the advantage of direct contact with the surface of the object on which they are produced. They are also lasting. The trumpet, too, is durable, but it transmits maarr through sound rather than through bodily contact. Its sound is imminent yet transient. The trumpet, however, has the advantage of great flexibility: it can be directed toward and blown over all the objects in the ceremony; it can be focused on individuals or blown over the assembled company. The power names are of short duration, and their impact must be immediate. However, they have very specific connotations: they recall the names of the dead, and they relate the abstract power to known individuals who are the human dimension of the wangarr (see also Warner 1958:280). Yet the power names also relate to a more general refraction of the wangarr ancestors, as names of the wangarr beings incarnate in the rangga (sacred objects).

The manifestations of the wangarr operate at three main levels: the level of the individual, the clan, and the society. The power names have the most individual connotations and the sound of the trumpet the most general, but used in combination in the performance of cere-

monies, the focus of each can be generalized or specified according to context. The trumpet, for example, can be blown over the painting being produced on a person's body, thereby individualizing its reference. On the other hand, the power names, when shouted out over the rangga, are oriented toward the generalized power of the wangarr being concerned. Paintings are intermediary between the individual and the society, operating primarily at the level of clan. However, in operating at the level of clan they function to bind an individual to his or her clan and to designate the relationship between the clan members and the wangarr beings whose power extends beyond the membership of the clan.

Blowing the trumpet over the paintings and incanting the power names are means of concentrating and directing wangarr power. As a whole, these actions provide a variety of sense experience which at one level all have the same significance. At other levels these experiences provide tangible expression of the different refractions of ancestral power.

I have argued that the meaning of paintings in the context of ceremonies is highly complex. Ceremony is one of the contexts in which meaning is both created and released. Paintings have meanings independent of any ceremonial context, through the set of iconographic and sociological meanings encoded in them. They also have existing sets of connotations associated with their past use in ceremonies, either through their association with particular individuals or through the ceremonial or societal themes that they have been integrated with as a means of expression. These past associations may be institutionalized through the conventional use of a particular mardayin or complex of ritual elements (songs, paintings, or dances) at a particular stage of a ceremony or for the performance of a particular religious event (e.g., the burial of a coffin). On the other hand, the associations between iconographic meaning and potential theme may consist of potential connotations that something could have and the potential appropriateness of the mardayin for the particular purpose. In either case it is the use of the paintings in context that releases the meanings into an arena of discourse where they are passed on to new generations. Ideologically such a release is always presented as the conventional way of doing things, as following in the footsteps of the ancestors. In reality it may involve the creation of new meanings as the connotations of a ritual element change through its use in a new context. Even in the case of denotative meanings such changes must occur. Over time, the words of songs and the form of designs are in many cases going to be linked to "new" ancestral origins. In one Yirritja moiety song cycle, in the course of the last two hundred years, first

the Macassans were incorporated as the referents of songs, then ancestral missionaries, and finally grader and bulldozer operators. In other cases, designs have been exchanged between clans and the "new" paintings have been quickly integrated within the new owner's landscape. And over time, as clans rise and fall, come together and divide, the indexical meaning of designs changes as they become associated with new groups.

Much of this process of change is masked by the structure of the inside : outside system of knowledge. The productivity of the artistic system in part creates the multiple layers of meaning that end up as the continuum of inside-outside knowledge, yet simultaneously the structure of the system of knowledge allows things to be buried. If one group takes over another group's designs and the transfer of ownership is agreed to by others, then the original ownership is never referred to in public and the connection with the previous clan is apparently forgotten. Yet if doubt exists as to the legitimacy of the transfer, individuals may be heard to infer darkly that "on the inside it really belongs to so-and-so."

The artistic system, operating in the context of the system of restricted knowledge, can both generate new meanings or ways of expressing meanings appropriate to context and hide old meanings or associations. Both these properties of the system can function to create a sense of the power of ancestral beings through enhancing or adding to the value of the objects that represent them. The productivity of the artistic system as a resource for creating and expressing meanings appropriate to ceremonial context and theme as well as to political circumstance, and the system's function of enabling new meanings to be revealed to individuals going through the process of initiation, provides a source of real power to the ritual elements (the mardayin). In addition, the sedimentation of political history as inside knowledge and the absorption of memories of the deceased in the names of sacred objects (on the inside) also provide a source of energy for the ancestral past.

8

The Components of Yolngu Art

Early on in my research into Yolngu art I rigorously pursued the question of what the art meant. My conversation with Yolngu artists was continuously punctuated with the phrase, "And what does it mean?" I would not be satisfied with a general answer, but sought the particular, asking the same question of each element in turn. My questioning must at times have seemed a little tiresome. My friend Narritjin Maymuru decided that there must be a time for questions and a time for work—his work, not mine. He was happy to answer my questions as long as I did not interrupt him while he was painting, because when he was painting, time was money. Of course there are seldom absolute rules in the discourse between friends, and as our relationship developed he would at times be happy to break off his work and talk, or talk while he continued his work. But I had learned my lesson, and he had asserted the value of his painting. So I spent many hours sitting in the shade of the veranda of his cliff-top house watching him paint and listening to the sea.

Of course at first this imposed restraint left me bursting with questions at the end of an

142

hour, and when Narritjin paused for a rest they would all come flood-
ing out. "And what does it mean? And what does it mean? And what
does it mean?" I remember one day early on, perhaps after a particu-
larly furious barrage of questions from me, the focus narrowed down
to one small area of a painting which consisted of a pattern of red and
black dots. " Well," said Narritjin, "it means blood and maggots, sand
and worms, itchy red spots and rotten flesh," and then he turned to
me with a smile and carried on: "One small dot, too many mean-
ings."

Soon I got used to the role of being the anthropologist on the Ab-
original veranda and began to make more of my opportunity of sitting
in the shade and watching someone else work. I began to enjoy my
work and relax into it, and to reflect on the painting that developed
slowly before my eyes. And the key questions I asked, at least to my-
self, began to change from What does it mean? to How does it mean?
As Guss (1989:91) writes, "Ultimately the real question is not what art
means but how." How does one small dot mean all these things and in
what sense does it mean any of them? And questions like these were
very much questions that I had to answer myself, as they are not ones
for which people have a ready-made answer. The way I set about an-
swering the question of "the how of meaning" was essentially
Saussurian, though perhaps I had better qualify this by saying that it
involved my concept of de Saussure's sign, for many recent critiques
of Saussurian semiotics seem to be concerned with a quite different
concept.

The central idea behind the Saussurian sign is that it consists of two
components, the signifier and the signified, each of which has an inde-
pendent existence in its respective system of similarity and difference.
The sign is the coming together of the elements from these two systems
of difference; it is not the representation of an object that exists in the
world outside. From a Saussurian perspective, the object comes into
being through its encoding in a sign system and can then be used in
communication by others who know the code. There is, of course, no
limit to the number of codes that an object may be encoded in, but in
each case it involves a conjunction between two different systems of
similarity and difference. This can be seen as the coming into being of a
different object in each case, or more realistically, since human beings
are brought up to make cross-references among codes, it provides a
different perspective on, or a different understanding of, the same ob-
ject. The Saussurian way of phrasing this is to say that the value of the
object depends on the particular sign system it is encoded in.

The importance of this Saussurian perspective to the anthropology
of art is twofold. The first is that it does not give priority to verbal lan-

guage over other systems of communication, but allows other systems an equally independent role in the encoding and transmission of objects and ideas. Second, it allows for the fact that different sign systems, by encoding things in different ways, may encode different things (or the same things with different values) and may have different communicative potentials. It is not possible to say the same thing in every code, partly because some codes have limited purposes and limited possibilities, but more generally because different codes have different properties and encode different things in different ways. The existence of multiple codes is one of the factors that provides for dynamism in human thought; it creates variation and alternative perspectives or values and through that process the possibility of encoding new ideas and objects. The sign systems available provide the limits of what it is possible at any one time to communicate but do not determine the limits of thought. The signifieds, what is thinkable, cannot be reduced to what is already encoded in the various systems, even though in order to be communicated to others they must be attached to signifiers and hence be encoded in a shared sign system. This apparent paradox lies at the heart of Saussurian semiotics and is only resolved when individual sign systems are seen as part of a continual process of semiosis in which new ways of communicating thoughts are continually being created by individuals seeking wider understanding of their ideas. The search for a medium to communicate a message, for a new conjunction of a set of signifiers with a set of signifieds, lies at the heart of much artistic and technological creativity—the discovering of ways to say what had previously been unsayable.

In this section I show how meaning is encoded in Yolngu art, which I see as a necessary prerequisite to asking what Yolngu art means. Indeed this question is in many ways a nonquestion. It is a little like asking, in general terms, What does the Yolngu language mean? The answer is that it depends on the particular sentences used and the context of their use. In learning what a verbal language can be used to mean, we have to understand first how it means; we have to learn its vocabulary, its grammar, and the pragmatics of its use. It is an analogous process that I am concerned with in this chapter. By first understanding how Yolngu art encodes meaning, we gain insights into why it is used in the way it is and what it means in particular cases. Of course what it means in the context of its use is not wholly dependent on what is encoded. We saw in the case of the shark painting in the Marrakulu woman's burial ceremony that its particular connotations were influenced by the ritual context in which it occurred and by the dances that were performed. An analysis of how something is encoded in a particular system is never going to explain its meaning fully, as this

involves wider questions of the way it is encoded in other systems, the individual's knowledge and position, and the context of its use. Nevertheless, it is a prerequisite for understanding the particular system concerned and how it relates to the whole.

It should be clear by now that in analyzing Yolngu art as a code, I do so knowing that the individual sign can only be understood as part of a system, that the operation of the system depends on pragmatic factors, and that the meaning of the sign—the relation between signifier and signified—is not in any ultimate sense fixed for all time but is something that has to be continually re-created. The great issues of semiology concern how the meaning of the sign is fixed for a time and the extent to which in certain cases it remains unfixed: how and to what extent the signifier and signified come together. I also acknowledge that the meaning of the sign varies according to the context of interpretation, the identity of the interpreter, and the information or key to the code that the interpreter already has. But I do not find it helpful to add a Peircean interpretant to the two-part Saussurian sign, for while acknowledging that the factors represented by the interpretant have to be part of the analysis of any semantic system, my feeling is that such factors are better bracketed off as part of the system of interpretation and communication rather than incorporated as a component of the sign.[1] The addition of the interpretant privileges in-

1. Peirce's interpretant is a useful and complex concept which integrates the sign within a theory of meaning that sees meaning being produced by a process of semiosis. The Peircean sign is tripartite, consisting of a signifier, a signified (object), and an interpretant. The interpretant, as Eco argues, is a mediating representation that is used to define the object (signified). Logically, however, the interpretant is also a component of another sign that enables it to act as a representation that bears on the meaning of the object. In this way the sign becomes linked in an interconnected chain of signs: "The interpretant is nothing but another representation to which the torch of truth is handed along; and as a representation, it has its interpretant again. Lo, another infinite series" (1976:1464). The concept of the interpretant has the advantage of formulating the sign in such a way that it is integrated within semiological process. It enables the sign to be approached from a diachronic perspective which sees meaning as fixed or created by the use of signs in context, with reference to past uses of the same signs and whatever body of information an individual brings to bear on the interpretative process. This dynamic component of the sign is why some people (e.g., Myers 1988:592) prefer the Peircean concept to that of Saussure (though Barthes 1972, for example, develops a similar concept working within the framework of Saussurian semiotics). While I largely agree with the perspective adopted by Myers, which stresses signification as a creative process (Myers 1988:604), I do not think the notion of the interpretant is a useful one, though what it represents (signs as part of a dynamic process, the problematic nature of the object) is something that must be taken into account in any theory of meaning. To me Peirce's addition of the interpretant to the sign is the result of expecting the sign to do too much, attempting to contain within its structure a whole theory of meaning rather than placing the sign within the context of a theory of meaning. What Peirce is really directing

Table 8.1 The Components of Yolngu Paintings

Component Types	Components
Ground and boundary components	1. ground
	2. border
Area subdivisions	3. dividing lines
	4. feature blocks
Representational systems	5. figurative
	6. geometric
	7. clan designs
Cross-hatching	8. cross-hatching

terpretation over production by making it part of structure rather than something structure takes into account and is affected by.

The Components of Paintings

Yolngu paintings are made up from a number of components. They are components in one of two senses; either being separate stages in the production of a painting, for example, the ground color, or separate components of the finished painting, for example, figurative representations. In the majority of cases, they will be both. The components are illustrated in table 8.1 and figure 8.1.

No word in Yolngu languages applies specifically to any of these components, yet I believe they are cognitively significant and culturally recognized. My grounds for this belief are that (1) In English, the distinction between the components is recognized by the application of different labels. (2) They correspond to different stages in the production of a painting, that is, one component is prior to the others in that it is usually completed before going on to the next. In some cases, for example, the painting of the ground color, the component represents a stage that has to be completed before the painting can be continued. (3) The production of the components involves activities which, in relation to the training of artists and the division of labor, are separated out by time, status, and sex. And (4), in some cases the components represent different semiological systems which are recognized as functionally distinct by the Yolngu.

Although in some respects the components may appear to be at dif-

attention toward is the development of a theory of the signified as something that is produced; it is in this respect that Eco (1976:1459) re-creates a bipartite sign out of Peirce's tripartite one by arguing that "the Peircean notion of interpretant reabsorbs the Peircean notion of the object of a sign."

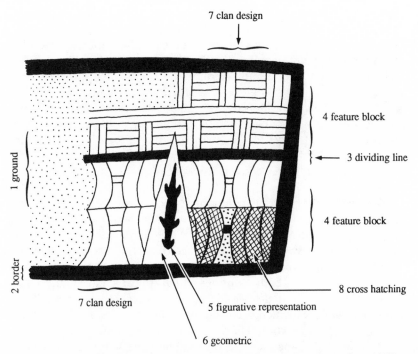

Figure 8.1 The components of a painting (after a Marrakulu clan painting by Mithili). The triangular geometric figure represents the molk ceremonial ground (see chap. 5), and also the river at Marnbalala. A water goanna (*wan'kawu*) is shown inside the triangle. The upper clan design signifies fresh water. The lower one represents rocky country inland from Marnbalala.

ferent levels—the base color, for example, being the ground for both figurative and geometric representations—in other respects they are not. Three of the components—ground color and figurative and geometric representations—can occur separately as body painting types, and overall it is the particular combination of components that differentiates paintings used in some contexts from those used in other contexts. These different categories of paintings are discussed in a later chapter.

The importance of distinguishing components extends beyond classification, however, because the particular componential structure of a painting affects both its aesthetic effect and the particular kind of message it can communicate. The components interact to produce the communicative code of Yolngu art, and, moreover, the different ways in which they are combined produce an additional level of signification.

Ground Color

Ground color is the base color painted over the entire surface of a painting. The paintings with the simplest formal structure are those which consist only of ground color, where the painted surface is covered uniformly in a single color. Single-color paintings form the majority of *miny'tji* produced at Yirrkala. Their most frequent occurrence is as body paintings, though virtually any object, from plastic bags to Toyotas to trees, can be painted with red ocher in certain circumstances. White and red are the most frequent colors used for single-color paintings. Yellow is used occasionally, but black is never used.

Ground color is the only component to occur singly as a completed painting. All other Yolngu paintings consist of combinations of two or more components, and in all the cases I have recorded, one of those components is invariably the ground color. In the case of these compound paintings, the ground color is usually red. Thomson photographed a number of body paintings which appear to have white as the ground color, with single color designs in red painted on them. These were all paintings which occurred in public contexts. I refer to them briefly in the next section. The only paintings I saw on a white ground were yellow V-shaped designs on the chests of people in mourning who had previously been painted in white.

The initial component in the production of virtually all Yolngu composite paintings on any surface is the uniform red ground color. I was never able to elicit any specific meanings for red as ground color. When asked, people would simply say that it prepared the surface for painting, although some artists also provided the technico-aesthetic explanation that it made the painting stand out.

However, there are clearly semantic and symbolic reasons why red is most frequently used as ground color. Red ocher is thought to be the transformation of ancestral blood: it is the sacramental color. Red body paintings are explicitly stated to represent ancestral blood. Red is thought to be ritually powerful and a color that establishes contact with the sacred. For this reason red is never painted on people if they are in a state of spiritual danger from pollution, illness, or bereavement. Thus in general the red base of a painting signifies ancestral blood and is a sign of the transformation of a surface from a mundane or ordinary state to an ancestral state. More specific references may be sung into the painting when it is produced in a ritual context. I referred to these meanings in a previous chapter as reflectional meanings. For example, in mortuary rituals, when a coffin painting is begun, people may sing in turn a series of red ocher sources that lie on the route of the

spirit's journey. In referring to the red ocher, they refer to the ancestral power that underlies it and for that moment give a particular connotation to the red paint on the coffin lid. It is thus possible to distinguish between the structural significance of the base, that is, the fact that it constitutes the first stage of a painting and that it initiates songs which embed the painting in the context of a ceremony, and its specific reference which depends on the particular ceremonial context in which it is embedded.

The painting of the base may take place some time before the remainder of the painting. For example, on one occasion the base of two ceremonial poles was completed a week before the next stage was begun. Analogous to this (again demonstrating the way in which the base can be separated out from the rest of the painting) is the fact that in the weeks prior to circumcision, a boy's body is painted on three occasions: the first time his face and chest are painted in red ocher, the second time his face is painted with an elaborate painting and his chest red-ochered, and on the final occasion, immediately before he is circumcised, his face and chest are painted with composite designs over a red-ocher base. Again the explanation given for this procedure was a pragmatic one: "It gets the boys used to the idea of being painted." Later on I argue that this is not the only explanation for this repetitive red-ochering and painting.

The base color does not interact with other components of the painting in that it is never referred to in the context of their interpretation. In the completed painting the red base is usually largely obscured by the components that overlie it, though the fact that the base color is red considerably affects the visual impact of the painting. Red is left as the color between the crosshatched infill. Logically it must affect the order of crosshatching. Red cross-hatching can never be applied first, since in order to show it must cut across lines of another color. A simple point, but one that affects the formal appearance of the painting.

The only occasion when red ground is given specific meanings is when it forms the base ground color of a superimposed component like a clan design. In this case the red is almost invariably repainted, and in any case its signifying function only operates in the context of the particular design.

The Border

At the time of contact, only paintings which had clan designs as a component generally had an outline border. Today virtually every painting has a border. The border is the first component painted after the ground; it defines the area of the subsequent painting.

The border is always yellow and is never attributed any meaning. It

is frequently repainted several times during the completion of a painting. Border as a component is dependent on the overall shape of the painting: it is a formal feature that does not signify separately. The same considerations apply to dividing lines, which therefore I consider in the context of feature blocks, of which they are a dependent component.

Feature Blocks

Feature blocks reflect, or are the surface manifestation of, an important generative and organizational component of the artistic system which I introduce later as the *template* of a set of paintings. Feature blocks are segments of a painting whose content has a unity not shared with other segments of the painting. They are frequently differentiated from one another by differences in the background pattern and figurative content, in addition to being separated by a dividing line or a dividing feature. Each feature block represents either a separate area of land or a separate mythological event, or both. The major feature blocks of a painting are usually delineated immediately after the border has been painted, thus setting the structure of the completed painting.

The Representational Systems

Two main representational systems are employed in Yolngu art: these I term *figurative* and *geometric*, respectively. For reasons that I go into later, the geometric system can be divided into two subsystems—geometric designs which are clan designs and those which are not. By a representation I mean simply a signifying element which represents or stands for a particular signified. All representations are signs in the Saussurian sense discussed in the beginning of this chapter.

The figurative and geometric systems have very different properties in that they encode meaning in different ways and have different signifying potentials. Moreover, each system can be considered in certain respects discrete vis-à-vis the others. The basic elements of each system must initially be analyzed in terms of the ways in which they contrast with one another and interact among themselves, before it is possible to appreciate how the representational systems interact with one another as component subsystems of a single artistic code.

The system of figurative representation consists of a set of iconically motivated signs. I use "iconically motivated" in the same sense it is employed by Humphrey (1973) and Munn (1973:87), to mean that there is a degree of formal similarity between the signifier and signified. In this case it is assumed that the figurative representation is the result of the selection and organization of graphic elements with reference to the shape of the object represented. Figurative representations

also fit, at least in some respects, Munn's (1966:937) definition of a continuous meaning system. Munn defines this system as one in which there is continuous variation between a set of signifiers and a set of signifieds such that each signifier represents only one meaning and each new meaning necessitates the innovation, at least as far as the particular system is concerned, of a signifying form which differentiates it from other signifiers within the system. Munn (1966) uses Yolngu figurative representations as her main example of such a system, and it is certainly the case that in a given context an artist intends the representation to signify unambiguously a single meaning. However, I argue that in many cases, the schema of Yolngu art are ambiguous in that morphologically the same signifier encodes more than one meaning.

The geometric system of representation consists of geometric elements, which occur either separately or organized into patterns. In contrast to the figurative system, there is a relatively arbitrary relationship between signifier and signified within the system. Although iconicity is certainly a factor influencing the relationship between signifiers and signifieds within the geometric art, it is not the main factor in the encoding of meaning in the signs, nor is it the primary factor in their interpretation. As the analysis progresses it will become obvious why at this stage I stress the differences between the systems, since it is the differences that are significant in understanding the ways in which the systems are used in the art.

Although for analytic purposes the component systems can be isolated, they are all parts of the same communicative code, Yolngu art. I mean this in two senses. First, in the majority of paintings, elements of both systems of representation occur together and interact. The meaning of elements of one system may be affected by their relationship with elements of the other system with which they are combined.

Second, even in cases where a painting consists exclusively of elements of a single representational system (i.e., it is all figurative or all geometric), then the significance of that painting can only be understood in terms of its relationship with paintings which exhibit a different componential structure. The Yolngu recognize the differing signifying potentials of the two systems and utilize these as components of the code as a whole to construct paintings which encode meanings in different ways in different contexts. From different perspectives, the representational systems can be seen as operating independent from one another, or interacting with one another, or in contrast to one another.

Cross-hatching, the final component, is discussed in the context of each representational system as well as subsequently in its own right.

Cross-hatching is employed as a distinctive feature of the geometric system and occasionally occurs in the context of figurative representations. When it occurs in the context of other systems of representation, it is a dependent feature of them.

Figurative Representations

Figurative representations are iconically motivated representations of objects of the human and natural environments. The representation is intended to "look like" the object represented and to be interpreted as such by those familiar with the iconographic code.

In all cases I recorded, the intention of the artist was to produce a representation of a single object, and there was no deliberate attempt to produce ambiguous forms. Occasionally artists represent objects for which there are no naturally occurring models, for example, mythical beings half human and half animal in shape (see, e.g., Kupka 1965:95), or the spirit familiars of *marrnggitj,* healers or "native doctors" (see Thomson 1961, pl. 1). In this case the "look like" criteria must be read as "is an acceptable representation of."

In the majority of cases, figurative representations signify familiar things, and their referential meaning is intended to be available to all interpreters. Indeed it is argued later that figurative representations are used in public art with the explicit purpose of reducing ambiguity and fixing the interpretation of a painting in a particular way. This does not mean that a figurative representation is fully explained in terms of its most accessible and immediate referential meaning, rather that recognition and knowledge of that meaning are an implicit part of any further connotations it may have; it is a first stage in interpreting it and a stage that is open to all. The shark in the painting on the Marrakulu woman's coffin lid, for example, had connotations in the context of her burial ceremony that contributed to the meaning of the image of the shark, connecting it to the journey of the woman's soul. The form of the shark also encoded references to meanings that may not be widely shared, that require access to esoteric knowledge; the reference of the shark's tooth to trees in the landscape at Warndawuy could be an example. None of this, however, alters the fact that the figurative representation of the shark is intended to be interpreted as such by all who see it, and indeed its interpretation as a shark is a prerequisite for any other meanings.

Yolngu artists sometimes criticize other people's figures on the basis of whether or not they look like the intended object. Thus Durndiwuy commented favorably on Welwi's catfish: "That really looks just like a catfish," and Marrkarakara commented adversely on Mithinarri's human figures: "They look like ants or some kind of insect." Indeed

Figure 8.2 Marrkarakara's boat (after a sand drawing by Marrkarakara, Dhaapuyngu clan).

Figure 8.3 The front seat of the boat (after a sand drawing by Marrkarakara).

Marrkarakara at times adopted a Gombrich-like stance to the problems of representing reality. He drew me the outline of a boat in the sand. The boat was drawn in profile, and in order to represent the seats he drew them vertically down the side (see fig. 8.2). This in fact is the normal schema employed by Yolngu artists for representing dugout canoes and clearly combines two perspectives—plan and profile. Marrkarakara apologized for drawing it "wrong" but explained that one could not draw the top and bottom views at the same time without one view looking wrong. Interestingly enough, it was only the front seat he saw as distorted. He drew another view of the seat (fig. 8.3) and said, "It really looks like this."

Yolngu use different criteria to criticize figurative representations than those they employ to criticize the way other components of a painting have been produced. Indeed people rarely criticize publicly other aspects of a painting. When they do make critical comments, it is usually to show how a painting deviates from an established ancestral pattern. The painting is said to be wrong because it is not as the old people used to do it or because it is not the way the artist was taught to do it. In such cases, especially if the critic is a senior man, the criticism is not a subject for debate, but a dictum to be followed. Examples are given when I discuss clan designs, but suffice it to say at this stage that the object of such criticism is to assert that a particular established way of doing a part of the painting is correct and that the way it has been done is incorrect. In this context, to state that some aspect of a painting is "new" implies criticism of it.

The case of figurative representations is somewhat different. The figurative component of a painting can be criticized for not following an established pattern if, for example, certain figures are included which should not have been and vice versa. However, I have never heard the form of a figurative representation criticized because it was not done as in the past. The main tenor of criticism is always that the representation does not look like its object. Furthermore, young people claim to draw figures better than members of the senior generation: "I draw

better than my father because I learned at school" (Warrpandiya); "This is my *mokuy* (ghost figure), I did it first at school" (Lumaluma). Consistent with this is the fact that figurative representations are one of the first components after the base and crosshatched infill that young people are encouraged to draw. Mutitjpuy and Liyawulumu both allowed their daughters to paint some of the figurative representations in their paintings.

However, it would be wrong to overemphasize innovation and variation. The examples cited in the preceding paragraph all concern paintings produced for sale to Europeans. Even in this context the majority of artists paint their own figures and encourage their children to paint them in a similar way. Moreover, there are likely to be strict constraints on variation in the form of figurative representations which occur in paintings produced primarily in closed ceremonial contexts, and in some cases details of the form of the figures are perceived as fixed components of ancestral designs. For example, the representation of goannas on either side of a hollow log is an important painting used in the Djungguwan ceremony. In this case the angles of the tails, the shellfish in their mouths, and the dotted pattern on the backs of the goannas are all fixed components of the representation, and signify a series of mythological and topographical referents. Initiates are instructed as to the correct way to produce this schema while the painting is being produced in the seclusion of the men's ceremonial ground. The schema is quite different from that normally employed for water goanna in the context of other paintings. When I saw this body painting being done at the Djungguwan ceremony at Trial Bay, the artist was receiving continual instruction and guidance from senior Marrakulu (the owning clan) members present. In the end he gave up, having made several unsuccessful attempts to satisfy the onlookers' requirements. However, there are relatively few schema of this type in Yolngu sacred art, mainly because the figurative component of the sacred art is greatly reduced.

In the majority of cases an artist employs a set schema for representing a particular content, and he uses the same schema on every occasion he represents the same thing. I cannot here discuss in detail morphological aspects of the system of figurative representation and will not attempt to outline the overall set of schema employed by Yolngu artists. However, I consider the extent to which figurative representations convey meaning independent of other components of a painting. This is a necessary preliminary to understanding the communicative functions of the figurative representations in the artistic code as a whole.

In the context of completed paintings, the intended object represented by a figurative representation can be readily identified by a number of people other than the artist. Although people are reluctant to proffer detailed interpretations of paintings unless they have the right to do so, they willingly give the moiety, clan, and the identity of the figurative representations of any painting with which they are familiar. In the majority of cases, senior artists correctly identify the clan ownership of a painting belonging to their own moiety, and less frequently in the case of a painting of a clan belonging to the opposite moiety. Almost without exception, artists correctly identify the moiety to which a painting belongs (forgetting for the moment paintings innovated specifically for the tourist market, which may have no clan or moiety markers). As natural species are allocated on a moiety basis, and as Dhuwa and Yirritja paintings only include animals belonging to their own moiety, the correct identification of the moiety of a painting should greatly increase the chances of correctly identifying the meaning of the figurative representations. Similar considerations apply to the identification of the clan to which a painting belongs, as representations of species of the moiety are differentially distributed among the member clans' paintings.

In order to discover the extent to which figurative representations could be interpreted independent of the context of a painting as a whole, I selected a series of thirty-one figures from photographs of bark paintings I had previously collected and drew them on separate cards. The meaning of the figures had previously been recorded from the artists. I then obtained interpretations of the figures on each card from five people belonging to different clans, asking for the name of each species identified. A summary of the results of this test is set out in table 8.2. In the left-hand column, the species intended by the artist and the moiety to which it belongs are given.

The results overall were that in only 48 percent of cases were the figurative representations interpreted in the way the artist had intended in the context of the painting. Thus a given set of figurative representations was "correctly" identified in less than 50 percent of cases when seen out of context. Incorrect identifications, however, were not spread evenly throughout the set of items; some were interpreted correctly by all five respondents, others incorrectly by all five.

Three drawings of possums were included in the test, two from paintings by Bokarra and one from a painting by Narritjin. In all but one case the possums were identified as such. There is in fact a distinctive schema for a possum, which is characteristically represented with its tail curved upward (see fig. 8.4). The curved tail is not a feature

Table 8.2 The Identification of Figurative Representations

Item	Species	Moiety	% Correct Species
1	Possum	Y	100
2	Possum	Y	100
3	Possum	Y	80
4	Turtle sp.	Y	20
5	Turtle sp.	D	80
6	Blanket lizard	D	80
7	Blanket lizard	D	100
8	Sand goanna sp.	Y	0
9	Water goanna sp.	D	100
10	Crayfish sp.	Y	100
11	Stingray sp.	Y	100
12	Stingray sp.	Y	100
13	Bandicoot	Y	40
14	Dog	Y	25
15	Flying fox sp.	Y	0
16	Duck sp.	D	0
17	Duck sp.	D	0
18	Bird sp.	D	20
19	Bird sp.	Y	0
20	Bird sp.	D	66
21	Cicada	Y	0
22	Catfish sp.	D	75
23	Catfish sp.	D	100
24	Garfish	D	100
25	Fish sp.	Y	50
26	Fish sp.	Y	0
27	Fish sp.	Y	20
28	Fish sp.	Y	0
29	Fish sp.	D	0
30	Whale	Y	20
31	Fish sp.	D	0

of any other figurative representation, and since there is only one possum species in Northeast Arnhem Land, this should be sufficient to enable its identification.

In other cases, however, schema are clearly ambiguous. One reason is that two animals which are separately named and belong to different moieties may be represented in the artistic system by a single schema. In these cases had the representations used in the test been marked by a moiety indicator (e.g., a clan design), the correct interpretation would have been given in more cases. Thus Welwi's drawings of a duck (fig. 8.5), intended to be a Dhuwa moiety species, were always identified as a Yirritja duck (*muthali*), and Liyawulumu's Yirritja sand goanna (fig. 8.6b) was likewise identified as a Dhuwa goanna (fig.

Figure 8.4 Possum schema (after a drawing by Narritjin, Manggalili clan). This representation was item 1 in the test (see table 8.1).

Figure 8.5 Dhuwa moiety duck schema (after a painting by Welwi, Marrakulu-Dhurrurrnga clan). This was item 15 in the test (table 8.1).

Figure 8.6 Schemas for goannas. (*a*) A Dhuwa moiety water goanna (*djarrka*) (after a painting by Larrtjannga, Ngaymil clan), was item 9 in table 8.1. (*b*) A Yirritja moiety sand goanna (*biyay*) (after a painting by Liyawulumu, Gumatj 1 clan) was item 8 in table 8.1.

b

a

8.6a) (*djarrka* or *wan'kawu*, "water goanna"). In the context of paintings with clan designs, these species were always correctly identified.

The examples of the duck and the goannas suggest that the schema concerned are best seen as homonyms representing two species, one Dhuwa and one Yirritja, which are ambiguous unless interpreted in conjunction with other components of the painting. This is demonstrated most convincingly by other representations used in the test. Two representations of turtles were included—one Dhuwa (*dhalwartpu*), the other Yirritja (*guwarrtji*). In four cases the Dhuwa turtle was correctly identified, but in four out of five cases the Yirritja turtle

was also interpreted as *dhalwartpu*. In the latter case the artist, Maaw', himself interpreted the representation "wrongly."

Indeed, both representations of turtles were by Maaw', and it was quite clear that he employs a single schema for the two species of turtle—one Yirritja (fig. 8.7), the other Dhuwa (fig. 8.8). The painting from which the Yirritja moiety turtle (*guwarrtji*) was abstracted was from Maaw's mother's clan, Munyuku. The painting included a characteristic Munyuku clan design (fig. 8.7), and in the context of the painting as a whole, the turtle was always interpreted as *guwarrtji*. Maaw' was both a senior member of his own clan and the senior waku of his mother's clan. He was called upon most frequently to produce Munyuku paintings in ceremonial contexts, and he had a major responsibility in instructing younger Munyuku artists in their clan paintings. The fact that he did not employ separate schema in the Dhuwa and Yirritja cases, therefore, has added significance.

The level of ambiguity of a schema depends on a number of obvious factors at different levels: the number of "like" things extant in the environment, the distinctiveness of the features the schema encodes, and its familiarity as a representation. For example, there are far more representations of fish in Yolngu art than there are representations of any other single thing. Interpretations of the cards with fish on them are indeed the most varied; in several cases each interpreter specified a different species. However, in two cases all five people gave the same "correct" interpretation—catfish (*djurlarrpi*) (fig. 8.9) and garfish (*warrukay*) (fig. 8.10), respectively. In these cases the representations encoded characteristics of the fish which do not overlap with the distinguishing features of any other fish schema: in the case of the *djurlarrpi*, parallel lines at the mouth representing whiskers (see fig. 8.9); in the case of the *warrukay*, a long narrow jaw barbed with teeth.

When a particular schema encodes distinctive features intended to be characteristic of a particular species, it is inappropriate to include them in a representation of a different species. The best example of this that I recorded occurred at Gatji, an outstation ten miles inland from Milingimbi in the western part of the Yolngu-speaking area. Magani, a Mildjingi man in his seventies, began a painting belonging to his mother's clan (Djinang-Marrangu). The theme of the painting was the two water goannas and the hollow log rangga. Magani's outline of the goanna (fig. 8.11) was rejected by the three Djinang men present. The reason for this rejection was explicit: the figure looked too much like a crocodile, a Yirritja moiety species. I was told that Mangani should not have drawn the transverse lines across the body of the figure as this was the way one showed markings on the back of a crocodile. In the case of a goanna, only the backbone should be represented, by a line

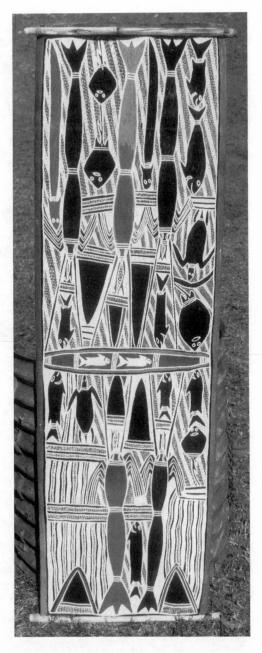

Figure 8.7 A Yirritja moiety turtle painting. Artist: Maaw'. A Munyuku clan painting of Yarrinya on Blue Mud Bay. Munyuku is the artist's M clan.

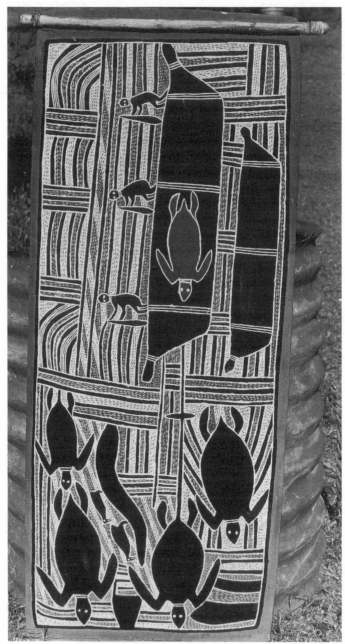

Figure 8.8 A Dhuwa moiety turtle painting. Artist: Maaw'. Clan: Djapu. Mokuy hunting turtles at Garrthalala on Caledon Bay.

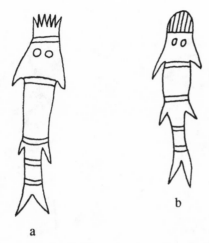

Figure 8.9　Two schemas for catfish (after paintings by Welwi, Marrakulu-Dhurrurrnga clan).

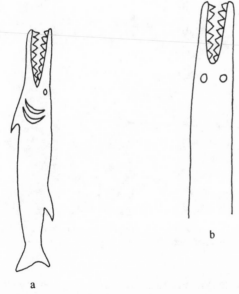

Figure 8.10　Schemas for garfish. (*a*) *Warrukay* (garfish) (after a painting by Welwi, Marrakulu-Dhurrurrnga clan). (*b*) A Djarrwark clan hollow log coffin (after a painting by the same artist).

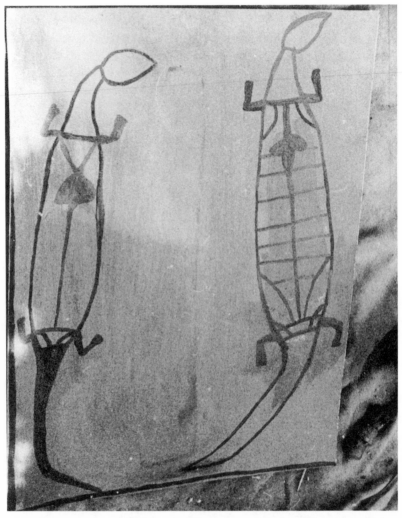

Figure 8.11 Magani's goanna. This painting was never completed. The goanna on the top was rejected by the other men present because it was "too like a crocodile."

through the center. When the goanna was redrawn by Djarrabili, one of the Marrangu men, it was drawn without the transverse lines (fig. 8.12).

I do not consider here in detail whether particular schema are general to Yolngu art or whether schematic similarities are a function of the operation of broad principles of representation or represent specifically learned schema. The answer probably lies in a combination of the two.

162

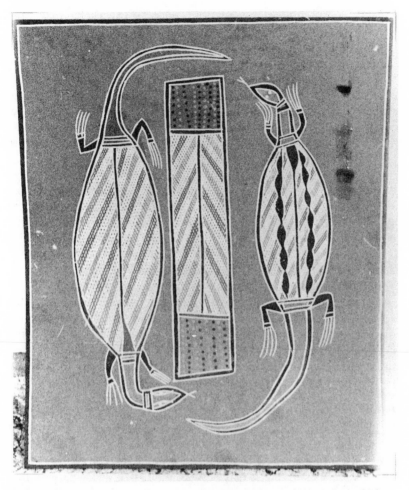

Figure 8.12 Djarrabili's goanna. Clan: Djinang-Marrangu. This painting, which re-placed Magani's (see fig. 8.11), shows acceptable representations of goannas.

Certainly all paintings of catfish, for example, encode the features re-ferred to above, though there is considerable variation in the way they are encoded. Thus Welwi employed two distinct schema for catfish—one incorporating the whiskers within the overall outline of the fish, the other extending them beyond the mouth (see fig. 8.9). He some-times included both schema in the same painting, both being given the same interpretation. Yangalka, a Djarrwak man, employs a slightly dif-ferent schema again from those used by Welwi, although he is acknowledged to have been taught the painting by Welwi.

In summary, although some schema encode features that make the schema easily identifiable at a specific level as representations of a particular content, on the whole this is not the case. In a sense this places the phrase "look like" in its proper perspective, which in terms of the Yolngu representational code means "is an acceptable representation of its content, which does not crosscut the schema for representing other categories of thing." Clearly the system allows considerable room for individual variation, and equally clearly the representations are not intended to signify specific meanings in all cases independent of the context of paintings as a whole. To a certain extent this analysis might be said to call into question Munn's (1966) description of the Yolngu system of figurative representation as a continuous meaning system, at least in as strong a sense as she implies. Although there are far more schema than in the geometric art and although the signifying potential of each schema is more restricted and more constrained by its iconic motivation, many schema are still ambiguous out of context. There certainly is not an unambiguous schema for each thing represented by the system. Moreover, there is considerable variation in the level of signification of elements within the system: whereas some schema signify a particular species unambiguously, others signify at a more general level (e.g., Maaw's turtle). However, Munn's distinction is essentially valid, since compared with the geometric system the figurative system is one in which distinctions at the level of signifier correspond more closely with distinctions at the level of signified.[2]

Infill

Figurative representations are usually painted all over in a single color, with the exception of certain specifically delineated features such as eyes, nose, and mouth, which if included are outlined in another color. Figures are usually black or yellow, seldom red, and even less frequently white. No meaning is ever given for the base color of figurative representations (except in the occasional use of white, where it is said to signify a dead animal or the spirit of the thing represented). Color is certainly not used as a distinctive feature to differentiate one schema from another. At Yirrkala, cross-hatching is not used within figurative representations, except where it occurs as a distinctive feature of clan designs included on the body of a figure, or where the figurative representation is separated from other crosshatched components.

2. Taylor (1987) provides a detailed analysis of the artistic system of western Arnhem Land in which the figurative component has a more central role than it does in the neighboring Yolngu system.

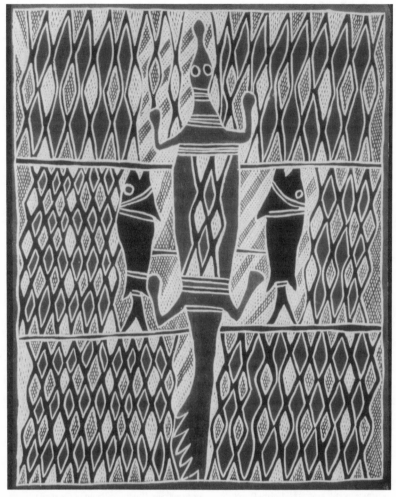

Figure 8.13 Crocodile and fire. Artist: Watjung. Clan: Gumatj 3. The ancestral croco-dile *baaru* at Caledon Bay.

Only a limited number of representations can have clan designs painted within them, and they belong primarily to the Yirritja moiety. Crocodiles and dugong frequently have clan designs connecting them with various myths of origin associated with distribution of fire (see fig. 8.13). In this case the association between the animal and the clan design exists as an internal representation of the myth of origin of the design and of the painting as a whole. Humanoid ancestral beings are

165

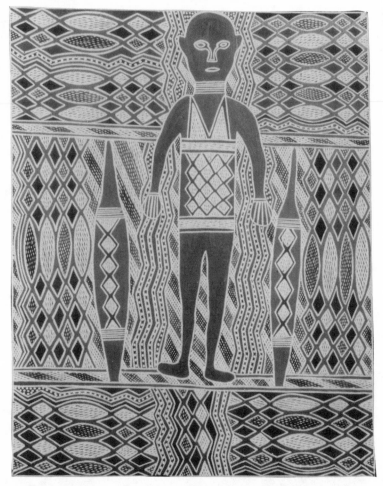

Figure 8.14 Barrama emerging. Artist: Yanggariny. Clan: Dharlwangu 1. The painting represents the ancestral being Barrama emerging from the water hole at Gaarngarn. The zigzag design behind his arms represents streamers of weed (*ngurrutj*) clinging to his arms. The diamond design on his chest represents the pattern made by the water weed.

also frequently represented with clan designs on them (see fig. 8.14). In this case the function of the clan design is similar; it refers to the origin of the design as an ancestral form and simultaneously designates the figurative representation as the representation of an ancestral being. Further reference to this topic is included in my discussion of divisions on the basis of content between the various figurative components of sets of clan paintings.

In only one case that I know of is infill used as a distinctive feature differentiating between figurative representations, though the infill is not cross-hatching but lines of yellow, white, and red dots. *Djaykung,* the Gaalpu snake at Garrimala, is always painted with this dotted infill, whereas *wititj,* the snake associated with the swallowing of the Wawilak sisters, is never painted with infill, though its coiled body occasionally incorporates a pattern of linked ovoids signifying the eggs of the snake.

The Geometric System of Representation

The geometric representational system consists of a set of basic elements which occur in paintings either singly or in combination with one another in a variety of different ways. When they occur separately as "geometric signs," the elements are the smallest meaningful units in the system (and analogous to morphemes in language). When they occur as components of clan designs, they are the minimal formal elements which differentiate one clan design from another (and in a sense are analogous to phonemes). This distinction is considered in more detail later on.

The geometric elements are components of what Munn (1966:937) defines as a discontinuous meaning system. Each element can represent a range of different meanings, for example, a circle can represent a water hole, a campsite, a mat, a campfire, eggs, holes left by maggots, nuts, and so on. On the whole, the range of meanings associated with each element seems narrower than is the case with similar elements among the Walbiri, but it is still considerable.

In Morphy (1977b) I term the range of meanings associated with each morphological element in a discontinuous meaning system *the signifying potential of a sign.* The signifying potential of a sign represents all the meanings that can be associated with a particular graphic element independent of its context. The signifying potential of a sign does not represent the extent to which it is ambiguous. In a given syntactic context, only a part of the signifying potential of a sign may be operational, certain meanings only being attached to the sign in the context of particular relationships with other signs in a painting. Unless this distinction is made, the results of analysis may be misleading. It is vital to distinguish between the signifying potential of a sign and its actual multivalency or ambiguity in a given context of occurrence. Thus we have shown that figurative representations have a wider signifying potential out of context than they do in any one context of occurrence. Out of context, at least some of the figurative schema are elements in a

discontinuous meaning system. In context, their multivalency (or perhaps more negatively, ambiguity) at this level is never utilized. In the case of the geometric representations, multivalency is an essential part of their meaning; they are not, however, multivalent in context to the full extent of their signifying potential. For example, one very general constraint in operation is that, in context, geometric elements can only signify meanings appropriate to the moiety or clan to which the paintings belong. Thus although a circle can signify a water hole or clan well in both Dhuwa and Yirritja paintings, in Dhuwa moiety paintings it is always a Dhuwa moiety well that is signified and in Yirritja moiety paintings, a Yirritja one. Or to take a more specific example, the signifying potential of a circle includes the conical woven pandanus mats (*nganymarra*) used in ceremonial contexts to cover women and initiates. Since the mat belongs to the Dhuwa moiety, a circle can signify *nganymarra* only in the context of Dhuwa moiety paintings. Again, as with figurative representation though to a lesser extent, knowledge of the ownership of the painting narrows the range of possible meanings of a sign.

Some of the general properties of the geometric system apply to geometric signs and to clan designs. The two key characteristics of the geometric representations that differentiate them from the figurative representations are that they are multivalent and that they require a key to be interpreted. These two characteristics are related: it is precisely because the elements could mean so many things that someone who has never seen the particular design before is unlikely to be able to interpret it. The geometric art can only be interpreted by someone who already knows something about the particular relationship between signifier and signified; it is that knowledge which provides the key. Now the key might be that the geometric art or graph concerned was produced as a mnemonic to illustrate a story. In that case someone who was present when the story was told would possess the key and would be able to interpret the graph. Next time the story is told, perhaps by a different person, a very different graph might be produced and the old key would no longer fit. Only those present at the second telling would be able to interpret the signs. The only way to make an old key fit is to produce the same graph or design again and again with the same intended set of meanings. To a considerable extent this is precisely what happens in the case of the sacred art of much of Australia. The design for a particular place or a particular ancestral being consists of a set form of arrangement of geometric elements which is reproduced again and again over time and which allows for continuity in the relationship between form and content, signifier and signified.

If we take a simple example of a combination of two design ele-

ments, a circle and a line, and imagine it to be part of a larger set design which is reproduced again and again in roughly the same form, we can see how it is possible for such designs to encode meaning (this example is hypothetical but based on actual cases). The first time a person sees the design, he may have no idea what it represents, beyond the signifying potentials of the signs. Later at a ceremony he sees the same design and is told on this occasion that it represents a water hole he knows as "kangaroo water hole," with the line representing a creek that runs into it. Next time he sees the same design he is able to interpret it; he knows it represents "kangaroo water hole." He has the key. Or does he? Because of the multivalency of the art, chances are he has only the beginnings of a key. On a later occasion when he is shown the design he says, "Ah! kangaroo water hole." And he is told, "Yes, and that water hole was made by the old man kangaroo digging in the ground with his tail to make a well for water, using his tail as a digging stick. And you can see there that design, it means digging stick and well." Now the young man knows the connection between the water hole and the kangaroo. Or does he? Some years later he sees the design again and connects it with a dance in which a man acting a kangaroo is digging a hole in the ceremonial ground with a digging stick. In the evening he is told, "You know that digging stick—that's really that old man's penis; he crept it along under the ground toward that water hole, and there was a lady kangaroo bending down to drink and he sent his penis right inside her." And so the meanings of the circle and line accumulate and add to the person's understanding of the relationship between the ancestral past and the social and physical geography of the land.

These two aspects of the geometric art—its multivalency and its requirement of a key for interpretation—are central to the Yolngu artistic system and are explored in detail in subsequent chapters.

Clan Designs

Clan designs are geometric patterns owned by individual clans or sets of clans within the same moiety. Morphologically, the majority of clan designs consist of repeated sequences of the same geometric element or combinations of elements (*minimal pattern units*). Frequently the individual minimal pattern units have no significance when isolated from their context as components of clan designs. Thus a typical Yirritja moiety pattern consists of a set of linked diamonds (fig. 8.15); a single diamond has no meaning as a clan design and never occurs in paintings. However, the properties which differentiate one diamond pattern from another clearly exist at the level of individual diamond. One diamond pattern may consist of a set of small equilateral dia-

Figure 8.15 A Yirritja moiety clan design.

monds, whereas another belonging to a different clan consists of a set of elongated diamonds.

Clan designs are a crucial component of Yolngu paintings in that they encode the relationship between people, place, and the ancestral past. The designs are believed to have been created first in the ancestral past by the wangarr beings who created or occupied a particular area of land. The design became a sign of ancestral creativity in that land and was handed on by the ancestral beings to the founding ancestors of the human groups which subsequently occupied the land. The clan design became part of the sacred law (mardayin) of the group, its charter for the land. According to Yolngu ideology, clan designs have been handed down through the generations, from the ancestral past to the present, maintaining a continuity over time in the relationship between land, clan, and the ancestral past. In reality, clans have died out and areas of land have changed ownership, but the ideology remains important and reality is quickly readjusted to maintain the illusion of ancestral continuity. If an area of land changes clan through the process of fission, fusion, or extinction of a clan, then the newness of the relationship is quickly masked by asserting a link between the new occupiers and the ancestral past, and the system carries on as if it had always been so. The process of takeover may not be smooth, but any rough edges are eventually smoothed over. (For a detailed analysis of this process see Morphy 1988.)

Clan designs thus function to differentiate the paintings of one clan from that of others. This was one of the main reasons given by Yolngu for their presence in paintings:

NARRITJIN: It shows it's a Manggalili painting.
DJEWINY: It means Marrakulu clan.
MARRKARAKARA: If I painted only pictures [figurative representations], then someone could say I was stealing the painting. If I paint the clan designs, then it shows the painting belongs to me.

Clan designs are the most direct way in which sociological meanings are encoded in paintings.

Each separate area of a clan's land has its own unique clan design,

which is associated with the ancestral being or set of ancestral beings who created the area, and it is that design which occurs on paintings associated with that area of land. As I argued earlier, my definition of the Yolngu clan is a group that acknowledges joint rights in land; consistent with that, its members exercise joint rights in clan designs. The set of designs belonging to a clan can be termed the *clan design set.*

As well as being part of a clan design set, each design is linked to others outside the clan which are on the same ancestral track or were created by the same set of ancestral beings. This can be referred to as the *ancestral design set.* The designs belonging to the same ancestral design set show morphological similarity, even though each particular design is in some way or other unique. For example, the set of Yirritja moiety clans associated with the wild honey, fire, and crocodile complex all have diamond-pattern designs, but each diamond pattern is different (see fig. 8.16) and each has a separate myth of origin (see Morphy 1988).

The overall effect of the clan design system is that the country is cloaked with a tartan of clan designs, each of which is associated with a particular social group and a particular ancestral being. Anyone who can identify the particular clan design and has sufficient knowledge of the system is, on this basis alone, able to associate the painting with people, place, and ancestral complex and in so doing to narrow down the reference of any other element in the painting to events and features that are associated with that particular place.

In order to show how meaning can be encoded in clan designs and the kinds of meaning that can be encoded, I focus on a single clan design belonging to the Munyuku clan, which is associated with an inland country of paperbark swamps (fig. 8.17). Most of the Yirritja moiety clans in Northeast Arnhem Land own a variant of the diamond pattern. The distinctive features of the Munyuku design are that the diamonds are large and equilateral (in contrast, for example, to the large elongated Gumatj diamonds and the small equilateral Dharlwangu ones), and that some of the diamonds have a bar dividing them in half. In the Munyuku case, the diamond pattern is primarily associated with the wild honey (sugar-bag) ancestor, though it is also linked with fire and the wet season floodwaters. In each case, elements of the design encode relevant meanings.

In interpreting the design as wild honey, the overall diamond pattern is said to relate to the structure of the honeycomb. Each diamond represents a cell of the hive, and each different kind of infilling a different content. The white cross-hatching represents grubs, the red, honey, and the yellow, pollen. The black dots that occur at the inter-

Clan Design	Owning Clan	Description
	Dharlwangu	Equilateral diamond, smaller than the Munyuku one.
	Munyuku	Equilateral diamond, larger than the Dharḻwangu one.
	Gumatj 1 and 2	Elongated diamond, shorter than the Gumatj 3 one.
	Gumatj 3	Elongated diamond, longer than the Gumatj 1 and 2 one.
	Mardarrpa	Separate strings of elongated diamonds, ending in ⌒⌒.

Figure 8.16 Variants of the diamond design type.

sections between the diamonds represent the bees, and the crossbars represent the tiny sticks that form part of the structure of native-bee hives and which stick in the throat when one eats the honey.

The diamonds have quite different meanings when interpreted as fire. As fire, the red diamonds represent the flames, the white diamonds represent ash left after the fire has gone, the red-and-white hatched diamonds represent sparks and smoke, and the crossbar represents a blackened log left behind after the fire has passed.

When interpreted as floodwaters, the diamond pattern represents the churned-up waters of the wet-season river as it rushes toward the sea. The white diamonds represent the foam on the water, the other crosshatched diamonds represent weed and debris carried along by the current, and the crossbar represents a hollow log being tossed about on the river's surface as it is taken downstream. The white diamonds can also be interpreted as the paperbark trees lining the riverbanks.

The meanings encoded in the diamond patterns are not entirely independent but are interrelated components of the ancestral complex. In this case the ancestral complex is a highly abstract one, and in the case of each notional being, that is, wild honey, fire, and floodwaters, it is difficult to draw the boundary around the concept. The wild honey ancestor in Munyuku country consists of the whole complex of things associated with wild honey: the bees, the grubs, the pollen, the honey, the hive, and the trees. Fire is part of the wild honey complex since hunters use fire to clear the ground when out looking for honeycomb and because fire is associated with the time of year when the honey is ready to collect. And the floodwaters are associated with the honey since this particular Yirritja moiety honey comes from the paperbark swamp where the bees feed on the nectar and pollen of the paperbark trees in flower. Nonetheless, although the wild honey ancestor is an abstract concept that includes reference to fire and the floodwaters in the paperbark swamps, it is also thought to have separate and, in some aspects, concrete existence. It has concrete expression in its track and in the places it creates, even if at times its track and its country overlap or coincide with those of other beings. It also has its own set of songs, dances, power names, and sacred objects.

Just as it is difficult to set limits on the concept of the wild honey ancestor, it is even harder to set limits on the meaning of the clan design. There is no simple external referent, and indeed the design is itself part of the wild honey ancestral complex, as a manifestation of the ancestral being. Perhaps it is most productive to see the clan design as an object for encoding meanings associated with the complex and as a reference point for the transmission of the concept. The process of encoding meaning into the design in this case varies from the direct

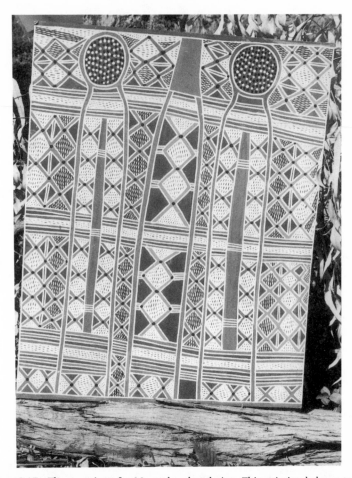

Figure 8.17 The meaning of a Munyuku clan design. This painting belongs to the country of Mandjawuy. The figures to the left and right represent the *birrkurda* (sugar-bag) *rangga*. The stick shape in the center of each represents the core of the object, the *garning* (digging stick, tree). The outer part of the rangga is made from rolled and bound paperbark. The central figure represents a paperbark beater, which signifies the ancestral being Banatja. This object is beaten on the ground at various stages in a Yirritja Ngaarra ceremony to warn women and children to avoid the area. It also represents the sound that the ancestral being makes. The clan design can be interpreted according to three different perspectives (see table opposite).

attribution of iconographic meaning to elements of the design, through the acquisition of connotative understandings of the designs gained from the use of the sacred law of the wild honey ancestor in ritual (see chap. 7), to individual insights and associations. The elements of the design, for example, encode components of the hive and

Clan Design	Interpretations
	1. As sugar-bag

• : bees

◊ : cells of hive

cross-hatching : honey and grubs

⇌ : sticks inside hive

) : entrance to hive and swarming bees

2. As fresh water

: flowing water

: sticks in running water

3. As fire

white cross-hatching smoke

red cross-hatching flame

red and black cross-hatching sparks

⇌ burnt log

of the fire; both the sound of the bees and the sound of the fire represent the power of the respective ancestral beings and are reproduced in ritual to provide power and strength for a particular purpose. The power associated with the sound of the bees becomes part of the concept of the wild honey ancestor and is likely to influence understanding of the design. And indeed in the Munyuku case, the "sound of the bees" is one of the power names that questions about the meaning of the painting elicit.

Although variants of the diamond design are owned by many different clans, the meaning of the design differs in each case in some components of its meaning. For one thing, a different clan and area of

land are involved in each case. In addition, the ancestral complex encoded in it probably differs, since components that go together in one place may be separate or absent in another. For example, in the case of the Mardarrpa and Gumatj clans, the fire complex is closely associated with *baaru* (crocodile) (fig. 8.13). A myth from Gunmurutjpi in Mardarrpa country to the north of Blue Mud Bay tells how the crocodile was burned when his bark hut caught fire and how he dived into the sea to quench the flames and left the fire behind him still burning deep beneath the waves. The fire burned the crocodile's back, producing the scaly pattern, and the burned bark hut became his serrated tail. In the Mardarrpa and Gumatj case, the diamond pattern represents the pattern on the crocodile's back, a meaning not shared with the Munyuku. The individual diamonds, however, can once again represent stages of the fire.

In the Gumatj case, the diamond pattern, with slight variations, is associated with a number of different places. In all cases it is associated with fire, but in addition, in one place it is linked to paperbark swamps, in another to wild honey, and in another to the crocodile. In each case the possible meaning of the design varies and the focal meaning differs. Yet the formal differences between the designs are so slight—a dot here, a slightly longer diamond there—that each diamond design in many respects echoes its neighbors and the meaning must carry across. In a way, the Gumatj case provides a model for the whole set of diamond designs across Northeastern Arnhem Land. Each pattern is discrete and occupies its own position, but the pattern in its fullest extent traces out a concept (an overlapping set of ancestral beings on a connected track which links the countries of many different clans) which gives unity to the set, even if by its very nature there is no single concept to be grasped as a whole.

The Iconicity of Clan Designs

There are two aspects to the role of iconicity in the encoding of meaning in clan designs. One concerns the problem of the formal resemblance between a signifier and a signified within the system. The other concerns whether or not formal resemblance at this level is the basis upon which designs belonging to one clan are differentiated from those of another, in particular as regards designs belonging to the same design set.

The system does indeed show a degree of iconicity at certain levels. Two levels of iconic relationship between signifier and signified have been referred to earlier in the chapter: one at the level of the design as a whole, the other at the level of infilling. Certain designs are believed to have originated as a consequence of the action of wangarr beings. In

many cases the designs produced are also said to have the charac-
teristics of certain natural forms. The diamond design, for example,
was said in one case to have the pattern of a piece of paperbark folded
by an ancestral wild honey collector, in another case to be the pattern
of the crocodile's back, in another to be the cells of the beehive and
so on.

The relationship between signifier and signified in the case of infill-
ing may also in some cases be patterned by factors of iconicity. The fire
pattern (fig. 8.13) is a good example. Here the appropriateness of the
form or color of the infill affects the relationship between signifiers and
signifieds.

Iconicity can only be postulated for some of the relationships be-
tween signifiers and signifieds associated with a particular clan design.
The designs are multivalent. Folded paperbark or the marks on a croc-
odile's back are not *the* meaning of a design. In each case they are one
of a set of meanings associated with the same design in the context of
particular paintings. Diamond patterns also signify water and various
different kinds of water weed. There seems to be no good reason why
such meanings could not be equally appropriately signified by other
clan designs, as indeed they are.

Even where Yolngu assert that an iconic relationship exists between
signifier and signified, it is only one of a number of possible and in
many cases equally appropriate associations that could be made be-
tween a particular signified and a number of different signifiers. Thus
there is no intrinsic reason why paperbark should be signified by a dia-
mond pattern, since a number of other patterns could be produced by
folding paperbark. The marks on a crocodile's back would perhaps be
even better represented by a square pattern. I would suggest that,
rather than the designs being iconically motivated, the possibility of
formal resemblances between signifier and signified is exploited in the
case of certain meanings attached to a design type.

Often the iconic relationship is itself a cultural artifact, shown partic-
ularly clearly in the case of folded paperbark. The paperbark, by being
folded in a particular way in the wangarr time, creates the iconicity
between signifier and signified. It could equally well have been folded
into squares. The relationship between diamond pattern and paper-
bark is reinforced in a number of other ways. For example, sacred
objects made of paperbark have diamond patterns sewn across the sur-
face bindings.

However, the difference between the designs of various clans cannot
be explained on a purely iconic basis. At a moiety level, Dhuwa moiety
designs, irrespective of any overlap in the meanings signified by them,
must differ morphologically from Yirritja moiety designs. Indeed, they

must consist of different types of geometric elements. Both moieties have sugar-bag designs (referring to different species of bee). The Yirritja moiety design consists of diamonds, while the Dhuwa moiety one consists of straight lines at angles to one another. Within a moiety, designs of the same set belonging to different clans are differentiated on a non-iconic basis. Although each clan may have a different myth of origin for the versions of its design, myths do not refer to formal features that differentiate one design from the next. Certainly each clan may have a separate myth which explains the origin of its version of the design in iconic terms (for example, diamond refers to crocodile or tortoise, or paperbark, or sugar-bag). These myths do not, however, refer to formal features that differentiate one clan's design from another belonging to the same set.

Each clan's diamond design differs from the diamond design of every other clan, but the system of reference for these differences, rather than being iconic, is the relationship between the groups themselves. In this respect, the clan designs correspond to a Durkheimian model of covariance between design and social group. At this level, the differences between the designs could be said to be sociologically motivated.

Yolngu clan designs can be contrasted with Walbiri *guruwari* men's designs, as differences between the two systems are quite striking.[3] Munn writes of design differentiation in *guruwari* designs: "The marked visual similarities between the designs for different species do not necessarily signify specific cosmological or other associations of the ancestors involved" (1973:176). Yolngu clan designs, on the other hand, operate to signify precisely this kind of connection, since paintings with similar designs on them are linked at the level of mardayin (ancestral complex).

A second feature of the Walbiri men's design system is that design differentiation does not correspond with segmentation at the societal level. Walbiri clan designs are primarily iconically motivated, and "there is no systematic subordination of the iconic element to a second abstract ordering system" (Munn 1973:177). Thus ancestral designs belonging to unrelated groups, and which have different mythological referents, can be visually similar because of the iconic nature of the design generation system. Such is not the case with Yolngu clan designs. For example, the designs belonging to clans of different moieties cannot overlap. In the clan design, Yolngu art has a component which at one level functions to differentiate the paintings of one social group

3. Taylor (1987, chap. 8) provides an excellent analysis of the concept of iconicity within the system, in particular in relation to the intention of artists and the basis of interpretation. See also Taylor 1989 and Morphy 1980.

from those of another and at a second level provides a network of interconnectedness between groups on the basis of the mythological relationships between clans. There is no analogous component in Walbiri art.

Although from an analytic perspective iconicity plays a relatively minor role in the system of design differentiation and generation, from a Yolngu ontological perspective clan designs are iconic. Clan designs were created through ancestral action and are integral to the concept of ancestral being. Clan designs can be referred to as the bones (*ngaraka*) of the ancestor, or the shadow (*mali*), and they are *likan* ("connection," as in the sense of being an integral part of the ancestral being). The very fact that clan designs are neither bounded by figurative form nor strongly associated with some outside referent through formal resemblance frees them to be an objectification of ancestral beings that is not fixed in its meaning and which can incorporate other things. The sacred object, the human body, indeed any object painted with the design can, in Donald Thomson's evocative phrase, "take on the likeness to the *wangarr*" (field notes 4.8.37). In this respect, iconicity is something created from within the system, and there is no need to overemphasize the question of resemblance to some external referent. Nonetheless, the flashes of resemblance to outside things that are taken up, the red sparks of the fire, the cells of the beehive, and the fact that such connections are posited in myth (the folded bark, the burned design) suggest that external iconicity plays some role in forming the image of the ancestral being and giving it concrete connections to other things. (These issues are taken up in more detail in the next chapter.)

Conclusion

In this chapter I have restricted myself as much as possible to showing how the components of Yolngu art encode meanings. Before looking at the way elements are combined to produce whole paintings, however, we must examine the different categories of paintings that exist, for the organization of components into meaningful wholes is not undertaken in isolation from the sociocultural context of use but is integrated within it. The grammar of Yolngu art is not some abstract system of potentials but a system structured through its use in particular contexts. The categories of Yolngu painting are thus not just the product of the artistic system, not simply particular ways of encoding meaning, but are also a product of the way knowledge is structured, of the system of restricted knowledge and the way it articulates with religious and political structures. In the next chapter I focus on these categories of painting as used in different and similar

contexts while considering the way different components interact to convey meaning.

Differentiating categories of paintings necessarily involves returning again to the system of knowledge, for the categories reflect both different conditions of access and different degrees of interpretability. The categories utilize the different properties of the representational systems to integrate the artistic system within the system of knowledge. Meaning in Yolngu art must be understood in relation to the way art structures knowledge, for meaning is dependent in part on how it is arrived at. The meaning of a Yolngu painting cannot be revealed at once; it cannot be consumed at one sitting, but has to be revealed in a structured way over time, with pauses for digestion in between. Meaning in Yolngu art involves a process of encoding which is in harmony with a process of revelation.

9

Changing with the Times: Categories of Art and the Composition of Paintings

A Diachronic Approach

In the basement of the National Museum of Victoria in Melbourne is housed the Donald Thomson Collection, the most remarkable of all collections of Aboriginal art and material culture. These come from Cape York and Central Australia as well as from Northeast Arnhem Land, but the material from Arnhem Land predominates. Thomson's Yolngu collections were made in Northeast Arnhem Land between the years 1934 and 1943, when he was at different times a government official, anthropologist, and, during World War II, an army officer in charge of a Special Reconnaisance Unit of Arnhem Land Aborigines watching for the Japanese invasion. But whatever his official position, Donald Thomson continued to add to his collection and continued to write meticulous notes on the material he collected.

In many ways Thomson's collections were his life's work and may become his most significant contribution to anthropology, but like a manuscript left lying in the desk drawer they remained almost unknown and largely untouched in his rooms in Melbourne until after his death in 1970. As a consequence, when they were finally

brought out they seemed as new as the day they were made—objects eerily frozen in time, only the faded labels betraying their age and history. Thomson's collections of objects and his photographs make it possible for us to step back in time into the Arnhem Land of the 1930s and to make comparisons across the years. The collection and the detailed notes which accompany it allow us to approach the question of categories from a diachronic perspective.

When I arrived in Yirrkala to begin my own fieldwork among the Yolngu, I came armed with a portfolio of photographs of paintings in Australian museum collections, including photographs of the bark paintings in the Donald Thomson Collection. I wanted to get Yolngu artists to redocument the paintings so I could see how consistent interpretations were over time, and I wanted to record their reflections on the changes that had taken place in the art over a forty-year period.

The first person I showed the photographs to was Narritjin. It was during my first week in the field, and I remember we were sitting on the sand outside his house in the lowering evening light. He instantly saw through my project. After looking through the photographs for a while with what must surely have been a deliberate lack of interest, he laid them down, looked at me quizzically, and said, "I know what you are trying to do; you want to show us that our art has changed. We will show you that it has not." In the end I became convinced that in a profound sense Narritjin was right, but on the surface many changes have occurred that have to be taken into account. Those changes are not so much in the art itself, though there have been some, as in the way the art is integrated within the cultural system.

A comparison of Yolngu art over the period between Thomson's fieldwork and my own in the mid-1970s shows much continuity. Many of the paintings collected by Thomson from the 1930s on would not have been out of place in collections made right up to the present. However, such surface comparisons may obscure some of the changes that have taken place. For example, many of the paintings collected by Thomson were not seen by Yolngu women, whereas when these images are produced today, women may have a hand in painting them. In the past the different properties of the representational systems were utilized to create different categories of painting, which neatly articulated with a system of restricted knowledge in which people were excluded from certain contexts, and in which many objects, including paintings of a particular category, were concealed from segments of the population. In recent years, many of these contexts have been opened up or reduced in significance, and much less is concealed. Furthermore, the categories of art have to an extent collapsed into a more heterogeneous set of paintings. Yet in spite of these changes, the artistic

system still operates to structure knowledge and control access to it, and the distinct properties of the representational systems are still exploited to this end.

In this chapter I examine the changes in different categories of art in Yolngu society, especially in relation to the system of maintaining differential access to knowledge by individuals of different status. I also examine the dynamic of the relationship between Yolngu and European society as it affects the Yolngu artistic system. Thomson recorded indigenous categories of art in detail as they existed in the 1930s, and I use his material as a basis for comparing the immediate postcontact situation with that existing today.

Thomson's Categories of Painting

Thomson's categories of Yolngu paintings were derived basically from informants' subdivisions of the body of Gupapuyngu clan paintings Thomson collected. He generalized these distinctions to apply to all the Yolngu-speaking clans. Six main categories can be abstracted from Thomson's field notes. These are listed in table 9.1, together with the main characteristics he used to define them. They applied to paintings on all types of media. Table 9.2 lists their contexts of occurrence.

The first category, *wakinngu*, can be loosely termed "decorative art." *Wakinngu* means "ordinary," "mundane," and "nonsacred." It is used in opposition to *mardayinbuy* (belonging to the sacred). When applied to animal species, *wakinngu* conveys the sense of "not in its capacity as a totemic species." As applied to paintings it refers to those that are nonancestral, which are not part of the clan's body of inherited sacred law and which are produced simply to make an object look more attractive. Everyday objects with wakinngu paintings on them do not differ in use from unpainted objects of the same type. The fact that they are painted does not prescribe or constrain the way in which they are used or who can use them (see Thomson 1939a:88, 89).

Table 9.1 Categories of Paintings at European Contact

Category	Thomson's Definition
1 Wakinngu	Nonsacred, "ordinary" designs not related to wangarr beings
2 Garma	Public paintings of totemic species
3 Bulgu	Roughly executed *mardayinbuy* paintings
4 Ngaarrapuy	Restricted, paintings of totemic species; "sacred"
5 Likanbuy, ranggapuy	The most sacred paintings used on the rangga (sacred objects), and on the bodies of male initiates and dead persons

Table 9.2 Categories of Paintings at European Contact

Relationship to Wangarr Beings	Category	Context
Nonancestral Not connected with the clan's rangga	Wakinngu Garma	Open
Connected with the clan's rangga and associated wangarr	Bulgu	Intermediate
	Ngaarrapuy Likanbuy	Restricted

The second category of paintings was termed *garma* paintings by Thomson. The simplest gloss for *garma* is "public aspects of the sacred law"; it is often translated by Yolngu as "outside" (see Warner 1958:20). Garma paintings are ones that can be produced and displayed in public places. They are not associated with the restricted phases of any ceremony and can be seen by women and young men. The main contexts for these paintings are grave posts, hollow log coffins, and objects used in ceremonies held in the main camp, to which women have full access.

The third category is *bulgu* paintings. These occur either on objects or as body paintings. The majority of objects on which bulgu designs occur are connected with the men's ceremonial life; in particular, they are painted on *bathi* (sacred dilly bags). Sacred dilly bags are kept and occasionally displayed in the main camp, although behavior in relation to them is subject to constraints: they are individually owned by members of clans and may be handled and used only by prescribed categories of people in defined contexts.

As body paintings, *bulgu miny'tji* can be painted on women and uninitiated men when a major stage of a particular ceremony is being performed on the men's ceremonial ground. They are also painted on the bodies of men as they move from the seclusion of the closed ceremonial ground toward the end of a major ceremony, in particular a Ngaarra, to join the women in communal washing (see Warner 1958:353). The paintings are clan-owned and, according to Thomson (1939b:2), were "the only *madayinbuy [sic] miny'tji* that may be painted on women and children."

The next category of paintings is termed *ngaarrapuy miny'tji,* which literally means "paintings belonging to the Ngaarra ceremony." However, Thomson used the term to refer to a particular class of body paintings produced in the context of closed phases of major ceremonies, including the Djungguwan, Ngulmarrk, and Gunapipi as well

as the Ngaarra. The paintings are figurative representations of totemic species and occur on the bodies of actors performing dances connected with them. Women should not see these paintings unless the paintings have been partially rubbed out, though this may be little more than a token smudge.

This restriction also applies to Thomson's category *likanbuy* or *ranggapuy miny'tji*. In this context, both *likanbuy* and *ranggapuy* refer to the fact that the designs can be produced on the rangga itself and that they refer directly to the rangga. They are also used at circumcision, on the bodies of initiates to whom the sacred object has been revealed for the first time, and on the body of a dead person of either sex (Thomson 1939b:1). Such paintings may also be painted on the body of a man who has recovered from a severe illness or has in some other way narrowly escaped death. A likanbuy miny'tji in Thomson's time was always done in seclusion, away from women and children, by men who were fully initiated into the ceremony concerned.

The final category of paintings identified by Thomson but not discussed in detail here is body painting done in a single, uniform color of white, red, or yellow. These paintings occur today in contexts similar to those of Thomson's time (see, e.g., chap. 7, "Reflectional Meaning").

Secret and Open, Inside and Outside, Paintings

The categories of paintings can be divided into two groups—those which in Thomson's day were restricted in an unmodified form from public gaze and those which were public. The two groups stood in an inside : outside relationship to one another. I leave aside for the moment wakinngu and ngaarrapuy paintings and concentrate my analysis on the opposition between likanbuy paintings, on the one hand, and garma and bulgu paintings on the other. In componential structure, likanbuy paintings contrast markedly with the other two, though for different reasons. The componential structure of all five categories is shown in figure 9.1.

The garma art has a high proportion of figurative representations. For a hollow log coffin, the painting may be divided up into a number of feature blocks representing different mythological episodes. The majority of garma paintings in Thomson's collection do not include clan designs. Only certain clan designs—those not primarily associated with the clan's sacred objects—can be included in garma paintings. The diamond design associated with the main Gupapuyngu rangga, *birrkurda* (sugar-bag), does not occur in garma paintings. Crosshatched infill occurs within the body of some of the figurative representations, but does not cover the area between the figures.

wakinngu

garma

ngaarrapuy

bulgu

likanbuy

Figure 9.1 The componential structure of categories of paintings at European contact.

The bulgu paintings consist simply of outlined and relatively non-specific clan designs. The majority of paintings in this category are characterized by an absence of cross-hatching. In the case of body paintings, the designs are outlined in white, red, or yellow on a red or white background. In the case of *bathi* (dilly bags), the outline designs are either painted on or defined by raised lines of string interwoven into the surface structure of the bag. The individual elements may be painted in different colors to form repeated sequences of alternating color sets, for example, red-white-yellow-red-white-yellow.

Likanbuy paintings have the most complex componential structure and frequently consist of all the components combined. However, the figurative component may be absent from a likanbuy painting and relative to garma paintings is always greatly reduced. The major components of likanbuy paintings are clan designs and other geometric elements. The entire painting is infilled with cross-hatching, with the exception of certain elements of the clan design. The figurative representations that do occur refer to meanings encoded in the rangga, for example, if the rangga is a transformation of an ancestral goanna species, then the painting may include a figurative representation of that species. Thus the key attributes of likanbuy paintings which differentiate them from other paintings are the particular combination of elaborated clan designs, the predominantly geometric content, and the presence of fine cross-hatching and detailed infill.

The Componential Structure of Likanbuy Paintings

Before considering the ontological, semantic, and aesthetic explanations for the form of likanbuy paintings, it will be helpful to explore the concept of likanbuy paintings a little further by considering what the phrase *likanbuy miny'tji* means. *Miny'tji* has already been glossed as "painting"; the suffix *-Buy*[1] can be translated as "about" or "associated with." Hence the category refers to paintings associated with *likan*, for which there is no simple translation. *Likan* can be applied to clan designs alone and hence the phrase could be translated as "paintings associated with clan designs." But as *likan* applies more to an attribute or aspect of clan designs rather than to their designation, such a translation would be evading the issue.

Likan has a number of meanings, some of which refer to sacred or ceremonial things, and others to mundane things. In the secular sphere, *likan* means "elbow," "fork between the branch of a tree and its trunk," and "bay between two promontories." All these meanings

1. The suffix *-Buy* has three variants: *-buy, -puy,* and *-wuy,* which occur in different morphophonemic contexts. *B* is used as a cover symbol for the alternating forms.

have something in common: they refer to objects which are discrete yet at the same time link other objects in relation to which they are defined. Thus the elbow connects the forearm to the upper arm, the branch is connected at the fork to the tree trunk, and the bay connects the two promontories.

In the sacred sphere, *likan,* while referring to clan designs and sacred (restricted) paintings, is also the word used for the "power" names of the clan's sacred objects shouted out at various stages in the performance of ceremonies (see chap. 5). According to Shapiro (1969), it is also used to refer to the songs chanted by men on occasions when the sacred objects are being displayed. All of these manifestations of the ancestral past may also be termed *ranggapuy* (relating to the rangga, "sacred object") or *mardayinbuy* (relating to the sacred or restricted).

I suggest that *likan* as it is applied to clan designs carries with it the connotation of connectedness, which is associated with its secular usages. Clan designs are one of the manifestations of wangarr beings: they can be referred to as the *mali* (spirit or shade) of the wangarr. Similarly, the power names are verbal manifestations of the wangarr beings and are endowed with maarr (power). The relationship between clan designs and power names is demonstrated by the fact that the latter are frequently listed as meanings for the former. Both are external signs or objectifications of the wangarr beings. In this sense they are like rangga, and indeed they are components of the rangga, since clan designs appear on the rangga itself, and the power names are referents of the rangga. But while components of the rangga, they exist independent of it. The rangga is the most restricted manifestation of the ancestral being and is only revealed in closed contexts. Clan designs and power names, on the other hand, appear in a wide variety of contexts, some open, some closed. They can also be used to establish the relationships between individuals and the wangarr beings in a way that sacred objects cannot: clan designs can be painted directly on an individual's body, and power names can be sung over the painting. Initiates are familiar with the clan designs long before the rangga associated with the same wangarr beings are revealed to them. Relative to the rangga, the clan designs are part of everyday discourse with the wangarr beings, and when the rangga are revealed to initiates, the clan designs on them will be a known component of an unknown object. Thus the clan designs are both manifestations of a wangarr being and extensions of the rangga, which is in turn a manifestation of the same wangarr being. The use of the term *likan* to describe clan designs thus emphasizes their role as manifestations of wangarr beings which, at the same time, provide a link between the wangarr and the wider society.

Likan has a number of other connotations apart from the idea of connectedness. Blood used in the Djungguwan ceremony is taken from the elbows of initiated men. The shouting of power names (likan) over the blood is believed to endow it with spiritual (wangarr) power. The blood is used to paint a design (likan) on the bodies of initiates. Thus in this case the term *likan* is the common denominator linking stages in the process of transforming human blood into wangarr blood. Blood itself becomes an extension of wangarr power, although the process is the reverse of the one which occurs in the case of paintings. Whereas paintings endow the human body with wangarr power, blood leaving the body is endowed with this power. The blood is then used to produce paintings which are themselves manifestations of wangarr, adding to the significance and power of the paintings. *Likan*, as elbow, thus refers to the culturally designated source of one of the major symbolic substances of Yolngu culture—blood.

Clan designs are also referred to as *ngaraka*, "bones," *ngaraka wangarr*, "bones of the wangarr," *ngaraka ngilimurru*, "our bones," and *ngaraka baapurru*, "bones of the clan." The animating spirits of the clan, and the maarr of the clan's ancestors, are thought to be located in the sacred objects, paintings, songs, and dances of the clan. In this sense the designs are the bones of the clan. They are expressions of its continuity with wangarr time and of its continuity into the future. Bones are also a metaphor for the "inside" nature of wangarr power. Bones are the concealed and inside part of a person's body, and *ngaraka* is used to refer to the core, or concealed part, of the sacred objects, and to clan designs which are the most restricted components of paintings. *Likan* may also have the further connotation of bone in this context, since bone is the inner component of the elbow. Certainly Thomson (1939b:2) records that *likan* was used to refer to the "bones" of the wangarr.

Likan is a metaphor of connection or connectivity. It focuses on the way paintings are linked with ancestral action and provides a connection between the past and present. In talking about the meaning of paintings, one of the most frequent words Narritjin used was "connection": "this design is connected with the spider," rather than "means" or "represents" the spider. Connection here is consistent with the idea that designs and their meanings arise out of ancestral action rather than simply represent it. The use of "representation" would suggest a gap between signifier and signified that is not consistent with Yolngu ontology. The connections of any design to the wangarr are of course multiple, and the metaphor of an "interconnected network of meaning" would be an appropriate one to apply to the semantics of Yolngu paintings: from the Yolngu perspective, the paintings arise out of the

events of the ancestral past and are a condensation of those events. In their use in the present, the paintings become part of a new network of connectedness in which the ancestral meaning (the iconological meaning) is linked to the present through its connection to contemporary events, its relevance to a ritual theme, its indexing of an individual as a member of a particular group. The network of interconnection is thus one that extends from the past to the present, its particular form being created by the use of the mardayin over a certain period of time. Although I have not heard Yolngu use the phrase "a network of interconnection" to describe this process, use of *likan* to refer to ancestral beings, clan designs, and the names that link people and sacred objects suggests that the idea is a key one in Yolngu thought.

Although it is impossible to provide a simple gloss to the phrase *likanbuy miny'tji,* the sense of the phrase should be apparent: it refers to the value of paintings as a manifestation of the ancestral past and as an integral part of a clan's identity. Clan designs are central components in the expression of these aspects and are appropriately the major component of these paintings. The only other paintings to have clan designs on them are the bulgu miny'tji. The designs in this case, however, are nonspecific in that they refer to an ancestral complex in general and not to its manifestation in particular clans and places. As a design without cross-hatching, worn by people who move from closed to open contexts, bulgu is structurally similar to the likanbuy design with its cross-hatching smudged, which is the version that appears in public contexts. Bulgu is a safe means of connecting inside and outside contexts—a painting that does not spiritually endanger the uninitiated or reveal too much.

A second aspect of the form of likanbuy paintings makes them appropriate for their position in Yolngu culture: the form is in itself a means of maintaining secrecy. Likanbuy paintings are central objects in the system of controlling the distribution of knowledge because knowledge of both the details of their form and of their meanings is restricted.

One way Yolngu control the distribution of knowledge of paintings is that access to paintings themselves is restricted. After a painting has been revealed to an individual, knowledge restrictions shift in dimension from control of knowledge of its form to control of knowledge of its meaning. Indeed viewing a painting is only an initial stage in the process of male initiation. Further revelation of restricted knowledge takes place as an individual is taught more about the significance of its form. In likanbuy paintings, meanings are encoded in such a way that the paintings cannot readily be interpreted. In this way, control is maintained by those already possessing information.

The predominance of the geometric in likanbuy paintings functions to obscure their interpretation. Clan designs and geometric representations have broad signifying potentials. The elements themselves are relatively non-iconic, though some elements of iconicity exist at certain levels of the system. In chapter 7 I showed how minor variations between similar clan designs affect the reference of the design and how the same design could have a multiplicity of meanings associated with it in different contexts. The designs themselves are multivalent, signifying clan, place, ancestral event, and so on. The same design may encode a number of different ancestral events, and the specified referential meanings of the geometric elements may vary according to the particular interpretation focused on. In order to interpret the geometric components of a painting, one has to know not simply what the signifying potential of the elements is, but which signifieds apply in the context of the particular painting. This system functions to restrict the amount of information imparted through the mere revelation of the painting and enables the secrecy of its meanings to be maintained.

In contrast to the geometric art, the figurative representations (which *are* iconically motivated) are readily interpretable by Yolngu in context to refer to particular things and are intended to be interpreted as such (see chap. 7). The limited number of figurative representations in likanbuy paintings reduces the number of readily interpretable signs in them. On the other hand, the properties of the geometric art in maintaining secrecy are explicitly acknowledged by the Yolngu: "If people look at this they think it means nothing" (Mithili discussing a purely geometric painting). "It doesn't look as if it has many meanings, but it has more than the other ones" (Welwi referring to a geometric painting in contrast to a figurative one).

I am not suggesting here that maintaining secrecy is the major explanation for the predominance of geometric motifs in the likanbuy paintings. The geometric art, because of its multivalency and potential ambiguity, encodes meanings in such a way that it can be used to make complex statements about the relationships between things that cannot be made in other ways.

In the last chapter I gave a hypothetical example of the way multiple meanings are encoded in the geometric art. Here I look at an example taken from an actual painting (fig. 9.2). This painting by Welwi, though not a likanbuy painting, illustrates well the contrast between the geometric and figurative elements. The painting relates to the mythology of the Djungguwan ceremony held at Trial Bay, discussed earlier. It represents the ancestral woman Ganydjalala hunting a kangaroo through forested uplands. According to the myth, as she chased the kangaroo she lit fires that drove the kangaroo onward. Eventually

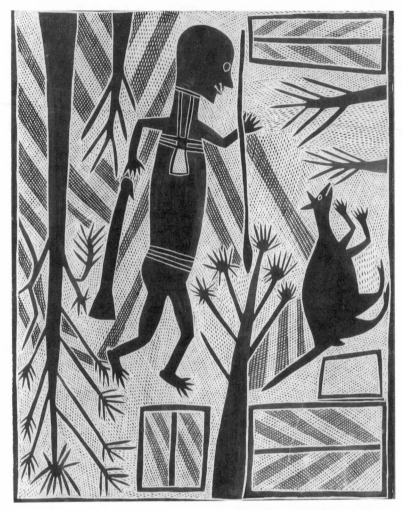

Figure 9.2 Encodings of meaning in geometric and figurative art. Artist: Welwi. Clan: Marrakulu-Dhurrurrnga.

the fire caught the kangaroo and burned the fur on its back, but it managed to escape into rocky country.

The story so far is encoded most obviously in the figurative elements—the bands of red cross-hatching representing the fire catching up with the kangaroo and the oblong signs representing rocks that the kangaroo hopped over. However, the kangaroo is also encoded in the oblong sign, which is, in fact, a Marrakulu clan design. The oblong represents the body of the kangaroo and the line down the middle its

backbone. The bands of alternating red and white cross-hatching represent respectively singed and unsinged patches of fur. But this is only the beginning of the meaning encoded in the sign. As it hopped on the stones, the kangaroo broke off little fragments that flew up and cut into its fur. The kangaroo thus invented stone spearheads. The oblongs in this case represent blocks of stone, and the diagonal line represents a fissure in the rock where it has been hit by the kangaroo or struck by a hammerstone. From different perspectives the sign can be seen to encode a range of activities associated with stone spear manufacture. More generally the design can represent the area around the stone quarry, with the red stripes signifying piles of struck flakes waiting to be wrapped in paperbark and placed in a dilly bag, which in turn can be represented by the oblong shape of the sign. Hence from different interpretative perspectives the sign can represent a single flake being struck, piles of flakes surrounding a quarry, and a set of flakes inside a dilly bag.

Thus the clan design encodes a coherent set of meanings that are related to one another by, in this case, a myth concerned with the origin of stone spears. The figurative representations do not encode the whole myth but represent a segment of it in a relatively unambiguous way, fixing the meaning of the geometric signs at a particular level. The painting *just* represents a person hunting a kangaroo through the forest.

It can be seen from this example that a variety of different paintings could be produced by representing figuratively different meanings encoded in the geometric art. The geometric art in this respect can be thought of as generating the figurative representations, and this is certainly consistent with the way Yolngu see the relationship between the two, the geometric art being inside and the figurative outside. Later I show how certain likanbuy paintings consisting of a structured arrangement of geometric elements act as templates for producing other paintings and hence have ontological primacy.

The Light of the Wangarr

So far I have considered only the semantic aspects of likanbuy paintings that differentiate them from paintings in other categories. According to Thomson, likanbuy paintings have a property of a different order, *bir'yun*, that they do not share with paintings in other categories. *Bir'yun* can be termed an aesthetic property since it operates independently of the specific meanings encoded in a painting, though as we shall see it interacts with them. *Bir'yun* is a particular visual effect resulting from aspects of the form of likanbuy paintings. Thomson (field notes 5.8.37) writes that the mundane or secular

meaning of *bir'yun* refers to intense sources and refractions of light: to the sun's rays and to light sparkling in bubbling fresh water:

> gong ngayi walu bir'yu-bir'yun marrtji
>
> fingers his sun scintillate go
>
> The sun's rays scintillate.

As applied to paintings, *"bir'yun* is the flash of light—the sensation of light that one gets and carries away in one's mind's eye, from a glance at the *likanbuy miny'tji"* (field notes 4.8.37). The bir'yun of a painting is the visual effect of the fine crosshatched lines that cover the surface of a sacred painting: "it is the sensation of light, the uplift of looking at this carefully carried out work. They see in it a likeness to the *wangarr"* (field notes 4.8.37). Thus bir'yun is the shimmering effect of finely cross-hatched paintings which project a brightness that is seen as emanating from the wangarr being itself; this brightness is one of the things that endows the painting with ancestral power. I have argued elsewhere (Morphy 1989) that bir'yun is an example of what Munn (1986) refers to as a "qualisign," a quality that operates as a sign. The sensations of brightly shining light and lightness are both associated with ancestral power. In ritual, in addition to crosshatched painting, naturally shiny substances such as fat, blood, wax, and feathers are used extensively to decorate objects and people. Highly shiny materials are thought to be ancestrally powerful, and lightning and rainbows are both considered manifestations of ancestral beings. Moreover, Yolngu who have experienced ancestral intervention sometimes refer to it as a flash of light or a bright light filling the head (see Chaseling 1957:168). This suggests that brilliance, shininess, is a qualisign that people learn to interpret as ancestral power and which indeed becomes one of the ways in which they experience that power; the brilliance of paintings is thus itself felt as a manifestation of ancestral power.

Thomson states that this brilliance is one of the reasons why a likanbuy painting is either wholly or partly obscured when a person painted with one goes into the main camp. The painting is obscured by smearing the crosshatched infill, thus reducing the fineness and separateness of the crosshatched lines to a smudge of pigment. Although some aspects of the form of the painting are discernable, it has lost its brilliance (bir'yun), and through losing this has lost some of its ancestral power, "its likeness to the wangarr."

In this form the painting becomes safe, the danger of the design is reduced, and women and children can come into contact with it. The danger of bir'yun is also given as the reason for denying women access

to certain places and certain sacred objects. The corollary of this protection, however, is that men keep some of the most powerful manifestations of ancestral power to themselves and deny women the opportunity to experience that power to the extent men are able to.

The concept of bir'yun also helps explain one of the main differences between likanbuy paintings and bulgu paintings (both of which consist largely of clan designs). Bulgu paintings, which occur in open contexts, are not *bir'yunhamirri*, "having bir'yun," whereas likanbuy paintings are. One of Thomson's informants described bulgu paintings as being *mali nhanngu likanbuy miny'tji*, "shades of likanbuy paintings," whereas likanbuy paintings can be described as *mali wangarr*, "shades of the wangarr." Bulgu paintings are a subordinate category of paintings to likanbuy, one stage further removed from the wangarr ancestors, reinforcing the distinction between closed contexts, which are closest to the source of ancestral power, and open contexts, which are farthest away.[2]

All clan paintings, both Dhuwa and Yirritja, are said to possess bir'yun (Thomson, field notes 4.8.37). However, depending on the clan and wangarr ancestor concerned, the bir'yun itself may have different connotations. For example, Thomson records that the bir'yun of a Gupapuyngu *birrkurda* (wild honey) design (an equivalent of the Munyuku wild honey design discussed in chap. 8) expressed *gapu raypiny*, "the light of fresh water" and the light of eucalypts in flower; *ngoy ngamathirri, ngoy kitkitthun*, "[the light makes] the heart go happy, [makes] it smile." The wangarr *birrkurda* is associated with fresh water and eucalypts in flower (the source of pollen for the bees), and both the meanings are encoded in the design. The visual effect of the painting, its bir'yun, is thus integrated with the semantic aspects of the painting, enabling it to express characteristic properties of the wangarr being that it represents.

In the majority of cases, as above, bir'yun is described as expressing positive emotions: *wakul*, "joyfulness," *ngamathirri*, "happiness," and so on. However, Thomson gives one detailed example in which bir'yun expresses negative emotions. It again concerns the shark but on this occasion refers to the shark in Djambarrpuyngu country before it reached Wurlwurlwuy in the country of the Djapu clan. The painting Thomson was concerned with was an entirely geometric painting rep-

2. Although Thomson did not collect paintings of this type from the vicinity of Yirrkala, there is no doubt that an analogous category of paintings existed in that area. The paintings collected by Chaseling in the late 1930s fit into this category. The paintings consist primarily of figurative representations and are characterized by an absence of clan designs (see Morphy 1977a). Although the paintings were not documented by Chaseling, Yolngu today describe them as *garma* or outside paintings.

resenting wells and watercourses created by the shark after it had been speared by the hunters. In this case Thomson records that the bir'yun of the painting is also referred to by a more specific term, *djawarul*. *Djawarul* is the proper name of a sacred well (*mangutji*) created by the wangarr shark at the place where the shark was speared by the ancestral being Murrayanara. *Djawarul* refers to the "flash of anger in the shark's eye—the blaze of the eye of the shark killed by stealth." The spirit of the wangarr shark is dangerous (*mardakarritj*) and was described as *miringu maarr*, "power of vengeance."

I argued in chapter 5 that from the perspective of the clan linked with the mardayin, the power of the wangarr is always morally positive. It cannot be used by sorcerers. It can, however, be used by clan members out to avenge the death of one of their number, whether killed violently or by sorcery. It can also be used against those who violate a religious taboo or infringe rights in women. In such cases the violent and aggressive dimension of the shark's power is signaled by the performance of dances and the use of ritual objects and attire that refer to the shark's anger and anguish. The connotation of the dances influences the sense in which the power of the wangarr is understood and perhaps even felt. Yolngu rituals and sometimes separate phases of rituals tend to have a particular ethos or emotional quality, which is evoked by the performance. Thus, in direct contrast to the vengeance dance of the Djapu shark, I was told that the Djungguwan is a ceremony of love, friendship, and happiness, and in that context, it could be argued, more positive images of ancestral power are generated.

Contemporary Categories of Painting

A simple comparison between Thomson's categories of Yolngu art and the categories of art produced by the Yolngu today is not possible. During the intervening period of some forty years, major changes have taken place in the artistic system as a result of European contact, in particular through the development of the art and craft industry at Yirrkala. Not only has this led to the creation of a new, functionally defined, category of art—art produced for sale to Europeans—but it has also resulted in a changed relationship between the componential structure of paintings produced in public and restricted contexts. Commercial art is primarily produced and displayed in public contexts (the craft store). However, on morphological criteria alone much commercial art is indistinguishable from the paintings of Thomson's likanbuy category, paintings which in an unmodified form were restricted from all but initiated men. Moreover, on purely formal criteria, commercial paintings crosscut other categories of art as well as including innovated designs that were not previously produced. In order to compare

Table 9.3 Categories of Painting in 1974–1976, Defined by Context

Context	Type
Open	$\begin{cases} \text{(1) Commercial (see table 9.4)} \\ \text{(2) Decorative (\textit{wakinngu})} \end{cases}$
Intermediate	$\begin{cases} \text{(3) Memorial posts (\textit{likanbuy}-type)} \\ \text{(4) Dilly bags (\textit{bulgu})} \end{cases}$
Restricted	$\begin{cases} \text{(5) Coffin paintings} \\ \quad\text{(\textit{likanbuy}-type)} \\ \text{(6) Paintings on men's ground} \\ \quad\text{(\textit{ngaarrapuy} + \textit{likanbuy}-type)} \end{cases}$

Thomson's categories with art produced today, it is necessary to make an initial distinction between commercial art and "traditional" art, that is, art produced in "traditional" cultural contexts and not for sale.

Table 9.3 shows a list of types of Yolngu art that occur today, including commercial art, defined in relation to the contextual typology that was applied to Thomson's categories (table 9.2). In parenthesis after each type I list the Thomson category with which the paintings correspond as far as their componential structure is concerned. Note that paintings structurally similar to those in Thomson's likanbuy category, and which in the past were displayed only in restricted contexts, today occur in a variety of different contexts. I now briefly discuss each type.

Decorative art as an indigenous category hardly exists today among the Yolngu. The reason is simple: few of the objects previously decorated are still produced by the Yolngu for their own use. Some old women still use decorated net bags, and spear throwers are occasionally decorated, but on the whole the artifacts that were decorated have been replaced by European equivalents—net bags by baskets, mats by towels and blankets, and so on.

Thomson's *garma* category no longer exists at Yirrkala except on commercial bark paintings. Garma paintings were associated mainly with hollow log coffins and publicly performed phases of mortuary ceremonies. Hollow log coffins are no longer produced in that the bones of the dead are no longer deposited in them. However, equivalent objects such as memorial posts and containers for the possessions of the dead are produced. The paintings on these fit Thomson's category of likanbuy paintings, that is, the paintings which include elaborately infilled clan designs and which were previously restricted. As the context remains an open one, paintings used on memorial posts have effectively been opened out to a wider context. Similar considerations apply to paintings used in circumcision ceremonies, but mainly

because the designs are no longer modified or covered before the boys rejoin their mothers.

I have placed both these types of paintings in the intermediate type, since the production of the paintings is still surrounded by constraints. Djuwany (memorial) posts are produced entirely in seclusion from women and uninitiated men. They are erected in secrecy at night, and women only see them once they are completed. Similarly, the bodies of initiates at circumcision are painted away from women, and while the painting is going on the majority of women avoid the area. Certain old women communicate between the painting group and the remaining people, bringing food to the men, dressing the initiate prior to painting, and continuing to dance around the periphery. Evidence suggests that this was the traditional pattern;[3] the innovation is that no attempt is made to modify the painting after the ceremony. However, as we shall see, the process of opening out is both continuous and uneven, and in the case of some clans it has been taken much further. By 1976, the women of certain clans had begun to take an active role in painting in ceremonies, assisting with designs being painted on male initiates' bodies and painting the designs on coffin lids. Things had moved a long way from the days when such paintings were hidden from the gaze of women's eyes.

Sacred dilly bags are produced and used in similar contexts, with similar constraints today as in Thomson's time. The designs on them are likewise minimally elaborated clan designs consisting of a basic outline.

Certain paintings are still produced in completely restricted contexts. Coffin paintings (with the exception of a few cases referred to above) are produced in seclusion, away from women. The lid of the coffin is usually painted inside a shade specially built for the purpose. Women largely avoid the area of the shade while painting is going on, and food is left outside the shade to be collected by the men. As soon as the painting is completed, it is covered with a cloth prior to the body being placed in the coffin. The lid is then hammered onto the coffin, and the whole thing is completely covered before being taken out of the shade. Coffin paintings are equivalent to the paintings on the body of a deceased person described by Thomson (Peterson 1976:97). They fit into Thomson's likanbuy category on formal grounds.

3. Thus Thomson records in his field notes that one of his informants, Raywala, with whom he traveled throughout Arnhem Land, was shocked that very old women in the Yirrkala area participated in the final stages of a circumcision ceremony and saw the painted bodies of the youths. This suggests that between the eastern and western Yolngu-speaking areas there were regional differences in women's access to sacred paintings.

Single-figure body paintings are still produced in the context of the men's ceremonial ground. For example, at the Djungguwan at Trial Bay, the paintings that were produced on dancers' bodies were similar to those illustrated in Warner's photographs of the dancers accompanying the sacred trumpet (see Warner 1958, pl. 5a and 5b). A likanbuy painting similar to figure 9.3 was also made on the men's ceremonial ground. These paintings were covered up before the dancers returned to the public arena.

Thus although paintings which are of the same componential structure as Thomson's likanbuy category are produced today in open contexts, there are still contexts in which paintings are restricted; paintings that uninitiated men and, in particular, women are not allowed to see are still produced. The difference lies in the fact that in the past, this restricted category corresponded to a particular morphological type, whereas today it does not. The same painting in fact may be produced in open and restricted contexts. The painting in figure 9.3 is a case in point. This painting was produced in an open context and worked on by Bokarra and his wife, the latter doing most of the cross-hatching on the painting. Previously Bokarra had produced the painting on a djuwany post for a Djungguwan ceremony. In this case the work was done in seclusion. Bokarra did most of the work himself with some assistance from Dula, the second most senior manager for the ceremony. Women and young men were prohibited from entering the house where the painting was being done. After completion, the posts were displayed publicly in the main camp.

The fact that in particular contexts a painting is restricted is significant, even though the painting itself is also produced in public contexts. The restrictions enable a boundary to be maintained between different individuals' knowledge of what was known to have been produced in a particular context. Thus although everybody is familiar with the form of a particular painting, some of the contexts of its use are restricted knowledge. I argued earlier that the existence of closed contexts means that all knowledge is subject to what I referred to as the mask of secrecy. Even if the outsider knows that substantive leaks occurred, the status of what is publicly known remains unclear. Moreover, by being denied access to contexts, people are denied information about the meaning of paintings, even if they would learn nothing new about their surface form. They may, for example, not know the connection between a particular painting and a certain sacred object and hence may not learn the reference of a particular element of the painting. By missing the context in which a painting is revealed or the ritual event that enacts its meaning, they may have less insight into its thematic content. We have seen that as far as the so-

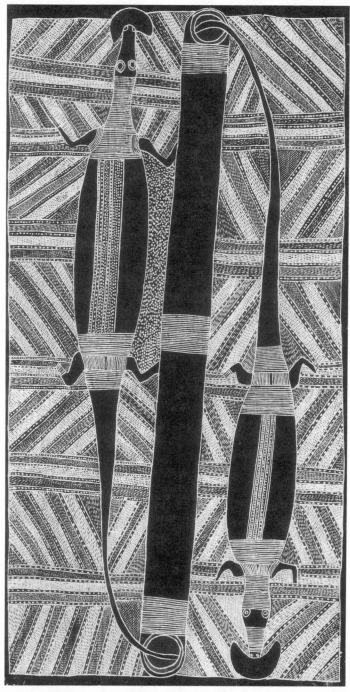

Figure 9.3 A Djungguwan painting of the likanbuy type. Artist: Bokarra.
Clan: Marrakulu (artist's M clan).

ciological meaning of a painting is concerned, its production on a particular man's body signifies something about the relationship of the man to the painting and to the groups owning the painting. By denying people access to the painting in this context, knowledge of the relationship between the individual and the painting is kept restricted.

The above discussion shows how, even when a painting has been opened up to a wider audience, its continued use in a restricted context operates to restrict knowledge about it. However, not all paintings occur in open contexts; many paintings still are restricted from the uninitiated. What has changed absolutely is that the difference between the restricted category and the public one can no longer be characterized in terms of the componential structure of the paintings. This was always the case with Thomson's ngaarrapuy paintings; today it is true for the likanbuy paintings also. In order to consider the composition of the restricted category as it exists today, I first examine in detail the commercial category of art because commercially produced paintings as a rule can be made in open contexts, whereas paintings that cannot be produced for sale are generally not painted in public.

Commercial Art

The Yolngu craft industry has developed over a period of fifty years, though only since the late 1950s has it begun to be of major economic significance to the Yirrkala community (see Williams 1976).[4] During this time, Yolngu have become increasingly aware of the consequences of selling art to outsiders, in particular of the impossibility of maintaining control over the secrecy of restricted paintings sold to Europeans (see Morphy and Layton 1981). Thus although until the mid-1960s any restricted paintings done for sale were produced in seclusion away from women and wrapped in cloth before being taken to the craft store, this did not prevent the paintings from returning to the community in printed form through various publications. Awareness of the consequences of selling restricted paintings to Europeans grew over a number of years, during which time many paintings had already been sold to outsiders. This meant that many paintings were already committed to a public arena before Yolngu were able to reimpose restrictions (Morphy and Layton 1981). Of course there is also the possibility that in many cases the intention of a sale was to open out the art.

4. I do not discuss here in detail why certain categories of art have been opened up to a wider public. The factors involved concern not only decisions made by the Yolngu themselves in the context of their own culture, but decisions made in relation to the European demand for Yolngu art, a demand mediated through craft-store managers, art dealers, anthropologists, and various government bodies. See Morphy 1983a, 1987; Morphy and Layton 1981.

The sale of art to Europeans is cited as one of the factors that led to the opening out of certain paintings in traditional contexts. The craft industry, however, was only one of the contexts in which previously restricted paintings were released publicly. I referred briefly to some of the others in chapter 2. In 1959, a number of sacred paintings and objects were incorporated in a permanent memorial in the center of Elcho Island settlement as part of what Berndt (1962) terms the Elcho Island adjustment movement. A number of Yirrkala clans participated in the movement. Two years later the Reverend Edgar Wells commissioned a series of painted panels to be placed beside the altar in the Yirrkala church (Wells 1971). Many of these paintings too had previously been restricted. In both these cases, Yolngu who participated were clearly aware of some of the consequences of their decision to produce the paintings, certainly of the fact that uninitiated men and women would see the paintings. The paintings in the Yirrkala church were said by the informants to be the reason why the paintings done on boys prior to their circumsion no longer had to be concealed.

The relationship between the commercial production of art and the opening out of paintings is a complex one, set in the framework of a dialectic between the traditional values of Yolngu culture and changed circumstances consequent on European contact. This dialectic manifests itself in terms of the differential responses of Yolngu clans. Today members of certain clans are deliberately continuing to remove restrictions on paintings at least at the level of form, as well as opening out other areas of the clan's ceremonial life to women and uninitiated men through the public performance of previously restricted phases of a ceremony. Other clans, however, have consciously attempted to preserve the integrity of their restricted category of art, though in all cases there has been some lessening of the boundaries between categories.

Table 9.4 lists a number of categories into which I have divided commercial paintings. In reference to these categories, however, bear in mind that a clan's paintings are controlled not by individuals but by owning clans and managers (see chap. 3). Decisions about which

Table 9.4 Categories of Commercial Painting

Clan-owned paintings	(1) Paintings that were once restricted, *likanbuy*-type paintings
	(2) Paintings based on *garma* paintings
Innovated paintings	(3) Modified *likanbuy*-type paintings
	(4) Paintings representing "public" stories, myths
	(5) Hunting stories
	(6) Innovated paintings with no mythological reference

paintings to produce for commercial sale are made largely at this level, and the members of different clans make different clan-based decisions. The categories of commercial art must be understood to operate in the context of clan-based decision making: the different categories and the different paintings included within each category represent different clans' responses to the problems posed by commercial art.

The first category of commercial painting consists of paintings that were once restricted and which are today produced in an unmodified form for sale. On the basis of their morphological structure, these are termed likanbuy-type paintings. Bokarra's painting from the Djung-guwan ceremony is an example.[5] The majority of clans, if not all, have produced one or two paintings from this category, the basis of selection varying according to clan. The Munyuku clan, for example, has released one painting from each of four major areas of land owned by the clan. The explanation given was that the painting would show Europeans which areas of land were owned by the clan.

The particular set of paintings produced for sale may vary over time. The case of the Djapu clan provides an interesting example. During the first years of my fieldwork, the clan restricted all paintings associated with the Djan'kawu sisters and released paintings associated with the shark *maarna*. Until the death of the clan leader Wonggu in the 1950s, Djan'kawu paintings were produced by the Djapu, and they continued to be produced in restricted contexts after his death. For example, one was used on the coffin lid of a Djapu child in 1976. However, on Wonggu's death his sons decided that Djan'kawu paintings should no longer be produced for sale. I originally hypothesized that the Djan'kawu paintings were the most important and that the sons were reimposing a "most restricted category" on the basis of degree of sacredness. Subsequent events cast doubt on this explanation. By 1978, most of the senior sons of Wonggu, the men who made the decision to restrict the Djan'kawu paintings, had themselves died. The senior members of the next generation then imposed a ban on paintings associated with the shark, and Djan'kawu paintings came into the open. Although the injunction on the shark paintings was only temporary, it suggested an alternative explanation which was supported by the fact that in two other cases the death of a senior man resulted in impositions of restrictions on paintings that had previously been produced in public. The obvious analogy is with the restriction on or repression of

5. Williams (1976:282), following Graburn's (1976:13) typology of art produced by non-Western peoples in response to the demands of European contact, terms this type of bark painting "functional [fine] art." This refers to paintings unmodified in form from ones used in traditional cultural contexts which are classified by the European purchaser, or rather the "primitive art" market, as "fine" art.

words associated with a person's name on his or her death. They are too closely associated with the person to be used. Again this fits well with my earlier discussion of the system of restricted knowledge: the mask of secrecy first shifts to obscure one set of paintings and then moves on to seclude another, while at the same time revealing the former. While at present the restricted set seems to be diminishing in size over time, it can potentially at any time be re-created, for there may never have been a Yolngu rule that for something to be restricted it must have been restricted for all time, and there is certainly no such rule today.

The second category of paintings is clearly derived from Thomson's garma category, and indeed this word was sometimes used to refer to them. The paintings consist of figurative representations of animals that were previously painted on hollow log coffins. Some of the first paintings from Yirrkala sold to Europeans fell into this category. These were the paintings sent by the Reverend Chaseling to the Australian Museum in the late 1930s. The majority of Chaseling's paintings are said by Yolngu to be either garma paintings or wakinngu (ordinary, nonancestral). One in fact is the same as a painting on a hollow log coffin illustrated by Chaseling (1957). Today, paintings of this type often have as a central feature a representation of the coffin, with the figurative representations that would have been on the coffin painted around it. The main difference between these paintings and the garma paintings recorded by Thomson (and represented in Chaseling's collections)[6] is that the space between the figures is infilled with crosshatching. Clan designs are not represented on the paintings, however, and in this way they are like Thomson's garma category.

The next category, modified likanbuy-type paintings, refers to paintings that derive from those in the restricted category but which differ from them in a number of significant ways. Morphologically, the main difference consists of an increase in the proportion of figurative representations and a corresponding decrease in the geometric component, in particular the clan designs. There are two main reasons for this modification of the restricted paintings: it makes them a more marketable commodity, and it enables the restricted category to be maintained intact. Paintings that are largely geometric have been harder to sell than ones with a large number of figurative representations, and as a consequence a lower price is paid for them (though this is changing as the market becomes more sophisticated). The second factor is more significant for the present discussion.

6. Chaseling's painting are located in three museums: the Australian Museum in Sydney, the National Museum of Victoria in Melbourne, and the Queensland Museum in Brisbane.

On several occasions, Narritjin explained to me that it was because he was producing commercial paintings for sale in open contexts that he painted so many figurative representations of animals in his work: "If I was away from women, the painting would be just the same but this possum, this bird, they wouldn't be here; I would put just a number for them." In other words, instead of painting a possum he would paint a geometric motif that could signify, among other things, a possum. I consider in detail the significance of such modifications of paintings as far as the Manggalili clan is concerned in a later section. Here I focus on the general implications of the replacement of geometric components by figurative ones.

There are many reasons why the increased figurative content should make a painting more suitable for public display. One is obviously that it makes the painting look less like the closed art at a formal level. Figure 9.4 represents a likanbuy version of Welwi's painting of the hunted kangaroo referred to earlier (see fig. 9.2). All of the meanings signified in the public painting are encoded in the more restricted painting, as can be seen from the caption.

The second reason, related to the first, is that by converting geometric elements to figurative representations, the multivalency of the geometric form is lost. Even if the meaning was not available to the interpreter, it obviates the issue by fixing the meaning of the painting in a particular way, in this case a hunter chasing a kangaroo through the forest. Nothing in the figurative content suggests a particular mythological context or geographical location.

The increase in the number of figurative representations as a means of making a painting more public is a logical corollary of the significance of the geometric component in the restricted category: it reduces its multivalence and focuses attention on one set of relationships rather than another. The absence of clan designs in many paintings of this category removes the paintings from the political arena and at the same time makes them less part of the category of ancestral design.

Modified restricted paintings are termed by Narritjin "traveling paintings." The word *traveling* has an intended double meaning. At one level the word refers to the fact that the meaning of the painting is fixed at a certain level to represent the journeys of ancestral beings across Northeast Arnhem Land, but not in such a way that it refers to specific land-transforming events that occurred in particular places. At a second level it refers to the fact that the paintings themselves are designed to travel; they are suitable for sale to Europeans and for wide dissemination. The clan design which is most frequently painted on Manggalili clan paintings of this type was referred to by Narritjin as a public or "traveling" design. It is a design which has no specific loca-

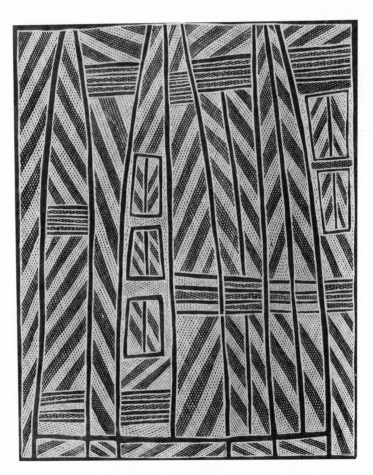

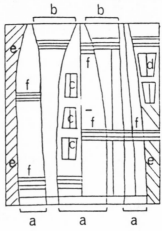

tional referent. It was also the first clan design that women members of the clan were allowed to paint, and this shows another way in which sociological distinctions expressed in the artistic system can be maintained in spite of changes that have occurred in recent years. Thus whereas in the past women would have been forbidden to paint clan designs, today Manggalili women are allowed to paint only a designated outside clan design, the right to produce the main clan designs being restricted to initiated men. Control of the system is still exercised by senior men, but this control is signified by new distinctions and is gradually increasing the freedom of women to use the system.

The fourth category consists of paintings that have been innovated in response to the demand for commercial art and which, although they are based on myths, are not derived directly from traditional paintings. One example of a painting in this category is the Bamapama painting (fig. 9.5), which represents one of a series of public myths concerning Bamapama. These myths are told to children as moral fables illustrating the consequences of breaching cultural norms. According to Narritjin, he invented the form of the painting some thirty years ago. Although a recent invention and not one used in restricted cultural contexts, the painting is regarded as belonging to the Manggalili clan and as subject to the same rights of ownership as other paintings he produces. Members of the two other Yirritja moiety clans who own the story also have the right to produce the painting, but according to Narritjin they should be taught the correct way to do it by him.

The final category of paintings consists of innovated paintings with no mythological reference. These paintings are produced for sale by women and uninitiated men. I have never heard people claim rights

Figure 9.4 The multivalency of the geometric art. Artist: Welwi. The painting represents the land over which the ancestral woman Ganydjalala hunted. The three elongated figures (*a*) represent ceremonial grounds (molk) created by Ganydjalala when she chopped down stringybark trees (*b*) in her search for honey. The cross-hatching within the molk represents bees, larvae within the hive, and dust thrown up by the feet of the dancers. The crossbars (*f*) represent djuwany posts positioned within the molk. They also represent a manifestation of Ganydjalala—in various places she and other ancestral beings associated with her transformed themselves into post figures. From a different perspective, the painting represents the stone spear quarry at Ngilipitji (see Thomson 1949b:87). The designs marked (*c*) represent stones split down the middle, and the red and white bands of cross-hatching within them represent piles of stone spearheads. The stone spears were moved to the edge of the quarry (*d*), where they are represented by (*d*) and by the red and white crosshatched bands (*e*). The figures (*c*) and (*d*) also signify kangaroo—the dividing line representing the kangaroo's backbone and the cross-hatching representing the fur of its back singed by the fires which were lit by Ganydjalala.

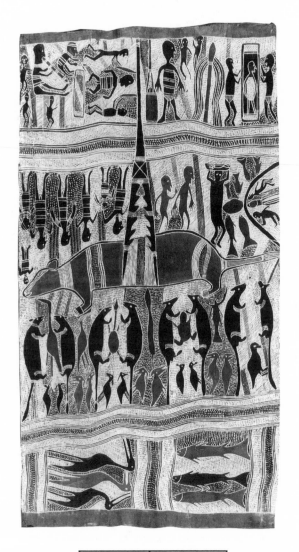

a	d
b	c
e	
f	
g	

over the designs, though people do sometimes complain that others are copying "their" design. The paintings consist of representations of animals and plants, frequently arranged to form symmetrical patterns. The paintings are covered with uniform cross-hatching but never include clan designs. They are referred to as *wakinngu* (ordinary) (the same term was applied to Thomson's category of decorative art), "anyhow," or "rubbish" paintings. The terms applied refer to the nonancestral non-clan-based nature of the paintings.

Conclusion

I now examine the significance of the differences between Thomson's likanbuy category of paintings and the paintings that belong to or are derived from that class of paintings today. In particular I consider two problems: the extent to which distinctions that operated in Thomson's time exist today and are manifest in the operation of the artistic system, and the consequences of the shift that has occurred in the dimensions of categorical distinction within the system.

Figure 9.6 shows the relationship between Thomson's likanbuy paintings and likanbuy-related paintings today, according to the level of distinction at which restriction can be seen to operate. Restriction is defined in relation to the opposition between initiated men, on the one hand, and uninitiated men and women on the other.

In the immediate postcontact period, likanbuy paintings were restricted at the level of form class (fig. 9.6, level 1). Access to paintings of the componential structure that characterizes likanbuy paintings was restricted to initiated men or men undergoing initiation into the mardayin with which it was associated. All other levels of distinction are

Figure 9.5 An innovated painting. Artist: Narritjin. Clan: Manggalili. Bamapama, a trickster ancestral being (see Warner 1985:545ff. and Groger-Wurm 1973:124), was sent to collect young men for a ceremony. He went to a nearby settlement (*a*), but asked for young girls instead of boys. He challenged them to a race, saying that only the fastest one would be selected for the ceremony (*b*). One girl, his classificatory sister, raced ahead of the rest, and eventually she and Bamapama were alone. They rested to fish at a lake, and Bamapama sent her to collect firewood. While she was away he inserted a fishbone in his foot, and on her return said that they would have to camp for the night because he was lame. They build a hut with a fire in the center (*c*). In the night Bamapama threw stones onto the roof, and frightened the girl by saying that the sound was made by a sorcerer. She moved over to his side, whereupon he raped her, killing her with his large penis. He hid her body in a bark container and returned to her camp (*d*). When people found out what had happened they started to beat him (*a*). He became wild, and began to spear dogs (*e*) and vegetable food (*d*), that is, things people do not normally spear. After a while, everything began to change. All the people turned into the animal species that were totems to their clan (*f*) and (*g*), and returned to their own clan territories. Finally, a great flood came and covered the area where the events had taken place.

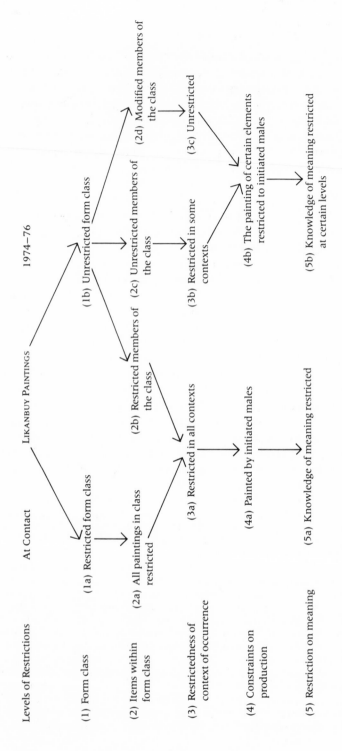

Levels of Restrictions

At Contact Likanbuy Paintings 1974–76

(1) Form class

(1a) Restricted form class

(1b) Unrestricted form class

(2) Items within form class

(2a) All paintings in class restricted

(2b) Restricted members of the class

(2c) Unrestricted members of the class

(2d) Modified members of the class

(3) Restrictedness of context of occurrence

(3a) Restricted in all contexts

(3b) Restricted in some contexts

(3c) Unrestricted

(4) Constraints on production

(4a) Painted by initiated males

(4b) The painting of certain elements restricted to initiated males

(5) Restriction on meaning

(5a) Knowledge of meaning restricted

(5b) Knowledge of meaning restricted at certain levels

Figure 9.6 The opening out of the likanbuy category.

redundant. If the form class is restricted, so too are members of that class in all contexts and so is knowledge of the meanings encoded in the paintings. In other words, restrictedness at other levels is a coimplication of restrictions imposed at the level of form class. The other levels at which restrictions could be imposed were relevant to the process of male initiation and to the control of the system by the senior initiated men. As I suggested earlier in the chapter, revelation of the form of paintings was only a preliminary stage in gaining access to knowledge of their meaning. The rights to produce and determine the contexts of use of a particular painting were vested in the hands of a few senior men.

Likanbuy-type paintings today are not restricted at the level of form class. However, many members of the class are restricted in that they are not produced or displayed in public contexts. And still more are relatively restricted in that they are infrequently produced and can only be done by a restricted set of people. The unrestricted members can be divided into two types—unmodified likanbuy-type (2c) paintings, and paintings modified on the basis of criteria set out earlier (2d). Unmodified paintings (2c) can be restricted in some contexts, for example, when produced as coffin paintings, whereas modified ones (2d) are never produced for restricted contexts. This corresponds to the distinction between paintings that can be produced commercially but are still used in traditional cultural contexts and commercial paintings of a type that are not used in such contexts.[7]

Although unrestricted paintings can be seen by women and uninitiated men, constraints are imposed on their role in producing the paintings. The extent to which they are constrained varies from clan to clan. In the majority of cases, women play a subsidiary role in the production of likanbuy-type paintings (2c) and cannot initiate the painting themselves.

In 1974 the one major exception was the Rirratjingu clan, in which two senior women had been given the right to produce a certain number of likanbuy paintings themselves. In nearly every other clan, however, women helped with the crosshatched infilling of the paintings and in some cases were encouraged to do the figurative component. Women did not draw the major clan designs nor did they determine the structure of the painting. This is significant as it helps confirm the basic relationship between the geometric component of

7. The distinction is not an absolute one but it applies in the majority of cases. Modified likanbuy paintings do have a didactic function (see Williams 1976:282). Moreover, in Morphy 1977c I give an example of a painting innovated for the commercial art industry which did have a use value in a traditional context. I have, however, never seen such paintings used on coffin lids or as body paintings.

the system and the figurative component—the latter being less restricted than the former. Similar constraints applied to modified likanbuy paintings which include clan designs as a component.

In the decade following my first fieldwork, the position has changed somewhat in that more women have begun to produce likanbuy paintings. Indeed by 1988, women of most clans produced, entirely by themselves, likanbuy-type paintings which in 1974 they would only have assisted with. In a comparatively short period of time, the opening out of paintings previously produced exclusively by men has resulted initially in women assisting with their production and finally in them initiating much of the production themselves. While in the beginning the process involved the use of existing categories and distinctions to create continuity with past exclusions by limiting the area of women's participation, with hindsight this can be seen as a process of transformation in which the categories were changing. Women, by participating in one stage of the painting, were by definition introduced to other stages and were placed in an ideal position to learn.

The final distinction operates at the level of meaning. In this case, public ideology is that the distinction is absolute and that there are levels of meaning that women and uninitiated men are denied access to. Although as I argued earlier, it is problematic what this means in practice, it is an unquestioned public assumption and reflects the ordering of knowledge along the inside-outside continuum.

Overall we can see that the changes that have taken place still enable restrictions to operate within the system, though the level at which those restrictions are imposed varies from clan to clan and painting to painting. All clans may well have maintained certain paintings in the wholly restricted category. In some cases the majority of a clan's paintings are acknowledged to have been released into the public arena, and in others many have been held back.

One of the main consequences of the changes that have taken place is that one major level of distinction has been eliminated—that of likanbuy paintings as a restricted-form class. From this it follows that bir'yun is no longer a distinctive feature of restricted paintings. Paintings with elaborated clan designs and fine crosshatching now appear in the public sphere.[8] The changes have also brought painting into the

8. Fine cross-hatching covering most of the surface of a painting, which in the past was an attribute of the restricted category of paintings, has become the distinguishing characteristic of Yirrkala art as far as the commercial art market is concerned. The evaluative criteria applied by European purchasers include the fineness and density of cross-hatching, and the prices paid for the art vary accordingly (see also Williams 1976:277). Cross-hatching is the most labor-intensive part of producing a commercial bark painting, and women have been encouraged to take over this part of the work. In

sphere of discourse between men and women in a way that it was not present before. Thus men instruct women in the techniques of painting and in the public aspects of the meaning of paintings. Women are also in a position to see for themselves the relationships between paintings belonging to different clans and to make deductions as to further meanings on the basis of the limited information they are acknowledged to have been taught. The effect, overall, is that although older initiated men still exercise control over the system and although restrictions on women's knowledge are still imposed, the parameters are shifting in the direction of a gradual opening out of many aspects of the artistic system.

the past, women were denied access to the finest crosshatched paintings, whereas today they are instructed to produce the finest cross-hatching they can. The frequency with which individuals are exposed to fine cross-hatching and the fact that it is no longer confined to the most restricted category of paintings suggest that its aesthetic impact may have been reduced. However, cross-hatching is still said to make a painting "bright" or "shiny" and to endow it with ancestral power (maarr). For an extended discussion of this aspect of the aesthetics of Yolngu paintings, see Morphy 1989.

10 Manggalili Iconography

At this stage in our exploration of Yolngu art we can look at the meanings that are encoded in a particular set of paintings and consider the ways in which the paintings can be interpreted. We are moving from how Yolngu art means to *what* it means and beyond that to its potential for interpretation. In some cases the interpretations may not be pushed as far as the reader may like, and on other occasions seemingly obvious interpretations may be ignored. These omissions may mean only that the mask of secrecy has passed across the pages of this book.

The paintings to be analyzed belong to a single clan, the Manggalili, and are by Narritjin Maymuru and his family. The paintings are chosen because I know them better than any other clan's set of paintings. But although the paintings belong to one clan and in many respects reveal the guiding hand of a single artist at work, people of many different clans have rights of one kind or another in Manggalili paintings. In ceremonies the paintings are integrated with the products of many other clans' sacred law. Other Yirritja moiety clans share similar paintings; the

paintings are associated with different places, it is true, but they share broadly overlapping sets of interpretations. Many of the mythic themes encoded in Manggalili paintings are shared in some form or another by all Yolngu clans. So, overall, they have no status other than as a subset of Yolngu paintings.

When I was searching for a quotation from Narritjin to begin this chapter on his clan's paintings, I thought how he himself might have introduced them. The answer was obvious; he would have begun by denying that they were his creations. He would never have denied that he or his clan owned them or that they painted them, but he would have denied that he had any hand in inventing them. So at the beginning of a set of chapters that is a celebration of Yolngu creativity and in particular of Narritjin's creativity, I feel morally obliged to reprove myself in advance with Narritjin's denial of the very possibility of innovation in Yolngu art: "We can't follow up a new way—the new way I cannot do that—I go backward in order to work. I can't do anything new because otherwise I might be making up a story—my own thoughts you see—and people over there, wise people, would look at my work and say, 'Ah! that's only been made up by him.' "

An Iconography in Context

By the term *iconography* I mean the relationship between the form of paintings and their meanings, that is, those meanings thought to be encoded in some way or another in the form of the paintings. I am concerned here mainly with meanings that I referred to earlier as iconographic, and with thematic meanings which operate at a collective level, even if (as we shall see) they are not in all cases widely shared. Meaning arises not only through the meaning of the elements employed in the artistic system, but through the relationship between the elements in paintings and between the different paintings. The iconography I present, although a descriptive one, cannot consist simply of a list of the possible signifieds of formal elements in Manggalili art or of separate interpretations of a set of paintings; it must also be concerned with the relationship between the interpretations of the paintings and variations in their form and componential structure. For meaning in Yolngu art exists in multiple interpretations of paintings, out of which an understanding of the meaning of the elements ultimately emerges. So this is how the iconography is presented: not as a fixed list of meanings but as an emergent iconography, one that is imminent in the form of paintings and which is stimulated by the interpretative process. Interpretations are a response to paintings, albeit a response mediated and constrained by sociological factors.

It should be clear by now that the position of the interpreter in rela-

tion to the painting (his or her status, knowledge, and experience) is a central component of any iconography of Yolngu art. Because art encodes meaning in the context of a system of revelatory knowledge, we must consider not only "what it means" but "to whom it means." As far as the form of the painting is concerned, we must ask not only what meanings it may encode but also what meanings it may obscure.

We could ask at this stage whether it is even possible to talk about the meaning of a painting in a semiological sense, and question whether there is *a* Manggalili iconography or many. In answer I would argue that Manggalili iconography as a whole is a coherent system, that the logical relationship between the various levels of meaning and the fact that they are interdependent make any attempt to divide them up into components of separate iconographies an arbitrary exercise. Although one gains knowledge by being taught more about the significance of a painting, one is always in advance of one's teachers because it is always possible to read more knowledge "out" than one is actually given. Part of the process of interpretation is keying in to the connotations of iconographic meanings by relating them to particular themes. It is thus possible to use the system to gain more information about it than one is told it contains. The extent to which that information is encoded within the system represents the communicative capacity of the code—its ability to generate messages.

It is difficult to test this proposition against individual experience. Partly because of the short duration of anthropological fieldwork, it is hard to determine the relationship between what an individual is taught and what he learns beyond what he is taught. More fundamentally, Yolngu ideology, which holds that all knowledge of the meaning of paintings is taught, operates against finding the answers to such questions. Moreover, an individual will not repeat even that taught information unless he has the authority to do so.

As I show in chapter 4, the authority to release restricted information is limited to one or two senior members of each clan. In their case it is difficult to separate what has been taught from interpretations that have arisen from introspections about the meaning of signs and symbols. We cannot always isolate inculcated knowledge from individual life experiences, or individual insights from collectively held knowledge. Clearly the two are related. Insights that are the result of individual introspection by senior men about the meaning of symbols can become part of the formal body of knowledge that subsequent generations are taught (as ancestral law). When constructing an iconography, ideally one should be concerned not only with what is known and said about the meaning of paintings, but also with meanings that are encoded in the paintings but which are not articulated at a

particular point in time. Contrary to Yolngu ideology, the meanings, as we shall see, are not a finite set. I aim to discuss Manggalili iconography in a way that demonstrates the potential productivity of the symbols.

The iconography is presented through interpretations of specific paintings. I first consider the outside or most public levels of interpretation and subsequently the relatively more restricted ones. The relationship between interpretations and paintings is a complex one. The interpretations I recorded may be seen as extracts from the chunk of ancestral law associated with a particular place. Although interpretations are engendered by paintings and can be related to specific formal elements of paintings, they also exist independently from particular paintings and are available to be applied to them. Different paintings can be interpreted in the same way, that is, they can be said to have the "same meaning." Thus, rather than discussing each painting individually, indicating how each signifying component has a number of signifieds at different levels, I show how the same meanings are encoded in different ways in the context of different paintings. This enables me to focus on the relationship between the paintings as sets and their meanings as networks of interconnection, placing multivalency in the context of the overall system of meaning and interpretation. It also enables me to approximate more closely the revelatory nature of knowledge of the meaning of paintings. Yolngu do not learn first one painting and its meanings at different levels before progressing to another (though some paintings indeed are more restricted than others); rather they learn the meaning of a set of paintings and subsequently further levels of meaning that apply to the same set. I show in the concluding part of the chapter how an abstract interpretative template underlies the set of paintings and is both a factor in the interpretation of paintings and in the generation of new paintings.

Interpretations of paintings were obtained from male and female members of the Manggalili clan as well as from nonclan members. The interpretations by nonclan members were always set at the most outside level, the one open to women and uninitiated men. These usually consisted simply of identifying the clan ownership of the painting, the place represented, and the referential meaning of the figurative representations. This level of knowledge does not necessarily represent that held by the interpreter. It represents the minimal degree to which nonclan members have the rights to divulge information about clan paintings other than their own without the consent of senior members of the owning clan. Mithili, a Marrakulu man and senior waku (ZS) to the Manggalili, was present on several occasions when Narritjin dis-

cussed inside meanings of paintings with me. He clearly had access to this knowledge but would never discuss Manggalili paintings with me in detail. The only occasion he used this knowledge was in Narritjin's absence, when he advised Narritjin's sons to tell me only the outside story for a particular painting and said that Narritjin would decide what else to tell me on his return. This example illustrates the constraints imposed on members of the clan which prevent them from divulging information without the permission of senior men. Bokarra, the second most senior Manggalili man, always deferred to Narritjin, even when it came to interpreting paintings he had produced himself, only giving me the acknowledged public level of meaning. This does not mean that all other interpretations are secret. It does, however, reflect the fact that all knowledge is potentially layered and that even in the case of the outer layer, hierarchical restrictions can be seen to apply in some contexts.

The lack of authority of the majority of individuals to pass on information about the meaning of paintings makes it difficult to define levels of interpretation beyond stating what is public knowledge and what is in some ways restricted. Information about levels that exist within the restricted category comes largely from Narritjin's interpretations of the paintings in his progressive revelation of knowledge to me. In addition, consistent differences in the level of interpretation adopted by other clan members provide confirmatory data. Comparison of the interpretations made by different individuals also enables me to show that, contrary to stated ideology, the distribution of knowledge of public and restricted meanings does not correspond precisely with the categorical distinction between uninitiated men and women and initiated men.

In the remainder of this chapter I discuss iconographic aspects of one set of paintings from Djarrakpi on Cape Shield. Other paintings are referred to only in relation to this set. Furthermore, I limit myself to analyzing two sets of interpretations of these paintings, both of which are known to the majority of people but one of which is inside relative to the other. In the two following chapters I consider further details and interpretations of the paintings.

The Iconography

The elements of Yolngu paintings fall into two classes of iconographical meaning: they refer either to mythological events or to topographical features. Although the distinction between the two classes is not always clear-cut (in some respects topographical features are a continuing manifestation of ancestral events), they can be conceptualized as belonging to separate domains of existence. Many Yolngu

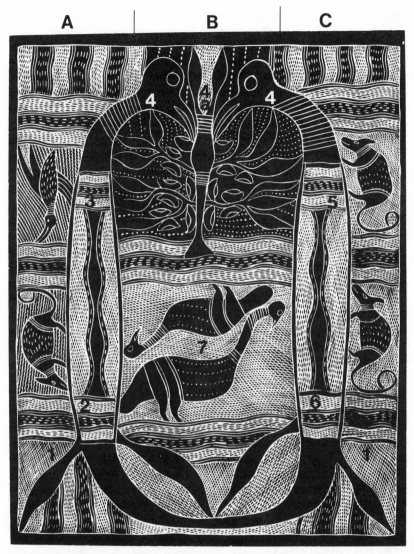

Figure 10.1 Djarrakpi landscape. Artist: Banapana. Clan: Manggalili.

paintings can be interpreted from two quite distinct perspectives: first as a record of mythological events, and second as a map of a particular area of land.

Figure 10.1 illustrates a painting by Banapana Maymuru, one of Narritjin's sons. The mythological events encoded in this painting concern the journey of the *guwak* (koel cuckoo), and the area of land represented is Djarrakpi, a brackish lake surrounded by sand dunes on

219

the coast of the Gulf of Carpentaria just north of Blue Mud Bay. The most outside interpretation, apart from the simple listing of the animal species represented by the ancestral beings, is the broad outline of their journey across Arnhem Land. I begin with the journey.[1]

The Journey

Two guwak, two possums, two emus,[2] and a number of other wangarr ancestors set out on a journey from Burrwanydji, a place in Ritharrngu clan country near Donydji outstation. Each night they camped, and the guwak (4) would sit on the top of a native cashew tree (*ganyawu*) (4a) and eat its fruit. The possum would climb the tree (4a) (also represented by the body of the guwak), spinning its fur into lengths of string. When he had spun a certain length, which differed from place to place, the guwak would tell him to stop. That length of string was given to the clan in whose country they were and subsequently became the length of the possum-fur string used by that clan. The emus (7) traveled with them, drilling with their feet for water as they went and creating water holes. This interpretation is known by all adult Manggalili. The next section was told to me only by Narritjin. It was, however, told by him to his sons as an outside interpretation and is contained in the public songs of the clan.

The guwak and the possum visited Gaarngarn in Dharlwangu country on their journey. There they talked to Barrama, a mythical being, and told him they were looking for a land to settle in. Barrama told them to keep walking southeast until they came to a country by the sea, where the sand was white-hot and there was plenty of seafood. When they got there they would find a *marrawili* tree, and under it they should make their camp. When they got there they found that it was as Barrama had said; the *marrawili* tree was there, but otherwise the landscape was featureless. *Marrawili* is the public name for a wangarr tree that is sometimes said to have the form of a native cashew tree and at other time said to be a casuarina. It is represented in different ways in different paintings (see the figures below).

In some stories Djarrakpi is the end of the guwak's journey, his final

1. The numbers in the text refer to figure 10.1, but the same numbering system is used for each of the paintings discussed to facilitate comparison. A, B, and C mark vertical divisions of the painting and are used to identify further the positions where meanings are encoded. For example, 1C refers to position 1 on the right-hand side of the painting.

2. Narritjin once said to me, when referring to the occurrence of totemic animals throughout Australia, that it is strange how all things come in pairs. However, despite this pairing, Narritjin and others usually referred to totemic ancestors in the singular. Hence, after introducing them in their dual existence, I follow Yolngu practice and only refer to them as pairs when relevant.

destination, and even the place of his death. But in other versions the journey of the guwak continued beyond Djarrakpi, northward along the coast of Arnhem Land to the Wessel Islands and on to Cape Stewart to the west of Milingimbi. This stage of the journey is seldom referred to when interpreting paintings from Djarrakpi, though it was told to us by Narritjin, Wuyarrin (the eldest daughter of his deceased elder brother), and Banapana in interpretations of the painting.[3] There is no real contradiction involved here. Djarrakpi is the final destination of the guwak as far as the Manggalili are concerned, since it was the end of the journey to establish their clan and lands. But the guwak is part of other clans' law too, and so for them his journey continues. Mythological beings are not subject to the constraints of ordinary mortals, so there is no reason why they should not die in many places!

Not all features of the journey are encoded in the painting. I include them because they were part of the interpretation given for the painting. Myths of journeys are one of the main ways in which Yolngu extend interpretation of paintings beyond the boundaries of what is encoded in a particular painting; together with the signs and symbols on the paintings, these myths form the basis of exegesis and can be used to refer to the connection between different paintings. In Banapana's painting, the actors in the journey are encoded in the figurative representations—the organization of the guwak, possum, and *ganyawu* tree signifies the manufacture of *burrkun* (possum-fur string) by the ancestral beings. These elements are sufficient to place the events in the context of a mythological journey, a context in which they have additional connotations. Thus Burrwandji is nowhere signified on the painting; it is, however, the place where the journey began.

The Painting as a Map

When they arrived at Djarrakpi, the ancestral beings found a featureless landscape, apart from a few trees, and by their actions they transformed it into the shape it has today. Narritjin had originally interpreted Banapana's painting for me employing the first perspective, as a record of the journey. When he returned from a visit to Djarrakpi several months later, he provided a second interpretation:

When the guwak arrived at Djarrakpi, he first landed in a grove of cashew trees (6). There he ate, while the possum spun its string.

3. Wuyarrin's real name is Nyapililngu. I have renamed her to avoid confusion with the ancestral being Nyapililngu, after whom she is named. Painting interpretations by Yolngu women were given to Frances Morphy, though in the full expectation that she would discuss them with me. There is no evidence of a separate body of women's interpretations as opposed to men's, and it would be a distortion of the way Yolngu talk about sacred law to associate the interpretations in their substance with either sex.

This place became the homeland for the Ritharrngu clan people at Djarrakpi. The first Manggalili Ngaarra ceremony was performed by the ancestral beings after they had prepared all the burrkun. The guwak used the distance between the two places (5 and 6) to measure out lengths of fur, which he later gave to the various other clans who gathered at Djarrakpi (the clans who share with Manggalili the burrkun and guwak mardayin). The lengths of fur string became gullies to the north of the lake (fig. 10.2), each of which is associated with a different clan. (For a European-style view of these topographical features see fig. 10.2.) After the possum had eaten, the wangarr ancestors danced with the burrkun to the marrawili tree (4) and measured out more string. The longest length was made for the Manggalili clan. This was transformed into the low sandbank that marks the edge of the lake at Djarrakpi on the far side from the sea (see fig. 10.2). It is represented in the painting by the body of the right-hand guwak.

A mokuy ancestral woman Nyapililngu was already at Djarrakpi. She lived in the trees on the other side of the lake (fig. 10.1, loci 2 and 3). She learned how to make string from observing the possum. She traveled up and down her side of the lake making possum-fur string, which was subsequently transformed into the coastal dunes that enclose the lake to the seaward side.

The emus (7), meanwhile, drilled in the lake bed looking for fresh water, but they found only salt water. In frustration they threw their spears into the sea, and from where these fell fresh water bubbled up, exposed as springs at low tide (in A, to the left of the guwak's head).

Figure 10.3 is a photograph of Djarrakpi showing topographical features which are encoded in the paintings. The painting in figure 10.1 precisely encodes the relationship between the major topographical features at Djarrakpi: the lake in a bowl of surrounding sandhills and banks. On his return from Djarrakpi, Narritjin used the painting as a topographical map to show me the final stages of his own journey there and the work that had been done in building the Manggalili settlement:

We arrived here [1C] in the Landrover and drove along the sandhills to the clump of trees [6], where we camped for two nights. We sang songs to let the guwak and possum know that we were coming. We then drove along to the next clump of trees [5], where we waited for Bangara [Narritjin's wife] to arrive. I then went off to where the marrawili tree [4] was and prayed. We then built our houses underneath the sandhill at the end of the burrkun possum string. We started building our airstrip here [to the right of the right-hand bird's head]

Several months earlier, Ian Dunlop had filmed Narritjin teaching his sons the meaning of a similar painting at Djarrakpi itself, shortly after

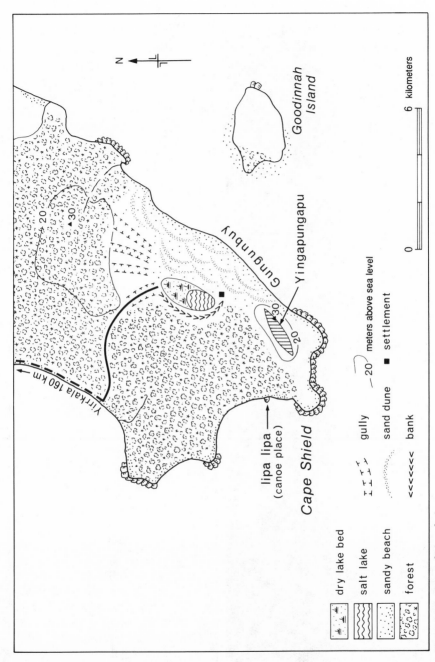

Figure 10.2 Map of Djarrakpi.

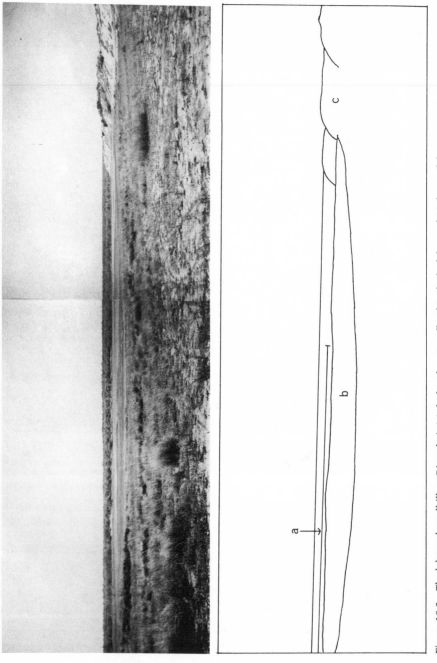

Figure 10.3 The lake and sandhills at Djarrakpi: (*a*) the burrkun (sandbank); (*b*) the lake; and (*c*) the sand dunes.

they had arrived there. It was the first time any of his sons had seen the place. Narritjin located his interpretation in terms of the individuals' life experiences and the lives of the ancestral beings who created the land. Narritjin's translation of part of what he said (in Yolngu) is as follows:

We came from Yirrkala and we came slow, slow, slow, slow as we got nearer to the marrawili. "This is where I am leading you to, and I will give you the same story, the way they [the ancestral beings] did it, and until today we have been doing the same." When we came here the first time we sat down for a week and waited; we were working the same as the old people. I told you for the first time about the burrkun, and I said, "Let the ancestors know what you are doing." (Dunlop 1981b)

Banapana's painting thus encodes messages about ancestral events and also about features of the topography. Both can be related to present-day events, as the above example shows, by using the painting as a map or to demonstrate a code of behavior. The example also shows how new meanings can become encoded within the system and how the significance of existing meanings may be reinforced. Djarrakpi settlement has become one of the meanings of the sign used for marrawili in Manggalili paintings of this structure, as a result of Narritjin's frequent reference to it when interpreting the paintings. Since the location of the settlement was chosen with reference to the guwak's mythical journey to the marrawili tree, the meanings mutually reinforce one another's significance.

Men's and Women's Knowledge of the Interpretations

All Narritjin's sons and his brother's sons over the age of fifteen were present at Djarrakpi when he provided the above interpretations of paintings. He told them he was only giving them an outside interpretation, because women and children were close by. Banapana, however, when interpreting his painting (fig. 10.1) for me, did not refer to the topographical references of the painting in any detail (though he knew them by this stage). He did locate the painting at Djarrakpi and stated that the emus were looking for water in the lake.

Gaanyul, Narritjin's eldest daughter, would not interpret any Manggalili paintings, saying that she knew nothing about paintings because she could not paint. Bumiti, Narritjin's second daughter, gave only referential meanings for the figurative representations on the painting. Wuyarrin, the eldest daughter of Narritjin's older brother, provided a detailed interpretation of Bumiti's painting (fig. 10.4) and said that Banapana's painting had the same meaning. Her interpreta-

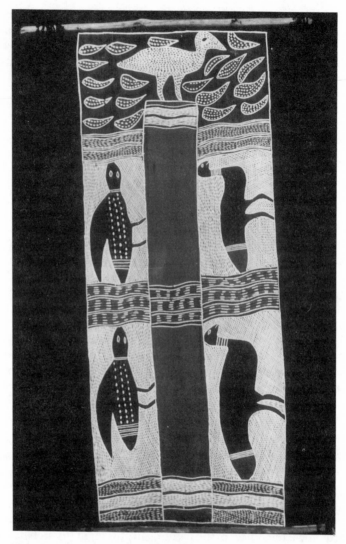

Figure 10.4 Bumiti's painting. Clan: Manggalili.

tion was at the same level as Banapana's, locating the painting at Djarrakpi but not giving detailed topographical referents. She identified the animals, which she said were performing a ceremony around a sacred object. She referred to the guwak eating his food on the cashew nut tree and outlined the journey from Donydji to Djarrakpi.

A comparison of the interpretations suggests that although Wuya-

rrin and Bumiti may know the topographical significance of the painting, as women they do not have the authority to discuss it further. Similar considerations apply to Banapana's interpretation of the painting. Thus although Narritjin stated that both the journey interpretation and the topographical interpretation are "outside," they appear to differ in the degree to which they can be expressed publicly by particular individuals.

The Meanings Encoded in Other Paintings

We may now consider how other Manggalili paintings encode the interpretations considered so far. Figures 10.5 and 10.6 illustrate two paintings by Narritjin which are structurally similar to Banapana's. The main differences between the two paintings and Banapana's painting are an elaboration of the geometric component and a reduction in the figurative. In figure 10.5 the cashew tree (marrawili) is represented by a painting of the rangga (sacred object) itself (4). Its interpretation as a cashew tree is indicated by the bunches of nuts hanging from the top. In figure 10.6 the tree is represented by the transverse lines below the right-hand guwak's neck (4). The bodies of the guwak in both cases represent the burrkun (possum-fur string). The prongs at the base of the burrkun represent the wings and feet of the guwak. They also represent the length of the burrkun distributed to other clans by the guwak, which are today seen in the form of gullies running through the sandhills at Djarrakpi (1). The body of the marrawili rangga (fig. 10.5) represents the lake, signified in Banapana's painting (fig. 10.1) by the presence of emus between the two guwak. The clan design in this instance is said to signify the water in the lake. The lake is also signified by the clan design in sections (7a) and (7b) of the painting in figure 10.6. The white cross-hatching signifies areas of fresh water in the lake, and the red signifies a dry part of the lake bed, which became the camping ground for the possum.

The figures representing the burrkun and the guwak also constitute a representation of the guwak rangga (sacred object). The rangga consists of a hardwood stick carved at one end into the shape of a guwak's head and pointed at the base. Before it is displayed, the guwak rangga is bound from top to bottom in possum-fur string taken from the burrkun. Two pendants are tied to either side of the rangga to represent at one level the wings of the bird, shown in the paintings by the outer prongs (e.g., figs. 10.1, 10.5, and 10.6). Designs are incised on the wooden core of the rangga. I have only seen the guwak "messenger" rangga, a sacred object which is carried by mediators in disputes that arise between groups during burial ceremonies. It differs from the main rangga in that it is smaller, it has a representation of the head and

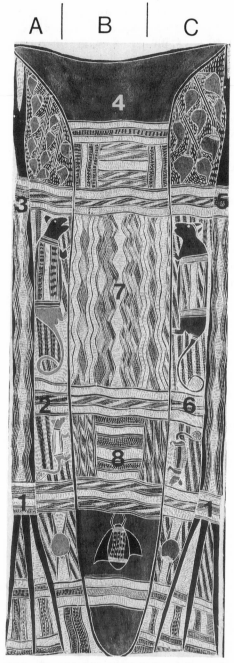

Figure 10.5 The marrawili. Artist: Narritjin. Clan: Manggalili.

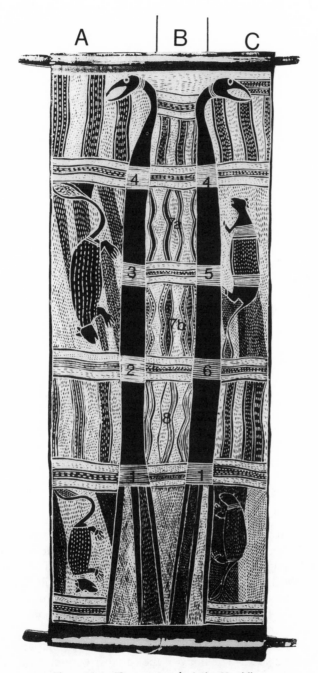

Figure 10.6 The two guwak. Artist: Narritjin.

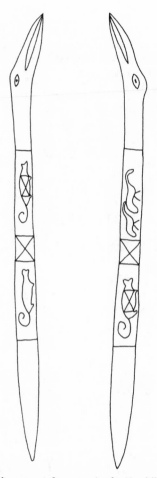

Figure 10.7 The guwak rangga (after a carving by Narritjin).

body of the guwak carved on the top, and it has no designs incised on the body. However, Narritjin did carve for me in soft wood a model of the guwak rangga, which he interpreted for me (fig. 10.7). Narritjin stated that he included the figurative representations only because he was doing the carving in public, otherwise he would have included only geometric motifs. The possums in particular would have been replaced by the cross, which is included within their bodies.

The carving encodes both of the interpretations of Banapana's painting considered so far. The body of the carving represents the cashew tree with the guwak on top. The possums are shown climbing up and down the tree, spinning their fur into string. The body of the carving

also represents the ceremonial string, the burrkun. The body of the carving can also be interpreted to represent the guwak carrying the burrkun from place to place. From the latter perspective, the body of the carving signifies the sandhills and sandbank which surround the lake at Djarrakpi, that is, the ancestral transformation of the burrkun.

The cross motif in figure 10.7 signifies a social group in that the distance between crosses represents the length of string spun by the possum for each clan. Each cross indicates the place where the guwak appeared on the tree and told the possum to stop working because he had spun a sufficient length for the clan. The cross is therefore said to represent the clans connected to the burrkun. At Djarrakpi this measuring is believed to have taken place alongside the lake. From this perspective the cross represents the three places on the lakeside where the guwak and other ancestral beings camped, each of which is associated with a particular clan.

The cross itself signifies burrkun in a different way, linking it in a paradigmatic chain with a St. Andrew's Cross spider, shuttle, and cloud. The possum learned to spin its fur by watching a St. Andrew's Cross spider spinning its web in the high branches of a cashew tree. He saw the spider at dawn when the web was thick with dew, which made it resemble a low, misty cloud. The shape of the shuttle used by women to make string is said to be based on the shape of the spider. The message-stick rangga used to summon people to ceremonies linked with the marrawili mardayin is shaped like a shuttle. In public it is covered with possum-fur string, and its outside meaning is spider and spider's web. The meaning "cloud" connects the cross back to the marrawili rangga itself, as the shape of the rangga (fig. 10.5) represents at one level a lowering cumulus cloud.

The cross also signifies a woman's breast girdle. The ancestral women Nyapililngu wore such a breast girdle, which consisted of crossed-over straps of possum-fur string. The cross therefore signifies the places where Nyapililngu camped on the other side of the lake from the guwak at Djarrakpi and where she spun string that was later transformed into the sandhills that run parallel to the beach.

The representation of the emu in the guwak rangga carving (fig. 10.7) signifies the dry bed of the lake where emus drilled for water. The eye of the guwak signifies the place where the emus threw their spears in frustration and created a water hole. The carving thus encodes, through its signs and their relationships, all the meanings of the paintings considered so far. The interpretation of the carving makes clear the structure of the paintings (figs. 10.1, 10.5, and 10.6). These paintings consist of three basic feature blocks (A), (B) and (C) signifying the lake (B) and the sandhills on either side (A and C). The feature block to the

left of the lake signifies the seaward side, and the one on the right the inland side. This division corresponds to the division of the Djarrakpi song cycles into freshwater and saltwater songs. In the paintings, feature blocks (A) and (C) have as their central figure a representation of the guwak rangga, signifying in one case (C) the burrkun made by the possum and its associated set of meanings, and in the other case (A) the burrkun made by Nyapililngu and its set of meanings.

Figure 10.8 illustrates a painting of the beach side only (i.e., feature block (A) of the other paintings). This is shown by the representation of the two female figures to the side of the rangga, denoting Nyapililngu, who hid in the sandhills, spinning string. Note the cross drawn across her body.

The central feature block (B) shows a different content in each of the paintings (figs. 10.1, 10.5, and 10.6) considered so far. In one (fig. 10.1) the lake is represented by the emus looking for water, in another (fig. 10.5) by the marrawili sacred object, and in the third (fig. 10.6) by clan designs signifying water. The fact that the marrawili sacred object signifies water among its many meanings is only one of the reasons for its central position in feature block (B). The marrawili signifies the place where the burrkun spun by Nyapililngu and the burrkun spun by the possum and guwak meet. It is located at the place where the low sandbank around the far side of the lake, the topographical manifestation of the guwak's burrkun, joins the high sand dunes of the seaward side—Nyapililngu's burrkun. "That's the home line for the man and that's for the woman; that's where they have been traveling. Both lines come together at the marrawili and make the male and female line joined together" (Narritjin to his sons). The position of the marrawili between the two burrkun (fig. 10.5) symbolizes both their separation by the lake along their length and the fact that they are joined at one end.

The figurative representation of the guwak's head has been largely redundant as far as the interpretation of the paintings from a topographical perspective is concerned. It does orient the interpretation of the painting in the direction of the marrawili (as the final destination of the guwak). However, this should apply only to the guwak in feature block (C). In the case of feature block (A), the guwak's head (as a signifier of guwak) is of negative value to the extent that it contains misinformation. Feature block (A) refers to the female ancestral being Nyapililngu, spinning string independent of the guwak. The ancestral guwak did not travel to that side of the lake. The organization of the elements, on the other hand, signifies the manufacture of the burrkun by the possum, directed by the guwak. However, it is not necessary to

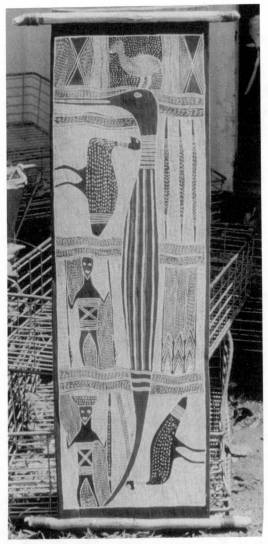

Figure 10.8 The beach side. Artist: Narritjin.

represent the sand dunes and the lengths of possum-fur string spun by Nyapililngu in this way: in a painting by Bokarra, the seaward side of the lake is represented simply by a digging stick (fig. 10.9).

Bokarra's painting (fig. 10.9) encodes a particular mythic theme associated with the sandhills at Djarrakpi. The painting represents Nyapililngu walking up and down the sand dunes with a digging stick

233

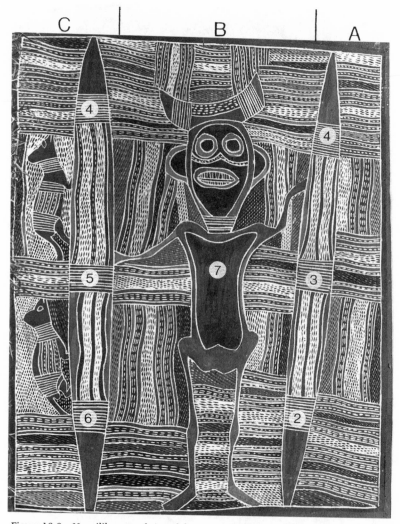

Figure 10.9 Nyapililngu on the sand dunes. Artist: Bokarra. Clan: Manggalili.

in either hand. On her head she carries a stringybark basket filled with wild plums (*munydjutj*) she has collected. However, Bokarra also stated that the two sticks represented the burrkun: the one on the left spun by the possum, the one on the right by Nyapililngu.

Although Bokarra located the painting in the sandhills on the beach side of the lake, the overall structure of the painting suggests that at another level it could have the same topographical reference as the paintings previously considered. And this interpretation Narritjin later

confirmed. This painting as a representation or encoding of the Dja-rrakpi landscape can be divided into the same three feature blocks as the previous paintings. The painting is oriented in the opposite direction, with Nyapililngu's head pointing toward the north and her feet to the south. The possums shown climbing up the left-hand digging stick signify the inland side of the lake, while the digging stick to the right marks the line of the coastal dunes. When the painting is interpreted as a representation of Djarrakpi, the significance of other elements of its structure becomes apparent. The bands on the right-hand digging stick (2), (3), and (4) become, respectively, the two places in which Nyapililngu spun possum fur, and the marrawili tree. Since Bokarra stated that the wavy lines down the center of the digging sticks signified lengths of possum string, the actions of the guwak and possum in measuring out the lengths of string for the different clans are also encoded. The central feature block is occupied by a representation of Nyapililngu herself. Nyapililngu is very closely associated with the lake and in particular with its salty tasting water; she can be thought of as a meaning encoded in the lake (see below).

The Template

We can now draw up a template that underlies interpretations of the set of paintings considered so far and that represents the structure of that encoding (fig. 10.10). The basic divisions on the vertical axes represent the three feature blocks (A), (B), and (C). The figure lists the main meanings encoded in each feature block and the main ancestral associations of each. Some of these have been discussed already; others become clear as the iconography unfolds. The numbers within each feature block represent specific loci of meaning; they represent positions on a painting at which a set of related meanings are focused. The numbered loci refer to the order and relative position in which signs representing a particular set of meanings should occur in any painting. The template as a whole can be viewed as a grid that, when lain across the surface of a painting, marks the relative positions for clusters of meaning items. Not all loci are represented in every painting discussed, but the order in which they are represented remains constant. A brief list of the meanings clustered around each position is given in the legend for figure 10.10. As we have seen, certain meanings are associated with more than one locus. Thus, for example, each position on the burrkun is associated with the possum, as the burrkun is itself spun from possum fur. Nyapililngu, however, is not associated with the bush (inland) side and is therefore not a meaning encoded at loci (5) and (6).

The meanings listed in figure 10.10 as encoded at each locus are

	A	B	C
	4		4
		4	
South			
	3		5
		7	
	2		6
North			
		8	
	1		1

Feature Block

A Beach, Female, Nyapililngu, Sandhills, *Burrkun*.
B Lake, *Marrawili*.
C Bush, Male, *Guwak*, Sandbank, *Burrkun*.

Meanings Associated with Loci in the Manggalili Template.

1. North end of lake, gullies in the sandhills, *burrkun*.
2. Nyapililngu, *burrkun* complex.
3. Nyapililngu, *burrkun* complex.
4. *Marrawili* tree, cloud, *guwak*.
5. Wild plum tree grove, *burrkun* complex.
6. Cashew tree grove, ngaarra ceremony ground, *burrkun*.
7. Lake, emu, spears, menstrual blood.
8. Dry lake bed, emus and spears.

ones which refer to specific events associated with a part of Djarrakpi (e.g., the camps of the ancestral beings, the emus searching for water, etc.). Other meanings not associated with specific events linked with a particular place can nevertheless also be signified in the paintings. For example, animals referred to in the song cycles associated with Djarrakpi, but which are neither major elements in the myth nor represented by a Manggalili sacred object, can be included in the paintings. The songs, as I stated previously, are divided into a saltwater, or beach, series and a freshwater, or bush, series. According to Narritjin, animals referred to only in the saltwater series should occur on that side of the painting only, that is, feature block (A); those associated with the freshwater side only should occur on the bush side (C). Some animals, such as the possum, are associated with both sides.

The template as I have discussed it so far has no validity except as an analytic construct derived from interpretations of a set of paintings. However, I believe that something very similar to it underlies the set in a more fundamental sense, in that it is involved in the generation of new paintings and in structuring new interpretations of existing paintings. The template is a structure that is active rather than passive.

There is no reason why, in order to be an active component of the system, the template itself should have a physical form. Indeed the template, though a generative structure, is likely to change over time. Nonetheless, in the case of Manggalili paintings (and similar sets of paintings belonging to other Yolngu clans) there are forms which can be considered versions of the template. These forms represent abstract encodings of the interpretations associated with the set. One of these is the landscape itself. The landscape created by mythological actions is the ultimate medium for encoding mythological events and does so almost by definition through ordering them in space. The landscape provides a spatial framework for encoding meanings that exist independent of the paintings, but to which all paintings are referable. However, although it provides the topographical pegs on which to hang mythological events, the landscape as it is *culturally* shaped is almost as much a product of the template as are the paintings. The landscape is not really an abstract grid. Mythological events occurred at some places or positions and left others largely (though never entirely) untouched. The positions of the places on the template correspond to the relative position of places in the landscape, for example, around the lake's shore, but the topographical plotting of the positions would produce a very different shape. The template gives order to the landscape almost as much as it does to the paintings. The grid that is produced is a product of the interaction between landscape and interpretation.

If we leave the landscape for a moment and return to the paintings, we find that there is a painting belonging to the Djarrakpi set that corresponds quite closely to the abstract grid (fig. 10.11). It is a painting we have not seen as yet, and indeed was one I did not know of until well after I had derived the Manggalili template analytically. The painting was collected by Ian Dunlop and subsequently documented by Narritjin, who had painted it. It is a prime example of the "too many meanings" Narritjin referred to, and as the analysis progresses we see just how broad a set of interpretations, of mythical events and topographical significances, can be related to the painting and encoded within it. At this stage I am concerned with how it encodes the interpretations considered so far.

In the painting in figure 10.11, the three elongated figures are said to represent digging sticks, used by Nyapililngu to walk up and down the dunes. At a second level they mark the lake at Djarrakpi and the key features to either side. The left-hand digging stick represents the coastal dunes, the central stick the lake itself, and the right-hand stick the burrkun—the low sandbank on the inland side. Orienting the painting in a north-south direction, the bottom line (1) marks the head of the lake where the gullies run behind the dunes. The squares on the right-side digging stick (6, 5, and 4) represent, respectively, the first cashew-tree grove, the wild plum trees, and the marrawili tree at the head of the lake. The equivalent positions on the other side represent the places where Nyapililngu spun possum-fur string, and the marrawili tree.

We can now review the different ways in which the meanings are encoded in the set of paintings and consider the implications for their intepretability. The digging-stick painting represents the most abstract way in which the meanings can be encoded; the signs on the painting combine to represent little more than the loci of meaning themselves. The signifying potential of the signs used in the digging-stick painting is extremely broad and at each locus is appropriate to one of the meanings concerned. The wavy-lined background design that covers the painting is a nonspecific clan design associated with a set of Yirritja moiety clans (see previous chapter). It signifies, among other things, water and sandhills. The dashed infill in the digging sticks is a specific Manggalili design element, the focal meanings of which center around possum (possum fur and possum claw marks in a tree). The square signs can signify campsites associated with ancestral beings and water holes. However, to interpret the painting at almost any level, one must either possess the information contained in the template or be able to deduce it.

Similar considerations apply to Bokarra's painting of the ghostly

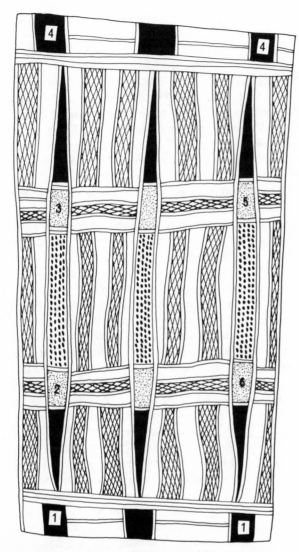

Figure 10.11 The three digging sticks. Artist: Narritjin.

Nyapililngu (fig. 10.9). In this case, however, there is an obvious descriptive interpretation: "Nyapililngu with her digging sticks walking up and down the sand dunes at Djarrakpi." To go beyond that interpretation, however, and to try and relate the painting to the topography of Djarrakpi, requires "inside" knowledge. The outside interpretation makes the painting as a whole represent an event that

239

occurred at loci (2) and (3) of the template. Yet the painting also marks those loci and can be interpreted as a map.

Banapana's painting, which we discussed originally (fig. 10.1), encodes certain of the meanings in a highly specific way. Thus locus (4) (fig. 10.10) is represented by a figurative representation of a guwak's head and by a cashew nut tree. These meanings are both associated with the marrawili sacred object, which is itself a manifestation of the ancestral cashew tree: the guwak's food is the cashew tree, and his final destination was the marrawili. However, although the meanings are appropriate to the locus, the way in which they are encoded orients their interpretation in a particular direction. Rather than being signs of the marrawili sacred object, they are two guwak eating nuts from the cashew tree. The possums similarly encode meanings at loci (2), (3), and (6), but again the outside interpretation, of possums climbing the tree and spinning their fur, is suggested. The emus are also shown at the appropriate locus, scratching around for water. The association between the emus and the lake is public knowledge, and again the interpretation is oriented in a particular direction.

With Banapana's painting as with the three-digging-stick painting, one must know the template to interpret the painting as a map of Djarrakpi. However, in Banapana's painting the template has been obscured by the encoding of certain of the meanings at each locus in an unambiguous sign, that is, a figurative representation of a tree, a possum, an emu, and so on. The signs chosen transform the template into a coherent set of meanings at quite another level: a description of the journey from Donydji to Djarrakpi, of the guwak eating his food as the possum spins his fur and the emu searches for water.

The painting illustrated in figure 10.6 has a similar organization to Banapana's painting. In this case, possums are shown located at positions (3) and (5). Possums are also drawn at locus (1), the place where the lengths of burrkun given to each clan were transformed into gullies in the sandhills. The main length of the burrkun is represented by a guwak sacred object. However, whereas in Banapana's painting the guwak sacred object was modified in a number of ways to look less like the sacred object (in particular by showing the birds eating cashew nuts), in this case its reference is clear. To people not possessing knowledge of the significance of the guwak rangga, the interpretation of the painting could still be "possums climbing up and down a tree spinning their fur, instructed by the *guwak*." This was the outside interpretation given for the painting. In order to interpret the clan designs in positions (7) and (8) as the lake and dry lake bed, information encoded in the template is required. Similarly, locus (4) is marked only by a hatched square (as also are 1, 2, 3, 5, and 6) and the guwak's head.

Narritjin's representation of the marrawili tree (fig. 10.5) differs from the painting in figure 10.6 in that the central sign of feature block (B) is a representation of the marrawili sacred object. The figurative representations again orient the interpretation of the painting away from the topographical features of Djarrakpi toward events on the guwak's journey. But the really interesting feature of this painting concerns the designs painted within the marrawili tree. The form of the design on the marrawili represents still another version of the template, although it includes an additional transverse line. This similarity is not surprising. Feature blocks (A) and (C) in the template incorporate meanings associated with the lake shores, and the marrawili in this painting occupies the position of the lake itself. The features of the shore can thus easily be encoded by marking their relative positions on the body of the rangga. With this hypothesis in mind, the rangga can be divided into three notional feature blocks: the left-hand side, the right-hand side, and the center. The left-hand side corresponds to the coastal dunes, and the right-hand side to the inland bank of the lake.

Conclusion

The Djarrakpi template is almost literally an example of something that is both a model *of* and a model *for*. It is also an analyst's construct and, in the form of the three-digging-stick painting, a cultural representation. But are we dealing with the same template in each of these cases, and if not, what is the relationship between them? How does the template that the anthropologist derives from analyzing the relationships between a set of paintings and their interpretations relate to the digging-stick painting that corresponds to the template in structure and appears to underlie the set of Djarrakpi paintings? In posing these questions we are working over very old ground concerning the nature of structure, the status of indigenous models, and the relationship between emic and etic perspectives. And it is important in the circumstances that I try and clarify the status I accord to the concept of template. I begin by relating it to the way individuals acquire an understanding of the meaning of paintings before considering the generative role the template may have in producing paintings.

A person is first taught the outside meaning of paintings. The outside interpretations of a painting relate elements of the painting together in a particular way which provides a satisfactory explanation of the perceived form (e.g., a guwak at the top of a tree instructing possums to climb up and down the trunk of the tree, spinning their fur into lengths of string, and so on). The individual continues to acquire more knowledge about paintings as more meanings are given and as the painting is reinterpreted. New interpretations relate elements of the painting to-

gether in a way that is different from the outside interpretation. According to one interpretation, the elements may be connected together as a whole to represent a quasi-figurative rendering of an event or a scene (the guwak perched on top of a tree); in another they may be connected in a linear sequence (marking stages of a journey), and in another interpretation they may be seen as spatial coordinates representing fixed positions on the landscape. Each new interpretation, rather than canceling out previous ones, articulates with them by adding complementary information, modifying previous understandings, sometimes amplifying them but nearly always bringing them forward, not leaving them behind. What is evolving is a productive structure that can be worked on and that the individual can relate to his or her own experiences. Once it is learned that the painting can be a map, then the individual's knowledge of that place, the image of the landscape, the taste of its waters all become potentially encodable in the painting. Once it is learned that the guwak created the features of one side of the lake and Nyapililngu created the features on the other side, the idea that a painting has a male side and a female side emerges. The template that is evolving provides, in effect, a set of possible meanings for elements on a painting; these meanings depend on the relative position of the elements as well as on details of their form. Once the structural similarities between paintings belonging to the same set are recognized, then the meanings can be applied across the set.

Of course individuals build up a slightly different template according to their own experience and knowledge, and also depending on their own creativity. However, there are considerable constraints on the content of the template. The paintings themselves provide a constraint, for they have considerable continuity over time and provide a continuing reference point for interpretations. The interpretations are usually given by a very limited set of people—those with the right and authority to give instruction about that particular set of paintings—so that at any point in time, consistent interpretations are given to initiates. The fact that several people may be given instruction at the same time also makes for consistency. The meanings of paintings are also represented in the actions of dances and in the words of songs, cultural artifacts that are again relatively durable and part of collective discourse. People acquire very similar building blocks of knowledge, even if eventually they acquire the possibility of doing very different things with them. The Yolngu cultural style is to learn almost in a rote manner the sets of words, meanings, songs, and designs associated with a place and only later to speculate on the connections between them. The very fact that the template is additive rather than subtractive may contribute to its durability over time. A new interpretation modifies the

template but does not transform it; over time its shape or content may change as different meanings are emphasized, but at each stage it carries much of its past with it.

The template can be viewed as a collective representation that underlies a set of related paintings. It is an emic version of the anthropologist's model—a model derived from ordering and relating meanings across paintings. But what makes the template more is that, as well as arising out of a set of paintings, it underlies them. For the template is what individuals are selecting from when they produce new paintings. In learning how the elements of a painting fit together in different ways in relation to sets of interpretations, the individual is acquiring a possible template for generating new representations to form part of the same set.

The template does not need a concrete form to be a factor in the production of paintings. The set of existing paintings and the inventory of available designs for a particular place, the mythological geography of the landscape, and the existing associations of elements and meanings all provide constraints and creative possibilities; the template could simply be a hypothetical abstract ordering of these elements. However, in many cases there seem to be designs that are concrete formulations of the template; paintings like the three-digging-stick painting operate as abstract generative structures that other paintings are derived from, and to which other things such as dances, songs, and land forms can be referred. Such designs operate as highly condensed mnemonics. The existence of such underlying forms fits in perfectly with both Yolngu ideology and the structure of the representational system. The ideology is that everything stems from the ancestral past, that surface forms are generated by underlying forms, that ancestral designs which are a manifestation of the ancestral beings should be able to produce surface forms. The geometric art is inherently multivalent; it both conceals and accumulates meaning. The geometric painting is the inside painting and has logical precedence over all other paintings: it is the one that all others can be referred back to.

The reason my model of the relationship between the various paintings and the meaning encoded in them was so similar in structure to the three-digging-stick painting is clearly that I was working backward along the path of creativity, from the surface form to the inner form that generates them. However, the template is not the *form* itself, but a *structure* of encoded meanings. The same structure can theoretically be associated with more than one place and with more than one set of paintings. Very similar geometric paintings can be associated with places in different clan territories, the three-digging-stick painting being a case in point. The paintings are likely to be ones on the same

ancestral track and will be associated with certain common themes, but they will each be related to different landscapes and as such will encode different meanings. It is a function of the multivalency of the geometric art that fairly similar designs could be related to a variety of different places. The digging-stick painting, for example, could be related to any place that has a tripartite structure of central feature plus two lateral features, as at Djarrakpi, where there is the lake with its two sides. In each particular case, the geometric design is made into or becomes an appropriate representation of the place by the meanings encoded into it and by the sets of other paintings that it is linked with or that it generates, in other words, by becoming a template.

11

Yingapungapu

I have so far considered the way a set of paintings encodes meanings that refer to the totemic geography of Djarrakpi, an important Manggalili clan center. I have not considered all the meanings encoded in the Djarrakpi paintings, and I have not considered in any detail the symbolic connotations and thematic meanings of the encoded events—how the paintings may refer to important themes of Yolngu life and worldview. For example, we know that the emu scratching the ground created water holes on his journey, but we have not yet considered what the significance of scratching the ground may be. In order to consider in detail the symbolism of these Djarrakpi paintings, we need a little more information, so in chapter 12 I explore further the events that happened at Djarrakpi, in particular events associated with Nyapililngu, and consider their connotations and the way they articulate with Yolngu beliefs about the nature of the world. However, before considering these events and the Djarrakpi paintings further, we must take a slight detour and look at a second set of paintings associated with an adjacent area of land. Yolngu mythology ex-

tends outward from places, and to understand the significance of events that happened at a particular place one must often understand them in relation to events that happened elsewhere. In some respects, indeed, mythology at Djarrakpi can be seen as a dialogue with events that happened immediately to the south of the lake (see fig. 10.2) and that resulted in the creation of the *yingapungapu*, a ground sculpture associated with death. The *yingapungapu* paintings involve many of the same ancestral beings, but, on the surface at least, they are associated with death rather than life.

Yingapungapu Ground Sculptures

A *yingapungapu* ground sculpture is used in the context of Yirritja moiety burial ceremonies. Relatives of the deceased who are involved in preparing the body for burial or in painting clan designs on the dead persons' chest, or who are contaminated in other ways by contact with the dead body, must spend the duration of the ceremony separated from the others present. This separation is focused on the yingapungapu or an equivalent sculpture (see Peterson 1976:97), within which those who have touched the body eat their food during the ceremony. Their food is prepared separately, and anything that remains uneaten must be buried in the central section of the sand sculpture. The area surrounding the yingapungapu is avoided by others, and it is believed that if they enter within the boundaries of the sculpture they will contract leprosy. The ground remains polluted after the sand sculpture has been smoothed over. Wuyarrin once said of a yingapungapu made the previous year for her father: "People don't go there. Last year dogs played there and they all died."

Yingapungapu sand sculptures are owned by three clans living at Yirrkala: Manggalili, Dharlwangu (Groger-Wurm 1973:100), and Mardarrpa. The main difference between the sand sculptures is said to be in the number of holes dug within them. Manggalili yingapungapu, for example, have four central holes (fig. 11.1), whereas Mardarrpa ones have six. Each clan's ground sculpture refers to a particular geographical location within the territory of that clan, where ancestral beings constructed similar ground sculptures. These ancestral sculptures are now manifested in the shape of the landscape. The Dharlwangu yingapungapu refers to Garraparra in the north of Blue Mud Bay (see Groger-Wurm 1973:100; Peterson 1976:102–3). The Mardarrpa one refers to Baaniyala opposite Cape Shield, and the Manggalili one to Djarrakpi.

The area of the ancestral yingapungapu at Djarrakpi is avoided today by Yolngu. The site is marked at either end by large boulders which indicate its extent, and they are said to act as a warning to those who

approach it. The area is said to be a burial ground for members of the Yirritja moiety, although it has not been used as such in recent years and probably not since before European contact. It is also said to be connected with a battle that took place between a number of Yirritja moiety clans, including Manggalili, Mardarrpa, and Dharlwangu at Djarrakpi; the bodies of the dead were buried in the yingapungapu. The area is believed dangerous, and people entering are thought likely to contract leprosy, or to become covered with sores and subsequently to die. Wuyarrin, Narritjin's elder brother's daughter, gave the yingapungapu as her reason for not going to live at Djarrakpi—the place was much too dangerous. Referring specifically to the yingapungapu, Wuyarrin stated: "Women are not allowed to go there. If they went they would get weak knees and wouldn't be able to walk. Men can't go there either. If Narritjin wanted to go there he would have to talk first. He would say to himself, 'I want to see that place—don't make me sick.'"

When I visited Djarrakpi it was shortly after Narritjin's eldest son had died, and he was afraid that his mokuy spirit was in the area. I was therefore unable to visit the yingapungapu. Thomson provides a detailed description of a similar "communal burial ground" in Marrakulu country (Peterson 1976:99). Thomson provides details of the nature of the contagion associated with a burial ground, and later in this chapter those details help us understand some of the symbolism of the paintings. The smell of the burial ground is itself thought to be dangerous; Thomson and his companions approached the burial platform by a roundabout route that took them upwind. Fires were lit in between the burial ground and the camp to cut off the smell. Thomson was told to leave his water bottle behind, as the "shade" of the maggot ancestor might "go into it and make [him] sick" (p. 100). Outcrops of stone in the area were carefully avoided. When the group reached a burial platform, a pipe of tobacco was smashed beneath it to placate the spirit. As soon as they had left the site, they washed themselves in a salt pan because "that maggot him bite you and me" (p. 100).

Yingapungapu Paintings

Figures 11.1–11.9 illustrate a set of Manggalili paintings directly related to the form and mythology of the yingapungapu. As far as I am aware, yingapungapu paintings of this type are primarily produced for sale to Europeans, though the yingapungapu as a design element occurs in a variety of different contexts. However, although the paintings do not function in the same way as the sand sculpture, they have the potential to be used in indigenous contexts where they can substitute for some of its functions. Of course in the Yolngu case it is misleading to

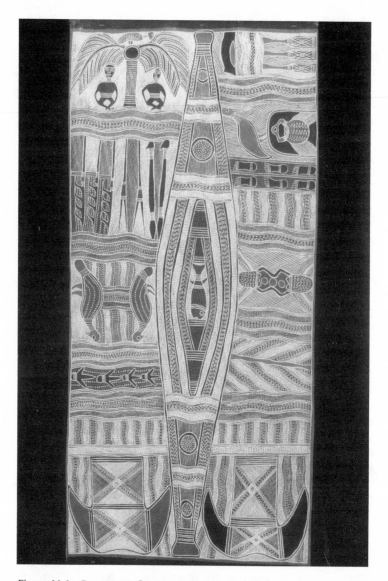

Figure 11.1 Banapana's first yingapungapu, with key to structure of the painting, opposite.

treat paintings produced for sale as a category separate from paintings produced for indigenous contexts. Apart from the fact that commerce in bark painting is part of the contemporary context, forms developed in one context frequently become used in another (see chap. 9).

The painting by Banapana illustrated in figure 11.1 provides an ex-

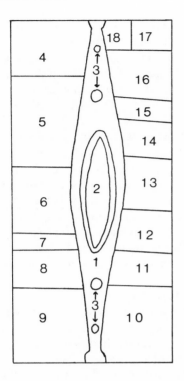

ample of the way commercial bark paintings have become integrated within the fabric of Yolngu society to the extent that they can be used to some traditional cultural ends at the same time as they are objects produced for sale to Europeans. The context of Banapana's painting has been described in detail elsewhere (Morphy 1977a), so I only provide a brief summary here.

A young Gurrumuru Dharlwangu boy died in a car accident near Yirrkala. Narritjin was responsible for preparing the body for burial, for placing the body in the coffin in the hospital mortuary, and for accompanying the body on the plane flight to Gurrumuru where it was to be buried. Narritjin was thus in a state of pollution for a considerable length of time (two weeks). Shortly after the death of the young man had been announced, Narritjin asked his eldest son, Banapana, to begin a bark painting of the yingapungapu. Narritjin explained that this would enable him to be immediately free of pollution restrictions on the completion of the ceremony, so that he could lead a normal life and share food with other people. Elsewhere (Morphy 1977a) I have suggested that the yingapungapu painting operated at a symbolic level in a way that was analogous to a yingapungapu sand sculpture, enabling

the pollution associated with Narritjin's handling of the dead body to be contained. The fact that the boy's death and burial took place in widely separated localities meant it was inappropriate for Narritjin to eat within the confines of a yingapungapu sculpture, even if the construction of one were thought desirable; thus the painting substituted for it. I use this painting as the focus for my discussion of yingapungapu paintings.

The painting represents the yingapungapu at Djarrakpi, and the central elliptical design represents the shape of the sand sculpture itself. The ancestral yingapungapu at Djarrakpi is located in a ridge of sandhills at the south of Cape Shield, just beyond Djarrakpi settlement. In topographical terms, the area of land represented by Banapana's painting and characterized by the ancestral yingapungapu adjoins the area surrounding the lake discussed in the previous chapter (see fig. 10.1). The marrawili tree marks the boundary between the two areas and is associated with both. It is frequently represented in paintings of the yingapungapu.

The position of the marrawili tree in this painting (fig. 11.1) orients the painting top to bottom in a north-south direction: the marrawili tree occurs at the northern boundary of the area represented in the painting. In all other paintings discussed in this chapter in which the marrawili is represented, it occurs in the top section. From a topographical perspective, in order to be consistent with the position of the marrawili tree, the right-hand section (A) of the painting should signify things associated with the saltwater side and the left-hand section (C) with the bush or freshwater side.

The mapping aspect of a painting means that it can be oriented in a particular way in relation to features of the landscape. It does not mean that the topography itself determines which of these features should be encoded in the painting and the way in which they should be encoded. For the yingapungapu paintings, a model can be constructed similar to the one suggested for the marrawili paintings. In the model the painting is divided into the three sections—(A), (B), and (C)—signifying a central feature (the yingapungapu) and lateral features (beach side and bush side). However, whereas in the marrawili paintings the topographical framework is the dominant one, underlying the paintings and influencing the position of representations, in the yingapungapu paintings it is less significant. This is partly because the yingapungapu paintings are focused on the sand sculpture and its meanings rather than on the place, and partly because the mythologically significant features of the topography are predominantly to the seaward side of the sculpture.

The mythological context of the yingapungapu paintings concerns

the death of the guwak far out to sea, the construction of the yingapungapu on his death, and his ascent to the Milky Way via the marrawili rangga. The left section (C) in all the paintings notionally refers to the bush side (explicitly so in two cases). In fact it frequently encodes meanings referring to the yingapungapu itself—the marrawili tree and the beach and sea. However, the fact that a topographic framework is still a relevant one was brought home to me by Narritjin when he stated that, given a large enough bark on which he could represent everything, topography was the basis upon which he would organize the painting.

Interpretations of the Yingapungapu Paintings

The yingapungapu paintings can be interpreted in the same way as the marrawili paintings discussed in the previous chapter, by placing them in the context of the journey of the ancestors from Burrwanydji to Djarrakpi. Narritjin initially interpreted the painting shown in figure 11.1 in this way. The interpretation was consistent with the outside interpretation recorded in the last chapter. However, he did not refer to the possum spinning the burrkun, which was a major theme of the marrawili paintings. The oval design was said to represent the lake at Djarrakpi, represented in section (B) in the marrawili paintings. In subsequent interpretations of the same painting, the design was said to represent the yingapungapu.

The yingapungapu sand sculpture, like any manifestation of the mardayin, is both something that refers to and can be located in the ancestral past and something that is part of present practice: it is both the ancestral yingapungapu at Djarrakpi and the sand sculpture used today in mortuary rituals. As a manifestation of the ancestral past, it exists outside time. In interpreting the paintings, people continually switched from one perspective to the other, from ancestral past to present practice. I largely retain the order in which the interpretations were given to me.

Interpretation 1

The first interpretation is recorded from Narritjin's older brother's daughter Wuyarrin. She was discussing the painting in figure 11.2, but her interpretation fits the yingapungapu paintings more generally.

The long thin thing that goes down the middle is a ground called *yingapungapu*. The circles inside are holes in the sand. The shapes at the top and bottom are clouds, *wululu*. Some Yolngu came in from hunting. The paddles in the painting are their paddles. The fish in the middle of the yingapungapu are *yambirrku* that they had caught. Beside them the circles

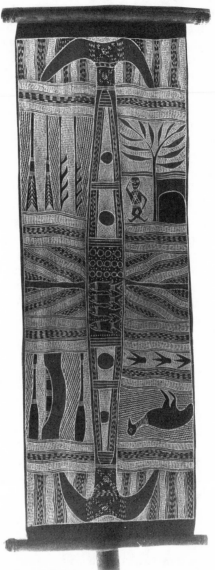

Figure 11.2 Banapana's second yingapungapu.

are turtles' eggs which they found. The spears are of two kinds—*barti* and *makurr.* They came in from hunting and sat in the shade of the tree and cooked fish. When they had cooked it, they took it to the yingapungapu ground. They ate the fish inside the ground and left it there when they had finished. They left all the fish bones and paddles on the sand. A bird called

gurluwitjpiti [wader sp.] and sand crabs came and ate up all the fish bones. The wavy lines in the picture are the footmarks of the bird and the sand crab. Nyapililngu [the human figure] came from her house, *gungun*. She was crying because she saw two clouds and no one looking after the ground. She felt sorry for the yingapungapu ground. The birds saw her crying under the shade. She was thinking of the sacred things: of the spears and the paddles and the holes. The sand was getting old and smelly from the fish bones and skins that the hunters had left there. She then went up high into the sandhills and sat down. She turned her head and looked at the clouds above the yingapungapu, and she stayed to look after the yingapungapu, after the others had gone. Yolngu don't go to that place today.

As we shall see later, Wuyarrin's interpretation of this painting differs from Narritjin's interpretation mostly in detail and in what is left out or left unspecified. The main points are that she makes no explicit reference to human death or to the function of yingapungapu ground sculptures in burial ceremonies, and that Nyapililngu is simply said to be mourning for the ground rather than for any particular individual. It is Nyapililngu reflecting on her land; it is the yingapungapu as ancestral country rather than as sand sculpture. Wuyarrin's interpretation is presented as the thoughts of an ancestral being. Feelings of love and sadness are presented as general, almost abstract, emotions that can be located in land rather than generated by specific events.

Interpretation 2

The following is Narritjin's outside interpretation of the painting in figure 11.1:

The name is yingapungapu—a ground for when you are dead [1]. You have finished your life and you go back underground for your body. Those are the men who made it, Yikuyanga and Murnumiya [4]. You can see them sitting down under that tree. Those are their spears and spear throwers standing under the tree [5]. Over there [13–16], that's the sand crab and his footmarks and the footmarks of the people traveling to the yingapungapu ground. They come up traveling, the sandy crab, after you have been eating, they and the worm, to eat all the fish remains that you have left behind. You can see the sand crabs carrying turtle eggs to their hole where they bury them [13]. You see those holes [3], that's where the close relatives of the dead sit, where they eat fish and where they light their fires. But the number one people, the people who are cleaning up your bones, collecting your body, they must stay right in there where the fish lives [2]; that's for the waku. The fish is a parrot fish because Yikuyanga used to catch parrot fish. The *marlwiya* [emus], they are the people who made the decisions for you in this area, the decisions you are following [6]. They are the wangarr [ancestors] who decided where people could sit. They marked the places for the fireplace [3] with their spears. The guwak men Murnumiya and Yikuyanga, they sit and

listen in the shade, they straighten out things for you and your family, they make sure you are peaceful with other clans. But the emu made the law for that place, and made the ceremony ground, and told you how many marks [1, 2, 3] you have got to put in that ceremonial ground. Those footmarks [15], they show the men going to collect fish in the canoe [17] and [18] to feed the people at the ceremony, and also walking along the beach to collect turtle eggs [shown by turtle tracks in (14) and the circles in (13)].

When they had finished everything, two clouds were there standing up [9, 10]. The clouds tell what has happened. When you see two clouds, you know that someone has died belonging to that area, and you can see the spirit belonging to the person passing away from the ground in the cloud. And you see the marks in the cloud [dashed infill in the cross itself and bars]—that's blood of the people mourning the death, and the ocher [blood] that they paint on their bodies. And the cross itself, that's the woman Nyapililngu and the possum-fur string that she spun to go across her breasts.

Narritjin's most outside interpretation, given in the midst of his children, contrasts markedly with Wuyarrin's; hers is descriptive of place and drawn from the perspective of Nyapililngu, whereas Narritjin's describes the sand sculpture and its mythological origin. Moreover, the mythology in Narritjin's case is set out almost in terms of rules set by ancestral beings and does not reveal details of the mythic context in which the sand sculpture originated. This interpretation is presented in very much the way that ritual knowledge is transmitted in formal situations down the generations; it is phrased in terms of rules and practices set in the past and followed in the present. There is little discussion, and the symbols are presented without explication. The form of the yingapungapu is discussed in terms of its functions: a ground in which certain relatives of a dead person reside during preparations for a burial ceremony, where they prepare and eat their food. The other signs in the painting are interpreted in relation to this, that is, they represent food consumed by the participants and people hunting to obtain food for the ceremony. In the interpretations, Narritjin is also confronting his children, who were listening, with the prospect of their death. He does so in a very matter-of-fact way at the beginning by introducing the yingapungapu as a "ground for when you are dead." But the topic is then apparently left behind as the interpretation moves to a description of the pollution behavior associated with the yingapungapu and the roles adopted by people in the ritual, shifting sometimes from ancestral precedent to present practice. However, in reality much of the symbolism of the story is concerned with the dead person, with bodily decay and the fate of the spirit.

Three important symbolic themes are briefly referred to: clouds as a symbol of death, the letting of blood associated with mourning, and

the sandcrab and worm dealing with food remains. High-standing cumulus clouds, especially when isolated from other cloud formations, are seen as a sign that a death has occurred in the country beneath the cloud. The symbol operates at two levels. At the first level, a cloud is considered in a literal sense as an index of death. As we have seen, at various stages in a mortuary ceremony, fires are lit to drive the mokuy spirit of the deceased away from the place of death (chap. 5). Areas of land associated with the dead person and parts of the clan territory linked with one of his or her names must be burned off before the land is opened for hunting. The clouds of smoke that result from these fires are believed to develop into cumulus clouds as they rise above the earth, and indeed the smoke does often appear to merge into the cumulus clouds that develop in the afternoon along the coastline. Clouds of smoke and clouds associated with smoke are thus naturally occurring symbols of death.

At a second level, clouds are seen as a medium for the passage of spirits from one place to another. Spirits rise up from the ground in the form of clouds which drift across the Arnhem Land sky and come down to earth again in the form of rain. The spirits then enter the watercourses and rivers and finally become incorporated in the rocks surrounding clan wells and in the sacred objects located in the bottom of the wells. From there, spirits can then enter women who wash in the wells or in waters connected with them, resulting in the conception of children. Thus clouds, as symbols of the passage of spirits linked in with the idea of rebirth, are another of the ways in which the Yolngu model their belief in the reincarnation of spirits.

Clouds are signified in Banapana's painting (fig. 11.1) both by the anvil-shaped outlines [9 and 10] and by the cross motif within them. In the previous chapter I showed how cloud was signified as part of a syntagmatic chain including possum, spider, and guwak. In the case of yingapungapu paintings, the meaning cross = cloud can be located in a different syntagmatic context, associating it with Nyapililngu, possum-fur string, and blood. The association between Nyapililngu (as a woman) and cumulus clouds is explicit: cumulus clouds billowing out at the top are seen as like a woman's breasts falling to either side of her breast girdle. The metaphor is expressed in the cloud designs, where the cross as breast girdle divides the two lateral extensions, which represent the anvil of the clouds (fig. 11.3). The same idea is contained in the body painting design (fig. 11.4).

The second theme, the association between blood and mourning, is encoded in the same symbolic configuration. The cross signifies a possum-fur string breast-girdle, and the dashed infill within the cross signifies the footmarks of possums as they claw their way up the

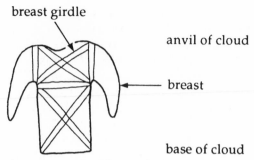

Figure 11.3 A cloud design (after the painting by Banapana shown in fig. 11.1).

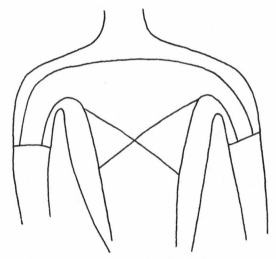

Figure 11.4 Body painting of a cloud (after a painting by Wuyarrin).

munydjutj (wild plum) tree. The infill also signifies blood dripping from the heads of women in mourning, as they cut their foreheads with digging sticks and stones to express grief. The top sections of figure 11.5 illustrate this. Women are shown around a yingapungapu, beating their heads with digging sticks and against the ground. One of the main components of the public story of Nyapililngu is the characteristic portrayal of her in mourning, using her digging stick to draw blood from her head. An implicit association is made between Nyapililngu cutting her head and possum clawing the bark of the wild plum. The wild plum exudes a red sap which symbolizes blood drawn from the tree by the possums' claw marks. One of the main women's dances at mortuary ceremonies is the possum dance, in which women

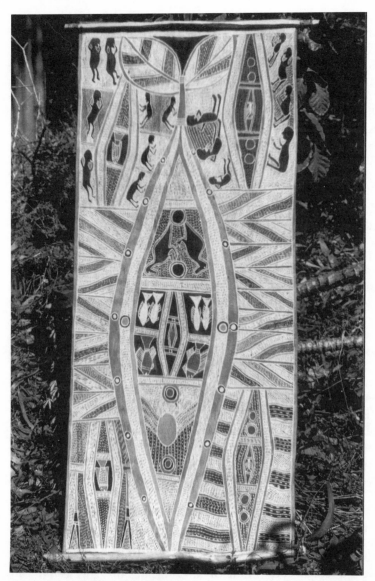

Figure 11.5 Narritjin's yingapungapu.

run their fingers up and down their breasts in a scratching movement, signifying the possums scratching the tree. Although the analogy with women cutting themselves in mourning is not explicitly made, the evidence strongly suggests that at one level the action symbolizes precisely this aspect of mourning. Narritjin, in his explanation of Ba-

napana's painting, generalizes the reference of blood to include the painting of the bodies of the participants in red ocher, as well as the blood of women cutting their heads in mourning. This explanation highlights the dual aspect of the significance of blood as a symbol in the context of burial ceremonies: as a symbol of loss in the case of women cutting their heads and as a symbol of renewal and strength in the case of the red-ochering of the participants' bodies (see chap. 8). The symbolic connotations of blood as a meaning in Manggalili paintings are considered in more detail in the next chapter.

The final theme to explore at this stage concerns the sand crab cleaning the ground after the people have eaten. This theme is elaborated in different ways in each of the four paintings illustrated in figures 11.1, 11.2, 11.5, and 11.6. After the people camped around the yingapungapu ground have finished their meal of fish and turtle eggs, they bury the remains in the center of the yingapungapu. Maggots begin to eat the remains of the fish (maggots are signified by the white dashed infill on the paintings, and also by the white circles surrounding the yingapungapu in fig. 11.5). The sand crabs then move over the ground and pick the flesh and maggots clean from the fish bones, uncovering the remains as they search for food. A seabird (*gurluwitjpitj*) (illustrated in fig. 11.5) is attracted by the exposed bones of the fish and feeds on what is left. (According to one interpretation, it also feeds off the sand crabs.) The sand crabs take some of the remains and bury them in their holes. They carry the food remains on their legs and spread particles of the fish, the blood and the maggots over the sand (again signified by the dashed infill—black, yellow, white, and red). Finally the tide comes in and washes away the last of the food remains, leaving the sand clean.

At one level this interpretation of the signs on the paintings is a simple descriptive statement of what happens to food remains left behind after a meal. It reflects Yolngu ideas of both cultural and natural order and the relationship between the two. It is at this level that Wuyarrin's interpretation (Interpretation 1) is to be understood. Yolngu carefully bury their food remains in one place in order to keep the sand and their camps clean. This is what the fishermen did in Wuyarrin's story. After a while the remains begin to decay and smell as maggots feed on the flesh. Then a process of dispersal takes place during which the bones are exposed and spread by the sand crabs and seagulls. The sand crabs pollute the sand by spreading the decayed material over it, but also help to create a new order by reburying some of the remains in their holes. Finally the tide comes in and washes the ground clean again. This interpretation is applicable to both the ancestral yingapungapu (to which Wuyarrin applies it) and the yingapungapu ground sculp-

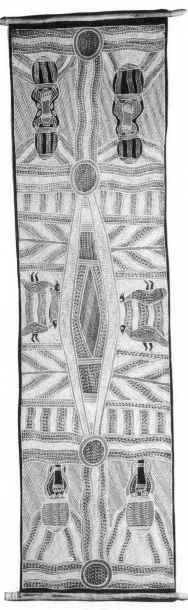

Figure 11.6 Yingapungapu and sand crabs.
Artist: Banapana.

ture. In a sense the latter is a specialized kind of midden, its main
function in a ceremony being a place to bury food remains.

At another level, however, the sand crab complex operates as a met-
aphor of the process of human death and burial. It also dramatizes
certain aspects of pollution beliefs and refers to the reason why people

involved in preparing the body for burial are separated from the others present. One of the inside meanings of this part of the painting, provided by Narritjin, is in effect an exegitical statement of the nature of the metaphoric relations involved:

That fish is really Yolngu, dead Yolngu. If a man has too much fish to eat and he is in a state of yingapungapu, and if he can't find the right man to share it with, then he must bury the fish in the ground. This is like him burying the body in the ground. When it is buried in the ground, the bones will be stripped clean of flesh by the maggots. Later on you go and collect the body, and collect the pieces of bone and put them in the bark coffin. This is like the sand crab and the rat running around collecting the dead fish and blood.

The fish in the paintings thus can be seen to represent the body of a dead person, and what happens to the body of the fish is essentially what happens to the body of the dead. The theme of death and burial releases the thematic connotations of the iconographic meanings. In the painting in figure 11.5, the fish is shown respectively alive, dead (white), and in skeletal form stripped clean of flesh. The two small yingapungapu to the right of the painting represent the ancestral women's hearths. The women are shown mourning beside the yingapungapu, the blood from their foreheads flowing into the sand sculpture. Narritjin said, "The blood goes to the place where the fish bones are. When you and I die, then our bodies go to the same place."

The sand crabs are like people stripping flesh off a corpse. They also represent people burying the body. In Banapana's painting (fig. 11.6), the metaphor is expressed in a more direct way, through sand crabs shown picking away at the flesh of human feet. This metaphor orients interpretation toward a particular thematic meeting.

The footprints (figs. 11.1, 11.6) also operate as a symbol of death at another level—as footprints in the sand which will be washed away by the incoming tide. The tide coming in over the sand is seen as a final cleansing agent in that it washes away all traces of the activities that took place: the footprints of the people, crabs, and birds; the marks of the turtle which lays its eggs on the beach; and the rotten remains of food. At a second level they can be interpreted to signify the finality of death for a person's physical being—the fact that soon after death all traces of physical existence will be gone, washed away like footprints in the sand. Later in this chapter I show how the tide mark, which today is a symbol of death, is believed to have been an agent of death in ancestral times.

The action of the sand crabs in scavenging among the remains of dead fish is seen as polluting. In particular it is said to release maggots from the flesh so that they are blown away in the wind to cause disease

and death. As Thomson's (Peterson 1976) description shows, the major source of contagion is thought to be the spirit of the ancestral maggot, which is manifest in the actual maggots eating the corpse and the rotten smell (*barrpa*) coming from the decaying body. The sand crab complex dramatizes the polluting aspects of death, expressing the danger associated with the yingapungapu ground and the pollution of those preparing the body for burial. The function of the yingapungapu ground is to contain and restrict this pollution within defined boundaries. The function of the people preparing the body is to reduce the dangers of contagion for others present, by disposing of the body of the dead person and all the things associated with him or her and by carefully burying or burning anything that may have been contaminated by their own contact with the corpse.

The yingapungapu men, that is, those handling the body, are not thought to be in danger of contagion while they are in a state of pollution. The people who perform this task should belong to a waku (ZC) or maari (MMB) group, though often an actual ZS will be said to be too closely related. This is not the place to provide a detailed sociological explanation of why these particular categories of relatives are considered free from the dangers of contagion (see Morphy 1984:106–8). Nevertheless it is important to emphasize that the actual maggots and the rotten smell of the corpse are not in themselves considered an automatic source of disease. It is thought that the agents of contagion can be directed against specific individuals; contagion is not of equal danger to all people. In particular these agents are believed directed against persons thought to be responsible either positively or negatively (through, for example, neglect) for the person's death. Members of MM[B] and [Z]C groups, because of their structural relationship to the dead person, are, ideally at least, not in competition with him and members of his group. They represent the category of relatives thought least likely to have borne ill will toward the deceased or to have been effective in causing his death. For similar reasons they comprise the category of people who are thought to be in less danger from the mokuy soul of the deceased.

Narritjin described the position of the yingapungapu men as follows: "Only certain people can look after the yingapungapu, can handle your body, your bones, and your possessions. He must not be frightened; he must not care that the body is maggoty and rotten, that it is very smelly. Don't be frightened, because if you are afraid, then they will get you. The worm will go after your body, go inside you and eat up your flesh. It will make you dry. You won't be long now, soon you will be dead."

The inside meaning of the fish as dead human being makes explicit

some of the symbolic connotations of the yingapungapu paintings that are implicit in the outside interpretations given by Narritjin and Wuyarrin. Although Wuyarrin did not refer in her interpretation of the painting to the function of the yingapungapu ground in the context of burial ceremonies, women are fully aware of its function in containing pollution and of its dangers of contagion. This suggests that the sand crab–fish bone complex has the same underlying significance to both men and women, even if its symbolic significance is not explicitly articulated except at the level of inside knowledge.

Narritjin stressed controlling fear, and fear itself is seen as endangering. Not surprisingly, the symbolism of the yingapungapu paintings is linked directly with the themes of Yolngu mortuary rituals and the emotions associated with death (Morphy 1984, chap. 3–5). But the emotions of fear and anger generated by death are generalized through Yolngu ritual process so that they become a potent force in Yolngu society: they are one of the things that contribute to the Yolngu concept of power. Images and emotions associated with one part of a mortuary ritual are taken up and transferred to other aspects of the ritual so that ritual acts become part of a chain of analogues in which the focus of emotion is shifted according to the particular referent. We have seen this happen in the case of the smelly and decaying fish, which creates a series of emotionally charged images that can be transferred easily to the dead and decaying human body. Analogous transfers can be effected with the emotions themselves.

Fear of the dead body of another and its opposite, freedom from fear of the dead other, are converted at various stages of mortuary rituals to fear of death of self and freedom from fear of death of self. One context in which such a transference occurs in mortuary rituals is in phases where the body of a dead person becomes the focus of a dance of vengeance (see Morphy 1984:77ff.). This dance, which usually takes the form of ancestral beings hunting for game, is interpreted from one perspective as the ancestral beings finding the body or spirit of the dead person to take it to the land of the dead: the ancestral beings are fearlessly seeking the body. From a second perspective, however, the ancestral beings' hunting is an analogue for people going out on an expedition to avenge the death. Controlling feelings of fear of the dead body and concentrating feelings of anger over the death create the inner strength required to go out and face the dangers of an avenging expedition and also perhaps to be unafraid of killing another person. Fear of dead others and fear of death of self, fear of being killed and fear of killing, are clearly not the same things, but they involve overlapping sets of emotions that echo across contexts. In stating that fear of a dead body may result in death of self, as Narritjin does, Yolngu are inculcat-

ing attitudes toward fear that can be applied in other contexts, and ritual acts often unite such contexts. For example, small "biting" dilly bags are used in a number of different contexts in which fear and anger are generated. They are gripped tightly between the teeth by boys being circumcised, by dancers in mortuary rituals, and by participants in actual avenging expeditions. The use, in different contexts, of the same means of controlling and focusing the emotions creates the analogy between the contexts, despite differences in the particular source of the emotion. The control and direction of fear and anger toward positively valued objectives are major themes of Yolngu life: fear and anger are both potential resources that can be culturally constructed.

The mythology of the yingapungapu, while associated with the negative aspect of emotions that are engendered by death, is also concerned with confronting the fear of death by presenting it as both inevitable and positive. This, however, concerns further inside interpretations. I return to the topic later in the chapter, but first I consider how some of the interpretations reviewed so far are encoded in the set of yingapungapu paintings.

Further Encodings of Interpretations

The figurative representations in figures 11.1–11.6 are particular elaborations of meanings encoded in the geometric art, many of which are encoded in the yingapungapu design itself. The painting illustrated in figure 11.7 represents the yingapungapu paintings in a condensed form (though as we see in the next chapter, it represents much more than this). This painting by Banapana (fig. 11.7) was said to represent the yingapungapu ground in the center, with two digging sticks belonging to Nyapililngu on either side. These were the sticks she used in mourning for the dead guwak. The dashed infill in the center of the design was said by Banapana to represent maggots, and by Wuyarrin to represent the seabird *gurluwitjpitj* and the sand crab walking around on the sand looking for maggots. Clearly these represent only two of the possible signifieds associated with dashed infill which are appropriate to the meanings of the yingapungapu. An overall set of meanings for dashed infill in yingapungapu paintings can be constructed by listing the full range of meanings given for this element of the painting in the interpretations as a whole. This meaning range is listed in figure 11.8. The same procedure can be adopted for each of the other elements in the painting, and the results are also listed in figure 11.8. The dashed infill clearly has a different set of appropriate meanings attached to it, according to the different syntactic contexts in which it occurs (i.e., according to its relationship with other components of the painting). Thus, possum claw marks are only given as a

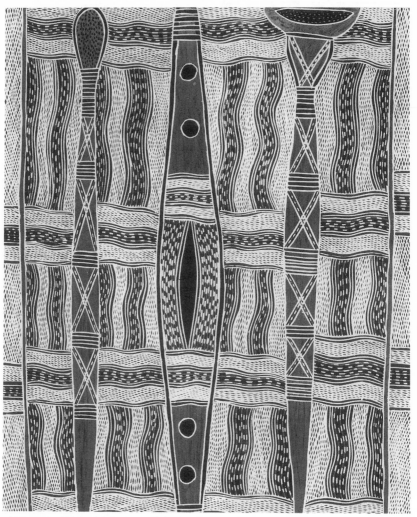

Figure 11.7 Digging sticks and yingapungapu. Artist: Banapana.

meaning in the context of the cross sign, which itself signifies possum-fur string. Maggots were given as a meaning only for the dashed infill occurring within the yingapungapu itself (although crabs' claws were said to be contaminated with pieces of maggot and rotten fish, which they spread over the area of surrounding sand).

For Narritjin's painting (fig. 11.5), I was given the following mean-ings for the dashed infill: maggot, fish, blood, footmarks, sand crab, and bird. In this case, however, unlike the painting illustrated in figure 11.7, the majority of the meanings are also explicitly represented by

Sign	Gloss		Signifying Potential	Main Connotations
:: ::	dashed infill			
		footmarks	1. maggots 2. possum 3. crab 4. bird	death, decay, putrefaction
		blood	5. fish 6. mourners 7. dead body 8. menstrual 9. foul-smelling wind	
◯	circle		1. turtle eggs 2. crab	
		hole	3. dug by emu (in sand sculpture) 4. campsite (of relatives) 5. fire place	function of yingapungapu
⦚⦚⦚	wavy lines		1. sandhills 2. tide mark	body painting design of guwak man
⊠	cross		1. Nyapililngu, breast girdle, possum string 2. cloud, place, spirit	mourning for (person, guwak, sand) sign of death
❘	digging stick		1. stick (walking, digging, scarifying)	Nyapililngu, mourning
(oval)			1. yingapungapu ground 2. fire places 3. midden 4. boat (?) 5. digging stick	death

Figure 11.8 The meanings of the signs on the yingapungapu painting illustrated in fig. 11.7.

figurative representations in the yingapungapu—birds, sand crab, and fish.

In figure 11.8 I have recorded two additional meanings for the yingapungapu which have not been discussed so far—boat and digging stick. Neither of these two meanings were given to me, but they are recorded by other authors. Groger-Wurm (1973:101) records for a painting by Narritjin that the oval design "is also the canoe which the

spirit of a deceased person has to build to travel to the land of the dead." The significance of this interpretation becomes clear in the next section.

Thomson records in his field notes that a Gupapuyngu clan yingapungapu represents a long digging stick (*watjurra*). Although I did not record this interpretation, a digging stick is indirectly signified through the blood of mourning women that collects in the yingapungapu. The blood flowed from the head of the mourning Nyapilingu as she cut her head with her digging stick. Even stronger evidence for the connection between the yingapungapu and the *watjurra* is suggested by the painting illustrated in figure 10.12. In the last chapter I showed how this painting represented in a condensed form the lake at Djarrakpi and the sandhills on either side. The painting was also said to represent the yingapungapu in the center and the two digging sticks on either side. In other words, it can be interpreted to have the same meaning as Banapana's painting of the yingapungapu with the digging-stick figures on either side. This is significant as it shows that the yingapungapu paintings can at least in part be related directly to the template that underlies the Djarrakpi paintings, the ground sculpture being associated directly with the lake. Indeed, as we shall see in the next chapter, the lake and the ancestral yingapungapu are in many respects the same thing in different places.

Many of the thematic and symbolic meanings that I have shown to be part of the interpretation elicited for the paintings are not encoded as iconological meanings of elements of the paintings. There is a sign that is referred to as if it encodes maggots, but not one that is referred to as encoding fear. Such meanings are connotations of the iconological meanings: maggots biting into flesh, as an image, may even engender fear. Paintings are not associated with a separate system of meaning from myth, ritual, and song but are integrated with them, so that much more may be included in the interpretation of a painting than is encoded in it in the strictest sense. However, it is also the case that meanings implicit in one painting may be made explicit in another; connotation may become denotation. The connotations of human body implied by fish is a case in point, for in some paintings the place of the fish is taken by the laid-out form of a dead human body. In a very real sense, an individual painting has no meaning but only interpretations that are in part the product of its form, in part the product of the set of paintings to which it belongs and of the wider ritual system of which the paintings are a part.

Further Inside Interpretations

The inside interpretations considered in this section are in many ways elaborations of the interpretations considered so far, which specify in more detail the mythological context of the yingapungapu at Djarrakpi. In particular, these inside interpretations relate the paintings to the marrawili and to other sacred objects owned or shared by the Manggalili clan. Although the myths refer to events that took place over a wider geographical area than that represented by the paintings, many of the elements of the myths are encoded in the signs on the paintings. It could be argued that the topographical reference of the paintings is extended by the broad signifying potential of certain of the signs included on them.

Interpretation 3

The following interpretation was given for Banapana's painting (fig. 11.1) by Narritjin. Variations of it were obtained on several other occasions in the form of myth.

Garanyirrnyirr [cicada] is a very strange animal. He yells out "eeeee," and then dies. Very hard, he takes his own life. He sings out for the salt water to come in, and then he dies, for the tide to come in, and when it comes in he dies. He is showing us what is going to happen, but he says nothing about the spirit land, nothing about what is going to happen to you after you die. He just dies.

[In ancestral times the guwak, after arriving at Djarrakpi, saw a cicada under the marrawili tree.] The cicada told the guwak, "I am climbing the marrawili tree and yelling out for the salt water to come in, and as soon as it comes near the land, I will be finished." And he says, "You two have got to do the same thing. You must get into the canoe and go far out to sea and there you will die."

Two fishermen, Yikuyanga and Murnumiya [guwak ancestors in human form], good fishermen who know how to live by the sea, were sitting under a tree, the cicada beside them. The guwak [in bird form] was sitting on top of the marrawili tree, yelling out to the salt water, "I have got to die on top of the tree, no one killed me, no one did anything against me—I just gave out my life to the marrawili rangga. Now you two under the tree, you have got to give out your lives under the water. Your spirit will go the Milky Way, *milnguya,* that's the living place for your spirit."

The two men went out to sea in their boat, and far out to sea the boat was overturned by a tidal wave. One of the men swam most of the way to Baaniyala [Mardarrpa country], where he died, and his body was turned into a stone. The other man's body was thrown up by the tide on the beach at Djarrakpi. His body was covered with designs made by the incoming tide (*bandumul*) as it washed over him. The designs became the clan design used

by the Manggalili clan. Nyapililngu, the ancestral woman, mourned the death of the guwak men, cutting her head with her digging stick. The spirits of the two guwak men went by way of the burrkun from the marrawili tree up into the Milky Way (see also Groger-Wurm 1973:101).

There is an internal inconsistency in Narritjin's interpretation. Yikuyanga and Murnumiya are said to be ancestral guwak in human form; they drown at sea following the instructions of the guwak in the form of a bird. The guwak in the form of a bird dies on the marrawili tree. The ancestral guwak thus dies twice in two different places.

The inconsistency reflects the fact that Narritjin's interpretation of the painting combines two myths that in many respects are structurally opposed. Recognition of this enables the contradiction to be at least partially resolved. The real question is not so much how it is possible for the guwak ancestor to die twice, which would imply an overliteral interpretation of the mythology, but what is the significance of the existence of two different myths concerning the death of the ancestral guwak.

One myth is that the guwak in human form took a boat out to sea, the boat was overwhelmed by the waves, and the bodies of the men were tossed back onto the land by the incoming tide. This is the outside version of the myth that I was given by Banapana and Wuyarrin, with one difference: in the outside version, the two men were said to be ordinary Yolngu, and there was no reference made to guwak ancestors. The second myth is the inside version, which I only obtained from Narritjin. It is, in some ways, the reverse of the outside version. The guwak brought about his own death by staying on land and causing the tide to come in and engulf him.

The relationship between the two myths can be analyzed in the following terms. One of the main ideological beliefs expressed by the guwak's suicide is that death is controllable. Unlike the cicada, the guwak knows what is going to happen to him when he dies and has devised a means whereby his spirit can rise up to the Milky Way (via the burrkun). He also refers to part of his spirit becoming incorporated in the marrawili rangga.

The guwak's death itself involves a reversal of reality. He dies by drowning on top of a tree, as a result of causing the sea to inundate the land. However, this reversal involves events that merely emphasize natural forces which are a familiar part of Yolngu experience. The king tides that sweep many miles inland along unprotected stretches of coastline and the enormous power of the gale force winds that drive them on are the destructive powers summoned by the guwak.

Clearly, actual human beings are not in complete command of their

own destiny in the way the ancestral guwak was, and in the myth, Yikuyanga and Murnumiya (human in form) act out the instructions of the guwak. The destiny of human spirits is dependent upon the intercession of the guwak and other wangarr ancestors (e.g., to enable the spirits to rise to the Milky Way or become incorporated in the marrawili rangga). The Yolngu view of spiritual destiny presupposes a belief in superhuman beings and powers. Death by drowning (in the past a frequent occurrence) is an instance of the lack of control that human beings have over their own death. Yet it involves the same forces that the guwak summoned to cause his own self-determined death. The juxtaposition (and existence) of the two stories can be viewed as a mechanism for endowing actual events with ancestral qualities. The guwak died in an impossible way, but the manner of his death is on the borderline of actual human experience. Humans cannot control their destiny as the guwak did his, but given the existence of the guwak his destiny becomes their destiny.

At a sociological level, the guwak's death exemplifies or provides a model for the Yolngu idea of "natural" human death (Morphy 1984:37ff.). A person should announce his or her death in advance and absolve all living relations and members of other clans from any responsibility for involvement in it. This is what the guwak does. This aspect of the ancestral guwak is congruent with the fact that the guwak rangga (see chap. 10) is used in contexts where it is necessary to mediate between disputing parties in a burial ceremony, and is one of the objects used to summon people to participate in a burial ceremony (see Peterson 1976:104, 105). It also partially explains why the guwak dance is one that can be performed when it is necessary to move a person's body during a burial ceremony. When the body is moved, the mokuy spirit of the deceased is thought to be particularly dangerous and liable to attack anyone it suspects of causing the death.

The guwak is a symbol of natural death, death which brings no repercussions on the living. The guwak is used symbolically to neutralize the anger of the deceased's mokuy spirit, and of living members of his clan, by being an expression of belief in the naturalness of a particular death.

The inside meaning of the painting discussed above is encoded in a number of ways in the paintings illustrated in figures 11.1, 11.2, and 11.6. The canoe and paddles (fig. 11.2) represent the journey out to sea undertaken by the two guwak men. The canoe was tossed up by the tide on the Blue Mud Bay side of Cape Shield, where it was transformed into a number of rocks on the beach. The marrawili tree is shown in two of the paintings. In the painting in figure 11.1, the guwak is seen on top of it. In this case the central part of the tree has the

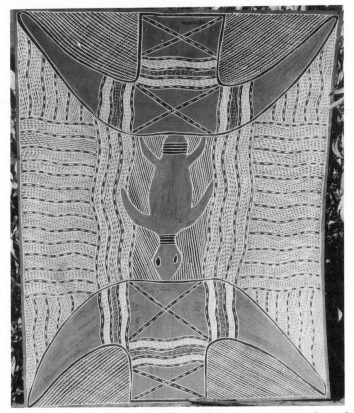

Figure 11.9 Turtle, wind, and clouds. Artist: Banapana. The painting shows the ancestral turtle advancing toward the lake at Djarrakpi, driving the wind and tide before it. The turtle is also signified in fig. 11.1, feature block (12), where the design inside the feature block represents the turtle's tracks as it moves up the beach beneath the yingapungapu.

form of a cylindrical hollow log coffin, suggesting the guwak's death. The design on the paddles was said to represent the cloud that arose out to sea when the guwak men drowned, and also to represent Nyapililngu, who began mourning when she saw the clouds out at sea and knew that death had occurred.

The turtle marks on the sand also signify indirectly the death of the guwak, in this case the death of the guwak on the marrawili tree. According to a connected myth, the tidal wave (*bandumul*) summoned by the guwak was caused by the ancestral turtle rushing toward the beach at Djarrakpi to lay its eggs in the sand. As well as pushing the tide before it, the turtle caused a strong wind (*lunggurrma*). This myth is illustrated

in the painting in figure 11.9. The cloud signs in the painting show its connection with the death of the guwak.

The inside interpretation adds further to the significance of the shape of the marrawili rangga (fig. 10.5). The head of the rangga, as we have shown, represents a cumulus cloud (and is explicitly interpreted as such). The cloud is a symbol of death and of female mourning. Since the guwak sat on the marrawili tree as he summoned the tide to come in and drown him, the top part of the marrawili rangga can be seen to encode reference to the death of the guwak and to the fact that he gave himself up to the marrawili.

Conclusion

Narritjin usually talked about the yingapungapu paintings and the Djarrakpi/Marrawili paintings as if they were categorically distinct, that is, as if they were different types of painting and were associated with separate places. Thus he told me that the yingapungapu is for people when they are dead and is not ranggapuy (i.e., associated with the clan's sacred objects). The marrawili rangga, on the other hand, is "your power, under the ground for when you are alive." The marrawili paintings and rangga are sources of spiritual power released in ritual performance to ensure the fertility of the world and to give strength and spiritual identity to individuals. It is through their cumulative exposure to such sources of power that men, in particular, gain in spiritual strength through the course of their lives. In contrast, the yingapungapu is designed to contain rather than release spiritual forces: it functions to protect people from the dangerous powers of contagion resulting from a person's death and from contact with the dead person's body.

Both the marrawili sacred object and the yingapungapu are concerned with the spirits of dead Yolngu. However, they are concerned with different dimensions of the souls of the dead: the marrawili with the birrimbirr soul and the yingapungapu primarily with the mokuy spirit. The marrawili sacred object is concerned with the creative aspects of death associated with the spiritual continuity of the clan. The guwak "gave himself up to the marrawili," and the marrawili is one of the sacred objects toward which the birrimbirr soul of dead Manggalili can be directed. While the designs incised on the marrawili may be also painted on the chest of a dead clan member, the yingapungapu design is not. The yingapungapu is concerned mainly with the negative aspects of death, with the containment of pollution, and with sociological aspects of death that affect the living. The difference between the two sets of paintings reflects the separate treatment of the birrimbirr and mokuy in burial ceremonies (see chap. 6).

However, the opposition between life and death, and between paintings of life and paintings of death, is not absolute. The spiritual power associated with the sacred objects and the *ranggapuy* paintings, as well as having potential to enhance life and provide strength, can also bring death. People who are weak through illness, pollution, or injury or people who accidentally come into contact with sacred objects or paintings are endangered by them. Such paintings cannot be used to restore the sick; indeed, the belief is that they would more likely kill them. It is only when the sick have recovered their physical health and sense of well-being that they are likely to have their spiritual health renewed by having a sacred painting placed on their body. Until then they need to be protected against dangerous spiritual powers, whether they emanate from the mardayin or from pollution associated with death. In this respect, the yingapungapu and correct pollution behavior are life-giving. Ironically, they take away life only from the dead in that they prevent the dead from harming the living.

The ambiguous nature of the relationship between the two sets of paintings is reflected in their symbolism. From one perspective, the meanings encoded in the paintings differ in many respects. Though the paintings share many signifiers and signifieds, the connotations of the signs are different in the two cases. For example, *marrngu*, the possum, is signified in both sets of paintings. In the marrawili set, the possum is signified by cross signs, by dashed infill, and by figurative representations. The reference is primarily to the possum's role in manufacturing the burrkun (possum-fur string) on the journey of the guwak and his companions from Burrwanydji. The burrkun was subsequently transformed into topographical features of Djarrakpi, which are represented in the paintings. As a sacred object, the burrkun is a major cultural property of the Manggalili clan and an important component of the ceremonial relationship between Manggalili and other Yirritja moiety clans. The possum thus played a major role in the mythological events encoded in the paintings. In the yingapungapu paintings, possum was only given as a meaning for the dashed infill in the cross sign. The primary reference of possum in this case is to the blood of mourning women, the possum-fur string breast-girdle being a sign of woman and possum scratch-marks being a sign of blood. The possum is not a major actor in the events that led to the creation of the yingapungapu ground.

Clouds likewise are signified in both sets of paintings. In both contexts there is a common element in their usage—clouds as a sign of distant places and events. In the marrawili paintings, clouds above the marrawili tree are a sign of Djarrakpi, the guwak's destination. Clouds are also integrated with the theme of possum-fur string. In the

yingapungapu paintings, clouds signify the place of death of the guwak men, and the death of the guwak on the marrawili tree. They also encode more general beliefs and practices associated with death and burial.

Even from these examples it is clear that the meanings of paintings do not form discrete sets. In the case of paintings belonging to closely related areas of land on the same ancestral track, the meaning of one set of paintings can be seen in the forms of another set in the sense that many of the same signifieds are used and also in the fact that the mythology overlaps. Because the same signs are used to represent meanings in both sets of paintings, it is possible that the meanings will be carried over from one painting to the next. This is shown by the fact that paintings trigger interpretations that scan a broad range of related mythology. Paintings, like the myths themselves, do not have finite limits to their content; the limits are more a matter of focus than exclusion. The paintings focus on the yingapungapu or the Djarrakpi landscape, but the meanings of the sign stretch out across the paintings. Yolngu signs are always in the process of becoming symbols in the sense defined by Fernandez (1977:126) in which there is a productive echoing of meaning and affect across contexts. The marks of the footprints of the possum in the marrawili paintings are represented by the same dotted infill that represents the maggots, blood, and rotten fish of the yingapungapu paintings. In the latter case it is associated with death and pollution, in the former with the power of the possum as ancestral being, but the connotation of the sign in the one case may enhance the meaning of the referent in the second case. As we saw earlier, the blood and the maggots are associated with emotions of fear and anger, fear of the pollution from the body, fear of death, anger at those who have caused the death. Yet fear and death are both components of ancestral power, possible images of power that are consistent with the fact that ancestral power is dangerous, that it can kill. Symbolism here involves the transformation of negative emotion into positively valued feelings of power (cf. Munn 1986). This image is made explicit in the case of one of the Yirritja moiety's sacred objects, the sacred mangrove tree, which is represented as a dead trunk riddled with mangrove worm, in turn an analogue for the bones of the human body stripped clean of flesh by maggots. It is significant that in myth, the guwak, drowning at sea, clung for a while to the mangrove tree as it was carried to the beach by the incoming tide.

The separation of the paintings into "paintings for life" and "paintings for death" implies a categorical distinction that the symbolism transcends, for in many respects each set of paintings connotes the other. This is reinforced by the ambiguities of the myths and of the in-

terpretation of the paintings. The yingapungapu is adjacent to the lake at Djarrakpi, yet in some cases it can be interpreted to be the lake at Djarrakpi. It is outside the set of the Djarrakpi/marrawili paintings, yet it can be encoded, as can the lake, in the central digging stick of the three-digging-stick painting, the painting that seems to replicate the structure of the Djarrakpi template. The paintings seem to center on the contrast between the yingapungapu and the lake and on the opposition between life and death. But in the first case there are strong hints that in some respects the lake and the yingapungapu are the same, and in the second case the sense in which they are opposed is becoming less clear.

12

Nyapililngu's Blood

The move from outside interpretations to inside ones involves the development of certain core ideas and themes of Yolngu religion. We saw in the last chapter how a number of themes associated with death and the fate of the soul were developed through establishing metaphorical connections between meanings encoded in elements of the paintings. The metaphors and analogies are clearly an outcome of the themes and also a means by which the themes are passed on to new generations of Yolngu. The connection made between dead fish and dead Yolngu, for example, is a way of expressing one of the key themes of Yolngu ritual—the recycling of spiritual power between the present and the ancestral past. The drifting cloud relates to the same theme. Both provide perspectives on the reincarnation of the spirits of the dead—the fish as dead body and spirit child, the cloud as an image of the spirit's journey.

The interpretations I present in this chapter develop further the theme of the spiritual cycle and a series of related themes concerning the relationship between the human and ancestral world and the spiritual continuity of the clan. The interpretations are influ-

enced strongly by another set of themes about the relations between men and women. These involve not only present power relations but also the role of men and women in procreation. These themes are not encoded in paintings. Rather, they are factors underlying the paintings' interpretation, influencing the way encoded meanings are organized in exegesis. In some ways these themes give coherence and a sense of direction to the sequences of interpretations that are part of the revelatory system of knowledge: they are emergent ideas about possible connections between things that are continually alluded to as a referent beyond the metaphor. In this respect the themes are symbolic connotations of paintings in a Schutzian sense (Schutz 1962); they are ideas, beyond the frame of everyday experience, that are not fully articulated but which are experienced through metaphor. The spiritual cycle, the concept of ancestral power, and the very idea of transformation itself are all ideas of this kind.

In the conclusion to the previous chapter I stressed the different foci of the two sets of paintings considered so far. The marrawili paintings focus on the continuity of human life and the Manggalili clan through the creative power of the ancestors; the yingapungapu paintings focus on death and pollution. I was also at pains to show that the difference in focus was a relative one and that many of the mythic themes and much of the symbolism crosscut the two sets of paintings. The next set of interpretations I discuss refer primarily to the first set of paintings, although they also help us better understand the yingapungapu paintings. Each interpretation in the sequence is said to be inside relative to the previous one, and there are further inside interpretations that I do not go into. All the interpretations are concerned with human procreation and with the ancestral woman, or women.

The Nyapililngu

The Nyapililngu are in some sense both singular and dual. There are two Nyapililngu at Djarrakpi, but in almost no respect do they have separate identities. They are often referred to as if they were one. They are always referred to as doing the same thing at the same time, but they are, however, sometimes represented as two; they sometimes do the same thing in different places along the shoreline at Djarrakpi. Very occasionally the Nyapililngu are referred to as a group of women. I too refer to them sometimes as one and sometimes as two. Nyapililngu is characteristically portrayed at Djarrakpi in two aspects: one as a woman in mourning, letting blood from her head; the other as a woman (or sometimes a number of women) in the sandhills at Djarrakpi, spinning possum-fur string, collecting wild plums and snails to eat, and making playthings for her (their) children. She is said to be extremely shy and

always hides from men: she hid from ancestral guwak, and she hides from living Yolngu.

Interpretation 1

Liyawulumu, a Gumatj 1 man, interpreted a Manggalili painting as follows:

That is Nyapililngu. Nyapililngu, Wurramukurr, Burdulwurdul are all women at Djarrakpi. They carry digging sticks in their hands and baskets on their heads, and cloth around their waists and another around their breasts. Nyapililngu hides herself away from men; she won't touch men, boys, nothing. When she sees men in the distance, on the beach, she hides. Her children hide.

The fact that Nyapililngu had children yet always hides from men suggests a fundamental contradiction in the outside story, or rather an unanswered question: Where do her children come from? The first level of inside story was given to me as an interpretation of Banapana's painting (fig. 11.7) discussed in the last chapter. The painting had first been interpreted for me by Narritjin as a yingapungapu and two digging sticks; this was also the interpretation offered by Banapana and Wuyarrin. Wuyarrin's interpretation differed from the others in one significant way: she stated that the left-hand digging stick was male and the right-hand one female. As we shall see later, this additional interpretation is significant because it alludes to the inside interpretations.

Interpretation 2

The digging sticks they are really a man and a woman. We make them look like digging sticks. We make them look the same way—not different from one another.
HM: How do you know which is which?
We don't know, but they know. Nyapililngu said to Barrama [an ancestral being at Gaarngarn (see chap. 4)], "Barrama, I want a man. Where is a man?" Barrama replied, "You don't want a man. You have got one already." "I haven't got a man," she said, and the two of them had an argument. "You go to the bush," said Barrama, "and you will find that you have got a man." And she found that there was a man living there in a different part. This man was called Murnumiya, and the woman Nyapililngu. You don't make them different, otherwise people will know. You have got to make them look the same and then people will think that they mean the same thing.

This, the first level of inside interpretation, clears up the problem of Nyapililngu's children in the simplest possible way: Nyapililngu had a husband all the time. Representing both of them by the same sign, a digging stick, is said to be merely a device for obscuring this fact from

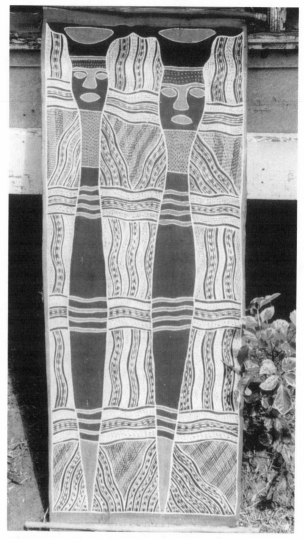

Figure 12.1 Digging-stick woman. Artist: Banapana.

the uninitiated. Three problems are suggested by this interpretation. One is why the information that Nyapililngu had a husband should be considered inside. The second is why Nyapililngu did not know of the existence of the man. The third is that if this is the inside interpretation, why does Banapana's painting orient interpretation in this direction? The carrying basket on the top of the right-hand digging stick is a sign associated with Nyapililngu and thus suggests femaleness. The phallic

shape of the other digging stick suggests maleness. Indeed, as I stated, the digging sticks were interpreted as male and female by Wuyarrin. Since in other Manggalili paintings, artists frequently painted facial characteristics (eyes, nose, and mouth) on the digging stick (see fig. 12.1), the interpretation of male and female human figures as a meaning for digging sticks in Manggalili paintings must be common currency. The reason why digging sticks are an appropriate sign for male and female human figures remains unanswered, as does the question of the relationship between the male and female humans represented.

One reason for signifying male and female by the same form is that it provides a means of representing the conversation between Barrama and Nyapililngu, the essential point of which is that Nyapililngu did not realize she had a husband all along. I was told this story on several occasions. One variant was obtained when discussing a painting similar to that in figure 10.11. The painting, it will be remembered, consists of three digging sticks (unmodified by the addition of other signs such as the carrying basket as in fig. 11.7). Narritjin stated that they represented three people on the sandhills at Djarrakpi talking to Barrama. Barrama this time told them to go into the woods and they would find that one of them was a man. On this occasion their ignorance is made quite explicit; it was not simply that the women had never seen the man, but that they did not know which of them was a man. The three digging sticks are a means of visually representing their lack of knowledge. According to this interpretation, two of the digging sticks were female (the two Nyapililngu) and one was male.

The first level of inside meaning, as I have shown, involves the digging sticks being interpreted to represent human figures. The second inside interpretation, and the one at which we now stop, does not alter this. It was provided for the same painting, which prompted the first inside interpretation (fig. 11.7).

Interpretation 3

The second inside interpretation is as follows:

Nyapililngu made everything on the beach side of Djarrakpi. She made the water holes, she made the stringybark, she made the possum-fur string, she made the feather string, and she made a man himself, her own husband. And nobody knows about this. There used to be only one digging stick, but now there are two. That means she has got a husband. Everybody asked her where her husband was, but they never know. They asked her if she had a husband with her. This one, that's her husband, that's his penis. This one, that's female, and that's her vulva. Very very tricky: you and me, we know some things; other things we will never know.

This interpretation differs in a number of important respects from the previous inside level. According to that version (Interpretation 2), men and women existed at the same time but were ignorant of the fact. The digging sticks represent Nyapililngu's confusion and lack of knowledge. In this latest interpretation, Nyapililngu preexists her husband and, more than that, creates him. The digging sticks represent the success with which she hid the fact from other people. According to both interpretations (2 and 3), the digging sticks represent, respectively, a man and a woman. In the first case, the oval is interpreted as a stringybark carrying-basket, which is an outside interpretation or public meaning. In the second case it is interpreted as a vulva, its inside meaning.

The Nyapililngu belong to a category of spirit beings whose status in Yolngu cosmology is somewhat ambiguous. Nyapililngu is not referred to as a wangarr (one of the ancestral beings who preexisted human beings), but as a mokuy, the same word that is used to refer to ghosts. She is one of a category of beings that seem to mediate between the ancestral past and the present by interacting with both wangarr beings and true human beings (*yolngu yuwalk*). The ambiguity is a profound one and may have something to do with cultural ways of conceptualizing the transformation from an ahuman world of the wangarr to a human world that has a wangarr presence. Mokuy seem to occupy the space between these two very different worlds—the world experienced in daily life and the world that can never be truly experienced by human beings because it is gone, and in as much as it exists today, it exists in a different dimension. The use of the work *mokuy* for ghosts of the dead and for these mediating ancestral spirits is probably significant, as they both occupy a space between two states of existence—the ancestral past and the lived present. Ghosts, however, are usually thought to remain forever separate from the ancestral past, unlike the birrimbirr soul of the dead person which does become reincorporated within it. On the other hand, Nyapililngu's connection with both worlds is a direct one: she interacted with the wangarr beings who ended their journey at Djarrakpi, and she also produced children who can be thought of as the founding human ancestors in the land. More than that, she continues to play a central role in the conception of children, for her blood provides one of the media of exchange of spirits between the ancestral past and the present.

When Nyapililngu cut her head in mourning, the blood flowed into the yingapungapu, but it also flowed into the lake at Djarrakpi; when Nyapililngu had children in the sand dunes, the blood again flowed into the lake, and it is this blood that is thought to be instrumental in spirit conception. As Narritjin said:

If you are living with your wife, then the spirit from Manggalili, the spirit from Nyapililngu comes to you and they give you children. They are giving you Yirritja moiety children. A mother should be watching out, and when she feels she has a baby then she knows Nyapililngu has given her a baby. Whether they give you a good baby or a bad baby is something you don't control, because the waters in the lake are still changing. Sometimes they make you happy, sometimes they make you sad; you don't know which one she has given you.

On another occasion, Narritjin told me that women conceived a Manggalili spirit child when they went down to the lake to wash.

The Blood of Life and the Blood of Death

From the outside perspective, the Djarrakpi paintings and yinga-pungapu paintings seem to be associated with discrete mythological events which are associated with different stages of existence and are the basis of different ritual performances. The former are associated with the ancestral genesis of Djarrakpi and the spiritual life of the Manggalili people. The main sacred object associated with the set of paintings, the marrawili rangga, has a place in the revelatory ceremonies of male initiation, such as the Yirritja moiety Ngaarra ceremony, rather than mortuary rituals. The yingapungapu paintings are associated with death, burial, and decay, and the sand sculpture is one mainly used in mortuary rituals. However, as I suggested in conclusion to the last chapter, the more one learns about the meanings encoded in the paintings, the more ambiguous the separation between them becomes, and the more necessary it becomes to see the two sets operating as a whole. The stories of the Nyapililngu seem at first to be associated with the lake at Djarrakpi, yet many of them were elicited as interpretations of a painting that had as its central feature a yingapungapu. What is the connection between the yingapungapu and the lake? What is the connection between the pollution-containing properties of the yingapungapu and the life-creating properties of the lake? What indeed is the relationship that is implied between life and death? In order to approach an answer to these questions, I first look in more detail at the way some of the themes of the Nyapililngu stories are encoded in the two sets of paintings and the symbolic associations that are created.

The Djarrakpi/Marrawili Set

The lake was created by the blood of the ancestral woman Nyapililngu as it flowed from her vagina. The red cross-hatching in the central sections of the paintings shown in figures 10.5 and 10.6 represent menstrual blood. Loci (2) and (3), which represent the places where

Nyapililngu spun possum-fur string (burrkun), also represent the places where she bled. The wavy lines across the marrawili rangga (fig. 10.5) represent her blood flowing down the sandhills and into the lake. The lake is said to be part fresh water and part salty ("bad tasting") water. It is the latter that is thought to be Nyapililngu's blood. In the more public versions of the story (chap. 10), the emu ancestor is pictured searching for water in the lake bed. Although he dug a number of wells, he was unable to find fresh water. The fact that the lake was created by the flow of blood from Nyapililngu is said to explain his lack of success. The vertical strata of the lake are divided into two distinct layers said to correspond with the dual aspect of its waters—part salt and part fresh.

Narritjin and his sons once tried to dig a well in the lake bed close to where they had built their settlement. When they had dug through the top layer of white sand, they came to a layer of fine red sand—sand so fine that, according to Narritjin, it ran back into the hole as they dug it, just like water. This layer of red sand was interpreted as a further confirmation of the truth of the mythological events.

The emus digging in the lake can be seen as symbolizing sexual intercourse. There are a series of complex connections between an emu's leg, fish spear, and digging stick, on the one hand, and lake, water hole, and vagina on the other. The emu's leg is analogous to the digging stick with which Nyapililngu cut herself. The emu's leg represents a pronged fish spear, and its neck and head a spear thrower (fig. 12.2). The ancestral emu is sometimes said to be digging in the lake with the fish spear. When he could find no water in the lake bed, it was his spear that he threw over the sandhills and into the beach. In dances, spears can be represented by digging sticks, and digging sticks are frequently used to represent the penis, as indeed is the case in Banapana's painting (fig. 11.7). The lake clearly has the connotations of a vulva: it is filled with women's blood and is the source of conception spirits; furthermore, it can be represented by the yingapungapu, which is itself a vulva-shaped sign. The fact that the emu is digging in the lake with a fish spear is of further significance in that fish both are symbols of the dead and represent conception spirits.

In paintings from Djarrakpi, digging sticks have both male and female connotations and, more surprisingly, can be thought to encode both male and female sexual characteristics. The digging stick is predominantly a female implement used by Nyapililngu for climbing up and down the sand dunes, digging up yams, knocking down wild plums, and cutting her head in mourning. The digging stick as penis is clearly a male attribute, though in Nyapililngu's case, something that she creates for her own use. The digging stick's shape makes it a natu-

spear thrower

fish spears

Figure 12.2 Emu as spear and spear thrower.

ral phallic representation, but it takes little modification to represent it
as a pointed ellipse, the yingapungapu, which is a vulva-shaped sign.

In the case of the Djarrakpi paintings, menstrual blood is associated
primarily with health and fertility, and more specifically with the
health and fertility of the Manggalili clan. The journey of the guwak
and possum to Djarrakpi to establish a homeland and the events that
took place there after their arrival represent a myth of origin of the
Manggalili clan territory. The myth is also concerned with the transfer
of power from the wangarr ancestors of the clan to its human (Yolngu)
members. The marrawili sacred object, the most important at Dja-
rrakpi, was already in the land. It acted as a reference point for the
other wangarr ancestors. The female ancestral being Nyapililngu was
also at Djarrakpi when the guwak arrived. She learned from the pos-
sum and guwak how to make feather string and how to spin possum
fur, symbolic materials later controlled by Manggalili men. Before
the arrival of the guwak, Nyapililngu lived without men and without
sex. She did not menstruate. Following the arrival of the guwak,
Nyapililngu created a husband to satisfy herself sexually. Her blood
flowed into the lake and became the spiritual generator of subsequent
generations of Manggalili clan members. Nyapililngu, herself half an-

cestral being and half Yolngu, mediated between the ancestral beings who established the Manggalili homeland and who are embodied in the shape of the landscape and incarnate in the Manggalili clan members whose territory it is today.

The Yingapungapu Set

The primary topographical reference of the inside story is to the lake and sand dunes of Djarrakpi, for the places where the Nyapililngu cut their heads were the places where they menstruated and gave birth. However, this does not separate the events from the yingapungapu; on the contrary, it further associates them.

I have already shown that the yingapungapu sand sculpture can be used as a sign for the lake at Djarrakpi. There are also reasons to believe that the shape of the yingapungapu represents a vulva, though I was never given this as an explicit interpretation. The yingapungapu, however, was said to represent one of the Nyapililngu, and the analogous elliptical sign on the right-hand digging stick in figure 11.7 was said to represent a vulva as well as the opening of Nyapililngu's carrying basket. One of the meanings given for the cross-hatching within the yingapungapu is women's blood; hence whether or not it represents a vulva, it can represent the lake as container of women's blood.

The outside story linking Nyapililngu, digging stick, and blood concerns her cutting her head in mourning. In the case of the yingapungapu paintings, she cut her head when she was within the sand sculpture she had built for the dead guwak, and the blood from her head wound flowed into the yingapungapu.

According to the inside story, Nyapililngu also bled, but in this case it was menstrual blood and afterbirth blood that flowed. It is in this context that the basket in figure 11.7 was interpreted to signify the vulva. According to other interpretations, the basket is filled with *munydjutj* (wild plums) which are tabu to menstruating women. In another painting (fig. 12.3), an elliptical sign on Nyapililngu's head was said to represent both the basket of wild plums and the cut she made in her head with her digging stick.

The blood from the head wound can be referred to by the same term as menstrual blood and afterbirth blood, and the blood released from the head and contained in the yingapungapu is analogous with the blood that, when released from the vagina, flowed into the lake. The spatial ambiguity of this myth reinforces this association in that the women not only cut their heads beside the lake, but also bled into the yingapungapu. The process of interpretation moves toward a position where there is no simple separation between the blood of mourning and the blood of birth; the blood from both sources mingles

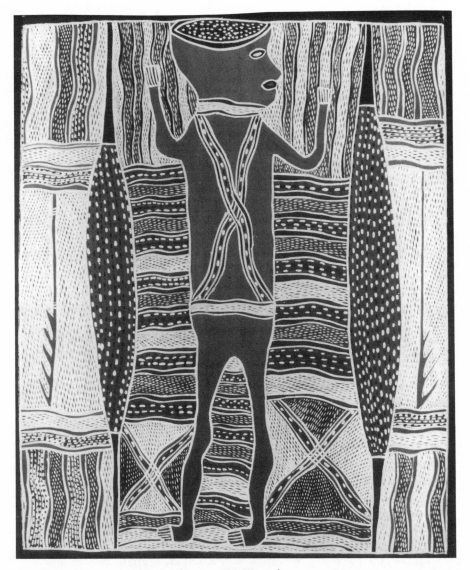

Figure 12.3 Nyapililngu landscape. Artist: Wuyarrin.

in the waters of the lake. If we review the mythology as a whole, women's blood can be seen as a symbol and perhaps even a mechanism for the regeneration of the human clan and for the continual exchange of spiritual substance between the human and ancestral world.

The cutting of the head in mourning is at one level clearly an ex-

pression of grief at the loss through death of a relative. Evidently it is a powerful symbol or expression of grief independent of any connotations it may have which connect it with ancestral menstrual blood. Equally clearly, if menstrual blood is an important element in the complex of symbols associated with death and burial, then it is possible that it could be encoded in the actions of women cutting their heads. That the stringybark basket carried by women on their heads is associated negatively with menstruation in the outside story through containing a fruit tabu to menstruating women, and associated positively in the inside stories, suggests that the blood of mourning is an analogue for the blood of birth.

In chapter 6 it was shown that one of the main themes of Yolngu ritual is the passing on of ancestral power from one generation to another by way of the sacred law of the clans. Integral to this process is the spiritual cycle whereby the spiritual power of the dead becomes incarnate in the living through the process of spirit conception. After a person's death, the birrimbirr spirit is guided back to a place in the clan lands where it can rejoin the ancestral forces in the land, finally to return again one day in the form of a conception spirit. The lake at Djarrakpi is one of the sources of conception spirits in Manggalili land; it is also one of the places to which spirits of the dead can be guided. Yolngu mortuary rituals abound with images of death and rebirth; the dead body, for example, is represented as an egg laid in a symbolic nest—the grave (Morphy 1984:99). The yingapungapu fits well into this pattern. Laying the body within the yingapungapu is in a sense placing it within a womb, associating it directly with the blood of the ancestral Nyapililngu, which at Djarrakpi is a source of conception spirits and of more generalized spiritual power.

There are many other ways in which the yingapungapu is associated with ancestral power and regeneration apart from Nyapililngu's blood. I have already referred to the power of fear and anger and its positive transformation through mortuary ritual. The process of decay also provides a series of images of the transformation from one state to another, and the process of cleaning flesh from the bones is one that signifies the passage of a person from a human to an ancestral state. The cleaned bones are associated with the clan's sacred objects (which are referred to as the "bones of the clan" and with the birrimbirr spirit, and provide a positive connection with the ancestral dimension. However, in the sets of paintings I have considered, these themes are not developed to the same extent as those associated with the Nyapililngu, and I do not consider them in detail here.

The Mystery of Women's Power

A second theme that runs parallel to the others in the interpretation of the two sets of paintings, and which is prominent in the Nyapililngu myths, is the question of the relationship between men, women, and ancestral power. As I suggested in chapter 7, the relationship is an ambiguous one. Women today play a subordinate role in ritual in that they are denied access to the inside ceremonial ground and the clan's sacred objects, and have less control over the system of restricted knowledge than men do. Men have a closer relationship with the ancestral powers and theoretically are in a better position to manipulate them than women are. In the ancestral past, however, women were in a very different position: in the myths of the Wawilak and Djan'kawu sisters, not only did women control the sacra and the ritual knowledge, but they were also powerful creator beings. The Djan'kawu, for example, gave birth to the members of clans of the Dhuwa moiety and created features of the landscape by their actions. Toward the end of these great myths a reversal occurred which resulted in men taking over the clan sacra and gaining control of the system of religious knowledge. In the case of the Djan'kawu sisters, while they were out hunting one day a group of men broke into their camp and stole all of their sacred paraphernalia, their digging sticks, dilly bags, and sacred objects. The men then set fire to the camp and when the women returned told them that a bushfire had destroyed their possessions. The women lamented their carelessness, and it was only much later on that they learned the truth when they saw in the distance men performing a ceremony with their sacred objects. The women fell down and hid their eyes because they did not want to see the ceremony. They said to each other, "It is no good now for us to get those sacred things. We must work hard and get food for the men from now on." And the men said, "It is a good thing we took these sacred objects from the women, because now they can get the food for us." This created the situation that has lasted until today in which men are politically dominant and in which a division of labor results in women doing the hard work of gathering while men hunt and take part in ceremonial performance.

The story of the theft of the sacra can thus be seen as a means of making the ancestral past consistent with the present, and justifying the present state of affairs by alluding to the gullibility and carelessness of the ancestral women. But, although men gained control of the sacra, the sacra themselves are fundamentally associated with women. In the case of the Djan'kawu, the sacra included the women's digging sticks and dilly bags, their blood, their mosquito mats, and so on. Even those objects that do not represent things that belonged to the women,

for example, sacred objects representing the tail of a goanna, are in fact associated with the women, for the Djan'kawu gave birth to them from their wombs, together with the children they left behind to populate the land.

There is much rich evidence, stretching from Warner's period in the field to the present, that symbols of female power are central to male initiation. I showed in chapter 7 how the early stages of male initiation involve making boys into women or at least associating them closely with female processes by dressing them with breast girdles and making them bleed. Of course Yolngu gender symbolism is open to a great variety of interpretations, some of them in harmony with the present status of women in society, others of which seem to contradict it. For example, boys are treated most like women in the early phases of their initiation up to circumcision. During this time they are both separated from women and in some respects made subordinate to male authority—their position as "women" in the ceremony may well gain part of its significance from the subordinate position of women in society. Yet they are also acting the role of ancestral women, and this associates them with female ancestral power—a process that continues throughout their lives. They also come into contact with male symbols—with phallic ceremonial objects and with substances that represent semen—but there is no sense in which male symbols succeed female symbols or replace them, or in which male symbols have priority over female ones or are more powerful substances. Of course, in context, individuals may emphasize one over the other, and Yolngu ritual and sacred law provides a rich reservoir of images from which to draw. In my own experience from working at Yirrkala, I sensed a slight priority given to female symbols and in turn to female ancestral powers. Certainly there is much evidence from all ethnographies of the region that female symbols are powerful. This need not of course mean that women are considered in any sense powerful. The symbols refer to ancestral women, and present-day women may be distanced or disassociated from the powers by being treated, as Warner suggests, as inherently profane. Symbols of female power may be appropriated by men and located in the restricted world of manifestations of the ancestral past, where the symbols can be controlled and manipulated by men in ritual. Yet even in that case, the power of the symbol must derive to a considerable extent from knowledge of and experience of women. This might be another case of the transformation of value through ritual process. In the case of actual women, female substances such as menstrual blood and afterbirth may be treated as polluting and dangerous, things to be feared, whereas when transferred to the ancestral dimension this fear becomes ancestral power and is associated

with the positive values of creativity and fertility. There is some support for this as a possible interpretation, for although menstrual blood is not treated as a major pollutant, some evidence shows it may endanger men and women. Women are told that, when menstruating, they should avoid certain lakes and stretches of water where ancestral snakes may emerge and swallow them.

In many contexts, however, men and women refer positively to those very attributes of present-day women that are used as the substance of ancestral symbolism. Women refer to their fertility and ability to give birth as self-evident powers which they possess and men do not. Men also allude to women's powers, and some men implied, in direct contrast to Warner, a natural sacredness in women. Narritjin always gave priority to women in any discourse over sacred powers. When he stayed in Canberra in 1978 as a visiting artist at the university, he gave a series of tutorials to students of the anthropology of art. He would always begin by somewhat mysteriously alluding to women's power: "In the beginning were those two women," or "we must start with the digging stick and the dilly bag, women's power."

The myths of Nyapililngu are very pertinent to these issues, since they are concerned with her creative power and her relationship with men. In the outside story, Nyapililngu is without men: she lives by herself on the sand dunes, she hides from men, but she has children. The story poses a problem, How did she have children? which the first inside story appears to resolve in the simplest way. Nyapililngu had a husband living with her all the time; she simply did not realize it. The second inside story, however, moves back in the direction of the outside story. Nyapililngu did not have a husband initially; rather, she created a man for herself. But he remained in the background, for although Nyapililngu made him, no one ever saw him: "They asked her where her husband was but they never knew." In the outside version of the myths, Nyapililngu hid from men; in the inside version, she hid the man she had created; and in none of the versions do men play a significant role. The only "male" figure with whom Nyapililngu interacts in a major way is the guwak, an ancestral being sometimes human, sometimes animal in form, who is referred to as her "brother," who established Djarrakpi as the homeland for the Manggalili clan, whose death Nyapililngu mourned beside the yingapungapu, the guwak for whom Nyapililngu bled.

The revelatory process provides a source of images, points of contradiction, and variations on a theme that can be used reflexively by individuals moving through the system. One of the things the Nyapililngu myths suggest is that in the transfer of power from the ancestral past to the human world, human males played very little role.

Nyapililngu is a female founding ancestor of the clan, and it is through her blood that spiritual continuity of the clan is established. The guwak is also a source of spiritual power for the Manggalili as an ancestral being whose actions and leadership created the landscape of Djarrakpi. It is the interaction of the guwak and the quasi-human Nyapililngu that resulted in the foundation of the clan. The situation on the surface contrasts markedly with the situation that exists among humans, where the women of the clan take their blood elsewhere, marrying members of outside clans, while the men ensure the spiritual continuity of the clan by controlling the manifestations and transformations of the ancestral past. Nyapililngu was the sister who stayed behind, but it is the men of the clan who control her blood. However, it is still spirit conception that initially produces the child, and it remains women who give birth. There is still considerable ambiguity in the role of men, and a mythic discourse in which men are either unnecessary or secondary may well be psychologically powerful.

I do not intend to do anything more than suggest directions in which the interpretation of these myths can be pursued. My main aim in this book has been to show how meanings are encoded in the art and how paintings are interpreted by people. However, individuals ultimately reach a stage of exposure to a set of paintings and a point of interpretation where the paintings themselves become productive elements in a discourse. When I have tried to show in this last section are some of the directions in which such thoughts may go in the process of connecting a set of paintings to some of the basic themes of Yolngu culture that are taken up again and again in myth and ritual.

13

Conclusion: Yolngu Art and the Creativity of the Inside

It is extremely tempting to conclude this volume by showing how Yolngu art as a cultural institution is a central component of the structure of the society or a key element in the process of social reproduction. But there is the nagging feeling that social phenomena are so interconnected that any starting point results in a journey through the whole sociocultural system, so that almost any sociocultural phenomenon can be made into a central institution that connects with everything else. Rather than looking for dominant structures and key institutions, it may be more productive to construct a thick description of the event or object. Such a description would allow for the interconnections necessary for interpreting the event to be seen, without at the same time imposing a structure on it. On the other hand, tracing the threads of connection backward may not ultimately be the most productive way of analyzing the reproduction of a social formation. No matter how thick a description is, it alone cannot explain continuities in patterns and structures over time. Sketching the background of an individual event, one quickly encounters the system of clan orga-

nization and the system of restricted knowledge which, no matter how one brackets them off, exist at a different supra-individual level. My a priori assumption is that such structures are reproduced through a process that involves the socialization of individuals into the world through collective representations and culturally structured knowledge, and their action in contexts that are framed by institutions or institutionalized behaviors. Neither the collective representations nor the institutions are fixed or universal; nonetheless, they are active in the process of structuration. The concepts I have used to analyze Yolngu art—concepts such as theme, template, and representational system—imply the existence of intersubjective cultural structures whereby individuals act with reference to shared understandings. Although this perspective is in continuity with a Durkheimian semiotics, it is one that I hope is free from social reductionism and from the reification of social phenomena. My concepts of theme and template, for example, characterize phenomena that are fuzzy around the edges, are dependent in part on context, are variable according to the position of the individual, and are liable to change over time. Perhaps every individual has his or her version of a particular template, which overlaps only partially with those held by others. Nonetheless, the particular template is the product of discourse over paintings, of attempts to communicate or rather achieve shared understandings, and its content is consequently structured at a supra-individual level.

Yolngu art is both an important institution and one that exemplifies features of the structure of Yolngu society and the Yolngu system of knowledge. Paintings, dances, songs, and power names are collectively the mardayin, the sacred law through which knowledge of the ancestral past—the wangarr—is transmitted and reenacted. Paintings are integral to the process of the transmission of the wangarr and also to the way in which it articulates with present structures and purposes. Yolngu art is, in this respect, as Munn (1973:5) following Lévi-Strauss has argued for the Walbiri case, an ordering structure. As such, an analysis of the properties of the artistic system should reveal structural features of the articulating systems as well as demonstrating how the artistic system contributes to the way relationships are established between systems.

From a Yolngu perspective, paintings are not so much a means of representing the ancestral past as one dimension of the ancestral past: paintings are mardayin; they are wangarr miny'tji. The ancestral past is both a metaphysical system that provides explanations for relations in the world by creating powers, values, origins, and destinies, and an integral part of the process of social categorization: relationships are

recast to make them accord with the ideology of continuity with the ancestral past (see Myers 1986:242). In keeping with those dual aspects of the ancestral past, Yolngu art provides a way of socializing people into a particular worldview in which certain themes become meaningful, in which certain values are created, and by which certain things can be done. Yolngu art also provides a framework for ordering the relations between people, ancestors, and land. However, the analyst must not carry these dualistic distinctions too far. since the metaphysical and sociological values of paintings are not neatly parceled out in Yolngu conceptualizations of them. For example, in talking about clan designs, people may say, "That is your ownership, that is your power," implying that the designs are simultaneously objects of power and signs of ownership. In a society in which ancestral creativity underlies everything, ancestral creations inevitably become part of the way other things are defined. Paintings thus have this dual aspect of representing relationships between things and being integral to those relationships; the paintings, together with other mardayin components, set the terms in which things are going to be defined. In chapter 3, for example, I argued that a clan could best be defined as that set of people who hold a set of mardayin in common, and later I showed how claims of ownership over land were linked to rights in and control of knowledge over mardayin. It is in processes such as these, processes involving the cultural definition of social categories, that structural continuity is produced.

Paintings gain value and power through their incorporation in such a process, through being integral to the way a system (of clan-based gerontocracy) is reproduced, and through being part of its ideological support. Paintings gain power because they are controlled by powerful individuals, because they are used to discriminate between different areas of owned land, because they are used to mark status, to separate the initiated from the uninitiated and men from women. Their use in sociopolitical contexts creates part of their value. However, their value is also conceptualized in other terms, in terms of their intrinsic properties.

Von Sturmer (1987:64) takes up this issue in an interesting discussion of the power of songs in western Cape York Peninsula. He is particularly concerned with the relationship between songs and the personal power of the singer and concludes his discussion by defining the issue in the following terms: "Is it the song which allows the controller/owner and/or performer to produce the effects, or is it the power which is seen to be vested in the controller and/or performer which allows the song to produce its effects?" He concludes, rather as I have done, that these two dimensions of power come together in

events that have a certain definitional quality in which both dimensions of power are coimplied (p. 73).

In this conclusion I want to go beyond the simple statement that different dimensions of the power of paintings contribute to the power of paintings as a whole, to see if there are similarities in the way paintings operate in relation to their functions in different contexts of action (ritual/political). My basic argument is that, in relation to functions such as the encoding of meaning, integration with the system of restricted knowledge, and articulation with the political system, paintings operate by connecting the general with the particular, the collective with the individual, and that this connection is reflected in the formal and aesthetic properties of the system. The properties of paintings that are relevant to one context of their use are relevant to other contexts too; properties that are exploited in the system of encoding meaning are also central to the way in which paintings articulate with the system of knowledge and the system of clan organization. The implication is that we are dealing with a system that has been developed over a considerable period of time and which, though it is multiply determined, nevertheless has a unity as a system that crosscuts function. It is a unity that involves the operation of analagous processes and the exploitation of different potentialities of similar formal properties, in different contexts.

Paintings, Meaning, and the System of Knowledge

As we have shown in earlier chapters, Yolngu art as a system of encoding meaning articulates with the system of restricted knowledge. As a person (in the past, in particular, a man) moves through life, he gains increasing access to knowledge and to contexts in which knowledge can be acquired. The whole process of life in Yolngu terms can be seen as one of movement from the outside to the inside. As a person follows along this continuum, he moves from a position where meanings are defined for him to one in which he in turn influences the way things are presented to others; he moves to a position of potential creativity. Such creativity takes the form of deciding the order of ritual elements in a ceremony (see Morphy 1984), of determining the components of a painting, and of controlling the release of meanings to others, in the process of which meanings can be changed. The outside-inside continuum is associated with a movement from figurative to geometric art (see chap. 9). The most inside paintings are almost exclusively geometric, whereas the most outside ones have a high figurative content. There are some exceptions, some generalized geometric designs that are, relatively speaking, outside, and some

figurative paintings that are relatively inside, but the general trend is from inside geometric to outside figurative.

Paintings frequently occur in sets associated with particular places (see chap. 10). At the center of each set is an inside painting of geometric form that corresponds closely to the template underlying the set. Other paintings in the set are all outside relative to that painting. Paintings can be seen as versions of the template produced by selecting elements of meaning encoded at particular loci and representing those meanings by a figurative representation. For example, a whole complex of meanings was associated with the central section of the marrawili template (fig. 10.10)—emus, digging stick, lake, blood, Nyapililngu, and so on. In the three-digging-stick painting—the most inside painting of the set—the lake, the inland side of the lake, and the seaward side were all represented by a digging-stick-shaped sign, creating a predominantly geometric painting. In other paintings, different figures are selected to represent the respective loci. In figure 12.3, the central figure is a representation of a woman, Nyapililngu herself. Digging sticks continue to represent the seaward and inland sides of the lake, but in the context of the painting as a whole they have quite different outside connotations. The painting represents Nyapililngu using her digging sticks to walk up and down the sand dunes at Djarrakpi.

The power of the geometric art lies in both its multivalency and its ability to express an order of relationships between things that figurative representations cannot. Geometric elements at particular loci encode relationships between land forms and the mythological events that took place there, without giving priority to any one meaning. If the element is replaced by a figurative representation, then the multivalency is masked—priority is given to its figurative meaning.

Geometric art, through its multivalency and its encoding of relationships rather than things, establishes relationships between objects and events that at other levels seem unconnected. In particular, it can show relationships between things which are left unconnected in outside interpretations and in paintings modified for public consumption. For example, in the outside interpretations of the Djarrakpi paintings (see chap. 10), no connection is made between the wangarr emu and the female ancestor Nyapililngu. The two are associated with separate places in the outside stories—the emu with the lake bed and Nyapililngu with the sand dunes. In outside paintings this separation is confirmed, with Nyapililngu shown figuratively walking up and down the dunes and the emus looking for water. In inside interpretations, however, connections can be made between Nyapililngu and the emu.

The emu elsewhere on his journey created water holes by scratching in the ground. At Djarrakpi he was unable to find fresh water. He dug in the lake but discovered water already there—salt water. From other myths we learn that the salt water originated from the blood of Nyapililngu that flowed into the lake when she mourned her dead brother the guwak. Hence a connection between the emu and Nyapililngu begins to be established. It is not so much that the geometric art actively encodes the connection as that the figurative art, as it is used, obscures any link.

The paradox of Yolngu art is that the geometric representations are multivalent, but their interpretation is initially obscured by the non-iconic nature of the elements, whereas the figurative representations obscure the multiplex relationships between things by orienting interpretations in a particular direction. Nevertheless, I have shown how it is possible for a Yolngu man of knowledge to extend interpretations beyond the boundaries of the themes explicitly encoded in them. We have seen too how, once we have the key to a largely geometric painting, it then becomes readily interpretable. Thus, in the case of the digging-stick painting, the knowledge that each locus represents a position around the lake at Djarrakpi immediately establishes it as a grid onto which a series of external referents can be mapped, a grid to which knowledge gained from outside the artistic system can be applied. Knowledge of the landscape at Djarrakpi, of some of the mythological events that took place there, of the taste of the lake's water, and of the color of the sand in the lake's bed can all be applied once the basic structure is known. I suggest that much of the power of the geometric art, the inside art, lies in the fact that a painting that was previously unknown to an individual through its restriction, and that eludes immediate interpretation, provides a framework for encoding and showing the relationship between so many things learned separately in a wide variety of contexts. In this respect, Yolngu art is an ideal component of a system of restricted knowledge since it encodes a multiplicity of meanings and condenses them into abstract forms which become highly productive once the code is revealed.

Generality, Specificity, and Spiritual Power

The movement from inside to outside coincides largely though not entirely with the movements from generality to specificity, multivalency to univalency, ambiguity to individuation. Yolngu paintings, songs, dances, and sacred names have the capacity to connect the general with the particular: the same component is able to signify meanings at a high level of generality and at a precise level of specificity depending on context (see also Merlan 1987:149). The outside referents of things

tend to be concrete objects of the environment—particular places, social groups, and individuals. The power name of an object or ancestral being is a person's name, the design signifies a particular area of clan land, the dance strengthens people for an avenging expedition, and so on. The specificity of meaning of ritual elements comes to the fore in the organization of ritual, where the elements gain specific meanings in the context of sequences of ritual action directed toward particular objectives. The sequences of songs, for example, represent sets of people participating in the ceremony, the coffin painting represents a place on the soul's journey, the power names represent predeceased relatives called upon to assist the soul on its way, and the connotations of the dances reflect the emotions felt by the participants in the ceremony. Specificity is created partly on the outside because it is on the outside, relatively speaking, that things are used, and use causes that juxtaposition of themes, particular purposes, and known individuals that creates specific meaning (cf. Volosinov 1986:102). Of course this does not mean that generality cannot be reached in outside contexts. The potentiality for connecting meanings beyond their immediate referent always exists as a potential of Yolngu ritual, sometimes extending the meaning of ritual actions on an individual basis (see Morphy 1984). Generality, moreover, can enter the outside through the use of words like *mardayin*, "sacred," to end discussion about something, and specificity can enter the inside by locating the meaning of a word as one of the names of a particular ancestral being. However, the use of the word *mardayin* in outside contexts is a form of closure that refers to the inside, and the use of a word to refer to a specific ancestral being is in some respects the springboard for the generality of the inside. The ambiguity of the meaning of a Yolngu object or song-word (see Keen 1977) lies in part in the fact that meanings are spread out as a continuum from outside to inside. On the outside they refer to everyday things, to a particular species of tree, to a bird or an item of material culture; on the inside they refer to an ancestral being or manifestation of that being. Again the process is one of moving from specificity or individuation to generality and multivalency: ancestral beings provide a point of condensation for a number of chains of connected meaning, since the same ancestral being is the referent for many outside things. The tracing back of their connections brings them together at that supreme locus of connection, the ancestral past. As Munn (1973:212) writes of the Walbiri, "In the . . . design system or, more generally, when the graphs are directly linked in Walbiri thought with the ancestors, then the "connective" function of the visual elements may come to the fore and serve to release the boundaries between different meaning items and domains of experience."

The distinctions between the general and the specific can clearly be applied both to components of the form of paintings (see chap. 8) and to the different categories of paintings that are associated with different contexts. The more geometric paintings are the more general. As I have argued, figurative representations function partly to make explicit certain meanings encoded in the geometric art: they operate to fix meaning in a particular way. The underlying geometric paintings provide a structure for encoding meaning that, in association with an interpretative template, encodes multiple meanings at different loci and makes possible the creation of a network of connections and relationships between ancestral actions, landscape, theme, and social group. Specific meanings are produced in the geometric art by selecting certain relationships and focusing on certain meanings as opposed to others. The digging-stick painting becomes a map of Djarrakpi by the interpretation of various loci as geographical features. Specificity is produced by selecting out of the template, but the template itself provides the framework for cross-referencing and generalizing the meanings by placing landscape in the context of mythical action. The geometric art enables the complex relationship between ancestral event, time, and geographical space to be condensed into a single productive form. Nyapililngu is associated with both the lake and the sand dunes through her creative actions: the lake is her blood, the sand dunes were transformed from the possum-fur string she made, yet she in turn lived in and around the lake and the dunes. Nyapililngu had children at Djarrakpi, hid from men, and mourned the death of her brother the guwak. Connected with different themes of Yolngu life, these events, some of them contradictory, fill out the picture of Nyapililngu and create a reservoir of productive imagery. Replacing the central digging stick by a figurative representation of Nyapililngu reduces the multivalency and creates a specific image associated with a particular event: Nyapililngu climbing up and down the dunes.

The system of clan designs itself is also associated with the process. In chapter 8 I showed how at a general level a particular design—a diamond pattern or a circle-line motif—is associated with a particular ancestral being or complex of ancestral beings. Underlying the set of variants on a diamond design is the generalized concept of the design itself, which is not associated with any particular group or place but with the ancestor. In this case the generalized design can occur in outside contexts as an outlined, non-infilled body painting (see chap. 9). In contrast to the generalized diamond design, each clan's variant does signify precisely, representing a particular clan (an implicit section of a clan) and a particular area of that clan's territory.

In public contexts the association between clan design, ancestral

being, and land is said to be immutable, set in the ancestral past and extending into the future. In practice such associations are subject to political process, and relationships continually vary over time; groups die out, and others divide in two and take their place (see Morphy 1988). At the general level, however, ancestral connectivity is maintained. The same ancestral being will be associated with the land, only the particular connections with the social group will have to be remade. The Yolngu system of knowledge creates a space between the general and the particular where these adjustments can be made in such a way that political process is masked. Changes in the ownership of designs are acknowledged on the inside by the group of elders who have control of the men's ceremonial ground, and knowledge that changes have occurred is also contained on the inside until eventually it disappears from memory. When a new association occurs in public between design and social group, it will soon be recast in the form of something that always was. The sedimentation of the history of change on the inside gives the appearance that change (or nonchange) always originated on the inside, in harmony with the movement from the general to the particular, from the ancestral past to the present day. The space between the general and the particular is the space where political action occurs, where decisions are made as to which clan owns which design, who should have which name, which ritual element should be used in a particular ceremony, and which meaning should be told to an initiate.

When we look at the form of paintings as a whole then, the most general component is the final component that is added, cross-hatching. In isolation from any particular context, cross-hatching is something that produces a visual effect, bir'yun, that is associated with that ultimate general phenomenon, ancestral power. Cross-hatching creates that intense flash of light that is ancestral power. It is highly significant that in the past women were denied access to crosshatched paintings in their unmodified form and would have been able only to glimpse them at a distance or see them when their surface brilliance had been removed by smudging the design. In excluding women from seeing paintings in their crosshatched form, men were excluding women from direct access to one of the manifestations of ancestral power at its most general. The whole process of exclusion indeed was one in which men kept control of ancestral power to themselves. Women had contact with ancestral power when it was directed toward them: ancestral power entered their bodies in the form of conception spirits, ancestral power is manifest in their being through the blood of menstruation and afterbirth, but they were denied access to the contexts in which men produced the most general humanly controlled

manifestations of ancestral power and in which the general began its transformation into the specific.

The inside is simultaneously the most structured and the least structured space in the Yolngu system. It is created from within by exclusions, by controlling the process whereby people gain access to it, and it is maintained from the outside by the danger it emanates and by restrictions and constraints on where people can go and what they can do. Yet once the inside has been reached, it is the space of maximum freedom, the place where creativity is centered, and the origin of new arrangements and understandings that may eventually appear on the outside. Although I have been using the concept of inside space partly as a metaphor for the logical core of the system of knowledge, as the end point of the connections that lead from the outside to the inside and coincide with the point of ancestral creativity, Yolngu society involves a hierarchical structuring of space that articulates with the system of knowledge (see chap. 5). The hierarchy of space involves a movement from the totally unrestricted public space, where despite restrictions of avoidance relations and gender distance people are able to witness all that goes on, through partially restricted spaces, such as the place where a coffin lid is being painted, where temporary and partial barriers are created to the observation of what is going on, to the context of maximum exclusion—the men's ceremonial ground. And undoubtedly the men's ceremonial ground, which from the outside appears as a highly dangerous and restricted space, appears from the inside as a space of great freedom, of relaxation and humor. On the whole, people who gain freedom of access to the men's ceremonial ground have the maximum freedom of movement that Yolngu society allows. As Myers (1986:235) writes of the Pintupi, "Initiation is a step towards the possibility of exercising . . . autonomy."

Creativity and Change

The Yolngu artistic system, the expressions of the mardayin, exists in a state of creative tension. Yolngu art mediates between the ideology of immutable forms and order originating in the ancestral past and the reality of sociocultural change and political process. It is in part through the use of art that, to slightly modify Stanner's (1966:137) memorable phrase, "Society and cosmos [are] made correlative." Creativity is integral to the way in which Yolngu art is used, for as we have shown, its production involves the selection and organization of elements of the mardayin for particular purposes, and it is through their use in particular contexts that the mardayin are reproduced. We have also shown how Yolngu art is in a constant state of readjustment to current political realities, and how it is part of the way those new

realities are achieved and accorded recognition. It is also possible to see how changes have occurred which affect the form and meaning of paintings. The structure of the system permits the generation of an almost infinite set of outside paintings by the use of the template as the basis for creativity. The particular paintings that appear depend on the particular metaphor or theme being highlighted, the particular topographical relation that is focused on, and the particular combination of figurative and geometric representations used. The sets of Mangalili paintings we examined in the last few chapters showed how these processes operated to produce sets of related paintings.

Yolngu art has changed over time, in details of the form of paintings, in the meanings that are communicated, in the categories of people who are excluded from knowledge of painting, and in the contexts in which paintings are used. Song cycles that referred once to Macassan trepangers are now associated with the activities of mythological Europeans, referring, for example, to bulldozers being started rather than to iron being forged. Ancestral designs are continually applied to new contexts on new objects, to outboard motorboats and house-opening ceremonies, to coffin lids for Yolngu burials and to table mats for sale to Europeans. Yolngu art has gained an important economic role through the development of an art and craft industry and has perhaps had an even more important role in the political relations between Yolngu and their colonists. The struggle for land rights and the implementation of land-rights legislation has made the function of paintings in establishing relations between people, ancestral beings, and land no less important than ever it was. The tension of the system caused by the apparent contradictions between ancestral inheritance and sociopolitical realities has if anything increased since it has become a matter of debate in European courts of law (see Williams 1986). Some things that were masked by their restriction to the inside have had to be brought, at least temporarily, into the open and made more explicit than perhaps they once were. Art was part of a process of forgetting past connections and giving authority to present ones. When European courts demand to know the details and mechanisms of how such processes of succession and change of ownership take account of the exigencies of demographic change and political fortune, then such a masking process becomes no longer as possible. Paintings perhaps begin to function a little more like title deeds in the European sense, since they are required to operate in a context where Yolngu practice articulates with European law. Nonetheless they still continue to function in ways very different from European deeds in that they establish spiritual connections and responsibilities between people, land, and the ancestral domain. The Yolngu system has almost certainly always

accommodated to changes in the ownership of land; today more people have to know that it does.

The use of paintings in political and legal relations with the state and the increasing importance of the art and craft industry have both been factors underlying the shift in categories of paintings and the opening up of the inside that I discussed in chapter 9. Anything that enters into public relations between Yolngu men and European outsiders cannot be kept restricted from Yolngu women. If, as I have argued, men used their control over the mardayin to keep women as outsiders, then increased access to the mardayin may function to shift women toward the inside. Yolngu women from early on were actors in political relations with European colonists; women were signatories of the bark petition sent to Canberra asking for land rights, and from the 1960s onward, women took an increasingly important role in the production of art for sale. By the 1970s, women as well as men were inheriting rights to paintings from their fathers, proclaiming those rights, and beginning to exercise them in ceremonial as well as commercial contexts. Although these changes are clearly a consequence of European colonization in their timing and in the form in which they occurred, it would be wrong to see them as a consequence of the breakdown of the system through the release of paintings to outsiders. The changes began to occur well before the mining operations at Nhulunbuy presented a direct threat to the Yolngu way of life and autonomy. They are best seen as part of a relatively considered, though by no means universally adopted, attempt by certain Yolngu to, in Maddock's (1972:1) terms, "remodel their society" as a response to the emerging colonial situation. Yolngu attempted to incorporate Europeans within their world and to get them to enter discourse on their terms (see Berndt 1962; Maddock 1972; Morphy 1983b). In order to do this, certain barriers within Yolngu society had to be broken down and certain categories reformulated. Women's access to sacred knowledge became integral to this process. Europeans became a new element in the system, a new set of people who had to be incorporated within the inside-outside continuum, and perhaps relative to Europeans, women became part of the inside group. Certainly senior men did not refer to women's increased access to knowledge in negative terms, as a consequence of leaks in the system, but in positive terms in relation to women's attachment to their culture, the work they put into ceremonies and painting, the efforts they put into learning. The emphasis was perhaps shifting toward passing on a particular way of life and set of cultural practices that exist in opposition to the encroaching European world, rather than using access to knowledge as a means of marking the difference between men's and women's relationship to

the mardayin. Such a shift in access to the inside may not have been such a radical break with the past for two complementary and to a certain extent opposed reasons: the inside is not necessarily threatened by the release of knowledge, and women were always more inside than public ideology acknowledged.

In chapter 5 and chapter 10 I argued that as a system of meaning and value, knowledge was and is widespread. What people were denied access to were contexts in which knowledge was created and in which decisions were made about its use. They were denied access to certain forms, and the inside referent of certain objects and words, and they had no way of gauging how much there was to know. Power, however, resided not so much in the substance of the inside as in the control of the system of knowledge, and through the creation of an inside space that was the male domain. The inside space is generative, and while people possessing knowledge of the system still have the power to create and occupy it, objects can still flow from the inside to the outside without destroying the inside. Yolngu men continue to create inside spaces, continue to exclude outsiders in a systematic way from access to certain contexts, still indeed maintain the restrictedness of certain forms and certain meanings.

The current position of women in relation to the inside may represent a shift toward a position that has for long been implicit. I argued in chapter 12 that the ambiguity of women in Yolngu myth reflected underlying contradictions in the relations between Yolngu men and women. Female symbols lie at the heart of much Yolngu myth and ritual, female ancestral beings have a major role as autonomous generators of culture and society, yet women are excluded from inside contexts and were in the past excluded from access to the most powerful and direct manifestations of ancestral power, from blood, sacred objects, and cross-hatching. Women's access to ancestral power was mediated and modified, sounds were diffused, body paintings came out in modified form, the sacred objects had their messenger forms that were known more widely, but women were denied direct access to many of the ancestral women's most powerful creations. Women's increased access to the inside may be construed as a movement toward the ancestral position, bringing to the surface something that was previously implicit in some inside contexts. Indeed in contrast to the situation presented by Warner, some Yolngu elders referred to women as intrinsically sacred and as possessors of power.

A Final Parable

Overall, the sense I got during my fieldwork at Yirrkala was of a system in the process of continual adjustment and transformation as a conse-

quence of the impact of both colonialism and incorporation within the Australian political and economic system. Among the changes were transformations in the relations between men and women that could only be briefly considered in this book and which demand a study of their own. The artistic system has clearly undergone a process of transformation since the early days of effective European colonization in the 1930s. This is exemplified by the changes that have occurred in the categories of painting and in women's increased access to and involvement in the production of paintings. Many aspects of the system appear in continuity with the past; indeed I have argued that the art, rather than passively responding to external change, has been an integral part of the Yolngu response to colonialism. One sometimes gets a sense of the Yolngu trying to transform their system, trying to maintain control over the direction of their future, but being caught in an exponential spiral of external forces that threatens to make the process of adjustment impossible.

I began this book with a parable of change, the painting of a coffin lid, which if dated in relation to my fieldwork was set around 1973, shortly after the town of Nhulunbuy had been built. At the time, no Yolngu person in the Yirrkala region had died as a direct or indirect result of the effects of alcohol, certainly not since the departure of the last Macassan fleet. I conclude with another parable, the time set just before my most recent visit to Yirrkala in 1988. A few months before the visit, Narritjin's eldest grandson died. He was in his early twenties. A brilliant child and an outstanding athlete, he died as a result of being hit by a car after he had been drinking heavily. He was buried in his father's mother's country at Caledon Bay, an outstation removed from the mining town, a place where Yolngu have lived as hunters and gatherers from time immemorial and where it takes very little imagination to believe that the inhabitants still have control over their own destiny. I was told that instead of having a coffin painting, he was buried in a shroud made by one of his father's sisters, a beautiful batik cloth that she had designed from one of his clan's paintings. The form of the design was one that Narritjin had passed on to his children and one that the boy's father had often painted before his death. Narritjin's daughter learned to perfect batik designs away from Yirrkala, when as a teacher she visited a Central Australian Aboriginal community with a party of schoolchildren. She was able to produce the design because she had permission to do it, and the decision to use the batik in the burial ceremony involved consultations similar to those that would have taken place over a coffin-lid painting. She herself viewed it as a profound gift to her nephew. The use of the design in a new medium and its reintegration within an indigenous cultural context provide a

parable for Yolngu creativity and for the way they have tried to reincorporate change within their system. The fact that batik was used creates echoes back to when Yolngu traded with the Macassans and when Yolngu first used cloth in mortuary rituals; it acts as a parable for the length of time over which Yolngu have interacted with outsiders and the continuities that have been maintained along the way. That a woman made the design is a parable of the extent of women's involvement in the production of the art of their clan. But the death through alcohol of a young man whose father and grandfather had died only a short while before is a parable for the enormous odds that Yolngu face when confronting the intrusion of the European world into their daily lives.

Note on Orthography

The Yolngu orthography used here is a modified version of the practical orthography in general use in the Yolngu-speaking area.

Vowels

Yolngu dialects of the Yirrkala area have three short vowel phonemes and three corresponding long vowels which occur only in the first syllable of words. They are written as follows:

		short	*long*
high front		i	e
high back		u	o
low		a	aa

Consonants

Yolngu languages distinguish six places of articulation for stop and nasal consonants. There is also a phonemic glottal stop, written / ' /. The stops and consonants are written as follows:

	bilabial	*dorso-velar*	*alveolar*	*post-alveolar (retroflex)*	*lamino-dental*	*lamino-alveolar*
stops	p	k	t	rt	th	tj
	b	g	d	rd	dh	dj
nasals	m	ng	n	rn	nh	ny

In the dialects of the Yirrkala area there is a phonemic distinction between /rt/ and /rd/ between vowels in word-medial position (e.g.,

wartu "dog" vs. *wardutja* "quickly"). In more western dialects a similar distinction applies at all points of articulation. For Yirrkala dialects the voiced symbols (b, g, etc.) are written at the beginning of words and following nasals; elsewhere the voiceless symbols (p, k, etc.) are used, except for word-medial "rd" when it is appropriate. Clusters of the form /nasal + stop/ are simplified where possible for readability. For example /rnrd/ is written as "rnd." The cluster /n/ + /g/ is written "n.g" (as in the clan name Wan.guri) to distinguish it from the velar nasal which is written "ng."

Liquids and Semivowels

The dialects of the Yirrkala area have two rhotics ("r"-sounds), two laterals and the two semivowels /w/ and /y/. The laterals and rhotics are written as follows:

	alveolar	post-alveolar (retroflex)
laterals	l	rl
rhotics	rr	r

/rr/ is a trill, and /r/ is a continuant.

For further details on the phonetics and phonology of Yolngu dialects see F. Morphy 1983:12–25.

Glossary

Baapa Father, father's brother.

Baapurru A complex term with three distinct but related referents: (A) term applied to a group of patrilineally related kin; (B) term applied to clan rituals associated with a person's death; (C) corpse.

Bathi Container, (sacred) dilly bag.

Birrimbirr Dimension of the soul which becomes reincorporated within the ancestral domain.

Bir'yun To shimmer, shine, scintillate. Used to refer to the aesthetic effect of finely crosshatched paintings, which is interpreted as a manifestation of the **wangarr.**

Bulgu A category of painting identified by Thomson, characterized by the absence of cross-hatching.

Burrkun Yirritja moiety ceremonial string made from possum fur. Also refers to the gravel bank at Djarrakpi that was formed out of a length of burrkun laid down by the **guwak** in **wangarr** times.

Dhuwa Name of one of the moieties.

Djungguwan Name of a regionally based ceremony.

Djuwany A category of spirit people associated with Wuyal and the Wawilak sisters; the name given to the ceremonial posts erected during a **Djungguwan** ceremony.

Garma	Publicly performed enactments of the **wangarr,** especially songs and objects associated with mortuary ritual (see Warner 1958). *See also* **mardayin.**
Gutharra	As an egocentric kin term, the primary referent is daughter's child (female ego), sister's daughter's child (male ego). As with all Yolngu kin terms, it is applicable to a set of classifactory kin. It is also applied by an individual to the clan to which his or her gutharra belongs, and by extension to clans which occupy a structurally similar position within the regional network of marriage alliance. At a sociocentric level, the application of the term *gutharra* to one clan or segment of a clan by another reflects their relative positions in the regional network of marriage alliances. *See also* **maari,** its reciprocal term.
Guwak	Koel cuckoo; an ancestral being of the Yirritja moiety with both human and bird aspects. It is particularly associated with the symbolism of mortuary rituals.
Likan	Elbow, bay, fork (between branch and trunk of tree), connection, in a more abstract sense, with the **wangarr.**
Likanbuy	Associated with **likan;** refers to the category of painting most closely associated with the **wangarr.**
Maari	As an ego-centered kin term: mother's mother, mother's mother's brother. *See also* **gutharra,** its reciprocal term, for full range of meanings.
Maarr	Spiritual power.
Mada	*See* **matha.**
Mala	Group, set.
Mali	Shade, reflection, shadow.
Malli	*See* **mali.**
Manikay	Song(s), in particular public clan songs.
Mardayin	"Sacred law," in particular that which is restricted as opposed to **garma.**
Marrawili	The sacred cashew tree at Djarrakpi.
Matha	Tongue, word, speech, language.

Miny'tji	Design, painting.
Mokuy	(A) A category of supernatural being; (B) the ghost of a dead person.
Molk	Ceremonial ground associated with the **Djungguwan.**
Ngaarndi	As ego-centered kin term: mother, mother's sister. Applied by an individual to the clan from which her or his mother comes. Unlike **maari** and **gutharra,** is not applied by one clan to another.
Ngaarra	A ceremony of either moiety focused on clan identity.
Ngaarrapuy	Literally, "associated with the **Ngaarra**"; a category of painting identified by Thomson.
Ngaraka	Bone, hard core, sacred core.
Rangga	Sacred object.
Ranggapuy	Associated with **rangga.**
Waawa	Elder brother.
Wakinngu	A person, animal, or object in its mundane aspect.
Waku	As an egocentric kin term, own child (female ego); sister's child (male ego). Waku have particular responsibilities with respect to their **ngaarndi** (mother's) clan.
Wangarr	Ancestral being, world-creative force, time of world creation.
Yapa	As an egocentric kin term: sister (male ego); elder sister (female ego). Two clans of the same moiety refer to each other as *yapa* if they occupy a similar position in the regional system of marriage alliance. Unlike clans which are in a **maari-gutharra** relationship, their male members have potentially competing claims to marriage with women from the opposite moiety.
Yinga-pungapu	Yirritja moiety ceremonial ground associated with mortuary ritual.
Yirritja	Name of one of the moieties.
Yolngu	Aboriginal person or people; used as a term to refer to the people of Northeast Arnhem Land and to the group of related languages that they speak.

References

Altman, J. C. 1987. *Hunters and gatherers today: An Aboriginal economy in North Australia.* Canberra: Australian Institute of Aboriginal Studies.

Barth, F. 1975. *Ritual and knowledge among the Baktaman of New Guinea.* New Haven: Yale University Press.

Barthes, R. 1972. *Mythologies.* London: Paladin.

Bateson, G. 1973. Style, grace and information in primitive art. In A. Forge, ed., *Primitive art and society,* 235–55. Oxford: Oxford University Press.

Bern, J. 1979. Ideology and domination: Towards a reconstruction of the Australian Aboriginal social formation. *Oceania* 50:118–32.

Berndt, C. H. 1965. Women and the secret life. In R. M. Berndt and C. H. Berndt, eds., *Aboriginal man in Australia,* 236–82. Sydney: Angus and Robertson.

Berndt, R. M. 1951. *Kunapipi.* Melbourne: Cheshire.

——. 1955. "Murngin" (Wulamba) social organization. *American Anthropologist* 57(1): 84–106.

——. 1962. *An adjustment movement in Arnhem Land.* Paris: Mouton.

——. 1976. *Love songs of Arnhem Land.* Melbourne: Nelson.

Berndt, R. M., and C. H. Berndt. 1954. *Arnhem Land: Its history and its people.* Melbourne: Cheshire.

Bernstein, B. B. 1971. On the classification and framing of educational knowledge. In M. F. D. Young, ed., *Knowledge and control,* 47–69. London: Collier/Macmillan.

Biernoff, D. 1974. Safe and dangerous places. In L. R. Hiatt, ed., *Australian Aboriginal concepts,* 93–105. Canberra: Australian Institute of Aboriginal Studies.

Chaseling, W. 1957. *Yulengor.* London: Epworth Press.

Clunies-Ross, M. 1989. Holding onto emblems: Australian Aboriginal performances and the transmission of oral traditions. In R. Layton, ed., *Who needs a past?: Indigenous values and archaeology,* 162–68. London: Unwin Hyman.

Clunies-Ross, M., and L. R. Hiatt. 1977. Sand sculptures at a Gidjingali burial rite. In P. J. Ucko, ed., *Form in indigenous art: Schematisation in the art of Aboriginal Australia and prehistoric Europe*, 131–46. Canberra: Australian Institute of Aboriginal Studies.

Cohen, A. 1979. Political symbolism. In *Annual Review of Anthropology*, vol. 8. Palo Alto, Calif.: Annual Reviews.

Coward, R., and J. Ellis. 1977. *Language and materialism*. London: Routledge and Kegan Paul.

Dunlop, I. 1981a. *Narritjin in Canberra*. Sydney: Film Australia.

———. 1981b. *Narritjin at Djarrakpi, Part 2*. Sydney: Film Australia.

———. 1987. *One man's response*. Sydney: Film Australia.

———. 1990. *Djungguwan at Gurka'wuy*. Sydney: Film Australia.

Durkheim, E. 1954. *The elementary forms of the religious life*. London: Allen and Unwin.

Eco, U. 1976. Peirce's notion of the interpretant. *MLN* 91: 1457–72.

———. 1984. *Semiotics and the philosophy of language*. London: Macmillan.

Elkin, A. P. 1961. Maraian at Mainoru. *Oceania* 32:1–15.

Elkin, A. P., R. M. Berndt, and C. H. Berndt. 1950. *Art in Arnhem Land*. Melbourne: Cheshire.

Faris, J. 1972. *Nuba personal art*. London: Duckworth.

Fernandez, J. W. 1977. The performance of ritual metaphors. In J. D. Sapir and J. C. Crocker, eds., *The social use of metaphors: Essays on the anthropology of rhetoric*, 100–31. Philadelphia: University of Pennsylvania Press.

Forge, J. A. W. 1966. Art and environment in the Sepik. *Proceedings of the Royal Anthropological Institute, 1965*, 23–51.

———. 1973. Introduction. In A. Forge, ed., *Primitive art and society*, xiii–xxii. Oxford: Oxford University Press.

———. 1979. The problem of meaning in art. In S. M. Mead, ed., *Exploring the visual arts of Oceania*, 278–86. Honolulu: University of Hawaii Press.

Geertz, C. 1975. *The interpretation of cultures*. New York: Basic Books.

Giddens, A. 1979. *Central problems in sociological theory: Action, structure and contradiction in social analysis*. London: Macmillan.

Gillison, G. 1980. Images of nature in Gimi thought. In J. MacCormack and M. Strathern, eds., *Nature, culture and gender*, 143–73. Cambridge: Cambridge University Press.

Goffman, I. 1974. *Frame analysis*. London: Penguin.

Graburn, N., ed. 1976. *Ethnic and tourist arts: Cultural expressions from the Fourth World*. Berkeley: University of California Press.

Gregory, C. A. 1982. *Gifts and commodities*. London: Academic Press.

Groger-Wurm, H. 1973. *Australian Aboriginal bark paintings and their mythological interpretations*, vol. 1: *Eastern Arnhem Land*. Canberra: Australian Institute of Aboriginal Studies.

Guss, D. 1989. *To weave and sing: Art, symbol and narrative in the South American rain forest*. Berkeley: University of California Press.

Hamilton, A. 1970. The role of women in Aboriginal marriage arrangements. In F. Gale, ed., *Woman's role in Aboriginal society*, 28–35. Canberra: Australian Institute of Aboriginal Studies.

Herdt, G. 1990. Secret societies and secret collectives. *Oceania* 60:361–81.

Hiatt, L. R. 1965. *Kinship and conflict*. Canberra: Australian National University Press.

———, ed. 1984. *Aboriginal land owners: Contemporary issues in the determination of traditional Aboriginal land ownership*. Oceania Monograph No. 27. Sydney: Oceania Publications.

Hodder, I. 1982. *Symbols in action*. Cambridge: Cambridge University Press.

Holm, B. 1965. *North West Coast Indian art: An analysis of form*. Seattle: University of Washington Press.

Humphrey, C. 1973. Some ideas of Saussure applied to Buryat magical drawings. In E. Ardener, ed., *Social anthropology and language*, 271–90. London: Tavistock.

Jones, P. 1988. Perceptions of Aboriginal art: A history. In P. Sutton, ed., *Dreamings: The art of Aboriginal Australia*, 143–79. Ringwood, Victoria: Viking.

Keen, I. 1977. Ambiguity in Yolngu religious language. *Canberra Anthropology* 1:33–50.

———. 1978. One ceremony one song: An economy of religious knowledge among the Yolngu of North-East Arnhem Land. Ph.D. diss., Australian National University, Canberra.

———. 1982. How some Murngin men marry ten wives: The marital implications of matrilateral cross-cousin structures. *Man* (n.s.) 17:620–42.

———. 1986. New perspectives on Yolngu affinity: A review article. *Oceania* 56(3): 218–30.

———. 1988. Yolngu religious property. In T. Ingold, J. Woodburn, and D. Riches, eds., *Hunters and gatherers: Property, power and ideology*, 272–91. Oxford: Berg.

Keesing, R. M. 1979. Linguistic knowledge and cultural knowledge: Some doubts and speculations. *American Anthropologist* 81:14–36.

Kubler, G. 1962. *The shape of time*. New Haven: Yale University Press.

Kupka, K. 1965. *The dawn of art*. New York: Viking Press.

La Fontaine, J. S. 1985. *Initiation: Ritual drama and secret knowledge across the world*. Manchester: Manchester University Press.

Love, S. 1953. Narrative of a journey through Arnhem Land in 1910. *Victorian Historical Magazine*, December.

McKeown, K. C. 1945. *Australian insects: An introductory handbook*. Sydney: Royal Zoological Society of New South Wales.

Maddock, K. 1969. Alliance and entailment in Australian marriage. *Mankind* 7:19–27.

———. 1970. Rethinking the Murngin problem: A review article. *Oceania* 41:77–87.

———. 1972. *The Australian Aborigines: A portrait of their society*. London: Allen Lane.

———. 1980. *Anthropology, law, and the definition of Australian Aboriginal rights to land*. Nijmegen: Katholieke Universiteit.

Merlan, F. 1987. Catfish and alligator: Totemic songs of the western Roper River, Northern Territory. In M. Clunies-Ross, T. Donaldson, and S. Wild,

eds., *Songs of Aboriginal Australia,* 142–67. Oceania Monograph No. 32. Sydney: Oceania Publications.

Morphy, F. 1983. Djapu: A Yolngu dialect. In R. M. W. Dixon and B. Blake, eds., *Handbook of Australian languages,* 3:1–188. Canberra: Australian National University Press.

Morphy, H. 1977a. From schematisation to conventionalisation: A possible trend in Yirrkala bark paintings. In P. J. Ucko, ed., *Form in indigenous art: Schematisation in the art of Aboriginal Australia and prehistoric Europe,* 182–204. Canberra: Australian Institute of Aboriginal Studies.

————. 1977b. Schematisation, meaning and communication in toas. In P. J. Ucko, ed., *Form in indigenous art: Schematisation in the art of Aboriginal Australia and prehistoric Europe,* 77–89. Canberra: Australian Institute of Aboriginal Studies.

————. 1977c. Yingapungapu: Ground sculpture as bark painting. In P. J. Ucko, ed., *Form in indigenous art: Schematisation in the art of Aboriginal Australia and prehistoric Europe,* 205–9. Canberra: Australian Institute of Aboriginal Studies.

————. 1978. Rights in paintings and rights in women: A consideration of some of the basic problems posed by the asymmetry of the "Murngin" system. In J. Specht and P. White, eds., *Trade and exchange in Oceania and Australia,* 208–19. Special issue of *Mankind,* vol. 11.

————. 1980. What circles look like. *Canberra Anthropology* 3:17–36.

————. 1983a. Aboriginal fine art, the creation of audiences and the marketing of art. In P. Loveday and P. Cook, eds., *Aboriginal arts and crafts and the market,* 37–43. Darwin: North Australian Research Unit.

————. 1983b. "Now you understand": An analysis of the way Yolngu have used sacred knowledge to retain their autonomy. In N. Peterson and M. Langton, eds., *Aborigines, land, and land rights,* 110–33. Canberra: Australian Institute of Aboriginal Studies.

————. 1984. *Journey to the crocodile's nest.* Canberra: Australian Institute of Aboriginal Studies.

————. 1987. Audiences for art. In A. Curthoys, A. W. Martin, and T. Rowse, eds., *Australians: A historical library. From 1939,* 167–75. Sydney: Fairfax, Syme and Weldon Associates.

————. 1988. Maintaining cosmic unity: Ideology and the reproduction of Yolngu clans. In T. Ingold, J. Woodburn, and D. Riches, eds., *Hunters and gatherers: Property, power and ideology,* 249–71. Oxford: Berg.

————. 1989. From dull to brilliant: The aesthetics of spiritual power among the Yolngu. *Man* (n.s.) 24(1): 21–40.

————. 1990. Myth, totemism, and the creation of clans. *Oceania* 60:312–28.

Morphy, H., and R. Layton. 1981. Choosing among alternatives: Cultural transformation and social change in Aboriginal Australia and the French Jura. *Mankind* 13:56–73.

Munn, N. D. 1962. Walbiri graphic signs: An analysis. *American Anthropologist* 64(5): 972–84.

————. 1966. Visual categories: An approach to the study of representational systems. *American Anthropologist* 68:936–50.

———. 1969. The effectiveness of symbol in Murngin rite and myth. In R. F. Spencer, ed., *Forms of symbolic action: Proceedings of the 1968 annual spring meeting of the American Ethnological Society,* 178–207. Seattle: University of Washington Press.

———. 1970. The transformation of subjects into objects in Walbiri and Pitjantjatjara myth. In R. M. Berndt, ed., *Australian Aboriginal anthropology,* 178–207. Nedlands: University of Western Australia Press.

———. 1973. *Walbiri iconography.* Ithaca: Cornell University Press.

———. 1986. *The fame of Gawa.* Cambridge: Cambridge University Press.

Myers, F. R. 1986. *Pintupi country, Pintupi self: Sentiment, place and politics among Western Desert Aborigines.* Washington, D.C.: Smithsonian Institution.

———. 1988. The logic and meaning of anger among Pintupi Aborigines. *Man* (n.s.) 23:589–610.

Parmentier, R. J. 1987. *The sacred remains: Myth, history and polity in Belau.* Chicago: University of Chicago Press.

Peirce, C. S. 1955. *Philosophical writings.* Ed. J. Buchner. New York: Dover.

Peterson, N. 1972. Totemism yesterday: Sentiment and local organisation among the Australian Aborigines. *Man* (n.s.) 7:12–32.

———. 1976. Mortuary customs of North-East Arnhem Land: An account compiled from Donald Thomson's fieldnotes. *Memoirs of the National Museum of Victoria* 37:97–108.

———. 1985. Capitalism, culture and landrights: Aborigines and the State in the Northern Territory. *Social Analysis* 18:85–101.

———. 1986. *Australian Aboriginal territorial organisation.* Oceania Monograph No. 30. Sydney: Oceania Publications.

Peterson, N., I. Keen, and B. Sansom. 1977. Succession to land: Primary and secondary rights to Aboriginal estates. In *Hansard report of the Joint Select Committee on Aboriginal Land Rights in the Northern Territory, 19th April 1977,* 1002–14. Canberra: Government Printer.

Peterson, N., and M. Langton, eds. 1983. *Aborigines, land and land rights.* Canberra: Australian Institute of Aboriginal Studies.

Reid, J. 1983. *Sorcerers and healing spirits.* Canberra: Australian National University Press.

Rudder, J. 1980. The song of the turtle rope. *Canberra Anthropology* 3:37–47.

Sahlins, M. 1981. *Historical metaphors and mythical realities.* Ann Arbor: University of Michigan Press.

———. 1986. *Islands of history.* Chicago: University of Chicago Press.

Salvador, M. L. 1976. The clothing arts of the Cuna of San Blas, Panama. In N. Graburn, ed., *Ethnic and tourist arts: Cultural expressions from the Fourth World,* 165–82. Berkeley: University of California Press.

Saussure, F. de. 1966. *Course in general linguistics.* London: Fontana.

Schebeck, B. N.d. Dialect and social grouping in North-East Arnhem Land. Australian Institute of Aboriginal Studies, Canberra. Manuscript.

Schechner, R. 1981. The restoration of behavior. *Studies in Visual Communication* 7(3): 2–45.

Schutz, A. 1962. *Collected papers,* vol. 1: *The problem of social reality.* The Hague: Martinus Nijhoff.

Shanks, M., and C. Tilley. 1987. *Social theory and archaeology.* Oxford: Polity Press.

Shapiro, W. 1967. Relational affiliation in "unilineal" descent systems. *Man* (n.s.) 12:161–63.

———. 1969. Miwuyt marriage: Social structural aspects of the bestowal of females in Northeast Arnhem Land. Ph.D. diss., Australian National University, Canberra.

———. 1970. Local exogamy and the wife's mother in Aboriginal Australia. In R. M. Berndt, ed., *Australian Aboriginal anthropology,* 51–69. Nedlands: University of Western Australia Press.

———. 1981. *Miwuyt marriage: The cultural anthropology of affinity in Northeast Arnhem Land.* Philadelphia: ISHI.

Silverstein, M. 1976. Shifters, linguistic categories and cultural description. In K. H. Basso and H. A. Selby, eds., *Meaning in Anthropology,* 11–55. Albuquerque: University of New Mexico Press.

Simmel, G. 1950. The secret and the secret society. In K. H. Wolff, ed., *The sociology of George Simmel.* Glencoe, Ill.: Free Press.

Sperber, D. 1976. *Rethinking symbolism.* Cambridge: Cambridge University Press.

Stanner, W. E. H. 1966. *On Aboriginal religion.* Oceania Monograph No. 11. Sydney: Oceania Publications.

———. 1967. Reflections on Durkheim and Aboriginal religion. In M. Freeman, ed., *Social organisation: Essays presented to Raymond Firth,* 217–40. London: Cass.

Strathern, M. 1985. Knowing power and being equivocal: Three Melanesian contexts. In R. Fardon, ed., *Power and knowledge: Anthropological and sociological perspectives,* 61–82. Edinburgh: Scottish Academic Press.

Taylor, L. 1987. "The same but different": Social reproduction and innovation in the art of the Kunwinjku of Western Arnhem Land. Ph.D. diss., Australian National University, Canberra.

———. 1988. The aesthetics of toas: A cross-cultural conundrum. *Canberra Anthropology* 11:86–99.

———. 1989. Seeing the "inside": Kunwinjku paintings and the symbol of the divided body. In H. Morphy, ed., *Animals into art,* 371–89. London: Unwin Hyman.

Thomson, D. F. 1939a. Notes on the smoking pipes of North Queensland and the Northern Territory of Australia. *Man* (o.s.) 39:81–91.

———. 1939b. Two painted skulls from Arnhem Land, with notes on the totemic significance of the designs. *Man* (o.s.) 39:1–3.

———. 1949a. Arnhem Land: Explorations among an unknown people. Part 2: The people of Blue Mud Bay. *Geographical Journal* 113:21–28.

———. 1949b. *Economic structure and the ceremonial exchange cycle in Arnhem Land.* Melbourne: Macmillan.

———. 1961. "Marrngitjmirri" and "galka"—medicine men and sorcerer—in Arnhem Land. *Man* (o.s.) 61:97–102.

———. 1975. The concept of "marr" in Arnhem Land. *Mankind* 10:1–10.

———. 1983. *Donald Thomson in Arnhem Land.* Melbourne: Curry O'Neil.

Turner, D. H. 1974. *Tradition and transformation.* Canberra: Australian Institute of Aboriginal Studies.

Turner, V. W. 1974. *Dramas, fields and metaphors.* Ithaca, N.Y.: Cornell University Press.

――――. 1982. *From ritual to theatre: The human seriousness of play.* New York: Performing Arts Journal Publications.

Volosinov, V. N. 1986. *Marxism and the philosophy of language.* Cambridge: Harvard University Press.

von Sturmer, J. 1987. Aboriginal singing and notions of power. In M. Clunies-Ross, T. Donaldson, and S. Wild, eds., *Songs of Aboriginal Australia*, 63–76. Oceania Monograph No. 32. Sydney: Oceania Publications.

Warner, W. L. 1958. *A black civilization.* Chicago: Harper and Row.

Webb, T. T. 1938. *Spears to spades.* Melbourne: Methodist Overseas Mission.

――――. N.d. Aborigines and adventure in Arnhem Land. Australian Institute of Aboriginal Studies, Canberra. Manuscript.

Wells, A. E. 1971. *This is their dreaming.* St. Lucia: University of Queensland Press.

Wells, E. 1982. *Reward and punishment in Arnhem Land.* Canberra: Australian Institute of Aboriginal Studies.

Williams, N. M. 1976. Australian Aboriginal art at Yirrkala. In N. Graburn, ed., *Ethnic and tourist arts: Cultural expressions from the Fourth World*, 266–84. Berkeley: University of California Press.

――――. 1985. On Aboriginal decision-making. In D. Barwick, J. Beckett, and M. Reay, eds., *Metaphors of interpretation: Essays in honour of W. E. H. Stanner*, 240–68. Canberra: Australian National University Press.

――――. 1986. *The Yolngu and their land: A system of land tenure and its fight for recognition.* Canberra: Australian Institute of Aboriginal Studies.

Williams, N. M., and D. Mununggurr. 1989. Understanding Yolngu signs of the past. In R. Layton, ed., *Who needs a past? Indigenous values and archaeology*, 70–83. London: Unwin Hyman.

Young, M. W. 1987. Malinowski and the function of culture. In D. Austin-Broos, ed., *Creating culture*, 124–40. Sydney: Allen and Unwin.

Index

Aboriginal artist, conflicting conceptions of, 29

Aboriginal fine art: changing market, 24; changing status, 28; characteristics of market, 23; defined by market, 21, 22

Adjustment movement. *See* Elcho Island

Aesthetics: of ancestral power, 299; European preferences, 26, 28; integrated within the purposes of ritual, 100. See also *Bir'yun*

Alcohol, 27, 304–5; effect on individual rights, 65

Ancestral beings: control over, 105; moiety-based, 44; paintings integral to, 102. *See also* Barrama; Birrimbirr spirit; *Birrkurda;* Crocodile; Djan'kawu; Emu; *Guwak;* Laanydjung; Mangrove tree ancestor; *Mikararn; Mundukul; Nguykal;* Possum; Shark; Wawilak sisters; *Wititj;* Wuyal

Ancestral designs, 131. *See also* Paintings

Ancestral events: depicted in paintings, 116; and phases of ritual, 128

Ancestral past: as the locus of connection, 297; paintings as dimension of, 292; spirit reincorporated within, 109; yingapungapu as manifestation of, 251

Ancestral power, (*maarr*), 83, 102; and the "brilliance" of a painting, 194; the danger from, 95, 102–3; in the Djungguwan ceremony, 133; fear and death as components of, 273; human use of, 134; marrawili paintings as source of, 271; the moral nature of, 107; transfer of, 283

Ancestral track, extension of, 72

Arena, concept of, 27; local, 27

Art: categories of, 21, 181–213; changes in categories, 4; closed and open contexts, 2, 4, 25, 182; commercial, 201, 202; contemporary contexts, 198; control maintained by men, 207; opening out of, 25, 202; as an ordering structure, 8, 180, 292; sale of, 2, 17, 20, 25, 36, 196, 202; theoretical approaches to, 6, 7. *See also* Figurative representations; Geometric representations; Categories of painting

Art and handicraft production: as part of outstation economy, 42; mission attitude to, 16; moral dimension, 29; sale at Nhulunbuy airport, 11

Artists. *See* Banapana; Bokarra; Bumiti; Durndiwuy; Liyawulumu; Lumaluma 2; Maaw'; Magani; Marrkarakara; Mawalan; Mithili; Narritjin; Welwi; Wuyarrin

Australian Museum, 204

Australian National Gallery, 23

Australian National University, 36; gift of painting to, 37

Australian society: Yolngu art and, 13; Yolngu incorporation in, 13